William Spencer Hamer

26 June 2005

Tintoretto

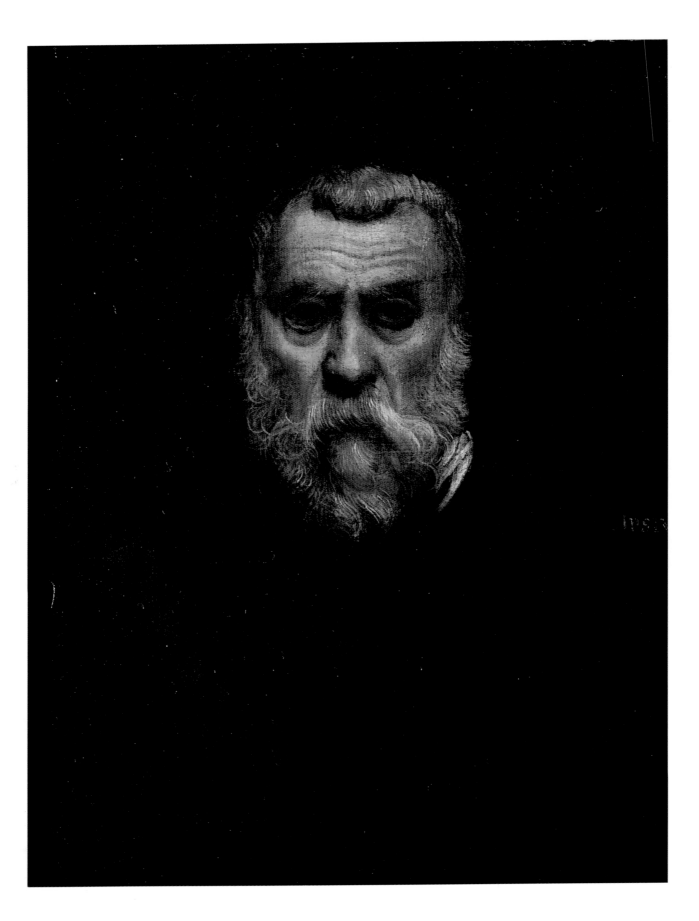

Tintoretto

Tradition and Identity

Tom Nichols

REAKTION BOOKS

For Olivia and Joseph

Published by Reaktion Books
79 Farringdon Road
London ECIM 3JU, UK
www.reaktionbooks.co.uk

First published 1999

Designed by Andrew Barron & Collis Clements Associates
Typeset in Ehrhardt
Printed and bound in Italy by Conti Tipocolor

British Library Cataloguing in Publication Data

Nichols, Tom
 Tintoretto: tradition and identity
 1. Tintoretto, 1518–1594 2. Painters – Italy – Venice –
 Biography 3. Painting, Renaissance – Italy – Venice
 4. Painting, Italian – Italy – Venice
 I. Title
 759.5
 ISBN 1 86189 043 5

Frontispiece
1 Jacopo Tintoretto, *Self-Portrait*, c. 1589,
oil on canvas, 62.5 × 52.
Musée du Louvre, Paris.

Contents

Chronology

1519

Jacopo Robusti (Tintoretto) is born in Venice, son of the cloth dyer Giovanni Battista Robusti, whose ancestors may have originated in Lucca.

1530–39

Tintoretto probably enters the workshop of Titian (*c.* 1490–1576) during this period. But the apprenticeship lasts only a very short time, and it is likely that Tintoretto transfers to another Venetian workshop in order to complete his training. Tintoretto signs himself as 'Master Giacomo, painter in the Campo di S. Cassiano' on an act of testimony dating from 22 May 1539, indicating that by this point he is already practising as an independent painter.

1540

Tintoretto paints the *Virgin and Child with the Infant Baptist and Sts Joseph, Elizabeth, Zacharias, Catherine and Francis*. He signs himself 'Iachobus' near to a stylized symbol of a wheel, which is probably a reference to the process of dyeing and thus to the occupation of his father.

1541–4

Tintoretto fulfils a number of mostly minor commissions, including work on furniture paintings and façade frescoes (sometimes in collaboration with Andrea Schiavone, *c.* 1515–63) and an altarpiece for the trade Scuola of the Venetian Fishmongers. His most progressive pictures from this period are large-scale paintings of the new horizontal (*laterale*) type, such as the *Conversion of St Paul* and the *Christ Among the Doctors*. Perhaps his most prestigious commission is from the young Venetian patrician Vettore Pisani who orders a set of sixteen octagonal ceiling paintings for a room in his palace at San Paternian.

1545–6

On 15 February 1545, the famous Tuscan writer and man of letters Pietro Aretino, who had been resident in Venice since the sack of Rome in 1527, writes thanking Tintoretto for the two ceiling paintings he had made for the bedroom of his house on the Grand Canal (Palazzo Bollani). One of these, showing the *Contest Between Apollo and Marsyas*, is probably identifiable with the painting now in Hartford (Wadsworth Athenaeum). Three Tintoretto portraits (*Nicola Doria*, *Gentleman Aged 25* and *Bearded Man*) date from these years.

1547–8

In August 1547 Tintoretto completes his first version of the *Last Supper* for the Venetian church of San Marcuola. His patrons are the Scuola del Sacramento attached to the church. Equivalent Venetian scuole of this humble parish-based type are subsequently to employ Tintoretto on at least eight further occasions in the course of his career. By April of the following year Tintoretto completes his *Miracle of the Slave* for the Scuola Grande di San Marco. The painting is controversial and is initially returned as unacceptable. In a letter, Aretino praises Tintoretto's realism in the painting but also criticizes his hasty execution. Perhaps in response to Aretino's attack, Tintoretto's long-standing friend and supporter in the Scuola di San Marco, the comic playwright Andrea Calmo (1510–71), writes to the painter praising his ability to 'portray a figure from nature in half an hour'.

1549–53

Probably around 1550, Tintoretto marries Faustina, daughter of Marco Episcopi, whom he had met in the course of his commission at the Scuola Grande di San Marco (Marco Episcopi held office as guardian da matin in the confraternity in 1547). In these years, Tintoretto consolidates his new-found status as a city-wide painter, fulfilling his first commissions for the Scuola Grande di San Rocco (1549) and the Augustinian Canons of San Giorgio in Alga (the organ shutters for the Madonna dell' Orto, 1552–6). In 1550, Tintoretto works on his first recorded official commission for some portraits for the state procuracies, and this is followed in 1552–3 by votive paintings for the Palazzo dei Camerlenghi (Treasurers' Palace), and a contribution to the on-going Alexander cycle in the Sala del Maggior Consiglio of the Ducal Palace (probably showing the *Excommunication of Frederick Barbarossa*, destr. 1577). Tintoretto's professional friendship with Anton Francesco Doni (1513–74), the Florentine *poligrafo* resident at Venice, is at its height.

1554–8

Tintoretto's eldest daughter, the painter Marietta (d. 1590), is probably born in 1554. In the following year the family are living in the district of San Marziale, where they rent the lower floor of a house owned by Baldissera di Mastelli. Tintoretto's official paintings in the Palazzo dei Camerlenghi and the Ducal Palace are criticized in Francesco Sansovino's *Delle cose notabili che sono in Venetia* (1556, published under the pseudonym Anselmo Guisconi) and Ludovico Dolce's *Dialogo della pittura* (1557). In 1556 Tintoretto is excluded from the commission to paint ceiling roundels in the Reading Room of the Libreria Marciana.

1559–61

In 1559 Tintoretto completes a second painting for the confraternity church of the Scuola Grande di San Rocco (*The Pool of Bethesda*). In the following year, he paints a portrait of *Doge Girolamo Priuli* for the Council of Ten, a commission which confirms his role as a leading state painter. Tintoretto and his workshop are almost continually employed in the official domain over the course of the following three decades. Tintoretto completes the *Marriage at Cana* for the order of the Crociferi in 1561. His two painter sons, Domenico (d. 1635) and Marco (d. 1637), are born in 1560 and 1561 respectively.

1562–6

In June 1562 Tommaso Rangone (1493–1576), Guardian Grande of the Scuola Grande di San Marco, commissions three further paintings from Tintoretto for the Sala Capitolare of the Meeting House. Around this time, Tintoretto is also at work on two enormous vertical canvases for the choir of Madonna dell' Orto, apparently winning the commission by offering to make the paintings for the nominal sum of 100 ducats. In June 1564, Tintoretto donates a ceiling painting showing *St Roch in Glory* to the Scuola Grande di San Rocco. It is likely that his gift was offered as a means of collapsing an artistic competition organized by the scuola a few weeks earlier. Having completed the rest of the albergo ceiling, Tintoretto goes on to paint the huge *Crucifixion* in 1565, and three further paintings for the entrance wall in 1566–7. On 11 March 1565 he is admitted to the confraternity, going on to serve as deacon and syndic in the course of the next eighteen months (the first of many positions he is to hold on the ruling bodies of the scuola). In October 1566 Tintoretto is admitted to the Florentine Accademia del Disegno.

1567–71

In 1567 Tintoretto completes two further paintings for the church of San Rocco. In the same year he paints a portrait of *Ottavio Strada*, who is on a visit to Venice with his father, Jacopo, antiquary to the Holy Roman Emperor Maximilian II (1527–76). He is commissioned to paint two *laterali* for the Scuola del Sacramento in San Cassiano, and supplies the first of many cartoons to the mosaicists in St Mark's (showing the *Last Supper* and the *Marriage at Cana*). A further commission from Tommaso Rangone is agreed, but the painting is never executed. In 1571, Tintoretto is at work on a series of nine *Philosophers* for the Vestibule of the Libreria Marciana.

1572–4

In 1572, Tintoretto donates a large battle painting showing the *Battle of Lepanto* (destr. 1577) to the Ducal Palace. Following his submission of two petitions to the Council of Ten, Tintoretto is granted the expectation of the next available *sansaria* (a salary of 117 ducats paid by the Venetian Salt Office to the state's preferred official painter) in September 1574. The petitions record that Tintoretto has eight children. In June 1574, the family move to a house on the Fondamenta dei Mori in the parish of San Marziale, although the property is purchased by Tintoretto's father-in-law, Marco Episcopi. In the following month Tintoretto receives a number of commissions from the visiting French monarch, Henri III.

1575–8

On 2 July 1575 the Scuola Grande di San Rocco accept Tintoretto's offer to make the central ceiling painting for the Sala Superiore of the Meeting House (showing the *Brazen Serpent*). In January and March 1577, the scuola accepts Tintoretto's proposals to complete the ceiling and on 2 December accepts his further offer to dedicate the rest of his working life to the completion of all further paintings required for the confraternity Meeting House and church. Tintoretto offers to submit three paintings each year (by 16 August, the feast day of St Roch) in return for a lifelong stipend of 100 ducats. He begins work on the first paintings for the walls of the Sala Superiore in 1578. In 1577–8, Tintoretto is also working on the re-decoration of the Ducal Palace following the fires of 1574 and 1577, producing frescoes for the Sala del Quattro Porte and four political allegories for the Sala dell'Atrio Quadrato. In this period, too, he wins his first significant commissions from foreign courtly patrons, painting four battle scenes for Guglielmo Gonzaga of Mantua (1538–87), and a series of four paintings illustrating the life of Hercules for the Holy Roman Emperor, Rudolf II (1552–1612).

1579–82

Perhaps the busiest period of Tintoretto's career. With the help of a workshop which now includes his children Domenico, Marco and Marietta, Tintoretto completes another set of four paintings for the Mantuan Ducal Palace. In September 1580 he is present in Mantua to oversee their installation, his only recorded trip away from Venice. Throughout this period, Tintoretto and his workshop are at work in the Ducal Palace, producing replacement votives, allegories and battle paintings for the Sala del Collegio and Sala del Maggior Consiglio. Tintoretto also enters an artistic competition to paint the enormous *Paradise* in the latter room, but is defeated by Veronese and Francesco Bassano. In accordance with the terms agreed in 1578, Tintoretto completes

the wall paintings in the Sala Superiore of the San Rocco Meeting House in 1581. He begins work on the equivalent paintings for the Sala Terrena (lower floor) in the following year.

1583–8

In 1583 Tintoretto is commissioned to paint an altarpiece (the *Nativity*) for King Philip II's El Escorial for which he is probably paid 400 ducats. In the following year he paints the *Adoration of the Cross* for the Venetian trade Scuola of the Linenweavers in return for as little as twenty ducats. On 28 December 1585 he secures the admission of his son Giambattista, his son-in-law Marco Augusta and two friends to the Scuola Grande di San Marco in return for a painting of the *Dream of St Mark*. In June of the same year Tintoretto paints the portraits of four visiting Japanese ambassadors. In these years he completes the Sala Terrena cycle for San Rocco, and brings the decoration of the Meeting House to a conclusion with an altarpiece (the *Apotheosis of St Roch*), and a painting for the staircase landing (the *Visitation*) in 1588.

1589–93

Following a second competition, Tintoretto is finally entrusted with the commission for the giant *Paradise* for the Sala del Maggior Consiglio of the Ducal Palace (probably complete by 1592). He supplies portraits of procurators and doges for the new Procuracy on St Mark's Square and, until 1592, continues to provide designs for the mosaicists in St Mark's itself. Tintoretto continues to receive his stipend from the Scuola di San Rocco and features among the office-holders of the confraternity until 1593. From June in this year Tintoretto and his son Domenico are members of the newly formed Accademia Veneziana Seconda. Tintoretto's final commission, for choir paintings and altarpieces in Palladio's San Giorgio Maggiore, is probably painted in 1591–2.

1594

Tintoretto dies on 31 May, following a 'fever of fifteen days', and is buried in the tomb of Marco Episcopi in the church of Madonna dell' Orto.

Preface

The present book does not pretend to be comprehensive. Its selectivity in the use of examples does, though, have the advantage of allowing a thematically focused analysis of Tintoretto's paintings. It is, indeed, the first full-length interpretative study of this complex artist to be published in English since Eric Newton's entertaining (but still Ruskinian) *Tintoretto* of 1952. It is intended that the contextual analysis offered here will provide the reader with a means of approach to Tintoretto's little-understood oeuvre and the historical issues (political, economic, religious and artistic) it so imaginatively engages. The Introduction and opening chapters set out the underlying theme in the book, examining Jacopo Robusti's artistic identity as Il Tintoretto ('the little dyer') in its historical context and his problematic relationship with the leading practitioners of art in his day, Titian and Michelangelo. These artists had achieved an unprecedented status (artistic and social), their names becoming synonymous with the two major traditions of Italian art in the period of Tintoretto's youth. This would, in itself, explain the necessity of the young painter's 'negotiation' with their styles, and yet his early assertively independent manner often appears to mock the very artistic authorities it refers to.

The focus on Tintoretto's formative period is maintained in Chapter 2, in which the painter's relations with a group of rebellious Venetian writers, publishers and playwrights are examined. In Chapter 3, the historical view of Tintoretto is deepened further by an examination of his popularizing attitude to the business of art and his inclusive approach to patrons. The contextual analysis provided in each of these chapters serves as a kind of interpretative platform for the narrower focus offered in Chapters 4 and 5, which deal with the most important artistic commission of Tintoretto's mature and later career: the decoration of the Meeting House of the Scuola di San Rocco between 1564 and 1588. In these deeply spiritual paintings, the self-repressing element in Tintoretto's professional identity finds its most successful expression. Despite the suggestion of ordinariness or *mediocritas*, evident in his nickname, Tintoretto here produced works that are among the most experimental and innovative in the history of Italian art.

Acknowledgements

My scholarly debts in the writing of this study are, of course, manifold. Many of the books on Tintoretto quoted in the text towards the end of the Introduction have proved influential, particularly those I have taken issue with, such as David Rosand's innovative work on the artist. Rosand's realization that Tintoretto could be explained only 'in context' was long overdue and proved fundamental to the approach adopted in this study, even if my conclusions with regard to his supposed *venezianità* ('Venetianness') are rather different. Professor Richard Verdi first interested me in Tintoretto, and I have received much professional and intellectual help from Paul Hills, whose suggestive articles on the painter opened up many avenues for further exploration. Malcolm Bull, John Gash, Richard Cocke and Francis Ames–Lewis all offered perceptive comments on earlier drafts of the text and supported me at different stages of my work on the project, while Jennifer Fletcher, Brian Pullan, Jill Dunkerton, Peter Humfrey, Philip Cottrell and Stephen Holt offered help of a more specific kind. My conversations with Michael Douglas–Scott and John Morrison helped me to frame a number of the arguments put forward here, and I would like to thank my colleagues in the Department of the History of Art at the University of Aberdeen for their practical support throughout. A generous grant from the Gladys Krieble-Delmas Foundation of New York allowed me to spend fruitful time in Venice in the course of writing. I would also like to thank Michela Balzarelli and Charlotte Smith for help in obtaining the illustrations. Finally, I owe a lasting debt to my family, who have supported me throughout.

2 Jacopo Tintoretto, *Self-Portrait*, *c.* 1546/8,
oil on canvas, 45.7 × 38.1.
Philadelphia Museum of Art.

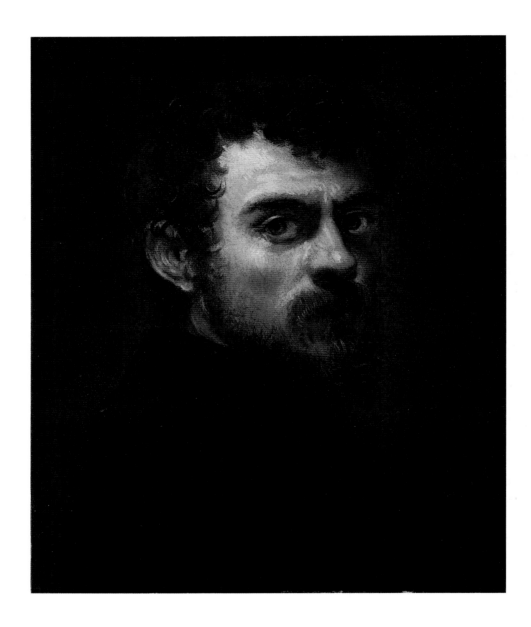

Tintoretto, Tradition, Identity

Jacopo Tintoretto was born and died in Venice. He is recorded away from his native city on only a single occasion (in September 1580, when he was briefly in Mantua) and the vast majority of his work was commissioned by Venetian patrons to adorn Venetian public buildings.[1] These simple facts immediately serve to distinguish Tintoretto from many other artists commonly identified with the development of Venetian art of the sixteenth century. Giorgione, Titian, Palma Vecchio, Bonifazio de' Pitati, Paris Bordone and Paolo Veronese all emigrated to Venice from subject cities on the Italian mainland (*terrafirma*), while others such as Pordenone, Jacopo Sansovino, Giuseppe Salviati, Andrea Schiavone and Lambert Sustris came from beyond the boundaries of the Venetian Republic. On the other hand, certain native-born painters (one thinks here of Sebastiano del Piombo, Lorenzo Lotto and Battista Franco) moved away from Venice, or led peripatetic careers. Few major artists associated with Venetian art remained so closely tied to their geographical origins, or to the network of local patronage and artistic opportunity available in Venice itself, as did Jacopo Tintoretto.

It therefore comes as something of a surprise to find that doubts remain over Tintoretto's right to belong to Venetian Renaissance tradition. 'Renaissance' does not seem the best term to describe his unusual manner of painting. (Some critics have argued that his work is better understood as Mannerist or even as 'proto-Baroque'.[2]) His evident involvement with sculptural values more familiar to the art of Florence and Rome seems to bespeak an active break with earlier Venetian painting. Something of this sense of rupture with the art of the past remains an undertone in the current textbooks on Venetian

Renaissance painting. Even if Tintoretto is an established fixture here, his position is somewhat ambiguous and insecure. For reasons which are rarely discussed, he is seen as the last great Venetian, his activity agreed to have brought the 'Golden Age' to an abrupt end. Perhaps more significantly still, this climactic position is not allowed its usual sense of narrative privilege, for it is Titian rather than Tintoretto who is typically seen as fulfilling the true goal (*telos*) of Venetian tradition.[3]

Even within Tintoretto's own lifetime leading authorities noted the painter's problematic relation to the art of the past. In the second edition of Giorgio Vasari's monumental *Lives of the Painters, Sculptors and Architects* (1568), for example, Tintoretto was criticized for painting in a fantastical, extravagant and bizarre style which sharply departed from 'the beautiful manners of his predecessors'. Tintoretto, Vasari opined, worked 'in a fashion of his own and contrary to the use of other painters'. This criticism is often understood as an aspect of Vasari's generally pro-Tuscan and anti-Venetian attitude. And yet, as our quotation indicates, his criticism was framed in much more general terms: the 'predecessors' in question are left unspecified and can be taken as either Tuscan or Venetian. In fact Vasari's view of Tintoretto's manner was based primarily on the opinions of leading writers in Venice. Tintoretto's career effectively began around 1540. In the course of the following two decades, the city's leading literati, such as Pietro Aretino, Francesco Sansovino and Ludovico Dolce, published works criticizing Tintoretto's lack of due conformity to pictorial taste.[4] In common with Vasari, these writers agreed that the painter had strayed beyond the acceptable boundaries of artistic tradition.

Living in the small world of Venetian artistic

culture, Tintoretto knew many of his critics personally and must have been fully cognizant of the appraisals they issued in the period of his youth and early maturity. He was no artistic naïf, as his documented friendships with leading writers, dramatists, poets and publishers (and his membership of two literary academies) clearly attest. His awareness of the particular significance ascribed to artistic tradition in his day, and his sense of its importance for his own practice, are indicated by the report that he pinned a notice over the door of his studio reading 'Michelangelo's design [*disegno*] and Titian's colouring [*colorito*]'. While it is unlikely that such a notice ever existed in the Tintoretto workshop, it does seem that the young painter saw himself as an heir to the great traditions of Renaissance art embodied in the still-living (but already God-like) figures of Michelangelo (d. 1564) and Titian (d. 1576). In 1566 Tintoretto even gained admission to Vasari's recently formed Accademia del Disegno based in Florence. Arguments continue over the exact nature of this pioneer academy of art, but its formation was certainly bound up with the ambitious ideas expressed in Vasari's *Lives*. Tintoretto's admission was probably dependent on an actual meeting with the author in 1566, when the Tuscan may have been in Venice to collect information for the revised version of his book.[5]

And yet there is little evidence to suggest that Tintoretto changed his manner of painting after joining Vasari's academy. Vasari had been particularly upset by Tintoretto's habit of leaving 'as finished works sketches still so rough that the brush strokes may be seen'. But in works such as the *Baptism* (see illus. 176, 177), painted in the late 1570s for the Scuola di San Rocco, Tintoretto's radical lack of finish (*non-finito*) is taken to new extremes. Given the almost provocative disregard for the words of written authority evident in such works, we may take it that Tintoretto's final instruction to his son Domenico in his will of 30 May 1594, requiring him to finish 'with the usual diligence' all incomplete paintings, was tinged with a knowing irony.[6] Diligence (*diligenzia*) was, after all, the very quality which his critics felt that he lacked. But if, in the matter of technique, Tintoretto continued to play the maverick individualist, his professional persona was more accommodating, characterized by an apparent subservience to the traditional model for artists in Venice.

The contradiction noted between radicalism in artistic method and orthodoxy in artistic persona may indicate that Tintoretto self-consciously fashioned his own artistic identity. This would have been encouraged to some extent by the wider cultural milieu in which he operated.[7] Rapid and far-reaching political and religious change in Europe in the first half of the sixteenth century generated a fluid cultural situation in which opportunities for 'self-fashioning' increased. In Venice, which had long enjoyed the cultural diversity of an international entrepôt, this trade in identities was particularly marked. The group of about 2,000 families who had governed the city since the 'lock-out' (*serrata*) of 1296 constantly reiterated conformity to their traditional identity as a selfless caste, committed only to the maintenance of the long-standing and much lauded public values of the Venetian state.[8] But a number of its most prominent families flirted with the courtly values of rival Italian states such as Florence and Rome (themselves increasingly conforming to the Spanish example), pursuing the values of princely consumption. Beneath the placid surface of social harmony and

control, these conflicts did battle within the Venetian patriciate. At issue was the question of tradition: should the ruling families maintain their age-old social image of self-restraint (embodied in the concept of cultural moderation or *mediocritas*), or should they move with the times and embrace the fashionable display culture of princely magnificence (*magnificentia*) developing elsewhere in the absolutist states of Italy and Europe? One important result of this dilemma was that neither 'republican' nor 'courtly' identities could be taken for granted. Each was carefully managed for public consumption, and did not offer a transparent view of a given social or economic reality.[9]

In keeping with this wider cultural dilemma, the long-standing debates over the social identity of painters intensified. Throughout much of the period since 1400 (particularly in Florence) ambitious artists and their supporters had tried to elevate the status of the artist in Italy. The most influential theorists tried to promote painting not as the workshop-based product of an artisan but as an exalted Liberal Art practised by the learned and socially elevated.[10] In 'traditional' Venice, conformity to such progressive ideas was by no means wholesale. Here, the working life of the painter had long been governed by the twin agencies of the guild, the Arte dei Depentori, and the family-based workshop. The continuing power of such structures inevitably limited the spread of progressive values such as self-expression and high professional aspiration among artists. It is significant in this regard that no equivalent organization to Vasari's Accademia del Disegno was proposed in Venice, where painters did not form an academy until as late as 1754.[11]

Notwithstanding the essential conservatism of Venetian artistic life in the period, pressure increased against the 'artisan democracy' of the Arte dei Depentori as the sixteenth century wore on. In Venice painting *de figura* (the kind of painting practised by leading artists such as Bellini, Titian and Tintoretto) continued to lack any clear institutional distinction, both from other types of painting (that of signs or playing cards, for example) and from other manual crafts practised by artisans in the city. But as early as 1511, the 'figure painters' attempted to weight the ruling body of the guild in their own favour, and it is likely that they already possessed a certain *de facto* prestige and influence not recorded in the guild statutes. When collaboration between painter types was necessary, as, for example, on the production of mosaics for St Mark's, the painters *de figura* were entrusted with the invention of designs for the more humble mosaicists to follow. As the century advanced further threats to the Arte's control over painting occurred. Thus between 1537 and 1542 the guild was forced to take legal action against a number of painters who were not inscribed, and in 1596 two 'gentleman' painters, Pietro Malombra and Giovanni Contarini, claimed that their non-professional status exempted them from membership. Neither Malombra (the son of a Venetian man of letters) nor Contarini (who had worked at the imperial court of Prague and had been knighted in 1580 by Emperor Rudolf II) thought of himself as an artisan.[12] The Malombra/Contarini challenge was undoubtedly encouraged by the meteoric career of Titian, who had enjoyed an unprecedented run of patronage from foreign aristocratic and royal houses since the second decade of the century, and whose fame and artistic prestige were, by the middle of the century, unrivalled throughout Europe. Despite the pleas of his

aristocratic patrons, Titian chose to stay in mercantile Venice where he ran a conventional family workshop and took an active role in the Arte dei Depentori into the mature part of his career. But by this stage such orthodox institutions neither circumscribed his practice as a painter nor defined his artistic identity.[13]

Titian's example raised the profile of visual art in Venice and undoubtedly played a part in attracting major artists such as Jacopo Sansovino from the Italian courts to work in the city. Titian's success also influenced local painters, encouraging the younger generations to look beyond the traditional parameters of painting in the city and to remodel their identity in accordance with progressive foreign categories. But it is also true that most artists in Venice lacked Titian's connections and could not realistically hope for an elevation in status similar to his. Moreover, the security and fairness offered by the orthodox conditions of artistic practice in Venice could be seen as preferable to the instability and favouritism of life at court. While the power of the guild-workshop system in Venice continued (and was supported by the corporate approach to patronage practised by the state and other public institutions), the older artisan identity for the artist continued to offer a viable alternative to the emergent courtly model.

Our knowledge of Tintoretto is based, in the first instance, on the surviving documents in Venetian state, parish and confraternity archives. The majority of these relate to specific commissions for paintings or to other legal and financial matters. Evidence concerning Tintoretto's artistic process, his friendships and the critical reception of his paintings is given in a number of published books from the period. Taken together, however, this primary source material gives us relatively little information with regard to the painter's attitudes to the contemporary issues of artistic tradition and identity raised in our discussion so far. For this we must turn first to the biography published by Carlo Ridolfi in 1642 (and again in a slightly revised form in 1648 as the first 'Life' in a series of biographies devoted to Venetian artists).

Ridolfi appended a number of anecdotes to his biography purportedly recording Tintoretto's opinions on life and art. One of these states:

when Tintoretto reached a mature age, with the encouragement of his wife who held the rank of citizen of Venice, he wore the Venetian toga. Thus it was that that lady used to watch him from the window when he went out in order to observe how well he looked in that dress. But he, instead, in order to annoy her, showed little regard for it.[14]

The story is repeated and greatly expanded in P.-J. Mariette's *Abecedario* (1713), where Tintoretto goes so far as to smear his patrician toga in the mud. The anecdote is of conventionalized type, its function in the first place to present Tintoretto as an exemplar of the great artist's proper indifference to worldly vanity. However, given the shifting identities of Venetian artists in the later sixteenth century, it may also be open to a more specific historical interpretation. It may indicate that Tintoretto was uninterested in adopting the high-ranking social identity advocated by ambitious artist-theorists such as Vasari. It is also interesting for the clues it gives with regard to the reasons underlying Tintoretto's parodic attitude. The unseemly ambition of Tintoretto's wife is cited as a product of her 'rank of citizen of Venice' and the documents

fully support this indication of her status. Tintoretto married Faustina Episcopi around 1550 and the couple went on to have eight children, three of whom (Domenico, Marco and Marietta) became painters. Faustina was from a high-ranking family whose members held a number of very prestigious positions in Venetian public institutions. The family were members of an élite non-noble rank, the so-called 'original citizens' (*cittadini originarii*), who had to show not only legitimate Venetian descent of three generations but also withdrawal from the mechanical arts (*arti meccaniche*) for the same period. This select group (for whom posts in the Ducal Chancery were exclusively reserved after 1569) were carefully fashioned by the patriciate in their own image during the sixteenth century. In the process, wealthy families arbitrarily excluded from political power were cleverly transformed from a potentially seditious group into one largely concerned with emulating their social superiors. But if this social background helps to explain Faustina's particular concern with Jacopo's toga, the contrasting attitude of wife and husband also suggests that the latter shared neither her desire to emulate the patriciate nor the social rank which generated it.[15]

Our lack of knowledge about Tintoretto's social origins certainly limits the value of contributions by those who have sought to see him simply as an artisan painter. In his unfinished book *Le Séquestré de Venise* (1957) Jean-Paul Sartre described Tintoretto as 'born among the underlings who endured the weight of a superimposed hierarchy [. . .] the son of an artisan' who valued only 'physical effort, manual creation'. In pursuing a model based on class conflict, Sartre assumed that Tintoretto was straightforwardly an artisan, and that his work necessarily reflected the values and aspirations of this oppressed social group. But even if Tintoretto's social origins were lowly this would not have made him an exception among artists in sixteenth-century Venice, for here (as elsewhere in Italy) most painters were recruited from the artisan class. Given that many other artists from a similar background were eager to adopt the manners and values of their social superiors, it is evident that Tintoretto's origins cannot fairly be used as a platform from which to argue that he attacked 'the patrician aesthetics of fixity and being'. The documents tell us only that Jacopo was the son of Giovanni Battista Robusti, 'dyer of silk cloths', giving no clear indication either to Giovanni's relation to the means of production or to his specific position within the Venetian social hierarchy.[16]

But if Jacopo's social origins were typical, his adoption of a professional nickname suggesting an explicit connection with Venetian artisan life was less so. The use of a nickname was not in itself unusual: such identifying labels were common throughout Italy, a reflection of the wider fluidity of Italian nomenclature in the Renaissance period. But with the emergence of new models for the artist, such names became a useful means of indicating an artist's social origin or professional alignment. In two early documents relating to Jacopo Robusti, the artist signs himself merely as 'mistro Giacomo' (1539) and as 'Ser Jacobus pictor' (1544); his first dated painting (see illus. 13) is similarly signed 'Iachobus' at the lower left, although the nearby symbol of a wheel might be a reference to the process of dyeing. In 1545, however, the poet Pietro Aretino addressed a letter to 'Iacopo Tintore'.[17]

It may thus have been Aretino, doyen of Venetian literary culture in mid-sixteenth century Venice, who coined Jacopo's professional name, although it was

quickly accepted by the painter himself, who signed the *Miracle of the Slave* (see illus. 48) 'Jacomo Tentor'. As a punning literary invention, the nickname owed more to Aretino's sophisticated humanist culture than to the simple artisan cloth-dyers it referred to, and there may even have been a strain of irony at the expense of the painter's lowly background in Aretino's initial usage. But at this point the nickname referred primarily to the equivalence between the processes of painting and dyeing, given that both used colours on a surface of woven cloth. Within a few years, however, the diminutive makes its first appearance in the documents. Thus, in a contract with the Augustinian canons of Madonna dell' Orto dating from 1551, the painter is referred to as 'Jacomo Tentorello' (the Venetian dialect spelling) and in 1552 the Florentine Anton Francesco Doni used the Tuscan form addressing a letter 'A Messer Jacopo Tintoretto ecellente pittore'. The addition of '*ello*' or '*etto*' thus coincided directly with the painter's new prominence as a city-wide painter around 1550, and thereafter was used by both the painter and his patrons. At this crucial point in his career, then, the painter takes a new control over his nickname. The suffix might refer to Jacopo's small physical stature; it more certainly makes reference to the occupation of the painter's father, and thus to Jacopo's social origins.[18]

Whatever Jacopo Robusti's original place in the social hierarchy was, as the professional 'Tintoretto' he took on an identity which allied him less with the high-ranking practitioners who featured in contemporary art theory than with the humble culture of the workshop. The nickname suggested a connection with the old-fashioned artistic identity which the new breed of theorists sought most to

suppress. The atypical nature of this identification is evident from the name changes adopted by other artists of Tintoretto's generation working in Venice. Paolo Spezapreda ('stone-cutter'), also known as Veronese, changed his surname to 'Caliari' shortly after his arrival in Venice, seeking to suppress his lowly origins by way of a connection with a well-known aristocratic family of Verona. Andrea di Pietro's nickname was superficially like Tintoretto's in that it had its origin in literary invention ('Palladio' was the guardian angel in a noble patron's courtly epic poem). But as with Veronese, the name change was motivated by the architect's desire for a more elevated social status.[19]

Tintoretto's often noted lower-class profile is thus better considered as a professional persona – like the high-ranking ones adopted by Veronese and Palladio – than as an indicator of a social reality. Taken at face value, Tintoretto's career would seem to make him a wholly representative Venetian painter. The appellation 'mistro Giacomo' in the 1539 document probably refers to his matriculation in the Arte dei Depentori at the outset of his career, while his continuing involvement with the guild is indicated by the presence of his brother, Domenico (apparently an illuminator), as a syndic in the Arte in 1577. Like the other major Venetian masters, Tintoretto ran a busy family-based workshop which survived for more than a century over the course of three generations, a fact which would seem to tie him still more closely to the traditional conditions of painting in Venice. Yet his career was also highly controversial, and not just with the academic theorists of art.[20]

If Tintoretto was more of a maverick individualist than his professional profile allowed, we must ask why he needed the cover provided by

this persona in the first place. Seen as a merely pragmatic move, Tintoretto's artisan identity offered a link to the growing number of 'lesser' patrons keen to commission paintings in Venice. It will be argued in the chapters which follow that this move was made necessary by Tintoretto's distance from the powerful circle which gathered around Titian in the middle of the century. More widely, Tintoretto's assumption of a moderate social profile can be understood to mark a point of opposition to the newly fashionable courtly academic values promoted by many writers on art in the period. Vasari criticized Tintoretto's technique rather than his lowly professional persona, but this was quickly registered by others who sought to foster a new intellectual and social status for painting. Federico Zuccari, first president of the Accademia di San Luca in Rome, even attempted to make Tintoretto's lower-class identity a cause of his artistic incompetence. In *Il lamento della pittura su l'onde venete* (1605), Zuccari mocked Tintoretto's professional prominence with reference to his nickname ('Alas, a Dyer has me in his thrall') and noted the issue of his supposed social origins in his religious imagery ('he made those heavenly citizens appear like common people in the market place').[21]

Zuccari here misses the point. If Tintoretto's identity makes deliberate reference to the older model of the artist as a simple craftsman, the very self-consciousness with which it is adopted announces a painter who is something different. If this identity determines the unusually humble settings, objects and actors which feature in many of Tintoretto's paintings, then we cannot assume that this imagery is innocent. Other formal elements in the paintings indicate the very provisional status of such 'artisan' references. The assertively loose

brushwork, the reference to classical, High Renaissance and contemporary sculptures and paintings (more especially in the earlier works), the penchant for difficult formal arrangements and elaborate perspective and lighting effects, all work to offset the popular import of the paintings. They bespeak the free play of a sophisticated artist who uses his wider artistic culture to mediate his chosen artisan ambience. The merely representational status of Tintoretto's 'artisanship' (*artigianato*) is fully acknowledged in the formal structure of his paintings.

Tintoretto's complex artistic identity is perhaps nowhere better revealed than in his self-portraiture. He painted himself on at least six occasions, although only three of these works can be identified today.[22] Ridolfi provides a precise description of the location and function of one of the lost self-portraits:

During that period ... many youths of fine intellect and replete with talent made progress in their art and competitively exhibited the fruits of their labour in the Merceria so as to find out the reaction of the viewers. And Tintoretto with his inventions and his original ideas was also on hand to show the results that had been brought about in him by God and nature. Among the works he exhibited were two portraits, one of himself holding a piece of sculpture and one of his brother playing the lyre, both night scenes which were depicted in so formidable a manner that he astonished everyone.[23]

The public exhibition of a self-portrait on the busiest trading thoroughfare in Venice could have had few precedents. If earlier Venetian painters such as Giorgione adopted self-portraiture as an autobiographical and essentially private genre,

3 Jacopo Tintoretto, *Self-Portrait*, *c.* 1546/8,
oil on panel, 45.7 × 36.8.
Victoria & Albert Museum, London.

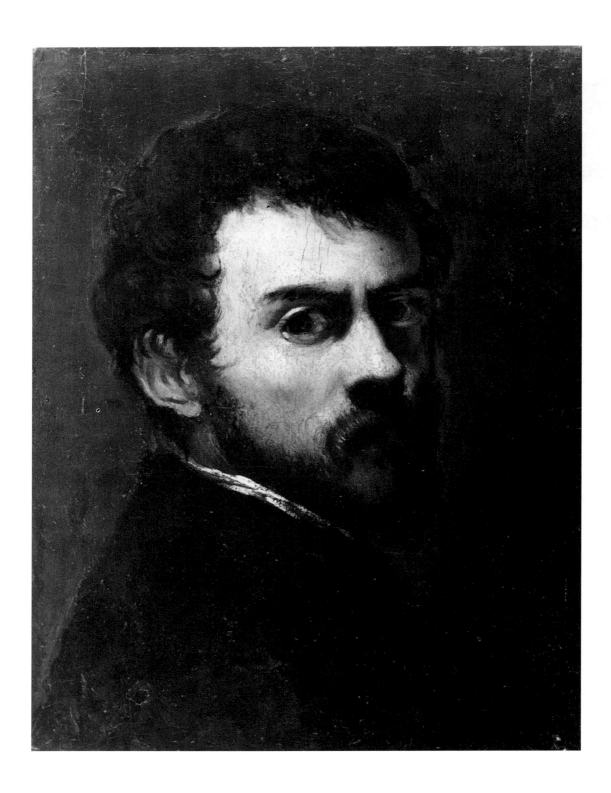

4 Palma Giovane, *Self-Portrait*, c. 1590,
oil on canvas, 128 × 96.
Pinacoteca di Brera, Milan.

6 Titian, *Self-Portrait*, c. 1562,
oil on canvas, 96 × 75.
Staatliche Museen Berlin (Gemäldegalerie).

5 Giovanni Britto, *Self-Portrait of Titian*, 1550,
wood engraving, 4.15 × 3.22.
Rijksmuseum, Amsterdam.

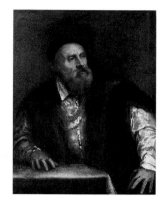

Tintoretto apparently used it for more pragmatic purposes, as a vehicle for self-advertisement. By displaying 'himself' to the shifting multitude thronging the Merceria, Tintoretto afforded this anonymous public a new level of authority. Ridolfi certainly sought to promote Tintoretto as a Venetian equivalent to Michelangelo, and the terms he employs to describe the lost portraits – his stress on their fearsome quality (*terribilità*) – are those typically reserved for the art of the Tuscan sculptor. And yet Tintoretto's identification with Michelangelo in his earlier period is well known, and it may be that he deliberately cultivated Michelangelesque qualities in the lost paintings.

In the self-portraits which do survive from Tintoretto's earlier period (illus. 2, 3) the curtailed bust-length format assures that the viewer's attention is focused exclusively on the sitter's head, which takes up a disproportionately large area of the picture surface. Features such as the concentrated lighting on the face and the enlarged eyes reinforce the simple intensity of this focus, giving the portraits an uncanny quality of omnivoyance. This unmitigated focus on the head is supported by the suppression of Tintoretto's body. This approach contrasts with that typical in Venetian self-portraits

of the time, where the body of the artist is typically made the locus for a display of high social rank and material wealth. Thus in Palma Giovane's *Self-Portrait* (illus. 4), the painter is at pains to show off his material 'richness' (*richezza*) through the detailing of rich fabrics and ermines in his dress (a display which appears to be sanctioned by Christ's gesture of benediction in the painting Palma works on). Palma here develops the model for self-portraiture established by his master, Titian, in the middle of the century (illus. 5, 6). In these works, Titian had stressed not only his wealth in the sparkling brocades of his vest and cloak, but his nobility, for he wears the massive gold chain bestowed upon him by the Holy Roman Emperor Charles V in 1533 – a gift which gave him the knightly rank of Count Palatine as well as Order of the Golden Spur.[24]

In Titian's self-portraiture, the overlap with the aristocratic portrait-type he had developed in the service of the European courts is quite deliberate, identifying the painter with the values of his socially exalted clients. This identification is typically made quite specific with reference to his Habsburg patrons (in a lost painting Titian showed himself holding a portrait of Charles's son, King Philip II). But in

both the images illustrated here the viewer is not permitted to meet the sitter's gaze: Titian is seen drawing (or perhaps writing), or is placed behind a table, occupying a dignified self-defined space.[25] We recall here that Titian resisted requests that he transfer to the Spanish court, preferring the independence allowed him by his residence in Venice. But in the context of his self-portraits (most of which were destined for the court itself) the abstraction of Titian's gaze is clearly not intended to fix a limit to the authority of his patrons. Such self-possession as it allows him is placed firmly in the context of an acknowledgement of continued service and debt. Titian's nonchalance is the direct result of the continuation of Habsburg favour and support.

In Tintoretto's self-portraits, by contrast, we meet the painter's stare head-on. Indeed, the formal simplifications noted above are intended to facilitate a collision between painter and viewer. Some such confrontation may also have been contrived in the lost self-portrait mentioned by Ridolfi, a necessity of its context in the impromptu exhibition on the crowded pavements of the Merceria. In contrast to Titian, the relationship between sitter and viewer remains unspecified, particular patron being replaced by anonymous observer. Titian's independent space is replaced by one defined externally by the marauding gaze of the public. Within these distinctions lie important clues to the very different orientation of Tintoretto's career, with its lack of exclusive personalized ties to private patrons and its thrust towards artistic and cultural inclusivity. And yet, in these paintings Tintoretto's identity finally remains more obscure than Titian's. While Tintoretto's self-portraits deny him the identity of the courtly practitioner, they also make him something other than the simple artisan painter

of Sartre's imagining. The fiercely concentrated features do little to contradict Ridolfi's conventionalized topoi: the sitter exudes inward intellectual power, his fiercely knit and concentrated features suggesting his unquantified inventive fury (*furor*). In this way they confirm the unyielding identity described by contemporaries such as the cartographer Cristoforo Sorte, who, after working alongside Tintoretto in the Ducal Palace in the early 1580s, noted that the painter's appearance (with 'gestures, expression, movement of the eyes ... alert and quick in argument') was wholly congruent with his creative fury in artistic execution.[26]

The tensions inherent in this ambiguous cultural position (that of the maverick individualist who identifies with the nameless majority) are still present in the famous self-portrait dating from just five years before the painter's death (frontispiece, illus. 1).[27] Despite a lifetime's work as a successful portraitist, Tintoretto here returned to the severely simplified construction of the early self-portraits, resurrecting their frontal and confrontational qualities. If anything the self-image has become more absolute in its determined lack of cultural mediation. Rather than submitting to the gaze of the public, the old Tintoretto stares it out. With its awkward frontality and exaggerated staring eyes, the portrait has justly been likened to Byzantine icons of God the Father, and it may be that Tintoretto deliberately draws on the well-known Renaissance topos of the 'divine artist' (*divino artista*) through which the artist is likened to God by his parallel ability to create at will.[28] Despite the intimations of frailty suggested by the creased pasty flesh, the Louvre painting is a triumphant image of the God-like artist, whose spiritual authority is one with his artistic creativity.

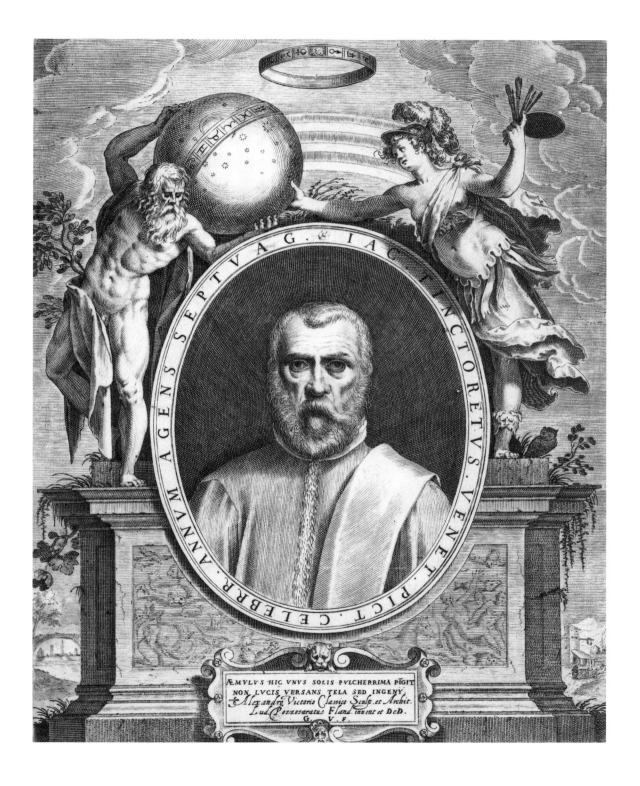

The potency of this late image of spiritual and artistic power, with its attendant implication of ultimate freedom from outward cultural determination, encouraged Manet to copy Tintoretto's painting at the outset of Modernism in 1854. In its more immediate historical context, however, such a proclamation of artistic independence proved difficult to assimilate. In the engraving by Gijsbert van Veen (illus. 7), the original hieratic simplicity of Tintoretto's painting is given an orthodox allegorical treatment. The inward power of the painter's gaze is undone by the conventionalizing apparatus which surrounds it, including lengthy Latin inscriptions, zodiacal signs, a supporting cast of classical deities (Atlas and Minerva), a marbled tomb and a Venetian landscape. In a move of which Faustina Robusti would certainly have approved, van Veen goes so far as to trim Tintoretto's beard, while also making the painter's body reappear sporting the conventional robe and stole of the Venetian ruling caste.[29]

Van Veen's print was designed by Tintoretto's erstwhile pupil Ludovico Pozzoserrato (Lodewijk Toeput), apparently for inclusion in the 'collection' of Venetian self-portraits assembled by the sculptor Alessandro Vittoria. It was, then, specifically intended as a 'finished' image of the artist for the consumption of posterity, and variants were used by subsequent writers on Tintoretto, including Carlo Ridolfi. It showed Tintoretto as a member of the venerable artistic tradition of Venice. But it was also a reinvention of the painter in more orthodox terms, one which made explicit the very aspects of Tintoretto's identity left unstated or ambiguous in his own self-portraits. In Pozzoserrato's hands, Tintoretto's fame as a painter is baldly stated, his special debt to Venice formalized, and the rewards

that his native city showered upon him emphasized. Given its context in a formalistic age obsessed with the fixing of conventional models, such reworking was perhaps inevitable.[30]

Despite the best efforts of early apologists such as Pozzoserrato, however, Tintoretto was destined to a long critical history as an eccentric outsider. Classical-academic writers of the seventeenth and eighteenth centuries typically followed Vasari's characterization of Tintoretto as driven by an excessive and uncontrolled 'fantasy' (*fantasia*) which issued in a random subjectivism of approach. Even those who sought to repair the painter's reputation could typically do no more than expand on Vasari's view. Thus when the Venetian patriot Marco Boschini approvingly described Tintoretto's art as a 'lightning flash, a thunderbolt or an arrow', he employed images of spontaneous kinetic energy which set it beyond the control of rational process. John Ruskin's famous (and vastly influential) rediscovery of Tintoretto, in the florid prose of *Modern Painters* (1846), involved a kind of restatement of Vasari's initial position, albeit from the opposing aesthetic viewpoint. Ruskin celebrated the painter's free exercise of his inventive powers, expanding Vasari's *fantasia* into a broader post-Romantic conception of 'Imagination Penetrative' (a capacious inner faculty which 'does not stop at outward images of any kind'). Tintoretto's supposed commitment to this inward spiritual dimension inevitably put him at odds with the sensual Renaissance world (as Ruskin conceived it), his paintings mounting a sort of purified 'gothic' challenge to its corrupted principles.[31]

The emphasis on Tintoretto's uncontrolled subjectivism has also proved influential among professional art historians. The main contribution to

Tintoretto criticism in the present century lies in the recognition of his debt to the artistic style of Mannerism. But once more, this debt has typically been seen as leading him beyond the scope of 'Venetian Renaissance tradition' into a private visionary world. For the leading proponents of the Mannerist view of Tintoretto (Max Dvořák, Luigi Coletti, Rodolfo Pallucchini, Paola Rossi), the painter developed a fantastical manner based on foreign models and characterized by reactive anti-classical and anti-naturalistic tendencies. Through his adoption of Mannerism, Tintoretto is seen as having cut himself off from Venice, or at the very least to have transformed its native artistic tradition into a 'receptive instrument for the expression of a visionary and expressionistic fantasy'.[32]

Tintoretto was certainly influenced by central Italian art in the earlier period of his career. But this recognition does not necessarily lead us to conclude that he rebelled against earlier Renaissance values. Mannerism was (as has long been recognized) born out of a sense of indebtedness to classically derived tradition rather than out of a rebellion against it. Moreover, recent studies have shown that all the major artists in Venice (including Titian himself) were significantly influenced by the style between 1530 and 1560. The explicatory limits of Tintoretto's connection with Mannerism are thus very evident. Little has been written on the way his response differed from those of other Venetian painters in the period, or on how any difference might reflect his more immediate and long-lasting relationship with the art of Titian.[33]

The terms by which art historians have typically analysed Tintoretto's Mannerism (the emphasis on his visionary *fantasia*, for example) are tellingly close to those employed by Vasari centuries before,

suggesting that the shift to 'objective' academic study has not fundamentally dislodged the early partisan and polemical models. This critical impasse has, however, been broken in a brilliantly argued book chapter by the American scholar David Rosand entitled 'Action and Piety in Tintoretto's Religious Pictures'. Here, Tintoretto is seen as the painter whose work is most fully representative of later sixteenth-century Venice. Against the long standing critical consensus, Rosand stressed 'the naturalism of Tintoretto's art', arguing that the 'directness of his pictorial language ... guaranteed a basic legibility' for his viewers. Recognition of this formal accessibility is seen as the key to understanding the content of his paintings which appeal 'to a basic popular level of Christian imagination'. While the paintings have a visionary import, this is 'neither mystical nor exclusively personal' but 'open and popular, common in the sense of shared conviction'.[34]

Rosand must be credited with the rediscovery of Tintoretto's nativeness, in the sense of his overriding commitments to a specifically local culture. If this culture was 'open and popular', and therefore distinct from that of the international Titian, it was also more characteristic of the Republic of Venice. The new view inevitably challenges the orthodox assumptions about Tintoretto's alienation from Venetian tradition. Rosand argued instead for a vital connection between Tintoretto's large-scale *non-finito* and the tonal approach of earlier painters such as Giorgione. This connection has been developed further by Philip Sohm, who traces the origin of a long Venetian tradition of 'painterly brushwork' back to Giorgione. According to Sohm, this tradition was developed through the course of the sixteenth

century by successive generations of painters, including Titian, Jacopo Bassano, Veronese and Tintoretto.[35]

The recent interpretations allow Tintoretto to possess all those 'traditional' qualities which had for so long been denied to him in the earlier literature: the painter is effectively returned to his native city and its famous school of painting. And yet too absolute a suppression of the 'eccentric' Tintoretto of the earlier literature takes us back to Pozzoserrato and the questions raised by his polished-up image of the artist. Why, it might fairly be asked, was Tintoretto's artistic practice so often met with bewilderment and suspicion by contemporary Venetian patrons and connoisseurs? And is it really possible to tie Tintoretto's radically exposed brushwork to the technical approach of Giorgione or any other Venetian painter? Too absolute a statement of Tintoretto's conformity to his context would miss the subtle interplay between opposing characteristics revealed by our earlier discussion of his artistic identity.

Despite his sociological approach, Rosand took relatively little account of the work of those scholars who have applied the methodology of historical materialism to Tintoretto. These studies have, it must be admitted, had very limited success in explaining his complex achievement. Arnold Hauser's attempt to read Tintoretto's paintings in terms of a wider reification of artistic culture in the sixteenth century owes much to the outmoded idea of crisis Mannerism. The shortcomings of Sartre's (tellingly unfinished) study have already been noted. On the other hand, Hauser's concept of stylistic reification (albeit in modified form) proves a useful interpretative tool for the analysis of Tintoretto's earlier style, as we shall see in Chapter 1. In a broader manner, Sartre's existentialist view of the painter as a 'frantic, harassed outlaw ... an intruder, almost a pariah in his own city', offers a welcome antidote to the anodyne contextualism of the more recent literature. Sartre understands Tintoretto's alienation as an issue of his identification with 'the underlings who endured the weight of a superimposed hierarchy', an idea which has proved influential in the writing of this book.[36]

Many problems remain with Sartre's thesis, however, given that his application of Marxist historiography to sixteenth-century Venice threatens to further obscure a very complex and fluid situation in which cultural identities did not always reflect social realities. As we have seen, the dominant ideology within the Republic was not 'aristocratic', the majority of the ruling patriciate continuing to adhere to mercantile trading values. Indeed, terms such as 'aristocracy' and 'bourgeois' cannot be usefully employed to denote clearly defined and opposed social groups in the Venetian context (Sartre described Tintoretto as attempting 'to incarnate bourgeois puritanism in an aristocratic Republic during its decline'). But if the largely undifferentiated economic 'base' makes an analysis in terms of social class problematic, the case is more arguable at the level of cultural 'superstructure'. In making such a reading, we would have to assume that the economic does not always narrowly determine the ideological. Our focus would fall instead on a mediated conflict in cultural values which was to some extent independent of underlying economic or class divisions. This would allow us to assume that 'courtly' values could become fashionable within a trading republic, and conversely that those opposing or resisting them were not necessarily from the artisan classes.[37]

The present study will seek to situate Tintoretto's art in relation to conflicts at the level of the cultural superstructure, while allowing that these are not readily describable as a direct issue of their social and economic origins. Here we may recall the sociologist Georg Simmel's notion that all cultural products are to some extent alienated from the forces that produce them (the 'tragedy of culture'). In an essay written in 1922, Simmel described Venice as a model of cultural reification, as 'the tragedy of a surface that has been left by its foundation'. As historians of culture, however, we are compelled to stay at this uncertain level. While it may be that the struggle between republican and courtly identities was ultimately a product of a wider transformation in social class (the 'refeudalization' of the urban mercantile élite at the end of the Renaissance evident in many parts of Italy and beyond), our study must elucidate the ways in which its echo registered on the ambiguous cultural surface.[38] Accordingly, this book will avoid making Tintoretto's art a direct issue of economic or class conflict, seeking instead to situate it in relation to the most contentious 'surface' issues of the period, those relating to identity and tradition. In the existing literature the issue of Tinteretto's relation with tradition has typically been polarized. In the earlier studies, Tintoretto is seen as a free agent (either eccentric or visionary) operating beyond the wider determinations of his historical context, while tradition becomes a fixed and monolithic entity whose machinations lie beyond the influence or control of specific individuals. In the more recent view of the painter as social conformist, 'tradition' merely absorbs 'Tintoretto' into itself, the two terms becoming synonymous. In both cases the particular topicality, fluidity and contentiousness of

tradition itself in Tintoretto's period are ignored.

Tradition is never quite the passive or enabling historical entity it might appear, and in the chapters which follow its potency as a manipulative ideological concept, with the power to disrupt and exclude, will be very apparent. For a long period in Venice, artistic practice was not troubled by theories of itself. The subservience of Venetian artists to the presiding republican ethos of the state meant that the definition of a distinct artistic tradition remained unimportant. In the period of Tintoretto's early career, however, the local tradition of painting was finally given a new literary definition by writers such as Pino, Biondo and Dolce. But if it is allowed that the new theory drew on the realities of existing artistic practice in Venice, it also simplified and distorted them to the extent that Venetian painting became (particularly in the hands of Dolce) synonymous with that of Titian. Dolce's equation took root, and many studies of Venetian Renaissance painting continue to be constructed around the idea that Titian's practice defined and fulfilled the tradition. But given the actual diversity and fluidity of artistic practice in mid-sixteenth-century Venice, Dolce's description of Venetian art was from the start selective and partial. In its original context, it may also have been more deliberately appropriative and exclusionary, seeking to transform a collective cultural achievement, led by a variegated and ever-changing community of painters, into that of a single creative individual. But such an attempt was inevitably contentious in a city still caught up in its founding republican ethos. Titian's ever-increasing identification with his high-ranking foreign patrons opened up the opportunity for Tintoretto to present himself as the upholder of the older values of Venetian *mediocritas*.

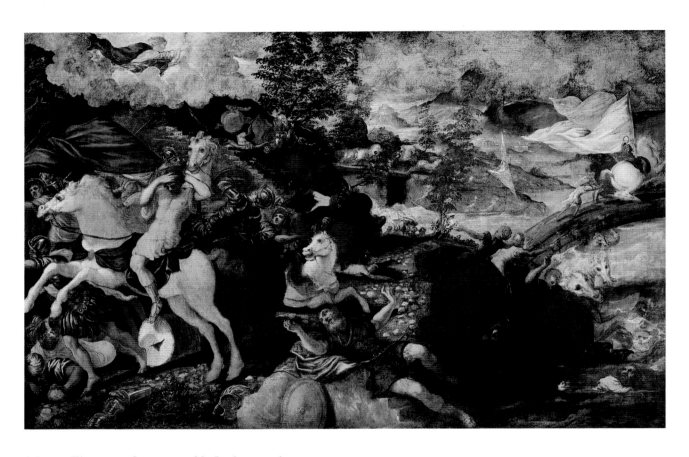

8 Jacopo Tintoretto, *Conversion of St Paul*, c. 1540/2,
oil on canvas, 152.4 × 236.2.
National Gallery of Art, Washington, DC.

Tintoretto, Titian, Michelangelo

Tintoretto and Titian

Tintoretto's artistic identity evolved as a kind of conscious and continual revolution against the model provided by Titian for painting in Venice.[1] If the work of many younger painters in the city was specifically indebted to Titian's towering example, that of Tintoretto was, from the very outset of his career, self-consciously defined against it. But the very intensity of Tintoretto's reaction was, like that of a rebellious son against his father, an admission of Titian's continued influence in artistic matters. Titian became a point of reference to which the young painter was constantly compelled to return in order to define himself. Tintoretto's sustained polemic made sense only while the authority of the old painter in Venice lasted. The gradual withdrawal of Titian from the city's artistic culture after 1560 coincided with the delayed emergence of Tintoretto as a fully independent master whose manner of painting was finally freed of its merely reactive tendencies. But the intensity of this antagonistic relationship left its mark, for in his mature and later work Tintoretto developed (rather than denied) the rebellious pictorial schemas of his youth, arriving at an individualistic manner which had few precursors and even fewer followers.

The reasons for the peculiar intensity of the young Tintoretto's reaction to Titian are not wholly clear, and certainly cannot be fully explained by any one factor. It would be tempting to follow, in the first place, the reports of Ridolfi and Boschini, who record the ejection of the young painter from Titian's workshop 'as soon as possible'. Ridolfi makes Titian's action a result of his recognition and jealousy of his apprentice's talent, while Boschini goes one step further, interpreting it as a response to the innate eccentricity of Tintoretto's designs ('Titian banished him from his house, having seen

him so ardent, bizarre and capricious in the greenness of youth').[2] Both accounts are certainly embroidered to make Tintoretto's banishment a proof of his genius via the revered opinion of Titian. But they may nonetheless have some basis in historical truth. If Tintoretto did indeed spend a short time in Titian's workshop, this would have been in the early 1530s. He is first recorded as an independent painter in 1539, and his earliest works cannot be dated much before this. For much of the fourth decade, then, Tintoretto's activity remains largely unknown. His apprenticeship to another painter is not recorded, a historical lacuna which undoubtedly gave rise to Ridolfi's notion that he was an auto-didact, but recent historians have rightly doubted this possibility. By May 1539, as we have seen, Tintoretto had almost certainly matriculated from the Arte dei Depentori, a qualification dependent on his successful completion of an apprenticeship with a Venetian master. But no convincing teacher for Tintoretto has been found. The style of the major works from this period – the *Conversion of St Paul* (illus. 8), the *Christ Among the Doctors* (illus. 11) and *Sacra Conversazione* (illus. 13) – certainly bears analogy with those of prominent painters in Venice in the 1530s such as Bonifazio de' Pitati, Andrea Schiavone and Paris Bordone. But his manner is not closely or consistently tied to any one of these masters.[3]

If the details of Tintoretto's apprenticeship remain mysterious, the early paintings illustrated here do have two related qualities in common. They share a marked distance from the favoured pictorial idiom of Titian while at the same time making pointed references to ideas and models derived from central Italian art. To some extent, of course, the self-conscious modernity of these paintings merely

reflects the young Tintoretto's responsiveness to
contemporary stylistic fashion. By 1540, the formal
values of central Italian Mannerism had spread to
Venice, not least through the contemporary working
visits to the city by painters such as Francesco
Salviati, Giovanni da Udine and Giorgio Vasari.
But these recent developments in artistic style might
not wholly account for Tintoretto's immediate
independence from Titian. If we allow that
Tintoretto was banished in acrimonious
circumstances from Titian's workshop shortly
before, then the immediate assertion of difference
must have contained a polemical edge.[4]

In the *Conversion of St Paul* (illus. 8) Tintoretto
refers directly to Titian's recently completed battle-
painting in the Ducal Palace, the Battle of Spoleto
(finished in 1538, destr. 1577). But the reference is,
at the same time, offered as a kind of corrective
revision. Tintoretto's equestrian conception of the
scene owes more to the work of the Michelangelesque
painter Pordenone than to Titian. He seems to have
known Pordenone's drawing for a *Conversion of St
Paul* (illus. 9) although his borrowing of the rearing
horse at the left might equally be based on a fresco
on the façade of the Palazzo d'Anna by the same

master (see illus. 30). The key figures of God and
Saul owe more, however, to Raphael's now lost
tapestry cartoon which had been present in the
Grimani Collection in Venice since 1521. Tintoretto
thus thoroughly modified his source with reference
to artistic ideas derived from central Italy.[5] The
reference to Pordenone is, as we shall see, a
significant one, given the Friulian's own overt
challenge to Titian's position at Venice in the 1530s
(Pordenone had even offered to paint the Battle of
Spoleto, following Titian's delay). The borrowing
from a work in the Grimani Collection, on the other
hand, is indicative of one important source for
Tintoretto's burgeoning interest in central Italian
art. The young painter undoubtedly knew well the
famous collection of antique and Renaissance art
housed in the family palace of Giovanni and Vettore
Grimani at Santa Maria Formosa. He painted a
portrait of Giovanni Grimani and possessed a cast of
a Roman bust in the collection, after which he and
his pupils made repeated studies. The palazzo,
decorated in 1539–41 with *all'antica* ceilings by
Francesco Salviati and Giovanni da Udine, was itself
the single most important monument to artistic
Romanism (*romanitas*) in mid-cinquecento Venice,
and a centre for the dissemination of central Italian
culture in the city. As such, it was a site of especial
importance for the young Tintoretto.[6]

In another large-scale work from this period,
Christ Among the Doctors (illus. 11), a breathtaking
plunge into pictorial space is necessary in order to
arrive at the tiny figure of the young Christ in the
background.[7] The radicalism of Tintoretto's formal
inversion is evident when one considers that
narrative composition in Venice was usually closely
tied to the picture plane, the viewer's eye processing
in orderly fashion across the image from left to right

10 Bonifazio de' Pitati, *Christ Among the Doctors*, c. 1536, oil on canvas, 200 × 180. Palazzo Pitti, Florence.

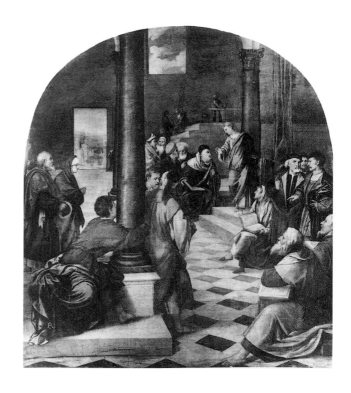

(see illus. 23, 24). The whole composition is animated by rapid and exposed brushwork which quickens our apprehension of individual form even while it leaves the picture surface as a kind of scarred battleground. Tintoretto's bold spatial manipulations undoubtedly owe much to contemporary painting in Florence and Rome, where sophisticated departures from the 'simple' centralizing compositions of the preceding High Renaissance period (1480–1520) were already a commonplace. But, as so often in the early career of Tintoretto, influence from abroad was mediated through the practice of local painters. An interest in spatial effects is already very evident in narrative paintings by Bonifazio and Bordone dating from the 1530s, where it is generated by the inclusion of theatrical architectural perspectives. These were typically based on the designs of Sebastiano Serlio, a former pupil of Baldissare Peruzzi in Rome, who had arrived in Venice in 1527. The violently recessional architecture in Tintoretto's *Christ Among the Doctors* may not be directly dependent on a Serlio design, but the theatrical qualities of the composition already reflect the new expressive possibilities these had created for narrative painting. In a number of subsequent works by Tintoretto from the 1540s, Serlio's continuing influence can be traced to specific illustrations in *L'architettura* (published in six parts between 1537 and 1551) (see illus. 68).[8]

Tintoretto's compositional inversion in the Milan painting may have been directly suggested by Bonifazio's depiction of the same subject painted *c.* 1536 for a room in the Venetian treasurer's palace (Palazzo dei Camerlenghi), where the protagonist is likewise removed from the centre foreground into depth (illus. 10). But there is no model here for the

massive ancillary figures which dominate the foreground of Tintoretto's picture. The complex twisting postures of these figures continually return the viewer's eye back to the picture plane, creating a vibrating tension between surface and depth that was to become a leading characteristic of Tintoretto's manner. These huge figures increase the drama of Tintoretto's spatiality, providing a dramatic contrast in scale with the distant figure of Christ. But their movements are essentially arbitrary, the exaggerated torsions and foreshortenings owing more to the painter's volition than to the dictates of nature. Here again, a distinction is marked from the naturalism of Titian's preferred mode.

Despite the playfulness of the composition, the *Christ Among the Doctors* already possesses an expressive urgency alien to the cool formalism of

11 Jacopo Tintoretto, *Christ Among the Doctors*, c. 1541/2,
oil on canvas, 197 × 319.
Museo del Duomo, Milan.

contemporary Mannerist painting. It was this 'disqualifying energy' which made John Shearman (with some justice) doubt that Tintoretto could be considered a Mannerist at all.[9] But if Tintoretto's work was (and was to remain) distinct from that of central Italy in this regard, it was equally far from the 'painterly' approach of Titian. It is true that Tintoretto's particular dynamism is, above all, an issue of his very free and confident handling of paint, and to this extent is a development of the older master's technique. In Titian's paintings too, colour is very actively worked on the picture surface. But even in the looser manner Titian developed around 1560, his 'colouring' (*colorito*) continues to support and further nuance the given illusionism of the image. If the decorated surface enters into a sophisticated play with the given illusion, then it does not undermine its efficacy. Tintoretto's technique, on the other hand, readily sacrifices this balance, the broad (although typically dry) brush stroke assuming a new priority over the demands of illusionism. If Titian always remained concerned with the decorative aspects of the coloured pigments themselves, Tintoretto was prepared to sacrifice these material qualities in order to emphasize his brush stroke as a kind of spontaneous gestural performance. The rough surface bears witness to the painter's improvising act of creation, obtruding his presence in a manner which pays little heed to Titian's 'objective' principles. Arcangeli's claim in the 1950s that the young man facing out of the composition at the foreground left is a self-portrait is convincing, as is the identification of a portrait of Titian leaning on a stick nearby (illus. 14). Perhaps his further proposal, that Titian is shown disdainfully turning his back on Tintoretto to symbolize his rejection of the young painter, is

13 Jacopo Tintoretto, *Sacra Conversazione*
(Virgin and Child with the Infant Baptist and Sts Joseph,
Elizabeth, Zacharias, Catherine and Francis), 1540,
oil on canvas, 171.5 × 243.8.
Private collection.

fanciful. But it nonetheless remains likely that the painting was very self-consciously designed in opposition to Titian's manner and, in formal terms at least, it can be taken as a clear expression of Tintoretto's immediate independence from it.[10]

Tintoretto's earliest dated work, the *Virgin and Child with the Infant Baptist and Sts Joseph, Elizabeth, Zacharias, Catherine and Francis* (illus. 13) was painted a year or two before the *Christ Among the Doctors* and the *Conversion of St Paul*, but already reveals the young painter's habit of presenting his paintings as aggressive revisions of Titianesque painting-types.[11] Like a number of other devotional

paintings attributed to this early period featuring the Virgin and Child or *sacra conversazioni*, the 1540 painting follows a well-established Venetian picture-type developed by Titian and popularized by his followers Palma Vecchio and Bonifazio in the previous decades. Indeed, two of the saints depicted can be closely related to figures in Bonifazio's paintings.[12] But despite these local derivations the composition is prised away from its Titianesque inheritance not only by the twisting postures and arbitrary gestures of the figures, the washed-out dissonance of the colours and the cursive brushwork but also by the central, very explicit, quotation in

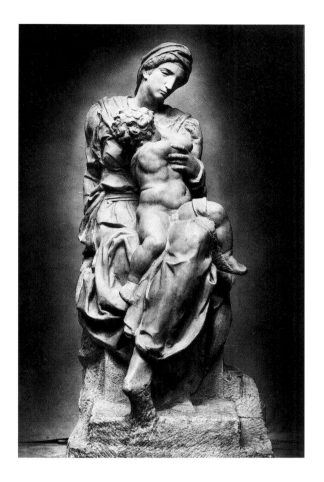

14 Michelangelo Buonarroti, *Virgin and Child (Medici Madonna)*, 1524–34, marble, 252.7 high. Medici Chapel, San Lorenzo, Florence.

the figure of the cross-legged Virgin. Although attempts have been made to establish the source of this figure as an antique Muse, probably then in Venice, it remains clear that Tintoretto's primary model was Michelangelo's recent *Medici Madonna* (illus. 14).[13] The very different position of the sprawling Christ child, which wholly undoes the naturalistic logic of Michelangelo's sculpture, indicates that Tintoretto did not know the original and worked instead from a statuette available in Venice. But the insistence of the quotation is nonetheless striking, a clear indicator that Tintoretto, from the very outset, sought to identify himself less with the sensual naturalism of Titian than with the intellectual and sculptural values of central Italy.

Titian's early antagonism to Tintoretto may lie behind the young painter's struggle to win significant public commissions in Venice before 1548, when he won city-wide renown with the *Miracle of the Slave* (illus. 48). As Ridolfi tells us,

Since at that time in Venice the only works that were praised were those by Palma Vecchio, Pordenone, Bonifazio and, especially, Titian, who usually got the most important commissions, there was no way for Tintoretto to make his true worth known and gain public esteem ... Thus in order to overcome these difficulties ... he undertook all sorts of laborious tasks. [14]

It is difficult to arrive at a clear understanding of Tintoretto's career in the period before 1548, given that many of the paintings included in the standard catalogue raisonné by Pallucchini and Rossi are clearly the work of pupils such as Giovanni Galizzi or later workshop replicas.[15] Among the 'laborious tasks' Tintoretto certainly completed were small-scale furniture or cassoni paintings (see illus. 83, 84), façade frescoes for Venetian palazzi and houses (see illus. 31–4, 36, 37), and also a number of large horizontal narrative paintings (*laterali*) for chapel side-walls and naves of churches.[16] Commissions for cassoni and fresco paintings were considered among the least significant on offer in Venice, while the *laterale* picture-type (to which works such as the *Conversion of St Paul* and the *Christ Among the Doctors* may well belong) was still relatively new in Venice and lacked the prestige and value of the upright altarpiece. Tintoretto did paint a few altarpieces in this period, but these were not in

15 Jacopo Tintoretto, *Deucalion and Pyrrha Praying to a Statue of the Deity*, c. 1542/4, oil on panel, 127 × 124. Galleria Estense, Modena.

prominent locations and their patrons were typically undistinguished. Thus the painting in Santa Maria dei Carmini showing the *Presentation of Jesus at the Temple* (*c.* 1541–2) was made for the trade-guild Scuola of the Fishmongers, and similar artisan confraternities commissioned the painter on several other occasions before 1548. Tintoretto's first version of the *Last Supper* (illus. 20), dated 1547, was painted for the parish Scuola del Sacramento of San Marcuola, the first of many commissions from such confraternities, who looked after the Reserved Sacrament between the masses in parish churches.[17] Missing from Tintoretto's early career is the kind of prominent official commission from the Venetian state which marked the arrival of painters such as Titian and Veronese on to the artistic stage. Such employment eventually followed in the years after the *Miracle of the Slave*, but in the preceding period Tintoretto clearly lacked the professional backing needed to bring him to the attention of the patriciate. He was on friendly terms with significant figures in the literary world such as Pietro Aretino and the publisher Francesco Marcolini, but the continuing disdain (*sdegno*) of Titian may have been enough to delay his breakthrough with higher-ranking Venetian patrons.

In keeping with this, the majority of Tintoretto's pre-1548 paintings sustain the stylistic polemic with the work of Titian established in his earliest works. In one of his more prestigious commissions from the period he painted sixteen octagonals with Ovidian subjects for a room in the palace of the young patrician Vettore Pisani at San Paternian (illus. 15). The exaggerated formal torsions and foreshortenings characteristic of this cycle show certain affinities with Titian's near contemporary ceiling paintings for the Venetian church of Santo

Spirito (illus. 16).[18] But as before the reference to the work of the older master merely provides an opportunity to mark a difference. Titian certainly referred to the art of central Italy in these and other works from the earlier 1540s, its example providing him with a new formal (and by extension, expressive) monumentality. Tintoretto, on the other hand, exploits central Italian art as an invitation to formal freedom and spatial play. While Titian's ponderous massing of form heightens the ideal import of his subject, the alteration to his style nonetheless remains coherent with its original naturalistic values. In contrast, the high-pitched and balletic quality of Tintoretto's figures (perhaps drawing on Giulio Romano's exuberant formalism at the Palazzo Te in Mantua) allows of no such mediation; rather, painting becomes a kind of exercise in formal gymnastics.

Even when (in 1545) Tintoretto was commissioned by Titian's great friend and supporter

17 Jacopo Tintoretto, *The Contest Between Apollo and Marsyas, c.* 1545,
oil on canvas, 139.7 × 240.3.
Wadsworth Atheneum, Hartford.

Pietro Aretino, he remained assertively independent of his patron's favourite. One of the two ceiling panels for Aretino's Palazzo Bollani on the Grand Canal is probably identifiable with the painting now at the Wadsworth Atheneum, Hartford, showing the *Contest Between Apollo and Marsyas* (illus. 17). Both the sketchy quality of the brushwork and the spindly figure-types with long limbs and small heads recall the manner of Andrea Schiavone, with whom (according to Ridolfi) Tintoretto collaborated in this period. The Dalmatian painter specialized in small-scale decorative works for private patrons, combining the graceful formal elongations of Parmigianino with a radical looseness in the handling of paint.[19] In Tintoretto's hands, this manner takes on a more vigorous narrative quality, particularly evident in the foreground seated figure

seen from behind at the right, a stock figure in his paintings from this period. The sudden twist of his head announces the arrival of the judge of the musical competition at the extreme right, his features modelled closely on those of Aretino himself. But if Tintoretto thereby neatly referred to Aretino's pre-eminent role as arbiter of artistic taste in Venice, his manner of painting remained very unlike that of Titian. In his letter of thanks, Aretino particularly commended Tintoretto's speed of production, noting that his paintings were finished 'in less time than normally might have been devoted to the mere consideration of the subject'. The young painter's rapid execution (*prestezza*) was (as we shall see in Chapter 2) destined to emerge as the key feature distinguishing his practice from that of Titian, and one on which Aretino was very soon to

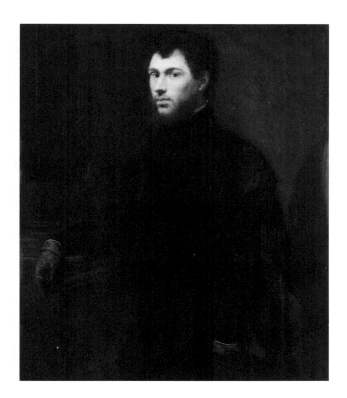

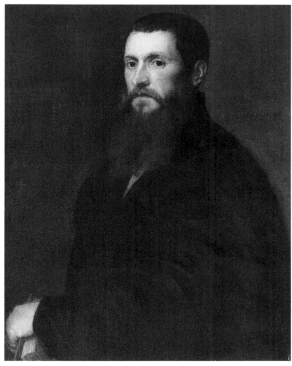

change his mind.[20]

One field in which Tintoretto inevitably followed Titian more closely was that of portraiture, where Titian's authority was particularly absolute by the 1540s. Even here, though, Tintoretto's difference is apparent, his approach marked by a distinct concept of the individual. In the *Portrait of a Young Man* (illus. 18), Tintoretto draws on contemporary Titian portraits such as the *Daniele Barbaro* of c. 1545 (illus. 19), to obtain an image of extreme simplicity.[21] But while in Titian's portraits formal understatement paradoxically supports the suggestion of psychological complexity, in Tintoretto it functions as a kind of limit to our knowledge of the individual represented. It is sometimes presumed that Tintoretto lacked the older master's ability to suggest by means of

understatement. But the limits to individuation in Tintoretto's portraits might also be taken in a more positive light, as the expression of a distinct set of cultural assumptions. In republican Venice, personal identity was less significant than place within the wider social order, and the often-noted repetitiousness of Tintoretto's portraiture in part reflects his acceptance of this communal ideology. Titian's illustrious sitter in the Prado painting was, of course, a Venetian patrician. But as a prominent member of the papalists' (*papalisti*) circle he was not typical of his caste and probably did not want to be shown as such. Titian's adaptation of a portrait-type he had developed for a foreign aristocratic clientele would have been wholly in keeping with Barbaro's courtly aspirations.

Tintoretto's immediate distinction from Titian

20 Jacopo Tintoretto, *Last Supper*, 1547,
oil on canvas, 157 × 443.
San Marcuola, Venice.

21 Workshop of Titian, *Last Supper*, 1557/64,
oil on canvas, 207 × 464.
Monastery of San Lorenzo, El Escorial.

had, then, a wider socio-political dimension. It was
not merely (or even primarily) an expression of the
will to artistic individuality, but was linked to his
different cultural position. We will discuss this
aspect of Tintoretto's 'rebellion' further in the
following chapters. For the present we need to note
that Tintoretto's reticent individuation in his early
paintings also had an important religious dimension.
In early sacred works such as the San Marcuola *Last
Supper* (illus. 20), a painting which set the tone for
Tintoretto's subsequent versions of the subject, an
analogous concern to downplay differentiation of
character is evident. In Titian's version of this
subject (illus. 21), the physiognomies (and therefore
the characters and dramatic responses) of the
Apostles are sharply distinguished, in keeping with
High Renaissance prototypes for the theme by
Leonardo and Raphael.[22] In Tintoretto, such
distinctions are carefully downplayed in order to
emphasize an alternative value of shared spiritual
response. Indeed, Tintoretto's habit of concealing
faces from view was to become a fundamental
characteristic of his religious narrative painting.
In contrast to his main models, Tintoretto sought to

re-establish a principle of selfless anonymity for the
Christian drama, a revision which at some level must
reflect contemporary movements of Catholic reform.
In the *Last Supper*, however, he also translated the
scene from the abstract classicized environment
preferred by Titian into a believable 'earthly' space.
In doing so, he borrowed details from urban artisan
life (such as the simple wooden stools and crude
pewter tableware), while he exposed the brawny
forearms of certain Apostles and gave them the dark,
tousled heads of Venetian townsmen of the lower
class. True piety is, in Tintoretto's conception,
relocated to a simpler, more immediate environment.

The above discussion shows that the
Tintoretto–Titian relationship certainly did not
begin and end as a matter of personal antagonism.

In addition to its socio-political and religious dimensions, it also had a context in contemporary debates over art theory. Titian's supremacy was, in fact, in the process of being promulgated in the printed word in the period under discussion. In response to Vasari's downgrading of the Venetian contribution to Italian Renaissance art (he had grouped the entirety of Venetian artists prior to Giorgione into two 'Lives', criticized Giorgione himself and left out Titian altogether), Ludovico Dolce published his *Dialogo della pittura* (1557). This featured Pietro Aretino as the authoritative spokesman on Venetian painting, setting out to define and defend a Venetian artistic tradition fully equivalent in aesthetic status to the Tuscan one described by Vasari. At the same time, this tradition was assumed to be embodied in the art of Titian.[23]

It is worth pausing to consider Dolce's argument in a little more detail. In a number of ways his version of Venetian tradition is modelled on Vasari's Tuscan equivalent as described in the Lives. Rather than arguing for its clean distinction from Tuscany, Dolce sought to connect Venetian art to the tradition of Giotto and Michelangelo, stressing that it shared a defining commitment to the intellectual principle of *disegno*. Following Pino and Biondo, Dolce promotes a particular Venetian skill in the area of *colorito*, but this is seen more as an additional skill than a means of fundamental distinction. Drawing on Vasari's analysis of Tuscan art, Dolce interprets Venetian tradition as classically derived and teleological, and as courtly in its present social patterning. It is no accident that Dolce describes Titian as another Apelles (*alter Apelles*), and explains his style in terms of an accurate re-creation of that of the greatest painter of antiquity. And just as Vasari pictured Tuscan tradition as having progressed through history towards perfection, so too Venetian tradition is seen as having reached its highest point in the present day. If the art of Michelangelo superseded that of all earlier Tuscan artists, so the art of Titian exacts an analogous judgement on earlier Venetian painters. If Titian's art is sanctioned by that of his predecessors, it is also clear that his new level of perfection finally exposes their shortcomings. This progressive modelling (which runs in the face of actual historical overlaps between artists and works) means that Venetian tradition, like its Tuscan equivalent, is seen as continually revising its own past in its inexorable movement towards perfection.[24]

In Dolce's treatise, Titian becomes the synecdoche of Venetian painting, his example substituting for the whole. Thus we hear that 'today there is one man who can stand in for them all'. But this substitution also occludes the contribution of other painters. Dolce mentions Gentile and Giovanni Bellini, Alvise Vivarini, Carpaccio, Giorgione, Pordenone and Lotto, but their work primarily serves as a foil to the splendour of Titian's genius. Dolce's account of the reception of the famous *Assumption of the Virgin* (see illus. 57) in the Venetian church of Santa Maria Gloriosa dei Frari indicates that the delineation of Venetian tradition in the 1550s is simultaneous with its appropriation by Titian:

the clumsy artists and dimwit masses, who had seen up till then nothing but the dead and cold creations of Giovanni Bellini, Gentile and Vivarini ... grossly maligned this same picture. Later ... they began to marvel at the new style opened up by Titian at Venice. And from then on all of the artists were at pains to imitate it; but because it took them off the beaten track, they never found their bearings.[25]

22 Titian, *Presentation of the Virgin in the Temple*, 1534/8,
oil on canvas, 345 × 775.
Gallerie dell'Accademia, Venice.

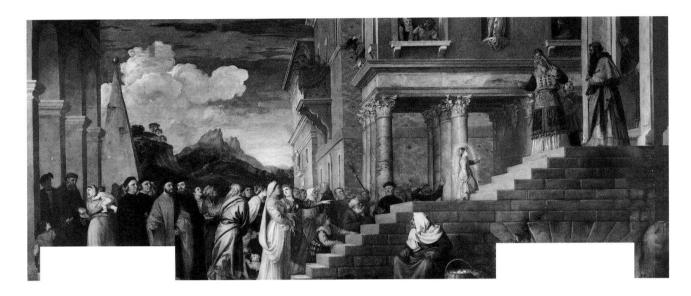

In such passages, Dolce drew very closely on Vasari's descriptions of the disruptive effect of Michelangelo's works on other artists in the Tuscan tradition. The classically derived idea of tradition as the shared project of the community, one which makes slow but inevitable progress towards a common *telos*, comes under pressure from a Judaeo-Christian notion of tradition as a series of unexpected (although preordained) interventions by chosen individuals against established practices. Like Vasari in his *Life of Michelangelo*, Dolce describes Titian's works in terms of divinely inspired miracles which can be neither understood by older artists nor adequately imitated by those following.[26]

As the embodiment of Venetian tradition, Titian also becomes the exclusive guardian of its practices: 'in Titian alone … one sees gathered together to perfection all of the excellent features which have been individually present in many cases'.[27] But at the same time his connections with both past and future painters are downplayed. In this way, Dolce allows Titian to absorb Venetian art into his own dominant

personality: the shared project becomes instead an expression of Titian's own individual volition (*virtù*). This appropriation, which may have been conceived under the supervision of the artist himself, served a number of very important professional exigencies. In addition to supplying a prompt 'patriotic' reply to the initial exclusion of Vasari, it proclaimed Titian's supremacy in the competitive artistic melting-pot of Venice itself, establishing his painting as normative against the very different manners of young painters such as Tintoretto.

While theory necessarily bore a simplifying relation to practice in this period, it remains likely that the idea of Titian as the embodiment of Venetian tradition had already found visual expression in certain of the painter's own works from the 1530s and 1540s. Many of Titian's mature paintings confidently assert their difference from the Venetian art of the past, while others self-consciously refer to it, offering to subsume its different phases and possibilities into the artist's own progressive manner. A salient example is the

23 Michele Giambono, *Presentation of the Virgin in the Temple*, c. 1450/2, mosaic. Mascoli Chapel, San Marco, Venice.

24 Vittore Carpaccio, *Presentation of the Virgin in the Temple*, c. 1504, oil on canvas, 130 × 137. Pinacoteca di Brera, Milan.

Presentation of the Virgin in the Temple commissioned by a Venetian confraternity, the Scuola Grande della Carità, in 1534 (illus. 22). Perhaps in deference to his patrons' conservative tastes, Titan's painting is self-consciously Venetian, at least when compared to contemporary works by other painters in the city (illus. 30) or by Titian himself from this period (illus. 16). Indeed, the image is offered as a synoptic summation of the various phases of art in Venice, and is dominated by the artist's sophisticated awareness of the past. Titian seems to anticipate Dolce, seeking to link his art with that of earlier Venetian painters, while at the same time absorbing their achievements into his own artistic ethos.[28]

Vital to the success of this project is the sense of continuity and balance between potentially conflicting artistic conceptions which Titian maintains within the painting. Thus elements of monumental classicism are introduced into the painted buildings in accordance with the current moves towards Romanism in contemporary Venetian architecture. But these *all'antica* motifs are integrated with buildings of a much more orthodox Venetian style, maintaining an important link with the architecture featured in the earlier versions of the subject by Giambono (illus. 23) and Carpaccio (illus. 24). In support of this connection, Titian carefully resurrects Giambono's luxuriantly decorated and illuminated surface, and Carpaccio's sense of measured spatial planarity. Reference back to the Byzantine and Gothic inspiration of Giambono's mosaic is allowed to intermesh with the orderly processional qualities of Carpaccio's narrative style. And yet the casual and animated naturalism of Titian's figure-style, with its vivid impression of sensual reality, is dependent on the further achievement of Venetian painting in the earlier sixteenth century, and particularly that of Giorgione.

25 Paolo Veronese, *Holy Family with the Infant Baptist,*
St Antony Abbot and St Catherine ('Giustiniani altarpiece'), *c.* 1551,
oil on canvas, 319 × 187.
San Francesco della Vigna, Venice.

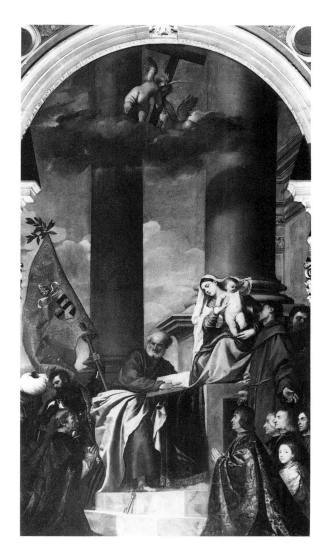

26 Titian, *The Pesaro Altarpiece*, 1519–26,
oil on canvas, 478 × 268.
Santa Maria Gloriosa dei Frari, Venice.

In such paintings, Titian's own sense of his works as representing the perfected *telos* of Venetian tradition is apparent, and this conception held sway over the city's artistic culture into the late 1550s. In this situation, Tintoretto's ejection from the Titian workshop, with which we began, had a much wider and more serious implication for his life as a professional painter, threatening to make him a kind of artistic orphan in his own city. In the classical theory of imitative tradition, as formulated in the writings of Seneca and Petrarch, the prime model is the son's emulation of his father. Ridolfi tells us that Tintoretto's young rival in Venetian painting, Paolo Veronese, accepted this naturalizing topos, considering Titian as 'father of the art', with himself, by implication, as son and heir. On the other hand, Tintoretto's rejection by the 'padre' was tantamount to rejection from Venetian tradition itself.[29]

On his arrival in Venice, Veronese approached Titian's massive example in a very different way to Tintoretto. In his first significant commission, he paid open homage to a famous Titian altarpiece, asserting connection with, and deference to, the art of the older master (illus. 25, 26).[30] In a sense, the Giustiniani altarpiece is more 'traditional' than its prototype, seeming to correct the personalized iconography and unusual pictorial structure of the earlier work in favour of a scrupulous orthodoxy. And yet Veronese's alterations to his prototype are felt as no more than variations on the established schema and never deny the rationale of the original. Veronese does refer to other non-Venetian styles in his altarpiece: for example, that of Parmigianino in the figure of St Catherine at the lower left, and more generally, perhaps, to the manner of Giulio Romano which had proved so influential in his earliest Verona period. But such additions (wholly sanctioned by the gently progressive model of tradition within which Veronese worked) are not allowed to challenge the authority of the underlying Titianesque mode. At the outset of his very successful career in his adopted city, Veronese assumed an attitude of self-sublimating deference to the manner of the dominant master in the city, merely offering to develop Titian's earlier style in accordance with more recent trends in painting.

27 Jacopo Tintoretto, *Presentation of the Virgin in the Temple*, 1552–3,
oil on canvas, 429 × 480.
Madonna dell'Orto, Venice.

28 Daniele da Volterra, *Presentation of
the Virgin in the Temple*, c. 1550–51, fresco.
Santa Trinità dei Monti, Rome.

In contrast, Tintoretto's *Presentation of the
Virgin in the Temple* (illus. 27), painted on the
exterior side of the organ shutters in the Madonna
dell' Orto, further develops the aggressive visual
dialectic with Titian which we have been tracing in
this chapter. The effect is intensified by the partial
connection Tintoretto asserts with the art of his
protagonist. The warm golden and red colour
tonalities and richly worked picture surface (which
are common to many Tintoretto paintings from this
period) deliberately recall the favoured palette and
painterly technique of Titian. Recent technical
examination has revealed that Tintoretto even went
so far as to employ dabs of gold leaf to bring out the
elaborate design on the patterned risers of the steps,
a technical archaism which proposes a connection
with much older Venetian art.[31] It comes as no
surprise that Vasari saw the painting as a
commendable exception among Tintoretto's works.
But its final effect is much less accommodating, the
pointed reference to Titian's summative painting
merely providing an opportunity for an
uncompromising revision to the original conception.
The bold assertion of difference from Titian is not
difficult to analyse: in contrast to the static, self-
contained horizontality of Titian's composition,
Tintoretto constructs an image of vertiginous
verticality, realized through the use of a plunging
dal sotto in sù perspective which violently pulls the
viewer into the picture space. In a manner which
recalls earlier works, such as the *Christ Among the
Doctors* (see illus. 11), Tintoretto offers a radical
spatial reorientation (we note with some surprise
that the picture field is in fact rectangular) which
shoots the protagonist into the background, leaving
the front of the painting to carefully contrived
accessory figures generating complex (but

complementary) juxtapositions of scale and
movement. While these massive figures aid the
spatial plunge towards the distant protagonists, they
also remain significant in their own right. Lit by an
arbitrary play of chiaroscuro, their exaggerated three-
dimensionality offers a scintillating display of figural
difficulty (*difficoltà*) to be enjoyed for its own sake.

It is no accident that Tintoretto framed his
revision to Titian with reference to a very recent
central Italian model, namely the painting of the
subject by Michelangelo's follower Daniele da
Volterra in the Roman church of Santa Trinità dei
Monti (illus. 28).[32] While Veronese integrated
references to recent central Italian style into a

manner and composition still dominated by his prototype, Tintoretto uses such references to mark the limit of Titian's authority. This distinction stands firm, indeed, for many of Tintoretto's paintings in the period 1540–60, and suggests that the 'orphaned' painter employed the formal vocabulary of central Italian Mannerism in a different way from his main rivals in Venice: that is, as a form of visual polemic against the artistic authority of the Venetian *padre dell' arte*.

Tintoretto and Michelangelo

This latter distinction is best established with reference to Tintoretto's early infatuation with the art of Michelangelo. We should not underestimate the controversial quality of Tintoretto's championing of Michelangelo in Venice during the 1540s and 1550s. Following a period of intense interest in the Tuscan amongst local artists and patrons in the preceding period (*c.* 1510–40), Venetian critical attitude began to harden against him, particularly after the unveiling of the Sistine *Last Judgement* in 1541. Aretino's outspoken criticism of Michelangelo's lack of religious decorum in this painting in a letter of 1545 was followed by criticisms of his artistic style in the Venetian treatises on art mentioned above. Among the books of art theory published in Venice at this time only Anton Francesco Doni's *Disegno* (1549) allowed sculpture to be superior to painting, design to colour, and Michelangelo to Titian.[33] Doni (see illus. 66) was a Tuscan who (despite his residence in Venice between 1547 and 1555) continued to enjoy significant connections with the Florentine court. He shared Tintoretto's admiration for Michelangelo in a hostile cultural climate, and it comes as little

surprise that the two men continued an active friendship through the period, or that Doni particularly commended Tintoretto's manner of painting.

Tintoretto's interest in Michelangelo was governed as much by his estrangement from Titian as by some innate artistic taste. Following his rejection by the leading Venetian painter, Tintoretto turned to the major artist in the alternative tradition of central Italy. At the same time, this identification could work as a means of turning the tables, the visual difference it stimulated presenting Tintoretto with a platform from which to reply to Titian's rejection. The young painter's particular fascination with the art of Michelangelo is, as we have seen, readily apparent in very early works such as the *Sacra Conversazione* of 1540 (illus. 13). For this painting he probably drew on a model of the sculpture available in Venice itself, and this procedure may be taken as more generally characteristic of his approach. Such a reliance may indicate that he never visited Florence or Rome (as has sometimes been argued), and therefore that he never saw a genuine work by Michelangelo. But by the mid-sixteenth century it was quite possible to arrive at an indirect knowledge of the Tuscan's work without direct recourse to the artistic monuments in central Italy. The sources of Tintoretto's knowledge of Michelangelo may thus be taken as twofold. On the one hand, he would have seen the works of artists (both central Italian and Venetian) who had seen Michelangelo's paintings and sculptures at first hand. On the other, he could draw on the many reproductive prints and small casts after Michelangelo's work which flooded into the city in this period.[34]

It is evident from Tintoretto's early paintings

29 Jacopo Sansovino, *Head of Jacopo Sansovino*, c. 1545,
bronze relief.
Sacristy Door, San Marco, Venice.

that he was more concerned with the dynamism of
Michelangelo's figure-style than with the decorative
variants of it such as the Grimani ceilings by
Francesco Salviati. In this phase he was particularly
influenced by the powerful muscular forms
dominating the work of artists such as the Tuscan
sculptor and architect Jacopo Sansovino
and the Friulian painter Pordenone (illus. 29). His
particular friendship with Sansovino is documented
by an inscription on a portrait of the artist dating
from the later 1540s ('Jacobus Tintorettus eius
amicissimus').[35] Both the Romanizing slant of
Sansovino's architecture and the mediated
Michelangelism of his sculptural style were to prove
important for Tintoretto's ground-breaking *Miracle
of the Slave* (see illus. 48). Equally important in this
period was the influence of Pordenone, whose most
important innovation following his arrival in Venice
in 1527 was his promotion of the technique of fresco
painting. It is true to say that Venice did not, like
many cities on the Italian mainland, have a long
tradition of monumental narrative fresco painting.
In many centres, such cycles had been fundamental
to the development of the classicizing values of the
Renaissance. The primary reason for the Venetian
lack in this regard was the saline climate, which
radically limited the life-span of frescoes painted in
the lagoon.[36] Despite this, Venetian commissions for
frescoes were common in the fourteenth and
fifteenth centuries, and the most prestigious large-
scale narrative cycle in the city (in the Sala del
Maggior Consiglio of the Ducal Palace) was painted
in the medium. Oil painting only began to be
preferred in the mid-1470s, when the Flemish-
inspired oil technique of the Sicilian painter
Antonello da Messina made a major impact on
Venetian artistic technique, and the state began
replacing the Ducal Palace frescoes with oil
paintings. But even after this official move away
from fresco, the older medium did not die out in the
lagoon. On a trip down the Grand Canal in 1495,
Philippe de Commynes noted that most of the
palace façades were painted, and in the sixteenth
century the developing fashion for painted façades
made Venice appear a 'painted city' (*urbs picta*). This
once ubiquitous genre of Venetian painting has now
largely disappeared, and it may always have been
seen as ephemeral. As Muraro has shown, painters
could not command high prices for such work.
And yet its popularity with patrons (as many as 68
painted palace façades are recorded) and its visibility
made it attractive even to major painters in the
city.[37]

Oil painting was, then, the more recent medium in Venice, and its prestige (particularly in the domain of large-scale public paintings) was not fully secured before the emergence of Titian himself on to the artistic scene. Indeed, it may be no exaggeration to say that the medium became specially identified with him. It was with his massive (and still dominant) presence before them that the Venetian theorists of the mid-century equated oil painting with Venetian art. The equation became an important part of their argument for a distinct local tradition to contest with that of Tuscany. Only slow-drying oil paint allowed for the skilful manipulation of pigment known as *colorito*. As Paolo Pino pointed out in 1548, oil painting was also superior to fresco painting in that it allowed a closer imitation of nature. The identification of oils with Titian (and by extension with all Venetian painting) was also made by leading Tuscan artists. Thus Michelangelo famously insisted on painting his *Last Judgement* in the Sistine Chapel in fresco, declaring that 'painting in oils was an art for women and for leisurely and idle people like Fra Sebastiano'. The slighting references to his erstwhile partner, the Venetian émigré painter Sebastiano del

Piombo, indicate Michelangelo's equation of oil painting with 'lazy' Venetian art, and the more difficult medium of fresco with his own tradition. On a fleeting visit to Venice in 1527, he is reported to have specifically commended Pordenone's prominent frescoed façade on the Palazzo d'Anna, now known only from a surviving preparatory drawing (illus. 30). In this case, Michelangelo would have been impressed as much with Pordenone's fresco technique as with the dynamic monumentality and ideality of his figure style.[38]

During his Venetian period (1527–39) Pordenone worked very successfully in oils. But his repeated work in fresco (both interior and exterior) would also have been recognized as in keeping with an assertively central Italian figure-style. In the context of the fierce professional rivalry that Pordenone developed with Titian during the course of the 1530s, these two interlocking features of his work constituted a form of visual 'argument' against the Venetian master. The often-noted contrast between the two painters was articulated in general terms around opposing Venetian and central Italian principles, Pordenone appearing as a Michelangelesque alternative to the style of Titian.[39] The growing rivalry was cut short by Pordenone's sudden death in 1539, the very year in which Tintoretto is first recorded as an independent master. In the following decade, the young painter precociously sought to take on Pordenone's oppositional mantle.

Although it would be an exaggeration to claim that Tintoretto was dominated by Pordenone's example in his earlier period, his influence does manifest itself at certain key moments. It is evident, as we have seen, in the Washington *Conversion* as it is in the telling modification to the airborne saint in

31–4 Antonio Maria Zanetti, *Female Figures*, four engravings after Tintoretto's frescoes on the Palazzo Soranzo, Venice. From *Varie pitture a fresco de' principali maestri veneziani* (Venice, 1760), plates 10–13.

35 Antonio Maria Zanetti, *Nude Seated Girl*, engraving after Giorgione's fresco on the Fondaco dei Tedeschi, Venice. From *Varie pitture a fresco de' principali maestri veneziani* (Venice, 1760), plate 4.

the *Miracle of the Slave* (illus. 48). Here, Tintoretto drew on the flying figure of Mercury on the upper left of the d'Anna façade to modify his more obvious sources in works by Michelangelo (illus. 47) and Sansovino (illus. 51). The connection between the artists may have had a patronal dimension too. Tintoretto seems to have inherited the support of the *dal banco* branch of the Soranzo family (whose family palace was in the district of San Polo) from Pordenone. Procurator Jacopo Soranzo was (Vasari tells us) Pordenone's great advocate against Titian at the Ducal Palace in the later 1530s.[40]

Tintoretto frescoed the façade of the family's palace in the early 1540s, and went on to paint a long sequence of portraits of Jacopo and his heirs in the following decades. If the remaining painted fragments of the Palazzo Soranzo façade can tell us little, the eighteenth-century engravings by Zanetti indicate that Tintoretto's early fresco style was framed with reference to the example of Pordenone (illus. 31–4), featuring large, complexly contrived figures placed in deliberately compressed spatial contexts.[41] The use of narrow architectural ledges adjacent to the picture plane allows Tintoretto to

36 Antonio Maria Zanetti, *Dusk*, engraving after Tintoretto's fresco on the Palazzo Gussoni, Venice.
From *Varie pitture a fresco de' principali maestri veneziani* (Venice, 1760), plate 8.

37 Antonio Maria Zanetti, *Dawn*, engraving after Tintoretto's fresco on the Palazzo Gussoni, Venice.
From *Varie pitture a fresco de' principali maestri veneziani* (Venice, 1760), plate 9.

generate a sequence of foreshortenings which causes the bulky extremities of limbs to break through into the viewer's space. Such an approach owes much to Pordenone's spatially dynamic d'Anna façade where the lower storey figures aggressively burst forward out of the painted frames. Although this *trompe l'oeil* effect is anticipated to some extent in Giorgione's earlier frescoes on the Fondaco dei Tedeschi (illus. 35), in which limbs also protrude beyond narrow ledges, the antagonism between struggling figure and constrictive ambient is not ultimately Giorgionesque, owing more to Michelangelo's nudes (*ignudi*) on the Sistine ceiling.

Tintoretto, then, was fully alive to the oppositional potential which the fresco medium had taken on in Venice following Pordenone's revival.

Like his forebear, he seems to have conceived fresco as a suitable medium for the promotion of a Michelangelism in the lagoon. Tintoretto was the most prolific painter of façade frescoes in mid-cinquecento Venice, producing cycles of paintings for as many as ten palazzi and houses across the city during the 1540s and 1550s.[42] Although our knowledge of this extensive activity is limited to a few surviving fragments and engravings, these do suggest that Tintoretto made frequent reference to Michelangelo in his fresco work. For example, in the frescoes on the Palazzo Gussoni façade, which fronted the Grand Canal, Tintoretto made his most explicit reference in a large-scale public work to Michelangelo's allegorical nudes in the Medici Chapel (illus. 36–9). However, in these

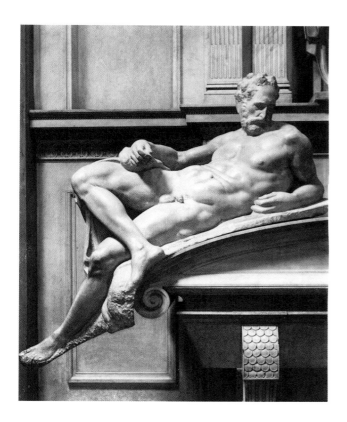

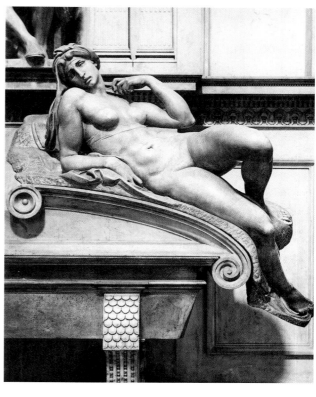

paintings Tintoretto also developed the concern
apparent in the Soranzo façade with sharply
foreshortened monumental forms, conceived in
strongly contrasting light and shade, whose lower
extremities burst forward to disrupt the forward
plane, an effect which complicates our reading of
the overall logic of the form (it may be no accident,
in this regard, that the classically minded Zanetti
preferred to leave out the protruding left foot of
each figure). Even on Ca' Gussoni, where reference
to Michelangelo is at its most overt, we are aware
that Tintoretto actively manipulates his source,
replacing its reserved classicism with a conception
based on a more direct engagement between image
and viewer.[43]

The freedom of Tintoretto's manipulations on

the Ca' Gussoni facade was, in part, a result of
his continuing distance from the reality of
Michelangelo's work. For although the frescoes
referred more definitely than any other of his works
to specific Michelangelo sculptures, it is also clear
that they were based on small-scale casts rather than
on first-hand experience of the originals. As Ridolfi
tells us, Tintoretto owned casts after the four
allegorical nudes in the Medici Chapel, completed
by Daniele da Volterra in 1557. But, as has recently
been proved, the Ca' Gussoni frescoes date from *c.*
1550–52, confirming that Tintoretto had access to
casts of the sculptures much earlier.[44] Indeed, this
is very evident from the reclining nudes which
frequent the foregrounds of important paintings
from the late 1540s such as the *Miracle of the Slave*

(illus. 48) of 1548, the *St Roch Healing the Plague-Stricken* (see illus. 185) and the *St Augustine Healing the Forty Cripples* (illus. 186), both of 1549. In this period too Tintoretto made repeated drawings after Michelangelo sculptures such as the Medici *Dusk* and *Day* (illus. 40–42), the *Giuliano de' Medici* and *St Damian* sculptures from the same complex (illus. 43), and the projected *Samson and the Philistines* group (illus. 49). These studies should not be divorced from those Tintoretto also made at this time after antique sculptures, based both on works he had seen in the Grimani Collection and on other statuettes in his possession (Boschini records that Tintoretto owned *modelli* after famous sculptures such as the Farnese *Hercules*, the Medici *Venus* and the *Laocoön*).[45]

In *Il Riposo* of 1584, the Florentine Raffaele Borghini noted that, in addition to casts after the Medici Chapel statuettes, Tintoretto procured models after many other modern Florentine sculptures 'so that he himself confesses that he recognizes as master, in matters of design, none other than the Florentine artist'.[46] Such a confession may owe more to Borghini's own Tuscan imagination than it does to historical reality. But the writer's

underlying recognition that Tintoretto's habit of drawing after sculpture was exceptional among Venetian painters is essentially accurate. Although Tintoretto often used such studies in his paintings, it is likely that they were not initially made with a specific work in mind. Rather, they are best considered as a coherent group of independent studies after revered classical and contemporary models. In the increasingly polemical climate of mid-cinquecento Venice, these studies would have appeared as a 'Tuscan' departure from the practice of Titian and his followers. A major tenet of Vasari's criticism of Venetian artists was that they did not give due attention to preparatory drawing. As Borghini recognized, Tintoretto's sculptural studies seemed to directly align him with the opposing tradition of Florence.[47]

And yet the promise of such a miraculous conversion is wholly undone in the drawings themselves, which are very different from the careful, anatomically correct studies after sculpture carried out by contemporary artists in Florence and Rome (illus. 44).[48] This difference is partially accounted for by the fact that Tintoretto dealt with transcriptions and interpretations. His casts after

42 Jacopo Tintoretto, *Study after a statuette of Michelangelo's 'Day'*, 1545/50, black chalk heightened with white lead on blue paper, 3.33 × 2.75.
Christ Church Library, Oxford.

43 Jacopo Tintoretto, *Study after a statuette of Michelangelo's 'Giuliano de' Medici'*, 1545/50, black chalk heightened with white lead on blue paper, 3.15 × 2.66.
Christ Church Library, Oxford.

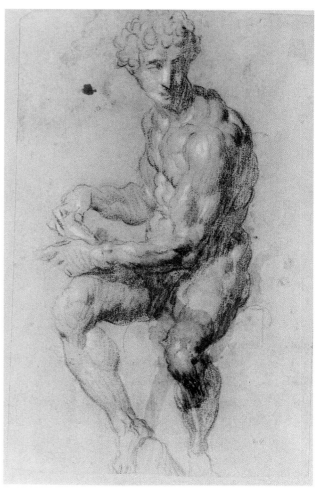

44 Francesco Salviati, *Seated Female Nude*, c. 1554/6, black chalk, 2.19 × 2.62. British Museum, London.

45 Michelangelo Buonarroti, *Day*, 1526–34, marble, 1.185 high. Medici Chapel, San Lorenzo, Florence.

46 Michelangelo Buonarroti, *Giuliano de' Medici*, 1521–34, marble, 172.72 high. Medici Chapel, San Lorenzo, Florence.

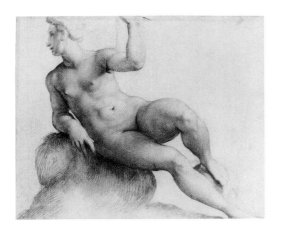
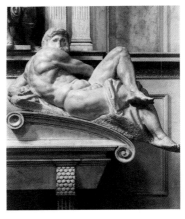
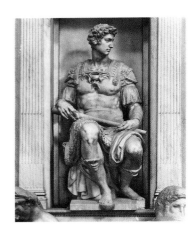

Michelangelo sculptures would, in particular, have given a very distorted impression of the originals, both in an objective sense – as a result of their small scale, low-grade material and diverse finish – and subjectively – as inevitable stylistic interpretations of the originals. Re-reading, then, is a prior condition of Tintoretto's approach to Michelangelo and classical sculpture. And yet the very circumscribed nature of Tintoretto's knowledge in this regard may have worked to his artistic advantage, for just as his early rejection from the circle of Titian offered him a vital measure of separation from the dominant manner in Venice, so his distance from Michelangelo allowed an equivalent creative distance with regard to the art of central Italy.

But this group of drawings also suggests that Tintoretto's intensive reworking of his source was a matter of more conscious artistic decision. On the one hand, Tintoretto stressed the sculptural integrity and monumentality of Michelangelo's form. This is evident, for example, in his preference for radically foreshortened viewpoints in his studies after *Day* (illus. 42, 45) or in the exaggerated attention to musculature in those after *Giuliano de' Medici* (illus. 43, 46). On the other, he exploits the lightweight quality of his casts to unhinge the given form from its rational coordinates in space, allowing it an effect of weightlessness alien to the monumental originals (illus. 38, 40). While the agitated white highlighting generates a chiaroscuro effect which promises to detail the corporal surface of the form, the arbitrary nature of its distribution simultaneously threatens to reduce material substance to a mere sequence of light and dark patches lying along the picture surface. Furthermore, while Tintoretto superficially circumscribes his forms with strong contour lines, the radical abbreviations of his handling, typified by scallop-shaped half-circles which rarely cohere, mean that the forms never achieve a Michelangelesque isolation from their surrounding context. The subjection of the fixed stillness and mass of Michelangelo's sculpture to a series of arbitrary and subjective viewing conditions indicates that Tintoretto's relation to Michelangelo was a distant one. But in these drawings Michelangelesque *disegno* is not simply subjected to the naturalistic logic of Titianesque *colorito*. For the flickering restlessness of these drawings results precisely from the lack of resolution they allow between the two contrary modes.

47 Nicolas Beatrizet, *Conversion of St Paul after
Michelangelo*, 1547, engraving.
Bibliothèque Nationale de France, Paris.

48 Jacopo Tintoretto, *Miracle of the Slave*
(Miracle of St Mark), 1548,
oil on canvas, 416 × 544.
Gallerie dell'Accademia, Venice.

The limits to Tintoretto's practical commitment to the traditionalist motto hung over the door of his studio are clearly apparent in these studies. The same is true of the most famous painting from the early period, the *Miracle of the Slave* (illus. 48). In this remarkable work, Michelangelesque reference again controls, and is controlled by, the Titianesque idiom. The immediate dominance of Michelangelo's example is apparent in the most general terms, for the composition was probably inspired by Nicolas Beatrizet's reproductive print after the Tuscan's

Conversion of St Paul (1542–5) published in 1547 (illus. 47).[49] Evidence of Tintoretto's drawings after Michelangelo litter the painting. For example, the muscular back of the soldier in red is clearly based on his studies after the *Samson and the Philistines* statuette in his possession (illus. 49, 50), while reference to the studies after the Medici allegories recurs in as many as five of the reclining figures, including the foreshortened body of the slave himself.[50] Less directly, Michelangelo's influence is apparent in the emphasis given to powerfully

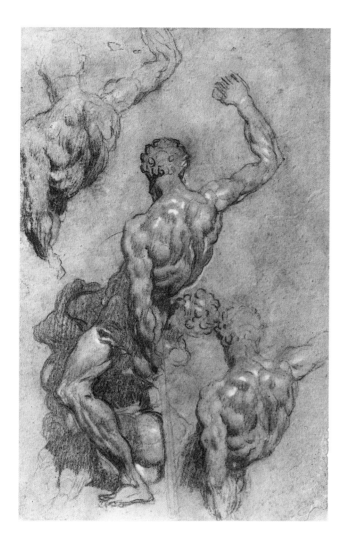

49 Jacopo Tintoretto, *Study after a statuette of Michelangelo's 'Samson and the Philistines'*, 1545/50, charcoal heightened with white lead on grey paper, 4.52 × 2.74. Collection of the Courtauld Institute of Art, London.

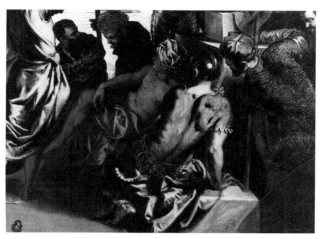

50 Jacopo Tintoretto, detail of illus. 48.

articulated human form in complex movement. This correspondingly reduces colour to an essentially supportive role. The glancing acerbic tones, shot through with relief-creating darks and bold white highlights, serve to generate an intellectual detachment in our apprehension of form. More generally, the poised artificiality of the arrangement encourages the viewer to enjoy form for its own sake, to take note of (and pleasure in) its knowing display of artistic *difficoltà*.

The heightened formalism of the *Miracle* is indicative, then, of a more general aspect of Tintoretto's interest in Michelangelo: the idea of form as an opportunity for the display of pure artistic virtuosity. Despite their iconographic content, the figures on Ca' Gussoni were mere vehicles for a show of Tintoretto's skill, their ornamental qualities the locus for a display of art independent of all other considerations (see illus. 36, 37).[51] In the *Miracle* too, Tintoretto's figures typically seem to owe more to the artist than to the prescribed subject. But alongside its promise of artistic licence, Michelangelo's conception of form could equally offer an important expressive dimension, opening the way to a language of heightened dramatic power. In order to demonstrate the working of this second dimension in the *Miracle*, we will need to return again to the artistic sources of the painting.

Another point of reference for the composition is the little bronze relief in St Mark's by Jacopo Sansovino showing the same subject (illus. 51).[52] The relief has much in common with Michelangelo's slightly later fresco, both images

51 Jacopo Sansovino, *Miracle of the Slave*
(Miracle of St Mark), 1541/4,
bronze relief, 48.3 × 65.4.
Tribune, San Marco, Venice.

featuring a foreshortened airborne figure moving head-first towards the viewer, above a prostrate, earth-bound figure arranged horizontally across the picture plane. As we have seen, Tintoretto reversed this solution with reference to Pordenone's flying figure on the d'Anna façade (see illus. 30). Tintoretto's St Mark flies into (rather than out of) the picture space, while his prostrated slave is shown in a radical foreshortening which directly echoes that of the saint above. This adjustment serves a double function. On the one hand, it more definitely connects the heavenly and earth-bound protagonists (the typically indecorous play of chiaroscuro between shadowed saint and brightly lit slave reinforces their intimate relation). On the other, it generates a dynamic pocket of space at the centre of the composition, one pregnant with symbolic possibility.

The pictorial rhetoric of the *Miracle* is worked around the unexpected invasion of these exaggerated plastic forms into what would be, in their absence, a much more orthodox composition. The foreshortenings of saint and slave make a sudden incursion into an essentially lateral and planar arrangement which may refer back to earlier examples of narrative painting in the city. For all the sense of sculptural relief, the composition is arranged so as to hold the eye near to the picture surface, and is replete with a mixture of exotic and quotidian detail reminiscent more of Gentile Bellini or Carpaccio than Michelangelo (illus. 24). This particular reference is evident from inclusion of details such as the oriental types who feature prominently in the existing cycle of paintings in the committee room of the scuola Meeting House. But reference to earlier Venetian painting is less marked

than that to the manner of Titian. Aretino did not misread the painting unduly when he praised its realism in the eulogistic terms he usually reserved for Titian himself ('The colours are flesh ... the faces, airs and expressions of the crowd ... so exactly as they would be in reality, that the spectacle seems real rather than simulated'). The rapprochement with Titian's dominant manner evident in other paintings from the period is, to this extent, already apparent in the *Miracle*.[53]

And yet the painting generated immediate controversy, as we shall see, and was initially returned to the painter as unsuitable, probably as a result of the extraordinary formal and spatial gymnastics introduced into the centre of the canvas. The passage displays a freedom of figural invention which explodes the naturalistic restraints inherent to Titian's conception of painting. But the spatial enclave shared by heavenly saint and faithful slave also has an expressive dimension, establishing the protagonists' spiritual intimacy with one another, and their distinction from the motley crowd of spectators and would-be executioners surrounding them. The 'impossible' spatiality of the two protagonists marks a moment of miraculous intervention in which rational laws are overturned. The twin potentialities of Michelangelo's artistic language are thus released in this audacious passage. The display of artistic *difficoltà* is made a platform for the ideal interaction between divine and mortal. And yet Tintoretto's Michelangelism is only effective 'in context', defined by its polemic against the surrounding Titianesque naturalism. In this sense, Tintoretto's early narrative manner is based on his deliberate collision of stylistic modes typically kept distinct in mid-sixteenth-century painting.[54]

Tintoretto's style in the major painting of his early period has often been described as a balanced response to the work of the two great artistic authorities of the age. But, as we have noted, the young painter remained at a distance from these towering figures. Although his knowledge of Michelangelo's work widened significantly after 1550, it nonetheless remained comparatively limited and mediated.[55] On the other hand, he seems to have been denied an entrée to Titian's influential workshop throughout the 1540s and 1550s. In contrast to Titian, Tintoretto's career was played out in a very local domain: just as Dolce's promotion of Titian's 'Venetianness' (*venezianità*) masked the internationalism of his expressive mode, so Tintoretto's aggrandizing eclectic programme ('il disegno di Michel Angelo e'l colorito di Titiano') concealed the peripherality of his position with regard to the leading figures in Italian art. Although it has been argued (by Rodolfo Pallucchini and others) that Tintoretto's early manner was born out of an innate artistic 'taste' (*gusto*), it is more fruitful to consider his style as an issue of professional power relations. In this regard, it may even be permissible to resurrect the idea of artistic alienation developed by Arnold Hauser. Hauser saw Tintoretto as a prime example of a more general stylistic reification in the period, and thus followed Dvořak, Friedlander and other historians in assuming that all Mannerist art was the product of an underlying social and cultural crisis in sixteenth-century culture.[56] But even if this assumption cannot now be sustained, it is still possible to argue that cultural (or, more precisely, professional) marginality played a central role in the formation of Tintoretto's very specific form of 'Mannerism'. This would not be to make his style the issue of some wider social malaise,

52 (opposite) Jacopo Tintoretto, *Voyage of St Ursula and the Virgins*, 1550/5, oil on canvas, 330 × 178. San Lazzaro dei Mendicanti, Venice.

53 Vittore Carpaccio, *Arrival in Rome*, c. 1494/5, oil on canvas, 281 × 307. Gallerie dell'Accademia, Venice.

or to see it in Hegelian terms, as somehow historically inevitable. Rather, it would allow that his manner necessarily occupied a given position or space within an increasingly differentiated cultural field, one in which prestige was increasingly localized in the products of leading practitioners. That Tintoretto's position was to some extent alienated from the values of this narrow élite is evident from the fact that his early manner was perceived by contemporaries as capricious and bizarre, rather than as a respectful homage to established artistic authority. Beneath the more overt discourse of 'traditionalism' in his early paintings lurks a tendency towards pastiche and even parody of the high traditions of Renaissance art.

This tendency is apparent from his habit (particularly in works of the earlier 1550s) of switching styles. In the altarpiece showing the *Voyage of St Ursula and the Virgins* (illus. 52), for example, the old quattrocentesque manner of Vittore Carpaccio is suddenly resurrected. In this case, Tintoretto's stylistic modulation was undoubtedly encouraged by the prescribed subject-matter: Carpaccio's extensive *St Ursula* cycle then hung in the Scuola di San Orsola, and was the authoritative Venetian representation of the subject (illus. 53).[57] Tintoretto accordingly dropped his 'modern' figure style in favour of Carpaccio's delicate handling and naïve processional composition. We noted earlier Tintoretto's technical archaism in the near-contemporary organ shutters for Madonna dell' Orto (see illus. 27), as if the painter actively sought to assert his connection with Venetian painting from the period before Titian. But the San Lazzaro painting nonetheless has the 'one-off' quality of a self-conscious pastiche. In virtuoso fashion, Tintoretto knowingly re-creates an outmoded

manner, displaying his ultimate superiority to his source. The inclusion of an ultra-modern flying angel of martyrdom in the upper part of the composition, with its massive scale, generalized treatment and spatial freedom, contradicts that of the delicate figural-types below: the angel's incongruity modifies our perception of the composition below, making its traditionalism appear as a kind of knowing stylistic trope.

A similar play across the surface of tradition is evident in the altarpiece for the church of the Crociferi showing the *Assumption of the Virgin* (illus. 54). Ridolfi reports that Tintoretto won this commission only by promising to paint in the manner of Veronese. It has recently been suggested that this offer was prompted by the negative response of Tintoretto's patrons to a more unorthodox initial painting, now in Bamberg (illus. 55).[58] In the second version, Tintoretto successfully suppressed those elements which caused offence to his patrons, arriving at a passable mock-up of

54 Jacopo Tintoretto, *Assumption of the Virgin*, c. 1555, oil on canvas, 440 × 260. Church of the Assunta ai Gesuiti, Venice.

55 Jacopo Tintoretto, *Assumption of the Virgin*, c. 1555, oil on canvas, 437 × 265. Obere Pfarrkirche, Bamberg.

56 (opposite) Jacopo Tintoretto, *St Louis, St George and the Princess*, 1552, oil on canvas, 226 × 146. Gallerie dell'Accademia, Venice.

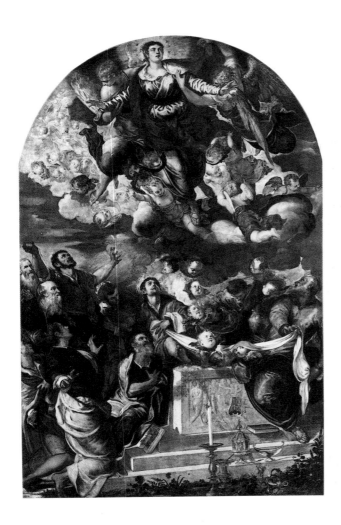

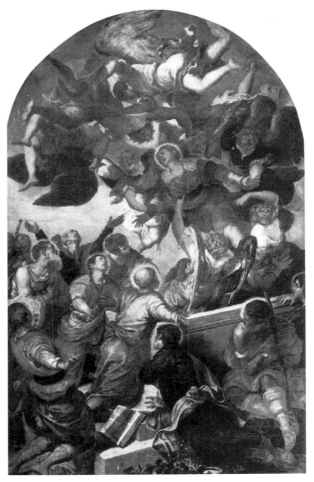

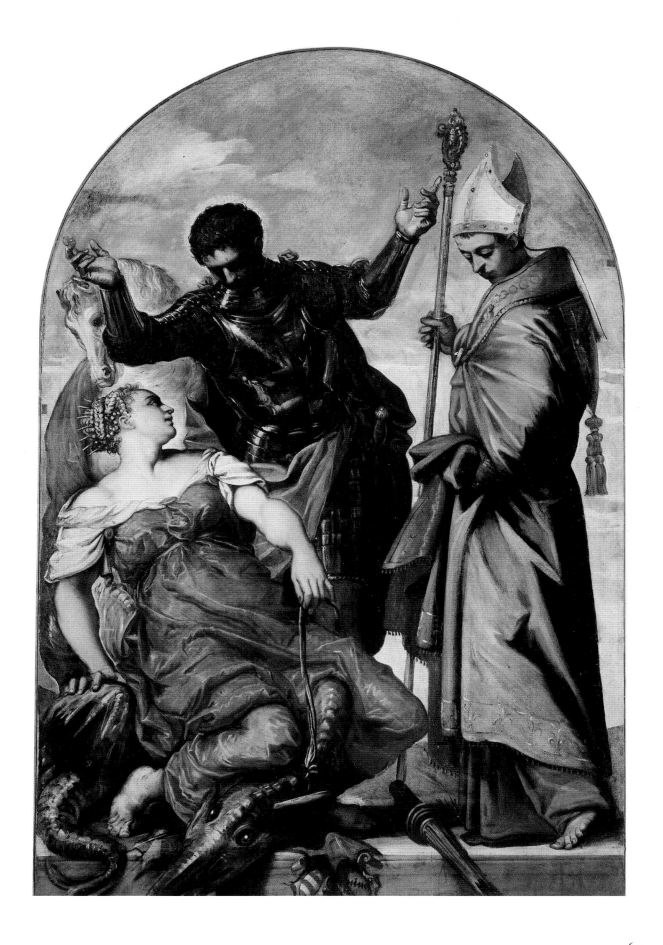

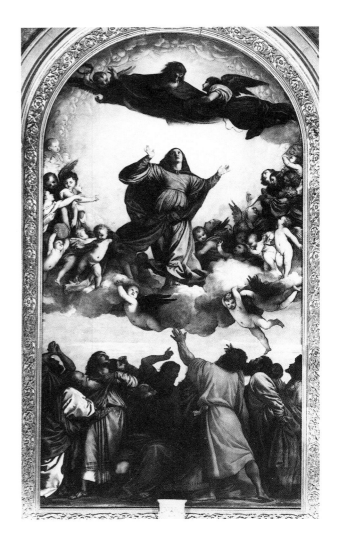

Veronese's deferential traditionalism. In contrast to
the de-centred spatial and figural dynamism of the
Bamberg painting, we now have a clarified image,
the tilting spatial vortex of the first version being
replaced by one of achieved 'Renaissance' weight
and symmetry. But if the silvery coloration and
heavy formal masses stacked against the picture
plane owe much to Veronese, then the underlying
reference is, of course, to Titian's *Assumption of the
Virgin* in the Frari (illus. 57). This double reference
may indicate Tintoretto's awareness of the
developing relationship between Titian and
Veronese, one which was confirmed in symbolic
fashion in this very period, when (in 1557) the old
painter awarded Veronese a gold chain for his
contributions to the Reading Room ceiling in the
Libreria Marciana. Ridolfi tell us that Titian had
also seen to it that Tintoretto was not considered for
the commission. The mimicry of Titianesque style at
the Crociferi thus coincided with the moment at
which Veronese's adherence to Titian's manner was
acknowledged and rewarded.[59]

However we take Tintoretto's show of orthodoxy
in the Crociferi, it is clear that the blatant stylistic
mimicry of a close rival went well beyond the
acceptable dictates of Renaissance imitation
(*imitatio*). It comes as no surprise to find that the
victim of his pastiche was upset with Tintoretto's
stylistic switches. In his *Life of Veronese*, Ridolfi
reports that Veronese appreciated Tintoretto's genius
(*ingegno*), but did not approve of his habit of
painting 'in any manner' considering that it might
even 'destroy the reputation of the profession of
painting'. Vasari had already commented on
Tintoretto's unusual stylistic pragmatism, noting
(in disapproving terms) his habit of switching
manner to win commissions. Here, Vasari drew on
much older ideas with regard to artistic *imitatio*: in
his *Libro dell'arte* (*c.* 1400) Cennino Cennini advised
the aspirant painter to hold to the style of one
painter (that of his master) in order to avoid
becoming 'fantastical' (*fantastichetto*). This was, of
course, Vasari's main charge against Tintoretto: as a
painter prepared to work 'in any manner',
Tintoretto's *fantasia* was not properly controlled,
undermining the normative transmission of artistic
values from master to pupil.[60]

58 Bonifazio de' Pitati, *St James the Greater and
St Jerome*, 1548, oil on canvas.
Fondazione Cini (on loan from Gallerie dell'Accademia,
Venice).

But if, in the San Lazzaro and Crociferi
paintings, Tintoretto's stylistic mimicry was
disruptive, in other paintings it was his propensity
towards unprecedented pictorial invention. This is
evident, for example, in a votive painting of
orthodox type for the Palazzo dei Camerlenghi in
Venice (illus. 56). It was a fundamental expectation
for works such as this that the painter should closely
follow the established schema showing static
gatherings of the name-saints of the patrons, as
established by Bonifazio de' Pitati in the previous
decades (illus. 58).[61] Instead, Tintoretto manipulated
the established schema to generate new formal and
expressive possibilities. He placed his saints in
different spatial planes, initiating a sophisticated
illusionistic display. The narrow platform on which
the figures are placed (a memory of the illusionistic
architecture of the Soranzo façade) is bedecked with
various foreshortened attributes which project
aggressively beyond its leading edge, confusing the
distinction between actual and fictive space. The
massive figures are brought up against the picture
plane, their complex *contrapposti* a demonstration of
formal *difficoltà* that threatens to obscure their
iconographic status.

The female figure is (given her crown)
identifiable as the princess saved by St George,
functioning as a sort of attribute of the saint behind
her. She is shown astride a writhing and recalcitrant
snake-like creature whose face peers out at the
viewer knowingly from between her legs. While St
George throws up his arms in excitement, St Louis
gathers his skirts about him in a movement of
instinctive pious revulsion. Tintoretto's invention,
which allowed a narrative (perhaps even comic)
dimension to a previously iconic painting-type,
apparently generated both confusion and

condemnation. Dolce identified the female figure as
St Margaret, suggesting that Tintoretto had used
'little consideration' in showing her 'riding on the
serpent'.[62] Had he realized the figure's merely
attributional status, he might have been more willing
to accept Tintoretto's invention. And yet Dolce's
concern with Tintoretto's lack of decorum was
perhaps less specifically iconographic. After all,
Tintoretto had shown a young female (with
shoulders and arms enticingly revealed) in the most
intimate physical proximity to the beast, the
humorous erotic undertone this intimacy suggests
threatening to undermine the piety and seriousness
of the holy gathering.

59 Jacopo Tintoretto, *Last Supper*, *c.* 1556/8,
oil on canvas, 221 × 413.
Chapel of the Sacrament, San Trovaso, Venice.

CHAPTER TWO
Tintoretto and Venetian Literary Culture

We can best follow the anti-traditional tendencies in the earlier work of Tintoretto by considering his connection with the so-called *poligrafi* (the group of writers, editors and publishers closely associated with the Venetian printing presses) in the decade following the *Miracle of the Slave*. In this period, the painter's approach has much in common with this literary circle and although the association was effectively over by 1560 it left an important formative mark on Tintoretto's manner. The close association of writers and artists was, of course, a well-established feature of Venetian cultural life by the mid-sixteenth century.[1] But further consideration of this connection is also of special relevance to our underlying theme, for literary culture was undergoing an intellectual transformation parallel in nature and import to that we have noted in the field of the visual arts.

In his influential *Prose della volgar lingua* (1525), the Venetian patrician Pietro Bembo (see illus. 64) proclaimed that authors writing in Latin should narrowly conform to the literary style of classical writers such as Cicero and Virgil. According to Bembo, writers in Italian should likewise adopt the so-called *Volgare*, a purified literary language closely based on the fourteenth-century Tuscan of Dante, Petrarch and Boccaccio. As Vasari was subsequently to do in the *Lives of the Painters*, Bembo stressed the need for conformity to classical precedent and to an accepted canon of Renaissance works. He thus invested tradition with a new level of authority and demanded full conformity to its exalted models. But in this case too, Bembo's promotion of a singular, monolithic style was controversial and disruptive, for the *Volgare* was defined against an existing plurality of regional languages and related literary practices in sixteenth-century Italy.[2]

Although Bembo's ideas were quickly taken up by many writers at Venice and elsewhere, others challenged its projected linguistic closure, reasserting the rights of a dialect literature based closely on the spoken word. This controversy (known as the *questione della lingua*) generated important divisions within the literary community in Venice. The *poligrafi* particularly rebelled against the new prescriptions for classical orthodoxy.[3] This circle (which can also be extended to include certain key figures from Venetian comic theatre) was primarily committed to fulfilling the popular demands of its paying public. Its quotidian culture was in many ways distinct from the more courtly group of literati who gathered around Pietro Aretino at the middle of the century.[4] Despite their own associations with the Venetian presses, members of Aretino's circle typically saw themselves as distinct from the workaday preoccupations of the *poligrafi* and aspired to the values of 'Bembism'. It was from within this ambitious group, which championed the art of Titian, that the criticisms of Tintoretto's painting noted at the beginning of this book first emerged.

Aretino was among Tintoretto's earliest patrons (see illus. 17) and initially commended the young painter's rapidity of execution. When he wrote to Tintoretto again in April 1548, this time in response to the completion of the *Miracle of the Slave* (see illus. 48), his tone had become more cautionary. After praising the painting's realism, Aretino appended a final proviso:

Blessing be upon your name if you can temper haste to have done with patience in the doing. Though, gradually, time will take care of this; since time, and nothing else, is sufficient to brake the headlong course of carelessness so prevalent in eager, heedless youth.[5]

60 Anon, *Portrait of Lodovico Dolce*, 1561,
woodcut from Dolce, *Impresa del conte Orlando* (Venice, 1572).

61 Jacopo Sansovino, *Head of Francesco Sansovino*, c. 1545,
bronze relief.
Sacristy Door, San Marco, Venice.

Aretino's specific criticism of Tintoretto's 'haste to
have done' (*prestezza del fatto*) was destined to form
the basis for further negative comment published by
the poet's literary disciples Francesco Sansovino and
Ludovico Dolce (illus. 60, 61) in the following
decade. Francesco, the writer son of Tintoretto's
'very good friend' Jacopo Sansovino, criticized the
artist for painting too much too quickly in the first
ever guidebook devoted to Venetian artistic
monuments (*Delle cose notabili che sono in Venetia*,
1556, 1561). Tintoretto may well be the unnamed
painter attacked in still stronger terms by the figure
of 'Aretino' in Dolce's *Dialogo della pittura*, the book
which sought to confirm Titian's role as the main
representative of Venetian artistic tradition.
Tintoretto's is probably the foremost among the
young painters criticized at the end of Dolce's book

for the 'avarice' (*avaritia*) which leads them to
'expend little or no effort on their works'.[6]

The early criticisms of Tintoretto published by
the leading literary lights of mid-cinquecento Venice
have often been noted, but analysis has typically
focused on the ways in which they might reflect the
relationship between Aretino and Tintoretto. Noting
the rapid hardening of critical attitude, and an
oblique reference to a Tintoretto misdemeanour in
another Aretino letter of 1548, Giulio Lorenzetti
argued that the two men fell out in this year, and
that the subsequent Aretinian criticisms resulted
from their unresolved hostility. More recently, Mark
Roskill maintained that the two men continued to be
friendly up until Aretino's death in 1556, and that
Dolce misrepresented the poet's attitude in his
Dialogo.[7] However this may be, the focus on

62 Titian, detail of the lower foreground of
Diana and Acteon, 1556/9, oil on canvas.
National Gallery of Scotland, Edinburgh.

personal relationships common to both these views tends to obscure the wider artistic and cultural implications of the Aretinian criticisms. It is no accident that the comments issuing from the Aretino circle have a very specific focus on Tintoretto's *prestezza del fatto*. The issue of speed in execution was of great importance both to artists and to writers in the mid-cinquecento. Indeed, it stood as a central bone of contention between those advocating the new, purified version of literary and artistic tradition, and those who disputed its authority.

Prestezza *in Artistic Theory and Practice*

Slow execution was typically associated with lasting artistic value in classical art theory. Thus Zeuxis explained that he painted 'slowly so that my pictures will live for a long time', and Apelles mocked the artist who completed a painting in a single day saying 'you need not tell me . . . the work itself shows it'. In the Renaissance too mistrust of rapid execution remained paramount. For example, Vasari himself was strongly criticized for completing his frescoes in the Cancellaria at Rome too quickly: Michelangelo's withering comment on being told that they had been finished in a hundred days ('e si vedi') directly echoed that of Apelles. However, the same theoretical tradition certainly championed works showing the kind of lightness of touch which merely *suggested* quickness of execution. According to Pliny, Apelles proved his artistic superiority to the laborious Protogenes by 'knowing when to take the hand away from a picture', and Vasari defined the perfected third stage of art historical development in the *Lives* in terms of a progression beyond the excessive diligence of quattrocento art. And yet this modern lightness of touch was not to be confused with mere time-saving.[8]

It was within this classically derived theoretical framework that Tintoretto's critics from the Aretino circle formulated their attitudes. Tintoretto's *prestezza del fatto*, understood merely as a product of his desire to save time, was seen as betraying the craftsmanly values by which the painter brought his work to the appropriate degree of finish. But it was also to be contrasted with Titian's own experiments in the direction of loose brushwork in his paintings from *c.* mid-1550s onwards (illus. 62). His free brushwork could be explained as a sophisticated pictorial refinement akin to that of Apelles. Probably drawing on a distinction already made in the Venetian circle of Aretino, Vasari contrasted the manner of the two painters in the second edition of the *Lives*. While works such as Titian's mythologies (the so-called *poesie*) for Philip II are loosely painted 'with bold strokes and an . . . even sweep of the brush', Vasari also notes that they are 'painted over and over again . . . with his colours, so that the labour involved may be perceived'. Titian's new method is described as 'judicious, beautiful and

astonishing' just because it 'conceals the labour' that has gone into it. As Vasari undoubtedly knew, his description of Titian's pictorial procedure bore close analogies with Baldissare Castiglione's key concept of nonchalance (*sprezzatura*) expounded in the *Libro del cortigiano* (1526), through which the ideal courtier was enjoined to conceal the laborious social construction of his personality beneath an appearance of easy casualness. The association thus gave Titian's unfinished later manner an important parallel and sanction in courtly social etiquette. In contrast, Vasari's description of the loose brushwork of Tintoretto does not allow of any such elevating associations, for the casualness of his painting is understood as actual rather than simulated. Tintoretto leaves 'as finished works sketches [*bozze*] still so rough that the brush strokes may be seen, done more by chance and vehemence than with judgement and design' (illus. 63). And his reasons for working in this manner are essentially mercenary for 'with these methods he has executed, as he still does, the greater part of the pictures painted in Venice'.[9]

It may be that the critical distinction examined above was, in the first place, inspired by the professional rivalry between Titian and Tintoretto. It is no accident that it was initially formulated by writers from the Venetian literary circle committed to Titian's cause. And yet the historical reality of both Titian's slowness and Tintoretto's speed cannot be doubted. Titian's career is littered with examples of his tardiness in the completion of paintings, delays which were more typically the result of the painter's internal working procedures than of external problems.[10] In Boschini's famous account of Titian 'at work' (supposedly based on the testimony of Palma Giovane) we hear of the master's exaggerated process of retouching and reworking. After making an initial sketch, Titian would turn his pictures to the wall and leave them, sometimes for several months. He was thus free to incorporate many changes of mind during the course of execution in his search for a satisfactory artistic solution. This was an approach geared to serve the expressive needs of the artist rather than the requirements of the patron. As such, it was an advantage secured by Titian's position as the leading painter of his day, and reflected his partial release from the artisan-mercantile ethos of 'time is money'. The patience of many Renaissance patrons with regard to the slow or erratic production of leading artists reflected their growing acceptance that artistic activity was distinct from other forms of production. Titian, like Zeuxis before him, could presume on an accepted correlation between slow production and the exalted status afforded to the works of a leading painter.[11]

For less prestigious painters, however, the 'time is money' ethos was not so easy to cast off. A well-known passage in Paolo Pino's *Dialogo della pittura* indicates that a very different professional situation generated the *prestezza* with which the young Tintoretto was associated. After quoting the standard Apelles topoi, Pino (himself a Venetian painter) criticizes the rapidity of Andrea Schiavone, Tintoretto's associate in the production of cassoni paintings and façade frescoes in the 1540s and 1550s. Pino's terms are very similar to those adopted by the Aretino circle to criticize Tintoretto, except that in this case the painters under fire are given the chance to answer back. Fabio, a courtly Florentine, condemns the 'practice of smearing [*empiastrar*]' as a 'shameful thing' governed by the painter's overriding concern to save time in execution. In reply the Venetian painter,

63 Tintoretto, detail of central part from illus. 156.

Lauro, does not dispute this interpretation on
aesthetic grounds, merely offering in mitigation the
grinding poverty faced by the painters in question:
'poverty is murderous I tell you and one work is not
paid enough for the money to last until the next is
finished. One goes as fast as one can . . .' The
historical accuracy of Pino's link between economic
contingency and the emergence of the new *prestezza*
in Venetian painting during the 1540s should not be
doubted. And yet this connection does not cancel out
the possibility of creative volition and aesthetic value
as he so readily assumed.[12]

Literary prestezza

Although it is thus possible to tie critical attitude to
artistic practice, we cannot presume that the former

was exclusively dependent on the latter. The
contrasting approaches of Titian and Tintoretto
were, in an important sense, defined by literary
categories. In *La carta*, Boschini quotes an
important saying of Titian's in this regard. The
painter, we are told, never painted a figure all at
once 'and used to say that he who improvises [*canta
all'improviso*] cannot compose learned [*erudito*] or
well-constructed verses'. The passage may be taken
as indicating Titian's own critical attitude to the new
loose manner abroad in Venetian painting. It also
suggests his formulation of this attitude within a
specifically literary framework. His simile draws on
the commonplace connection between painter and
poet exemplified in the Horatian idea of an
equivalence between poetry and painting (*ut pictura
poesis*). But in contrasting the poet who improvises
with the poet who composes erudite verses Titian
also made reference to the contemporary
philological controversy mentioned earlier, the
so-called *questione della lingua*.[13] The leading
protagonist in this debate was, as we have seen,
Pietro Bembo, the famous Venetian man of letters,
who, as Vasari approvingly reports, 'took pains over a
sonnet for months or even years'. As a friend and
patron of Titian (illus. 64), the poet may have played
a significant role in encouraging the painter's
preference for carefully constructed 'Bembist'
works. It has been argued that the rapid spread of
Petrarchism (*Petrarchismo*) in Italian literary culture,
following Bembo's lead, had a discernible impact on
the painting style of Parmese artists such as
Parmigianino. Such ideas also affected painters in
Bembo's native city, where the new literary style was
all the rage, and the overlap between literary and
visual culture ever more significant.[14]

Titian's famous friendship with Pietro Aretino

(illus. 65) could only have contributed to his preference for erudite works of art in a much less straightforward way. Aretino's position *vis-à-vis* the *questione della lingua* was far from consistent. Through his association with publishers such as Francesco Marcolini, Aretino undoubtedly exploited the professional advantages offered by the printing presses in Venice. It is in this context that we can best understand his statements that he preferred to let his works be printed without correction or embellishment. When he came to write about Titian's paintings, Aretino stressed their naturalism and spontaneity rather than their careful construction or erudite references. Moreover, he often expressed his poetic theory in terms of speed and the originality it engendered (*il prestezza e il suo*).[15] But despite his rivalry with Bembo, Aretino was in no sense a consistent opponent of the older poet's classicizing principles. Although he sometimes condemned literary pedantry, he never displaced the ultimate authority of Bembo's prescribed literary models. In the well-known *Parnassus* letter of 6 December 1537 the throne is reserved for 'divin Bembo'. If the rapid epistolary style adopted in such publications ran contrary to Bembo's ideals, Aretino's work in more established genres can stand as early examples of their fulfilment. In keeping with this, Aretino did not scruple to chide Titian himself when he felt that his favourite's work lacked adequate finish. Thus he was not happy with the loose brushwork employed in the Pitti portrait illustrated here, which appeared to him as 'more sketched than finished'.[16]

Aretino was particularly keen to distance himself from the circle of younger *poligrafi* in Venice, whose literary production fulfilled few of Bembo's criteria. In the *Parnassus* letter, he makes clear his contempt for writers whose success was solely dependent on market conditions, satirizing those struggling to climb the poetic mountain by association with the city's thriving printing presses: 'The fools with their breeches down, up to their necks in a lake of ink blacker than the fumes of the printing press; there is no more absurd spectacle in the world.' In publishing his first volume of letters he was again keen to distinguish himself from writers who were dependent on book sales for their living. In a letter to Marcolini (22 June 1537), he described such men as no better than pimps who empty the purses of their whores each evening:

I pray that with God's favour the courtesy of my patrons will recompense me for my writings, and not the misery of those who buy them, which would offer an injury to

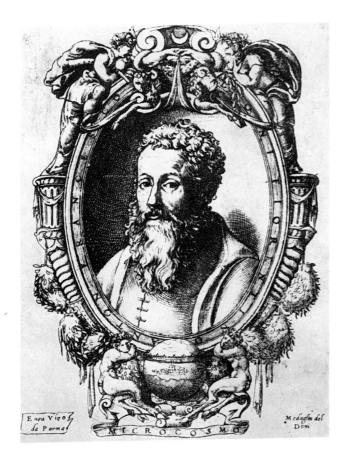

66 Enea Vico, *'Medal' of Anton Francesco Doni*, engraving from A. F. Doni, *La prima parte de le medaglie del Doni* (Venice, 1550).

virtue and make the liberal arts mechanical. And it is clear that those who sell their work become dealers in their own infamy.[17]

Such pronouncements do not entirely square with Aretino's own use of the presses to secure access to the wider literary market. But they are indicative of his continued exploitation of his special relation with courtly culture (and the prestige it offered) throughout his Venetian period. Aretino undoubtedly escaped from the servitude of the Italian courts through his residence in Venice, but the careful maintenance of the foreign connections and values he had brought with him was equally important to his success. It was precisely this pivotal position between the open world of the *poligrafi* and the more restrictive but refined one of the courts that allowed Aretino such authority in Venetian artistic culture by the middle of the century. It was a position shared in many ways by Titian, who stayed in market-oriented Venice, while at the same time fostering (often through Aretino's agency) patronal and aesthetic links with foreign courtly patrons.[18]

It is not entirely surprising to find that the writers who most positively evaluated Tintoretto's paintings in the period of Aretino's dominance were those from whom the poet was most keen to distance himself. These were writers who did not enjoy any equivalent connections with leading patrons and whose consequent dependence on the printing presses Aretino saw as making 'the liberal arts mechanical'. As noted in Chapter 1, Tintoretto enjoyed the friendship and professional support of the Florentine *poligrafo* Anton Francesco Doni (illus. 66). Doni and Tintoretto were particularly close in the early 1550s, when the writer readdressed an earlier letter to the painter and listed him as one of the most notable figures in Venice in his *I marmi* (1552). In this year also Tintoretto was a member of Doni's quirky Accademia Pellegrina and in 1553 sent the writer his portrait as a gift (now lost, see Appendix I, no. 6). In return, Doni dedicated his new edition of the *Rime del Burchiello* to Tintoretto. While Doni says little directly about Tintoretto's manner of painting, it is likely that he particularly appreciated his intense response to the work of Michelangelo in these years (see illus. 36, 37, 40–43, 48, 49). Doni himself had, we recall, unfashionably re-asserted the absolute primacy of Michelangelo's art in his *Disegno* of 1549.[19]

Another literary figure with *poligrafi*

connections, the comic playwright Andrea Calmo, published a long eulogistic letter to Tintoretto in 1548, the very year of Aretino's initial criticism. In addition to his career in the Venetian popular theatre, Calmo was active as a satirical poet and epistolary writer, extending his literary activity into genres in which *poligrafi* such as Doni were particularly prominent. He too exchanged a series of public compliments with Doni, and like him took a very lively interest in the visual arts.[20] In his humorous letter Calmo celebrates the very aspect of Tintoretto's painting which Aretino and his followers felt it necessary to condemn:

but you twiddling with your paintbrush and a small crumb of white lead and egg white portray a figure from nature in half an hour, and goodness knows how many cobblers, tailors and builders one might find in twenty years who could scarcely even learn to handle the colours.[21]

Calmo here reverses Pino's equation of the new *prestezza* with poverty and lack of professional or aesthetic status. On the contrary, rapidity of execution is seen as the freely chosen means by which the painter distinguishes himself from manual craftsmen such as cobblers, tailors and builders. For Calmo, it is precisely Tintoretto's speed which transforms the apparently mechanical act of painting into a creative one. Whether or not this identification was specifically intended as a polemical retort to the critical position adopted by Aretino and Pino in 1548, it does indicate the existence of a circle in Venice which positively evaluated the new visual *prestezza*. If Titian's meticulous and extended process of picture-making can be aligned with the canonical categories

proposed by Bembo and Castiglione, it may be that we should link Tintoretto's abbreviations to the artistic process with the assertively *ad hoc* literary culture of the Venetian *poligrafi*.

The success of the *poligrafi* was, as Aretino mockingly noted, dependent on the wider paying public rather than on the backing of high-ranking private patrons. Thus Doni was still searching for private backing during his initial visit to Venice in 1544, but after settling in the city in 1547 he no longer solicited aristocratic support and worked as an editor, translator and printer. He even went so far as to mock the patronage system by dedicating each part of every book he wrote to a different individual. Calmo complained of his lack of a patron in his *Lettere*, and it is evident that he never enjoyed the support of a major literary figure such as Alvise Cornaro, who did so much to enhance the career of his predecessor in Venetian comic theatre, Angelo Beolco ('Il Ruzzante'). As Aretino was keen to point out, the *poligrafi* were thus professional writers in the sense that they lived off the money they made from the sale of their books. This subjection to market conditions required that they write continuously, and at speed. Doni, for example, published seventeen low-priced books (not including those he edited or printed) in just five years, between 1549 and 1553, several of which were over 500 pages long. Calmo operated under similar conditions, publishing six comedies, two books of verse and three of letters between 1549 and 1556.[22]

Shorn of its context in economic contingency, this literary *prestezza* became the source of a new aesthetic. Doni advertised that he wrote without plan or correction, boasting of his speed and fecundity. In the introductory letter to *I mondi* he claims to have written the work in just twenty days,

and in *La zucca* he tells his readers that the book has 'grown like a gourd that is fully ripe in six or eight days'. The case is less clear-cut with a playwright such as Calmo, whose plays were typically published after their performance in the theatre. In this case, the written text was to some extent superfluous or distorting, given that in the theatre itself many passages were spoken *all' improviso*. Within the new aesthetic, rapidity, spontaneity, improvisation and versatility were promoted, and it was accepted that literary outpourings produced without aforethought or correction were 'truer' than those which were carefully pre-planned.[23]

Another important characteristic of the *poligrafi* circle was its propensity to parody. On occasion the subjects of this humour were the lower classes. In Calmo's comic plays and poems the mock-heroic antics of the lowly protagonists are a source of constant amusement. Popular discussion of theological issues could also serve satirical purposes: in *poligrafi* works such as Alessandro Caravia's *Il sogno di Caravia* (1541) and Pietro Nelli's *Le satire alla carlona* (1565), the 'learned' conversations of the common people (*popolani*) are readily mocked. And yet these same humble protagonists were just as often allowed to express serious opinions, and to reveal the hypocrisy of their social superiors. Doni typically promoted the uneducated and simple to stand as paragons of piety, wisdom and moral authority. In a letter published in 1546, he recounted the supposed confession of a dying weaver, while *I marmi* is based on a conversation overheard on the steps of the Duomo in Florence between a poultry-seller, a merchant and an anonymous third person. The three decide that the established Liberal Arts are wholly inadequate to teach men virtue or wisdom.[24]

The *poligrafi* readily turned their satire on literary high culture. They were especially critical of the new formal orthodoxies prescribed by Bembo and followed by the many contemporary authors who took Petrarch and other canonical writers as their models. Doni, Calmo and Caravia all attacked the fad for Petrarchian poetry, taking pleasure in mocking the learned with their spurious deference to unassailable authority figures and tedious linguistic pedantry. The traditional literary canon comes under fire in the prologue to *La zucca*, for example, when Doni explains that his preferred subheadings, 'banter' (*cicalamenti*), 'jokes' (*baie*) and 'chatter' (*chiachiere*), have been chosen because:

I am not entitled to call them Mottos, Arguments, or Sayings, as I am no Aristotle or Dante to pronounce such things, nor some other great genius who spews out maxims with every utterance. Who am I other than Doni, a spoiled legend who can't utter other than jokes and perhaps prattle?[25]

Doni's ironic celebration of his divorce from serious literary tradition (here represented by the lofty figures of Aristotle and Dante) and consequent self-identification as a purveyor of 'jokes' can stand as a paradigm for the entire activity of the *poligrafi* circle. To some extent their work can be considered as an extended literary joke expressing the parodic inverse of serious cultural values.

Tintoretto and the Poligrafi

The *poligrafi* propensity to mockery brings to mind Mikhail Bakhtin's famous thesis that European high culture defined itself in the mid-sixteenth century precisely through the exclusion of jokes from its

domain. Bakhtin argued that humour became the defining characteristic of an opposing carnivalesque culture, and as such was the major means by which the values of the established order were challenged. His thesis would make explicable the developing division between an official and serious literary language, such as Bembo's *Volgare*, and the popular and humorous work of the *poligrafi*.[26] Its wholesale application to Venetian literary culture of the mid-cinquecento would, though, generate an over-simplified view. As with the case of Rabelais, the fact that the *poligrafi* produced written texts inevitably means that we do not deal directly with an oral popular culture, but with artistic representations of it.[27]

In this regard, we can note that Tintoretto, Doni and Calmo adopted a very similar approach to their professional identity. Artistic posture was more significant here than the reality of their social origins. The recent discovery that Calmo's father was – like Tintoretto's – a dyer is certainly significant, and may even suggest that the playwright and painter knew each other from adolescence onwards.[28] But the fact that the *poligrafi* circle shared lower-class backgrounds does not in itself explain their propensity to advertise, and even to exaggerate, these origins. This would have more to do with the present domain in which they worked, functioning as a kind of marketing ploy to secure a connection with the wider Venetian public. We have seen how this could work for 'the little dyer'. Doni likewise sought to connect himself with the popular culture of the city, laying stress on his lowly social background (he was the son of a scissors-maker) and mocking those whose status was dependent on inheritance alone. Calmo's frequent proclamations of his origins among the fishermen

and boatmen of the lagoon were wholly fictitious, a self-mocking reference to his habit of taking the parts of peasants in his comedies.[29]

While the adoption of lowly identities may initially have been fuelled by a shared perception of professional marginality, the *poligrafi* circle did not thereby seek to delimit the social scope of their audience. After all, Doni fully exploited his on-going connections with the Medici court in Florence and with certain members of the patriciate in Venice.[30] If neither he nor Calmo gained consistent backing from leading aristocratic families, it does not follow that their work was aimed exclusively at the non-noble classes. The popularizing orientation of the *poligrafi* entailed an inclusive and indiscriminate solicitation of the market, a proceeding which neither prioritized nor excluded any one social group. But such posturing did help to define their position against the courtly writer/artist who featured in texts such as those of Bembo, Castiglione and Vasari. It may even have operated as a kind of counter-identity intended to parody and undermine contemporary moves towards an élite status for writers and artists. At the same time, the restatement of the values of Venetian *mediocritas* had a wider patriotic dimension: the emphasis which artists such as Calmo and Tintoretto laid on their supposedly humble origins implicitly connected them with the city of Venice itself, which, according to the sixth-century Roman writer Flavius Cassiodorus, had its origins in a simple fishing settlement in which all inhabitants lived together in humble equality. Cassiodorus' image of primitive democracy was a common point of reference for sixteenth-century Venetians concerned to elucidate the particular virtues of their republic. To this extent, the humble social identity promoted by the *poligrafi* circle

67 Jacopo Tintoretto, *Christ Washing His Disciples' Feet*,
c. 1547–9, oil on canvas, 210 × 533.
Museo del Prado, Madrid (on loan from El Escorial).

knowingly referred to one of the enduring myths of
Venice.[31]

Tintoretto may not have especially identified
himself with the non-noble majority in Venice, but
his inclusive approach inevitably entailed a
popularizing orientation. This is reflected in the
assertively humble conception of his earliest *Last
Supper* (see illus. 20), noted in Chapter 1. The
popolani actors who appear here are broadly
analogous to those in the contemporary writings of
Doni and Calmo. In his next version of the subject

in San Trovaso, which probably dates from the
poligrafi period (illus. 59, see p. 68), Tintoretto even
more contentiously relocates the sacred scene to a
cluttered artisan basement, characterizing the
foreground Apostles as tipsy Venetian
contemporaries of the lower classes.[32]

Both these paintings were commissioned by
parish Scuole del Sacramento whose statute books
(*mariegole*) insist on man's essential equality in the
body of Christ. A commitment to the kind of simple
reformed religion practised by such confraternities

seems to have been shared by Anton Francesco Doni, providing a pretext for the promotion of the uneducated in his work, and the basis of his egalitarian utopian fantasies. Other figures with connections to the *poligrafi* circle, such as the publisher and bookseller Vincenzo Valgrisi, and the goldsmith/occasional writer Alessandro Caravia mentioned earlier, were keen supporters of the Scuole del Sacramento in Venice. Valgrisi was *guardian grande* of the Scuola at San Giuliano, while Caravia expressly commended the humble piety of

such organizations in contrast to the wealth and vanity of the Scuole Grandi.[33]

But this reformist interest in simple piety was never wholly distinguished from the propensity to joke noted above. In Caravia's *Il sogno di Caravia*, the author's pro-Lutheran religious sentiments are expressed through the comic words of the Venetian clown Zanipolo Liompardi, and Doni fully exploits the humorous potentials of his elevation of the simple, whether they utter religious sentiments or attack the values of their social superiors. In

Tintoretto's earlier religious paintings, too, the free combination of high sentiment with low humour is often present within a single composition. In the *Christ Washing His Disciples' Feet* (illus. 67), Tintoretto creates an image which suggests the simultaneous existence of different levels of reality, never allowing the viewer to settle comfortably on a single mode of apprehension. This unnerving effect is generated, in the first place, by his characteristic combination of an unreal architectural backdrop (also present in the San Trovaso *Last Supper*) with closely observed details of figure and object in the foreground area. But the individual motifs also give out conflicting messages: the comic realism of the Apostles struggling to pull off their leggings contrasts (or even contests) with the dignity and pathos of the exchange between Christ, Peter and John. The unorthodox removal of these protagonists to the right margin of the picture (also a response to the original location of the painting on the right wall of the choir of San Marcuola) allows the secondary leg-pulling motif to challenge our concentration on the serious religious narrative presented.[34]

Tintoretto drew directly on Serlio's stage-set architecture for the background which is based on the *Scena Tragica* (illus. 68), itself derived from a description in the well-known treatise by the ancient Roman architect Vitruvius (*De architectura*). Tintoretto's understanding of this classical theatrical category is clear from his very apposite application of the architecture to a Christian subject with tragic implications. But the idealized and noble buildings required by Vitruvius are treated in very summary fashion, and take on a dream-like or visionary quality, their promise of a higher, more perfect reality limited by the antics of the Apostles in the foreground. In the San Trovaso *Last Supper*, this area is presented as if it were a realistic view into a common private house more befitting the Vitruvian *Scena Comica*. The oddly disjunctive effect of both paintings is, in part, a result of Tintoretto's combination of dramatic modes which, in classical theatrical theory at least, were perceived as distinct from one another.[35]

A similar combination of low and high is present in the pendant painting for San Marcuola, where the iconic central figures are swamped by the excited, unpremeditated responses of the Apostle groups who swarm round the table toward them at either side (illus. 69). In the San Trovaso *Supper* (illus. 59)

69 Jacopo Tintoretto, detail of illus. 20.

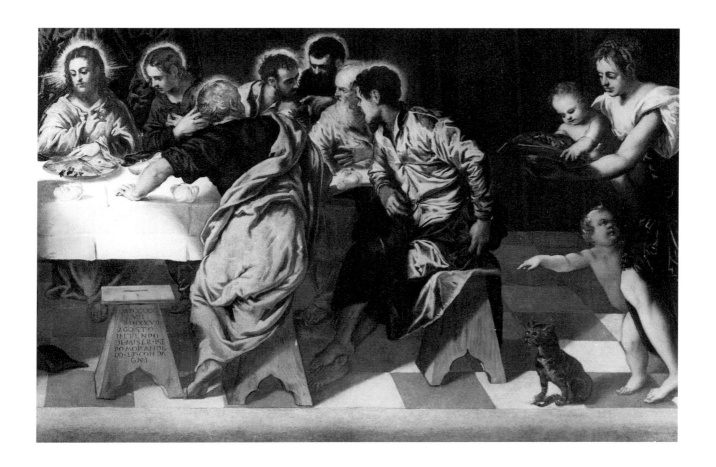

the banal action of the foreground Apostle-artisan
reaching back for a casket of wine becomes the
primary means of visual entry into the painting: we
must register his unruly presence if we are to gain
access to the more idealized figure of Christ beyond.
The very admission of such details into the hieratic
space of the *Last Supper* was enough to undermine
the ideal content (and therefore aesthetic value) of
such works for classical-academic critics. Thus
Poussin's friend and patron André Félibien argued
that Tintoretto had treated the subject 'without
nobility or dignity' (1679) and the arch-classicist
Luigi Lanzi complained that his Apostles 'might be
taken for gondoliers' (1792). Such critical attitudes
may have influenced the disastrous decision to
provide the San Marcuola painting with an idealizing
architectural backdrop between 1728 and 1736.[36]

Despite the reappraisal of Tintoretto in the
following century, critical discomfort in the face of
the painter's social downgrading of the *Last Supper*
continued. Jacob Burckhardt (1855) described the
San Trovaso painting as 'degraded to a common
banquet', while even the typically eulogistic Ruskin
saw it as 'vulgar' and 'far below Tintoretto's usual
standard'.[37] And yet the cultural relocation of the
drama does not, as these commentators presumed,
necessarily work against its moral content, just as
the prominence allowed to potentially comic motifs
does not exclude the possibility of serious utterance.

In the action of one disciple struggling to remove
the leggings of another, we may also have an
illustration of the kind of active Christian charity
(*amor proximi*) to which the commissioning
confraternity was expressly committed.[38] And in the
inebriated action of the Apostle-artisan toppling
backwards to reclaim his wine in the San Trovaso
Last Supper Tintoretto simultaneously refers to its
newly transformed Eucharistic significance.

The intention here was not simply to parody the
subject, as many of Tintoretto's critics have
assumed. Rather, it was to produce a new genre of
religious imagery located in the 'comic' lowlife
domain, but with a high 'tragic' significance. This
was a project shared by others in the *poligrafi* circle
who sought to make their work accessible to the
wider Venetian public, and in so doing chose not to
clearly distinguish humour from morality. Such a
mixing of expressive modes proved problematic for
the strict taxonomies of classicizing culture. But in
their original parish context, Tintoretto's *laterali*
were clearly much more successful, expressing the
combination of active piety and humility (*humilitas*)
to which their patrons were committed.
Paradoxically, it was the more orthodox Veronese
who was called before the Inquisition for including
comic 'buffoons' and other lowlife accessories in a
Last Supper painted in 1573 (illus. 70). Veronese's
famous reply to the effect that his humorous
accessories are placed 'outside the place where Our
Lord is represented' was, though, much more than a
clever riposte. For, unlike in Tintoretto's parish
Suppers, the lowlife figures in his painting are
separated from the sacred protagonists by a massive
fictive architecture which intervenes to establish
underlying decorum between comic and tragic
modes.[39]

71 Paolo Veronese, *Venus, Mars and Cupid, c.* 1561/2,
oil on canvas, 47 × 47.
Galleria Sabauda, Turin.

Tintoretto's Mythologies from the 1550s

In another well-established area of subject-matter in
Venetian art, that dealing with erotic mythological
themes, Tintoretto's humour is also apparent,
although its particular relation to *poligrafi* culture is
more complex, given that humour was already an
established feature of the genre. Titian had included
humorous asides in the ground-breaking
mythologies featuring Bacchus and Venus that he
painted for the Duke of Ferrara between 1519 and

1526, and later in the cinquecento this playful
approach was developed by Veronese in works such
as his *Venus, Mars and Cupid* (illus. 71). The
inopportune intrusion of Cupid leading Mars's
horse into the privacy of the lovers' bedchamber
indicates that this work was intended to stimulate
light-hearted amusement. Such humour does not
undermine the sensual content of the image. Rather,
it justifies its eroticism, ensuring a clean distinction
from the 'serious' realm of religious and patriotic
painting. Neither does Veronese's humour discount

72 Jacopo Tintoretto, *Leda and the Swan*, 1550/5,
oil on canvas, 167 × 221.
Galleria degli Uffizi, Florence.

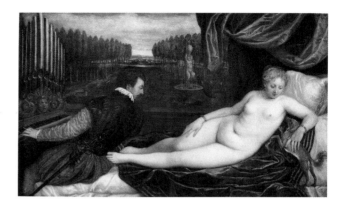

73 Titian, *Venus with an Organist and Dog*, c. 1550,
oil on canvas, 136 × 220.
Museo del Prado, Madrid.

the possibility of an association with contemporary literary debates on the nature of ideal love and beauty, or detract from its more general relation to the hallowed world of classical antiquity.[40]

But if Veronese's visual jokes did not compromise the accepted decorums of the genre, the same cannot be said of the group of mythological works which Tintoretto painted in the period of his association with the *poligrafi*. The sharply parodic tone typical in these paintings has parallels in the contemporary writings of Doni and Calmo, and might even be taken as defining a more general Rabelaisian point of opposition to the development of courtly culture in Venice and to the classicizing tradition this culture so keenly promoted.[41] While it is true that Tintoretto often adopts local pictorial models for his depiction of mythological subjects, he does not allow the viewer to settle comfortably within the standard range of association for such works. Carlo Ginzburg has argued that two essentially separate 'iconic circuits' were operative in Venetian painting of this period, and that these were firstly distinguished by the distinct audiences they served, the one 'public, widespread and socially undifferentiated, and the other, private, circumscribed and socially elevated'.[42] The special ironic humour of Tintoretto's mythologies is, to a great extent, a result of the overlap or collision he allows between these two conventionally discreet domains.

In the *Leda and the Swan* (illus. 72), Tintoretto ignores the famous central Italian models for the subject by Leonardo, Michelangelo and Giulio Romano (well known in Venice through paintings and engravings), referring instead to the Venetian type of the reclining Venus pioneered by Giorgione and developed by Titian, Palma Vecchio and others

in the first half of the century (illus. 73).[43] But while we might still be tempted to read Tintoretto's *Leda* as a vehicle for the iconic display of the female body (with its overlapping invitations to erotic and intellectual contemplation), it is also true that his heroine is laid open to the potential absurdities of her given narrative in a manner which departs from the more idealizing approach to antique subjects typical in Venetian painting. This is, in part, a result of Tintoretto's exaggeration of the purely mechanical aspects of the narrative. The admission of small secondary details and episodes into the painting (the two birdcages and the motley collection of animals) disturbs our visual absorption in the idealized beauty of Leda's naked form. We must assume that the ungainly swan (whose position at the lower right margin affords him no clear distinction from the other foreground creatures) has just been released by Leda's servant from his crude wooden cage. He waddles across to Leda's side, where his response to her casual caress is to wriggle his phallic head and neck toward her reclining body. Ignoring the central Italian models for the subject (in which woman and bird already embrace), Tintoretto selects an earlier moment, as if he wished to avoid too explicit a depiction of an unnatural

74 Jacopo Tintoretto, *Venus, Vulcan and Mars, c.* 1550/1,
oil on canvas, 135 × 198.
Alte Pinakothek, Munich.

union. The swan–Jupiter must first overcome the
challenge of a small (but jealous) lapdog before finally
arriving at his destination. For her part, Leda seems
transfixed by the parallel confrontation between cat
and duck near to the cage, as if this alternative
confrontation between different animal species offers
a veiled commentary on her own imminent coupling
with the swan. Such references were undoubtedly
encouraged by the narrative itself, which could (at
least from a moralized Christian perspective) be seen
to exemplify the unnaturalness of an adulterous act.
As we shall see, the theme of sexual betrayal was a
particular preoccupation of the *poligrafi* circle.44

In the near-contemporary *Venus, Vulcan and
Mars* (illus. 74) Tintoretto is in similar mood,
offering an ironic literalism which once again
undermines the poetic and idealizing potentials of
the classical subject. The story of the famous affair
between the gods of love and war is treated as a
riotous *à la mode* bedroom farce on the theme of
adultery. Tintoretto locates his scene in a narrow
and cluttered Venetian bedroom with pointedly
contemporary fittings and decorations. Gone are the
usual fantastical details (the luxuriant pastoral
landscape, Vulcan's enormous net, the impressive
spectacle of the panoply of the classical gods) which

75 Jacopo Tintoretto, *Venus and Vulcan, c.* 1550–51,
pen and brush, black ink and white lead on blue paper,
20.4 × 27.3.
Staatliche Museen zu Berlin (Kupferstichkabinett).

typically serve to distance the scene from the exigencies of contemporary reality.[45] Despite the characteristic diagonal plunge into depth, the spatial effect is intentionally claustrophobic, the classical actors seeming like outsized mannequins in their shrunken and commonplace urban environs. The humiliation of the Gods is merciless, as they are reduced to mere ciphers for the everyday foibles of lust, deceit and jealousy. The elderly Vulcan has already reached the bed where (in a gesture which recalls that of the gormless satyr pulling the drapery from the sleeping Venus in another often depicted episode) he unceremoniously subjects his adulterous young wife to a genital examination. If Mars, the god of war, is reduced to the absurd as he cowers beneath the bed, his ruse about to be defeated by the excited yapping of a small dog (ambiguous symbol of fidelity and carnality), the reclining foreground figure of Venus still promises to retain something of her conventional dignity. And yet the connection with the standard type for the reclining Venus is suggested only to be undermined. For, like Mars, Venus is also shown in a state of awkward disarray, her attempt to cover herself from Vulcan's prying eyes ending by revealing still more of her nudity. Caught in such an ambiguous gesture, she is allowed none of the timeless repose traditionally bestowed upon her in Venetian painting.

The wider significance of Tintoretto's sexual humour in such paintings should not be underestimated. The imagery of Venus, in particular, had come to function as a kind of focal point for erudite aesthetic response in Venice, her beauty offering a link between sensual experience and the refined intellectual world of classical antiquity.[46] By subjecting her – and other classical heroines conceived as her types – to the rigours of a banal narrative realism, as by the new stress on moral exigencies and consequences, Tintoretto attacked precepts dear to classicizing Renaissance imagery. His approach also offered a visual critique of the closed 'iconic circuit' which sustained this élite culture in Venice, reinterpreting its favoured pictorial genre as a vehicle for popular theatrical farce similar, in its scurrilous and disrespectful tone, to the stories (*novelle*) and comic theatre of his friends Anton Francesco Doni and Andrea Calmo.

The connection of Tintoretto's 'fractured fable' in Munich with the *poligrafi* circle has, in fact, already been noted in the recent literature.[47] Venus' scandalous affair was the subject of mocking discussion in Doni's Accademia Pellegrina, while satirical commentary on deceit in marriage (based on the writings of Juvenal, Erasmus and Boccaccio) was a stock theme in the literature produced by the circle. The theatrical quality of Tintoretto's approach to his art also offers a point of connection here. His fundamental conception of his painting as a form of visual theatre is suggested by his habit (noted by Ridolfi) of 'staging' his works by placing wax and clay figurines in strongly lit boxes in order

76 Jacopo Tintoretto, *Susanna and the Elders, c.* 1550,
oil on canvas, 167 × 238.
Musée du Louvre, Paris.

76 Jacopo Tintoretto, *Susanna and the Elders, c.* 1550,
oil on canvas, 167 × 238.
Musée du Louvre, Paris.

to generate pictorial ideas. Tintoretto was not alone among Italian artists in using such aids, but their effect on the final appearance of many of his paintings is unusually marked.[48] On many occasions Tintoretto's use of such devices removed the need for compositional sketches altogether. But a surviving sketch for the Munich painting indicates that when he did make these drawings, they were used to record a composition already arranged with the use of a *piccola casa* (illus. 75).[49] Although many key details are missing (Mars, the dog, Venus' drapery, the sleeping Cupid), the narrow box–like space of the final picture is already firmly in place. Tintoretto's manipulation of categories derived from

classical theatre has already been noted above. His friendship with the playwright Calmo would certainly have encouraged his use of such sources. While Ridolfi records that Tintoretto himself 'invented bizarre caprices of dress and humorous sayings for … the comedies that were put on in Venice', members of his workshop such as Martin de Vos and Lodovico Pozzoserrato made paintings of scenes from the early *commedia dell' arte*, with which Calmo was heavily involved.[50]

Tintoretto's humour was not confined to his mythological painting in the *poligrafi* period. In two paintings showing *Susanna and the Elders* from the 1550s the apocryphal theme is treated as if it were

77 Jacopo Tintoretto, *Susanna and the Elders, c.* 1555,
oil on canvas, 146.6 × 193.6.
Kunsthistorisches Museum, Vienna.

78 Marcantonio Raimondi, *Venus Drying Her Foot*,
engraving.
Bibliothèque Nationale de France.

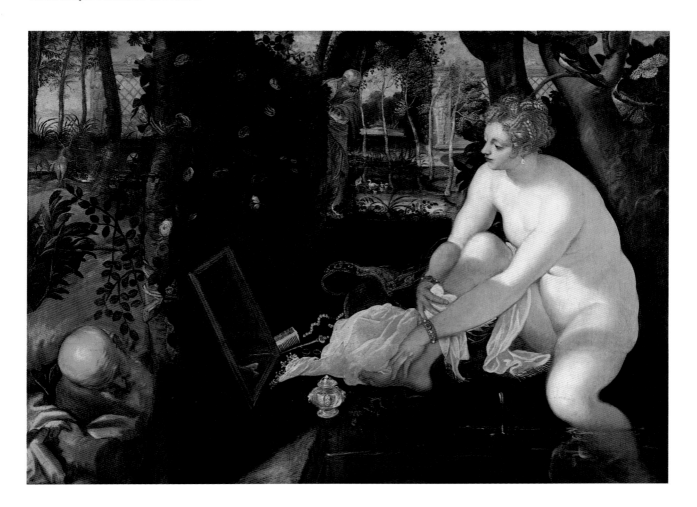

an erotic mythology. In the earlier of these, now in
the Louvre, Tintoretto mocks the theme by
including quotidian details such as the heroine
having her nails clipped (illus. 76). In the painting
now in Vienna a much more subtle dialectic between
viewer and image is set in play (illus. 77).[51] This
popular Renaissance subject had often been used as
a vehicle for the display of nudity. But in
Tintoretto's painting Susanna is conflated with
Venus in unusually explicit fashion. Her form is
derived from central Italian models showing *Venus
Drying Her Foot* (illus. 78), with reference to the

79 Titian, *Venus with a Mirror*, c. 1555,
oil on canvas, 124.5 × 105.5.
National Gallery of Art, Washington, DC.

80 Paolo Veronese, *Susanna and the Elders*, 1580/5,
oil on canvas, 151 × 177.
Museo del Prado, Madrid.

more specifically Venetian type of *Venus with a Mirror* (illus. 79). As in the *Leda*, Tintoretto avoids the conventional narrative moment which shows Susanna's discovery by the Elders, or the point where she becomes aware of their invasive gaze (illus. 80). This moment had allowed for the suggestion of the heroine's chaste virtue, given that she typically struggles to cover her nudity, or actively resists the Elders' sexual advances. In northern iconography, Susanna is typically unaware but is shown clothed and looking up to heaven. Tintoretto, in contrast, refers directly to Venetian conventions for the depiction of the erotic female nude: Susanna has all the famous iconic passivity of a Titian Venus, her lack of direct engagement in the narrative sequence further aiding her transformation from virtuous wife to sensuous beauty.[52]

But Tintoretto's Venus-style transformation of Susanna stands in a deliberate state of tension with the given theme, the serious implications of which are suggested by details such as the garden herm on the background pergola (which may jointly refer to Venus and to the phallocentric fantasies of the Elders) and by the thieving magpie which lurks in the tree above Susanna. The mirror, which functions as the underlying metaphor for the whole painting, is itself an ambiguous symbol, distorting as well as reflecting reality, an aid not only to self-knowledge but also to desire, deception and 'False Love'. In a painting about the implications of looking (Susanna at herself, the Elders at her, and the viewer at both her and the Elders) the very allure of the heroine's shining form is fraught with moral consequence. If Susanna is the goddess of love (the hedge is peppered with roses, sacred to her), then the crouching Elders become equivalents to the animalistic satyrs who creep up on her unaware in paintings of the *Sleeping Venus*. And yet they do not actually view the body they desire. Here, Tintoretto may refer directly to the verses in the *History of Susanna* recording the isolation attendant upon their sexual fantasies: 'they [the Elders] perverted their own mind, and turned away their eyes, that they might not look unto heaven, nor remember just judgements'. But these deflected gazes also extend the moral blame to include the viewer himself, for it is us rather than them who most readily consume the body of Susanna/Venus, enjoying the aesthetic play of light over the soft curves and outlines of her flesh. In doing so we go further, even, than the

81 Jacopo Tintoretto, *Temptation of Adam, c.* 1550/3,
oil on canvas, 150 × 220.
Gallerie dell'Accademia, Venice.

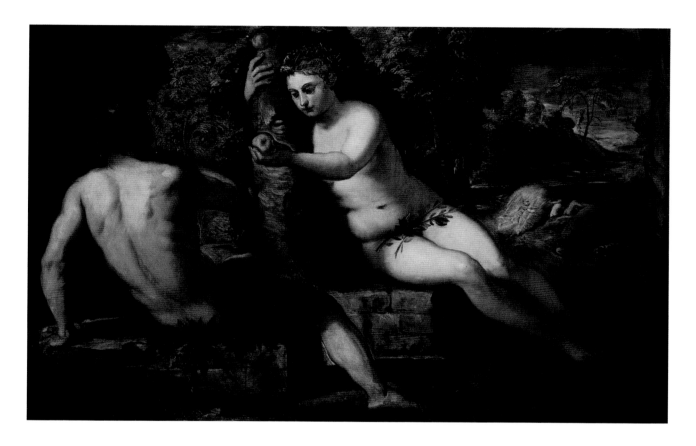

corrupt Elders themselves. It is no accident that the foreground Elder is shown trying to take up a position equivalent to our own in order to arrive at a better view of his prey. At the same time, these 'moral' elements are mixed with comic ones. Tintoretto's conception of the Elders owes much to the old lechers (*vecchi rimbambiti*) who feature in sixteenth-century comedies. The conflation was, indeed, well recognized in the *poligrafi* circle: in *I marmi*, Doni casually describes an old lecher he had met as 'un Vecchio di Susanna'.[53]

As in the mythologies discussed above Tintoretto thus makes our reading of the female nude problematic. In the *Leda and the Swan* and the *Venus, Vulcan and Mars* this is achieved through the introduction of an inappropriate tone of narrative realism in combination with a focus on the ethical implications of such erotic themes. The *Susanna and the Elders* shares this latter concern, as it does an underlying focus on sexual deceit. In this painting the play between conventionally distinct areas of sacred and secular iconography is more subtle still. For here the conflation of Susanna with Venus is laid as a sort of snare for the unsuspecting viewer, whose visual entrapment finally makes a moral point. The Vienna painting also introduces the theme of temptation into Tintoretto's oeuvre, one which is handled again, in more explicit form, in the near-contemporary *Temptation of Adam* from the Genesis cycle for the Scuola della Trinità (illus. 81).[54] In this

work, too, Tintoretto implicates the viewer by suggesting an identification between his gaze and that of the tempted figure of Adam. The protagonist is placed in an extreme foreground plane and (like us) appears to look into the painting from beyond its domain. Like Adam, we are confronted by the beautiful, sexually alluring figure of Eve, whose nudity and semi-reclining posture still recalls the Venetian iconography of the reclining Venus. As in the *Susanna*, the viewer's own visual consumption of the beauty of the female nude is made a vital component of the drama, but one with serious moral repercussions. Unlike Adam, whose vision is obscured by the shining flesh of Eve, and who will (despite his present hesitation) take the apple she offers, we have the advantage of seeing beyond the immediacy of her body into the future, glimpsing the bleak scenario of divine punishment in the landscape beyond. In works such as these, looking and the desire it engenders have already become an explicitly ethical matter, and in the process the secular bubble of Renaissance erotic art has been burst.

Prestezza *as a Technical Value*

It would seem that the *poligrafi* were particularly alive to the comic and bizarre elements in Tintoretto's paintings. The way in which they understood and appreciated his work is indicated by the comic mode in which they prefer to address him. Calmo adopts a half-mocking approach in his letter of 1548, and yet the tone is warm and intimate, confidently assuming that its addressee will enjoy the self-conscious display of verbal irregularities, and perhaps recognize in them similarities to his own work. Doni's readdressed letter to Tintoretto is also presented in the form of a burlesque. Here he

recounts his visit to the famous art collection of Paolo Giovio, the humanist friend to Vasari and an important influence behind the taxonomic project of the *Lives*. But instead of providing a coherent listing of Giovio's possessions, Doni peppers his description with intentional errors, mispronunciations and forgotten names. He plays the illiterate in front of Giovio's art collection, mocking the classificatory *all'antica* culture it reflected, and fully anticipates that Tintoretto will share his joke. It is no accident that Doni went on to make the painter dedicatee of his new edition of the *Rime del Burchiello* in 1553. The comic realism of the renegade quattrocento barber-poet was an important literary inspiration for the *poligrafi*, and Doni confidently assumes that Tintoretto will see a parallel to his own paintings in the *Rime*. These he describes as the work of a 'poet-painter of grotesques' whose 'bizzarie' has never been suppassed.[55]

A keen appreciation of Tintoretto's loose brushwork was probably a central factor in the *poligrafi* reponse to his work. Here they would have seen important parallels to their own preferred literary manner. When, in the following century, Marco Boschini mounted his spirited defence of Venetian painterly brushwork, he self-consciously adopted an irregular Venetian dialect, announcing his intention to write in the same sketchy, improvisatory manner as the paintings he described. But in stressing this overlap between word and image, Boschini may have drawn on a connection already recognized in Tintoretto's day. Bembo himself, the great enemy of local dialect, had identified the qualities of the local language in very similar terms, identifying Venetian as 'softer, more imaginative, more rapid and more alive' than other

varieties of Italian. Calmo's letter to Tintoretto was written in an exaggerated local dialect form and the playwright may have seen Tintoretto's *prestezza* as directly equivalent. Calmo's improvised language, like Tintoretto's detached brushwork, drew deliberate attention to itself, constantly advertising the manipulating presence of its author in the work. Such a manner could even threaten to obscure the reader's understanding of the subject-matter, just as Tintoretto's detached brush strokes could disrupt the illusionism of his paintings.[56]

Doni recognized a similar overlap. His books are presented as swiftly executed improvisations and in his dedication to Tintoretto he refers to himself in self-mocking fashion as 'Il Negligente'. It was precisely Tintoretto's supposed negligence that so provoked the Aretino circle. Doni may thus have been referring to a common charge laid against the *poligrafi*, while at the same time assuming a parallel between his own rapid, unfinished literary manner and that of Tintoretto. In an important passage in his *Disegno* (1549) Doni's sympathy for loose brushwork in painting, and the imaginative freedom it could generate, is more explicit. Antique grotesques (*grottesche*) are particularly praised just because they defy the usual narrowly representational aims of painting in the pursuit of 'abstract, bizarre fantasies and strange variations'. Non-representational brushwork has a similar power, for it too moves beyond its merely imitative functions. Doni describes the pleasure to be had from imagining 'animals, men, heads and other fantasies' in a loosely executed 'landscape sketch'. As a viewer, Doni finds that a rough sketch allows him the freedom to project into the image from the 'chaos of my brain'. Like Doni's own loosely constructed prose, the freely executed painting invites a new level of active imaginative engagement.[57]

It was just this random or haphazard element in Tintoretto's technique that was picked out for criticism by his opponents, seeming to offer a threat to the rational control they understood as essential for meaningful artistic achievement. We have seen how Giorgio Vasari contrasted Tintoretto's loose brushwork ('done more by chance and vehemence than with judgement and design') with Titian's. Tintoretto's randomness suggested to Vasari that his work was, in fact, conceived as a kind of extended joke at the expense of serious art. On two separate occasions in his short account, Vasari gives voice to the suspicion that Tintoretto paintings were intended as spoofs (*baie*), made to mock the great Renaissance tradition of painting.[58] Given the equivalent propensity of the *poligrafi* for literary *baie* (the same word used by Doni to describe his satirical approach in *La zucca*), Vasari's perception cannot be readily ignored. He had, of course, his own reasons for fearing Tintoretto's 'jokes'. As spokesman for an ambitious profession seeking admission into the sphere of the established Liberal Arts (and a consequent identification with the high culture controlling this curriculum) it was imperative that Vasari kept the seriousness of 'modern art' (*arte moderna*) ever before his readers. In Vasari's eyes, Tintoretto's most inadmissible joke lay in the area of the painter's technique, that is, in his habit of 'working haphazardly and without design'. Vasari was particularly disturbed by the revealed brush strokes he saw in works such as the *Last Judgement* (illus. 82). In this case, Tintoretto's technique obscured the viewer's perception of the given subject-matter, and thus mocked the central aesthetic premise of Renaissance art: its effect of lifelikeness.

Tintoretto's non-correction was, to some extent, like a signature of authorship, both proclaiming and promoting his presence in the work, while at the same time drawing attention to his 'performance' as an independent artistic value. In this extemporizing approach, numerous swirling *pentimenti* are strewn across the paint surface, leaving a visible public record of the painter's artistic process, with all its sudden changes of mind and direction. It was precisely this furious creative process that Calmo focused on in his admiring letter of 1548, describing it in terms of a theatrical performance in which the controlling presence of the painter/performer is always apparent in the arena of the canvas. But if such an approach challenged the orthodox principle of mimesis, it might still have been appreciated by the wider populace. Tintoretto's loose brushwork may even have been specifically intended to appeal to this broader constituency.

The wider popular appeal of Tintoretto's brushwork is, in fact, noted in an important passage in Virgilio Malvezzi's *Il Coriolano e l'Alcibiade* (1633), first noticed in the modern literature by Philip Sohm. Malvezzi records the praise Tintoretto's colouring had won among the uneducated common people (*volgo*), going on to oppose this popular success to the refined tastes of the intellectuals (*intelligenti*), who recognized the true superiority of Raphael.[59] Malvezzi's choice of Tintoretto (rather than Titian) to represent the failings of Venetian painting is very significant, as is his specific connection of the painter's loose brushwork with the tastes of the wider populace. Vasari had, after all, already shown that Titian's 'painterly brushwork' was a courtly refinement, intended for the discerning eye of the connoisseur. In this sense its context of reception was very similar to the private and select culture which provided the ground for Giorgione's own experiments in this direction earlier in the century. But as the passage in Malvezzi specifically indicates, Tintoretto's loose brushwork took root in a very different social domain.

The distinction noted here suggests that we should be very wary of making Venetian *colorito* the expression of a single, internally coherent artistic tradition. In academic art theory of the eighteenth century the technical/social distinction between Titian and Tintoretto was well recognized. Both Raphael Mengs and Luigi Lanzi insisted on a clear distinction between the two painters, as did Joshua Reynolds in the course of defining the 'Great Style' in the *Discourses*. Reynolds explains his placement of Venetian painting in an 'inferior class' with reference to the same Ciceronian contrast of reason with sensuality which had underpinned Malvezzi's account. But he goes on to partially exempt Titian from his more general charge against Venetian painting, and it is no accident that he refers to a specifically social category in doing so (Titian is

allowed to have 'a sort of senatorial dignity about him'). Conversely, Tintoretto's performative manner lacks these elevating associations. His display of 'the mechanism of painting' has 'seducing qualities' which were (Reynolds allows) intensely appealing. But in classical-academic writing, confining artistic appeal to the sensual realm was also to confine its social limits. Like Malvezzi before him, Reynolds understands Tintoretto's loose manner as serving the visual appetites of the general populace ('the young and the uneducated'), rather than appealing to the moral refinements of the learned connoisseur.[60]

That Tintoretto's unfinished technique was originally developed in an essentially open and popular cultural context is suggested by the appreciative responses of the *poligrafi* circle. More specifically, it would seem that such brushwork developed within a picture-type with decidedly popular associations, and that it may originally have owed more to economic contingency than to aesthetic choice. In a number of small-scale paintings attributable to his earliest period, Tintoretto radically abbreviates his treatment of form, the sketchy effect being reinforced by his employment of a limited range of broken tones, close to one another on the colour scale (illus. 83, 84). Rather than defining form through the use of contrasting patches of local colour, Tintoretto here draws in paint, the visible brush stroke defining the necessary contours. In these works, the abbreviations of human figure, trees and rocks constitute a kind of visual shorthand, in which transitional features are ignored in the name of the schematic essentials of form.[61]

Works such as these were intended to adorn furniture, and support Ridolfi's report that Tintoretto associated with painters of this type who peddled their wares from temporary wooden booths set up in St Mark's Square. Ridolfi tells us that it was in this public (but professionally marginal) context that Tintoretto first learned the 'method of handling colours' particular to the cassoni painters. Venetian panels of this type from the cinquecento were, in fact, governed by technical conventions which distinguished them from the mainstream production of monumental paintings. But while the sketchy brushwork typical of the genre may have originated in the elect circle of Giorgione, by the mid-sixteenth century its associations with the sophisticated culture of its originator had largely evaporated. Rather than a display of painterly virtuosity, the rough manner common to many Venetian cassoni panels had become no more than a reflection of the adverse professional economic conditions under which they were produced. The artists involved were known to be 'painters of lesser fortune' (Ridolfi) who could not win more lucrative commissions, and whose engagement in the making of merely functional objects was increasingly frowned on by the ambitious leaders of the profession. In the passage from Pino's *Dialogo* quoted earlier in this chapter, the association of the new rough manner in Venetian painting of the 1540s with the painting of cassoni is made explicit.[62]

While the defining characteristic of Tintoretto's brush stroke was its decisive move beyond mimetic 'responsibility', we should beware of assuming that it also moved towards some proto-modernist defiance of the given subject-matter. For Tintoretto (as more widely for the *poligrafi* circle) the admission of process into the meaning of the work was seen as giving it an added truth to subject, one unmatched by the falsifying works of meticulous definition and finish. The circle in question were not modernists *avant la lettre*, valuing technical procedure above all other commitments. Indeed, their frequent assertions of artistic independence cannot be taken at face value. Thus, as we shall see, Tintoretto's rapidity of execution was used to win him the key commission of his career at the Scuola di San Rocco. The demands of continuous rapid output necessitated a more pragmatic approach – to style as well as technique – than could readily be admitted by the proponents of the new aesthetic. Flexibility was of fundamental significance and the variety of Tintoretto's output in painting is comparable in this regard to Doni's production of literary works of many types.

It is this factor above all others that has rendered attempts to define Tintoretto's artistic development so problematic in the twentieth century. Art historians have often approached this question with the assumption that technical and stylistic development was firstly determined by some coherent inner principle. But our discussion of Tintoretto's performative picture-making suggests that multiplicity and rapid virtuosity were more significant for him than organically united expression: he manipulated a broad artistic repertoire in an unusually disinterested way throughout his long career. In the last chapter we noted his habit of making pointed reference to well-known, often-contemporary compositions by other masters. While this was not in itself unusual in the Mannerist epoch contemporaries certainly found Tintoretto's habit disruptive. It does, though, have much in common with the pragmatic exploitation of existing literature undertaken by his friends among

the *poligrafi*. Doni regularly borrowed concepts, sentences and even longer passages from the work of more established writers in order to please his readers and increase his literary output, and whole passages in Calmo's plays are lifted verbatim from comedies by Machiavelli and Beolco.[63]

The artistic circle under discussion would probably have justified such stylistic and technical variability with reference to their supposed artistic freedom. The unfettered movement between different manners, like the combination of conventionally distinct modes within a single work, could be seen as an act of defiance against the growing academic and religious demand for conformity to tradition in the arts. The free combination of spoken dialects, expressive modes and literary styles in the work of the *poligrafi* clearly contradicted Bembo's arguments for a singular and purified literary language based on selected historical models. As we have seen, an analogous set of prescriptions was in the process of being formalized in visual art theory in the middle decades of the sixteenth century, and it likewise broadly followed Bembo's lead, condemning the pluralistic spontaneity of Tintoretto as alien to its ethos of erudite classicism.

The visual and literary practice of Tintoretto and the *poligrafi* had a mutually beneficial effect, articulating through different media a similar opposition to the growth of artistic orthodoxy in mid-cinquecento Venice. They shared a creative distance from courtly culture and a related commitment to the values of rapidity, spontaneity and flexibility in their artistic practice. Tintoretto's early critics from the Aretino circle associated his new *prestezza del fatto* with the open, mercantile conditions of literary production operated by the

polgrafi. Given its socially inclusive implications, Tintoretto's art could not be readily assimilated by those established figures keen to promote a high social status for the painter, following the example of Titian. But the creative intensity of the interchange between Tintoretto and his literary friends was necessarily short-lived. Doni left Venice under a cloud in 1555, and Calmo's reputation in the theatre diminished.[64] The 'opposition' also splintered, with Aretino's death in 1556, and Titian's gradual withdrawal from the public arena of art. By 1560, Tintoretto's professional position had correspondingly changed. He was now an established painter, winning many commissions across Venice, and his professional prominence called for the development of a less reactive approach to painting.

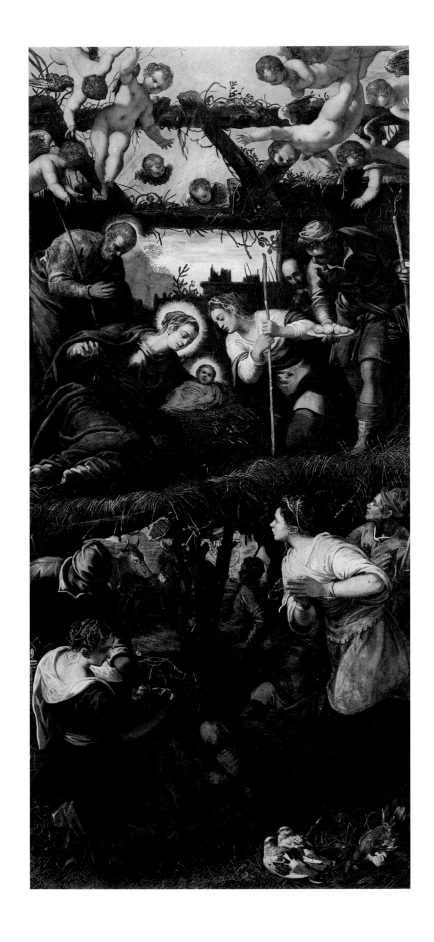

Prices and Patrons

Tintoretto's Business Strategy

Tintoretto's association with the *poligrafi* owed much to their shared market mentality. Writers such as Doni lionized the new aesthetic of *prestezza* just because it suited the practical contingencies governing literary production for the printing presses. Tintoretto's *prestezza* was likewise an aspect of his wider solicitation of the market for paintings.[1] Although he certainly could not dispense with patrons, necessarily remaining tied to the traditional system through which artistic commissions were awarded, he consistently pushed at its accepted boundaries and decorums, whether this meant exhibiting ready-made paintings on Venetian streets, aping the styles of immediate rivals, ignoring the rules of artistic competitions or installing unsolicited paintings in public buildings. In this chapter, we will examine the economic basis to Tintoretto's career, and suggest that his most notorious professional habit – offering his paintings at below their usual value – was the cornerstone of his success. Tintoretto's pricing formed part of a coherent business strategy which was both determined by, and reflected in, the wider pattern of his patronage.

The financial rewards that Venetian painters could expect did not (by Tintoretto's day) greatly differ from those on offer in more 'progressive' centres such as Florence and Rome. The so-called *sansaria* (an annuity awarded by the Salt Office to the state's favoured painter) totalled about 117 ducats and was no match for painters' salaries in other Italian cities and courts. But this cannot fairly be taken as representative, given that Venetian patrons regularly agreed prices close to its value for individual paintings. Cinquecento history paintings for the main state room of the Ducal Palace (the Sala del Maggior Consiglio), for example, were valued at between 100 and 300 ducats, and similar prices were paid for equivalent paintings commissioned by the Scuole Grandi. Venetian altarpieces by leading painters also regularly commanded three-figure fees. Such figures indicate that in any one year the most successful painters could expect to earn at least as much as a citizen (*cittadino*) civil servant in state employ (up to 200 ducats per annum), and perhaps even as much as a patrician castellan (*podestà*) (up to 500 ducats).[2]

Painters could accumulate substantial wealth: Paris Bordone, for example, was in a position to provide each of his four daughters with a dowry of 200 ducats. Although Tintoretto, in contrast, placed two of his daughters in nunneries, and did not provide dowries for the others, he was nonetheless increasingly well off. Despite the plea of extreme poverty made by his widow six years after his death, Tintoretto typically earned well in excess of 100 ducats per annum from the 1560s onwards, an income which would have put him among the higher earners in Venetian society (see Appendix 1, nos 10–39). From 1578 his income was increased still further with the addition of a salary from the Scuola di San Rocco (100 ducats), and on the occasion of the tithe (*decima*) in 1581, he declared ownership of a large house (on the Fondamenta dei Mori, valued at 500 ducats), a farmhouse with eight productive fields at Carpenedo (bought in 1576 for 313 ducats) and the inheritance of the usufruct of Antonio Comin's estate (valued at 400 ducats).[3] And yet, if these figures reveal the relative financial ease of his maturity, the earlier *poligrafi* period we have been examining in the previous chapter must have been less comfortable. Such wealth as Tintoretto did accumulate in later life was based on a proactive policy formulated when his professional position was very much less secure.

Tintoretto's wealth was never exceptional and may have been less substantial than that enjoyed by contemporaries such as Paolo Veronese, who quickly accumulated sufficient disposable income to dabble in real estate, or Palma Giovane, who (in contrast to Tintoretto) left a substantial amount of money to his relatives in his will. No other Venetian painter could match the wealth accrued by Titian, who lived like a gentrified patrician in a spacious suburban villa on the outskirts of the city. On the marriage of his daughter, Lavinia, in 1555, Titian provided a dowry eight times the size of that given to Bordone's daughters. His unusual wealth was dependent on his long success with foreign courtly patrons willing to pay very highly for his services. The extent of his financial independence from local patrons is evident from the fact that little more than a sixth of the 600 ducats he could annually expect from his various pensions in 1550 was paid by the Venetian state.[4] Titian argued often with his Venetian patrons (both official and ecclesiastical) over the value of his paintings. He was in dispute from as early as 1516, when the authorities refused to accept his demand for a fee of 400 ducats for the *Battle of Spoleto*. After litigating against his patrons over the price of the *St Peter Martyr* altarpiece (1530, destr. 1867), Titian subsequently attempted to raise the prices of further altarpieces for Santa Maria degli Angeli and Santo Spirito in Isola to 500 ducats. His response to the objections of the nuns at the Angeli was to send the painting to Charles V, who reputedly gave him 2,000 ducats. In the 1560s, this confrontational line was pursued by Titian's son Orazio, now in charge of the workshop. He declared himself unhappy with the fee of 100 ducats for a painting in the Ducal Palace and refused to accept the 1,000 ducats offered by the authorities at Brescia for three ceiling paintings.[5]

Given that no other Venetian painter enjoyed equivalent patronage from abroad, it follows that few were really in a position to emulate Titian in his inflationary pricing policy. Indeed, it would appear that the majority of younger painters at Venice did not actively pursue an independent business strategy at all, merely submitting to the prevalent valuations of their work offered by patrons or (on occasion) other artists. Tintoretto, on the other hand, did develop a more assertive policy, in so far as he too manipulated the prices of his paintings in an unusually independent fashion. In as many as fourteen of the commissions listed in Appendix 1, involving more than 50 paintings, the painter played an active role in determining the price (nos 1, 2, 6, 12, 13, 15, 19, 22, 25, 26, 28, 30, 33, 35). Significantly, however, his manipulations of price tended in the opposite direction to those of Titian, his career being littered with examples of his paintings being offered at lower prices than his patrons might reasonably have expected to pay. Now this was sanctioned by age-old practice in the lagoon, and in this sense the painter appealed to traditional values in the face of Titian's progressive departures. Towards the close of the fifteenth century, Gentile Bellini and Alvise Vivarini had worked at the Ducal Palace and left the fee for their work to be decided *ex gratia* by the patrons at some later point; and in the same period (1492–1504), Gentile and his brother Giovanni offered paintings to the Scuola Grande di San Marco at discounted prices.[6] But in Tintoretto's hands the patron-oriented approach was greatly exaggerated and in the process its significance was changed. Before Tintoretto, such discounts and donations to public institutions were certainly used by painters to win prestigious commissions. In Tintoretto's career,

however, they became the linchpin of a wider marketing process that aimed – sometimes in an aggressive fashion – both to counter Titian's example and to generate ever more work.

Tintoretto's special offers usually went substantially further than those of earlier Venetian painters, as if to make a point about Titian's inflationary demands. In 1572, for example, when Tintoretto completed a large battle painting for the Sala dello Scrutinio of the Ducal Palace (Appendix 1, no. 19, destr. 1577), Titian's earlier argument with the authorities over the price of the *Battle of Spoleto* seems to have been in his mind. In pointed contrast to Titian's inflationary demand, Tintoretto donated his painting. In a subsequent petition of 1574, he drew attention to the fact that he had forfeited a fee of 300 ducats (identical with that finally paid to Titian). Although Tintoretto followed the example of Bellini and Vivarini in completing his painting in advance of any reward, his generosity went much further. The appeal to precedent was simultaneous with an exaggeration of its ethos which bound his patrons to return the favour. Shortly after, the state granted Tintoretto's right to the *sansaria* due to become available at Titian's death. The fact that it was never paid, however, suggests the high risks attendant on Tintoretto's gift and reward tactic.[7] His famous sequence of donations and discounts at the Scuola di San Rocco (to which we will return in Chapter 5) bear a similar relation to earlier Venetian practice (Appendix 1, nos 15, 25, 26). As at the Ducal Palace, the painter went well beyond the example set by earlier Venetian artists. Following their initial proposals, the Bellinis had, in fact, produced only a single discounted painting for the *albergo* of the Scuola di San Marco in the subsequent 25 years, and for this Gentile had still received as much 150–200 ducats. In contrast, Tintoretto completed the entire decoration of the Meeting House within 25 years, producing more than 50 paintings at greatly discounted prices.[8]

While other painters did occasionally use similar methods, Tintoretto made them a mainstay of his approach. More frequently than his contemporaries, he gave uncommissioned paintings away to prominent literary figures and princely patrons of art (Appendix 1, nos 6, 12, 22, 30), anticipating – and often receiving – a future return, whether in the form of publicity or new commissions. On occasion, his readiness to forfeit his fee actually created a significant commission where none had previously existed: this was the case at the Palazzo Soranzo, where the family had not even wanted to have their palace façade painted (Appendix 1, no. 2, see illus. 31–4). Elsewhere, he proved himself willing to work exceptionally cheaply in accordance with the financial constraints of his patrons. It is fair to presume that the low price of twenty ducats for his altarpiece for the linen-weavers (no. 32) was typical of the other paintings he made for the Scuole attached to the guilds. Perhaps also the low fees he negotiated with the Secular Canons of San Giorgio at the Madonna dell' Orto were tailored to match the increasing budgetary limitations of the congregation (Appendix 1, nos 5, 13, see illus. 27, 156).[9]

Tintoretto's readiness to drop his prices was often noted with both concern and irritation by contemporary artists and connoisseurs. Ridolfi records that his offer to paint the huge choir paintings in Madonna dell' Orto for just 100 ducats 'spread about giving the established painters grounds for jeering, seeing the manner in which Tintoretto appropriated the most conspicuous

86 Jacopo Tintoretto, *Triumph of Doge Nicolò da Ponte*,
c. 1579–82, oil on canvas.
Palazzo Ducale, Venice (ceiling of the Sala del
Maggiore Consiglio).

commission in the city, though he had no current
testimonials confirming his ability'. At the Ducal
Palace, as Ottonelli records, Tintoretto embarrassed
Veronese by refusing to accept his high valuation of
the ceiling painting showing *Doge Nicolò da Ponte*
(Appendix 1, no. 28, illus. 86) and Ridolfi reports
that a similar situation arose with regard to the
Paradise (Appendix 1, no. 35, see illus. 94) itself later
in the decade: 'Such were the ways Tintoretto often
adopted in his negotiations, thus arousing the hatred
of other painters, since it seemed to them that he
damaged the reputation of art by not maintaining
the requisite decorum.'[10]

We may take it that chief among these critics
were members of Titian's circle, as Tintoretto's
propensity to drop his prices struck directly against
the older master's policy of raising his. Such a
proactive policy had, however, its own *raison d'être*
within the professional domain, given Titian's
supreme reputation and the fact that Tintoretto had

constantly to struggle against the older master's
dominance and hostility. Perhaps born out of an
initial position of professional marginality, it
subsequently became an important means of
widening his patronage base within the Venetian
context, putting his paintings within financial reach
of even the most humble clients. But such a
devaluation would have made little economic sense
if it were not supported by other compensatory
strategies. Chief among these was the controversial
rapidity of execution noted earlier. As members of
Titian's circle were keen to point out, Tintoretto's
loose brushwork stemmed less from aesthetic
imperatives than from his demeaning desire to
shorten the time involved in making a painting.
Their point was (as we noted) typically made
through a contrast with the leisurely and drawn-out
approach of Titian himself.

This critical contrast would seem to have a clear
basis in historical fact. Titian even made his most
prized patron, King Philip II, wait years for
paintings when moneys were owing to him. But his
Venetian patrons suffered more regularly.[11] In the
petition which followed the donation of the *Battle of
Lepanto*, Tintoretto made pointed reference to his
completion of the painting 'in dieci mese', perhaps
in order to mark the contrast with the 23 years
which it had taken Titian to deliver his *Battle of
Spoleto*. Tintoretto often used his speed of execution
as a competitive weapon, for example at the Scuola
di San Rocco, where it won him the initial
commission and was central to the work's further
progress. His agreement in 1578 to produce three
paintings a year effectively committed him to work
three times as fast as might have been expected.[12]
He apparently produced some paintings in as little
as a week. On 6 February 1573, he agreed one of his

most startling time-limits – to paint nine paintings for Gerolamo da Mula before 15 April (Appendix 1, no. 21). While such rapidity was exceptional among Venetian painters, it was not unprecedented in his own career: another surviving contract, dated 6 March 1557, committed the painter to producing three large paintings 'finished and complete' for the church organ in Santa Maria del Giglio in just sixteen days (Appendix 1, no. 8).[13]

A third feature of Tintoretto's business practice particularly noted by his contemporaries was the sheer volume of his output. The complaint that Tintoretto 'took on too much' (Sansovino) to the detriment of the quality of his work became a standard one in the early literature. Vasari boasted in the *Lives* that cinquecento painters 'can execute six paintings a year, whereas earlier artists took six years to finish one painting': a very rough computation of figures based on Pallucchini and Rossi's catalogue indicates that Tintoretto may have painted as many as 650 paintings in the course of a career spanning between 55 and 60 years. This would be an average of between ten and twelve paintings per year, a volume of output possibly as much as double that noted as typical among contemporary painters by Vasari, and one that easily outstrips Titian. Such a sustained high rate of production, working in tandem with his quick execution, would have offset the low prices Tintoretto often negotiated.[14]

Recent research indicates that Tintoretto employed assistants from the earliest phases of his career onwards, and his workshop organization was clearly essential to the successful fulfilment of the business strategy discussed above. In addition to north Italian painters such as Giovanni Galizzi, Tintoretto also attracted northerners such as Martin de Vos at a relatively early point in his career,

although the precise contribution of these individuals remains uncertain. After 1570, the personnel of the Tintoretto workshop becomes clearer, although the role of each individual in each commission is difficult to assess. It is evident, however, that very few paintings from this period (apart from those at San Rocco) can be attributed to the master alone. When commissions piled up (for example, between 1577 and 1582 when the shop was at work in the Venetian and Mantuan Ducal Palaces in addition to the Scuola di San Rocco) the core painter members of the family – Jacopo and his sons Domenico and Marco and daughter Marietta – were joined by at least four other artists: Antonio Vassilacchi (Aliense), Andrea Michieli (Vicentino), Pauwels Francke (Paolo Fiammingo) and Lodovico Pozzoserrato. It is likely that the Netherlandish painters in this group were allowed to develop their penchant for naturalistic detail, landscape and still life, while his local assistants executed large-scale figure compositions using a pictorial language based more closely on Tintoretto's own, but also incorporating stylistic elements from other leading Venetian masters, such as Veronese and Palma Giovane.[15]

As Jacopo's will of 1594 confirms, the master increasingly left the execution of paintings to his shop foreman, Domenico, having himself generated the initial compositional idea. Such practice was wholly typical in Venice: after 1550 Titian himself had made increasing use of his family and other assistants to cope with increasing demand. Veronese also operated a rather precise division of labour in his workshop, one which increasingly freed him from the actual execution of the work in hand. Tintoretto, however, may have gone one step further: it seems likely that by the 1580s Domenico

87 Titian, *Martyrdom of St Lawrence*, 1547–56,
oil on canvas, 493 × 277.
Church of the Assunta Ai Gesuiti, Venice.

was also free to generate semi-independent
compositions, only loosely based on his father's ideas
(a prominent example would be the *Paradise* for
the Ducal Palace). The Tintoretto workshop
organization departed from the norm of the later
sixteenth century in other ways too. For example,
Tintoretto did not typically follow Titian's
distinction between autograph and workshop
productions. In 1564, Titian informed Philip II that
he would have to pay 200 ducats for an autograph
replica of the *Martyrdom of St Lawrence* (illus. 87)
but that he could have one by the workshop for just
50 ducats. As we have seen, Titian supported such a
price differential by supplying only his most
important clients with autograph paintings. This
practice could cause dissatisfaction among those
lesser patrons unable to secure a genuine Titian:
in 1564, the Brescian authorities went so far as to
refuse the asking price for three ceiling paintings
because they had not been executed by the master
himself.[16]

Such examples are evidence of both Titian's
especial artistic kudos and also the emergence of the
values of artistic connoisseurship. Tintoretto's policy
was apparently more pragmatic and indiscriminate.
For example, it would appear that he himself was
largely responsible for the execution of the altarpiece
in San Silvestro for the trade Scuola of the
Bargemen around 1580, but in the same period left
the execution of the history paintings commissioned
by Duke Guglielmo Gonzaga of Mantua to his
workshop (see illus. 117, 126). Correspondingly, the
price he received was not typically determined by
the extent of his personal involvement in the work.
The most expensive of his altarpieces listed in
Appendix 1 are those for foreign patrons in
Dalmatia and at El Escorial (nos 14, 31, illus. 85),
both given to the workshop in the critical literature.
The fee for the workshop *Coronation of the Virgin* in
San Giorgio Maggiore (Appendix 1, no. 36) is the
highest known among his Venetian altarpieces, and is
more than double that received for the *Deposition* in
the same church, usually considered to be
Tintoretto's last autograph painting (Appendix 1,
no. 38, see illus. 211). We cannot, of course, infer
from these examples that artisan patrons were
systematically given priority over high-ranking
aristocrats, or that workshop paintings were always
more expensive than those by Tintoretto himself.
But the master's particular commitment to the
highest possible output may have militated decisively
against a policy which readily discriminated between
patrons and clearly distinguished between autograph
and workshop paintings.[17]

Tintoretto's business practice undoubtedly had
important implications for his controversial manner
of painting. A work until recently in Fort Worth
(illus. 89), may be identifiable with one of the two

88 Jacopo Tintoretto, *Raising of Lazarus, c.* 1580/5,
oil on canvas, 178 × 254.
Museum der Bildenden Künste, Leipzig.

88 Jacopo Tintoretto, *Raising of Lazarus, c.* 1580/5, oil on canvas, 178 × 254. Museum der Bildenden Künste, Leipzig.

histories (*istorie*) painted so rapidly for Gerolamo da Mula in the spring of 1573 (Appendix 1, no. 21). Tintoretto and his shop painted as many as seven versions of this subject, although there are no exact replicas among them. On the other hand, both general compositional ideas and individual figures readily recur. The foreshortened nude next to Christ in the 1573 version (a derivation from the Medici allegories) is used as Lazarus himself in the workshop picture now in Leipzig (illus. 88), while the Lazarus (based on the protagonist in Titian's *Martyrdom of St Lawrence*) repeats a figure-type often used in unrelated paintings (for example, see illus. 74). The general composition also develops earlier ideas and was important for the subsequent *Lazarus* paintings at Lubeck and San Rocco (see illus. 189). The constant recycling (with variations) of both individual figures and compositional inventions indicates the limits of the shop's formal vocabulary, and is evident in other works from Tintoretto's mature period which were produced cheaply and under a time constraint: the six extant *Philosophers* in the Biblioteca Marciana (Appendix 1, no. 20, illus. 90) are no more than formal variants on each another, and in one case Tintoretto merely

reversed his figure to produce a further painting showing *St Jerome* (illus. 91). As we shall see, forms and compositions recur throughout the Scuola di San Rocco cycle. Whether the paintings were to be executed by master or assistant, such formal economies must have facilitated the shop's overall policy of rapid execution and cheap pricing.[18]

Other aspects of Tintoretto's approach to figure-painting may also have helped this process. The painter's ability to produce a figure from nature 'in half an hour', noted by Calmo in 1548, would certainly have been aided by the visual economies he exacted within each painted form. In the painting formerly at Fort Worth (illus. 89) we are rarely given a full view of the heads of the main figures, and facial expression is further concealed by the abbreviated handling. Instead, dynamic posture and full bodily movement are indicated by the broad movements of the brush. The lack of individuation is enhanced by the repetition of gesture and movement among the figures. The background area is hidden in shadow, which allows the painter to indicate with minimum definition the presence of the twenty figures required by the contract signed with his patron. More generally, the use of a bold chiaroscuro scheme and a narrowing palette in many mature Tintoretto paintings offered an opportunity to radically reduce the amount of literal formal description (whether of figures, objects or landscapes) necessary to each composition.

Let us now briefly sum up our analysis of Tintoretto's business strategy. Tintoretto evidently enjoyed a level of financial success broadly comparable with that of other leading painters in Venice, but his means of achieving it were not standard. While the overall flexibility of his approach had clear Venetian precedents, and certain

89 Jacopo Tintoretto, *Raising of Lazarus*, 1573,
oil on canvas, 67.5 × 77.5.
Private collection, courtesy of Sotheby's.

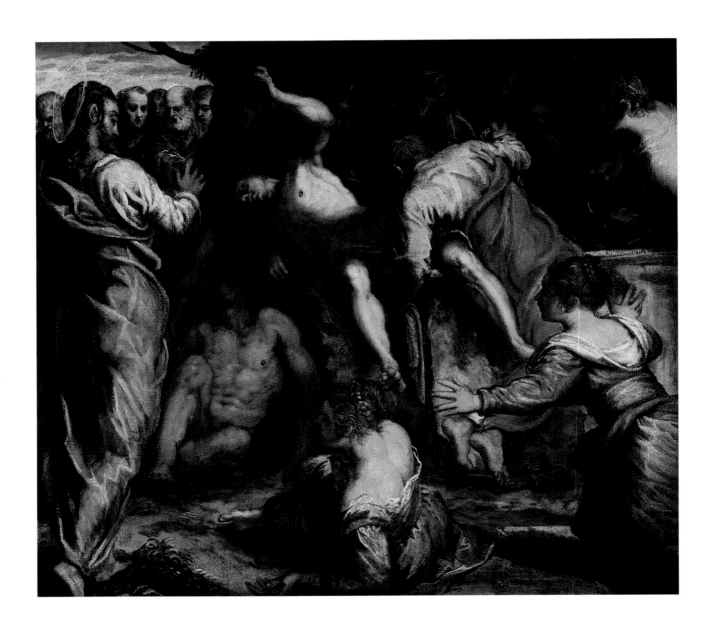

of his rivals also operated independent business strategies, his policy was not merely normative. It can be seen as an aspect of his wider polemic against Titian, and in many ways was defined against that of the older master. Instead of offering selected wealthy patrons a smaller number of paintings at inflated prices (allowing demand to outstrip supply), Tintoretto operated an open, client-oriented policy based on flexible pricing, quick execution and high turnover (allowing generous supply to stimulate further demand). The result was an open, market-driven policy which effectively filled the void left by Titian's increasingly exclusive interest in high-ranking foreign patrons.

Tintoretto's business strategy was supported by an approach to patronage which neither tied him to any one patron or patron-type nor discriminated between clients on the basis of their social status. More than any other major Venetian painter of the time, he focused on artistic commissions offered within the precincts of his native city. The presence or records of his paintings in as many as 41 Venetian

churches stands as a testament to the dense concentration of his patronage within the crowded urban matrix. He also worked frequently in the Meeting Houses of the Venetian Scuole and was, at least from about 1550 onwards, more or less constantly engaged on paintings for state buildings. His work for local private clients is less well known, but was also fairly extensive, particularly in the field of portraiture.[19]

Tintoretto's lack of a wider international reputation undoubtedly played a role in determining this concentration, just as, conversely, Titian's increasingly extensive commitments abroad opened up opportunities at home. When Tintoretto won his first significant Venetian public commission at the Scuola di San Marco early in 1548, Titian was away in Augsburg securing his momentous connection with Philip II. Titian's absence at this point may be taken as paradigmatic: commissions were open to the painter precisely in the Venetian domain which Titian increasingly eschewed. A further consequence of Tintoretto's narrow geographical focus was his lack of selectivity between painting types and patrons. And yet, to a significant extent, Tintoretto's inclusive approach represents a response to a more general expansion in the market for paintings in Venice.

In many ways Venetian patronage retained its long-established parameters throughout the sixteenth century. But in addition to employment from the patrician and citizen castes, artists received increasing numbers of commissions from more humble patrons, such as the trade-guild Scuole (Scuole dell' arte) and the parish-based Scuole del Sacramento. By the end of the century, the majority of ordinary Venetians (the *popolani*) possessed their own votive paintings, portraits or reproductive prints.[20] This expansion was generally encouraged by the patriciate, who recognized artistic patronage as a useful form of social cement. But while it certainly sustained a thriving community of artists, it inevitably led to further differentiation within the profession. The high professional aspirations of leading practitioners were, paradoxically, a direct result of the spread of the market for art down to lower social levels. As we have seen, top painters such as Titian and (to a lesser extent) Veronese were increasingly in a position to select between patrons and picture types. The importance of such selection was recognized by contemporary writers on art, and the frequent complaints over Tintoretto's 'over-production' are correspondingly related to his lack of discrimination in this regard.[21]

State Patronage

Tintoretto painted more pictures for the Venetian state than any other painter in sixteenth-century Venice. And yet a closer look at the historical circumstances suggests that he remained some way behind Titian and Veronese in patrician affections. This apparent contradiction is indicative of the wider cultural conflict within the patriciate in the second half of the sixteenth century, to which we will shortly turn. For if Tintoretto's careful conformity to the orthodox model of the Venetian painter (the selfless servant of the Serenissima, ever ready to supply paintings at high speed and low cost) made him a popular choice, the very *mediocritas* of his artistic profile may have been off-putting to those patricians concerned to adopt a more 'aristocratic' identity. The ambivalent patrician response to Tintoretto thus reflects a differential within the ruling caste similar to that we have noted in the artistic community. The cultural situation

expresses an equivalence between the fields of production and consumption well known to sociologists (described by Pierre Bourdieu as a 'structural homology'[22]).

In discussing Tintoretto's problematic official career, then, we need to distinguish between the painter's approach to the patriciate, and the patriciate's approach to their painter. It has often been presumed that Tintoretto was ill at ease when working on official commissions. Hans Tietze, for example, argues that his work in this domain is of lower quality than that he made in the non-noble context of the Scuole, and suggests that his relative lack of interest is expressed by the fact that he left the execution to his workshop. The underlying cause is presumed to be the painter's lower-class origins and sympathies.[23] But it is dangerous to make Tintoretto's unclear social background a source for his artistic preferences, and there is no evidence to suggest that he operated a reverse discrimination against high-ranking patrons. Indeed, his acceptance of the standard social division between artistic producer and consumer was a central tenet of his professional identity as 'the little dyer'. Moreover, in his Venetian state paintings Tintoretto proved himself a very subtle and sympathetic interpreter of patrician values, both orthodox and progressive.

The patriciate, on the other hand, remained less convinced of their faithful servant. This much is evident from the chronology of his official employment. Tintoretto's first official commissions do not date before 1550, when he was already in his early thirties and had been practising as an independent master for more than a decade. In contrast, Titian collaborated on state paintings with Giorgione before he was twenty, and within five years (in 1513) had won the most prestigious official

commission available (for the *Battle of Spoleto*). On this occasion, he also succeeded to Giovanni Bellini's *sansaria*, which seems to have meant that he became the state's recognized official painter. Veronese was also afforded almost immediate official recognition on his arrival in Venice around 1550 at the age of 22. He dominated two prestigious state commissions within the next five years, including that for the Reading Room ceiling of the Libreria Marciana.[24]

Tintoretto's exclusion from the Marciana commission did not last long: within five years he was at work in the vestibule of the library, and from this point onwards he was the busiest Venetian painter in the official domain, producing a seemingly unending flow of portraits, votive, history and ceiling paintings for many state buildings. But despite this he failed to achieve clear pre-eminence over his main rivals as a state painter. This can, in part, be ascribed to the impact of the two disastrous fires in the State Rooms of the Palace in 1574 and 1577, which created an immediate demand for a vast quantity of replacement paintings, forcing the state to employ all the major painters' workshops in the city. But the indications are that patrician taste at the Palace continued to favour Titian's preferred painter from the younger generation, Paolo Veronese. Although Tintoretto and his assistants worked extensively in the building from the mid-1570s to the early 1590s, Veronese was apparently considered the senior painter. Thus, he was awarded the first significant commission (for the ceiling of the Sala del Collegio) after the first fire, and was subsequently given the job of valuing two (and perhaps more) of Tintoretto's contributions to the redecorations (Appendix 1, nos 27, 28, illus. 86, 203, 204).[25]

Patrician preference for Paolo must also explain his victory over Tintoretto in a competition held

between 1579 and 1582 to paint the jewel in the crown within the programme, the vast picture to hang over the doge's tribune in the Sala del Maggior Consiglio (illus. 92, 93). Tintoretto's eventual fulfilment of this commission was largely dependent on Veronese's death in 1588 (illus. 94, 95) Ridolfi reports that the *Paradise* caused such delight that 'the very senators congratulated him and affectionately embraced him for having brought to conclusion that great piece of work to the enormous satisfaction of the Senate'. The patrician delight is understandable, given that the energies of Tintoretto's vast painting lent triumphant expression to their aspirations. The old painter proved himself particularly alive to the central symbolic significance of the Sala del Maggior Consiglio for the ruling caste, and his painting effectively gave its east wall (against which Doge and Senate now sat) an altar-like significance. Playing on his long-established skill in suggesting continuity between real and pictorial space, Tintoretto produced an image which restated the age-old notion of the patrician regime as a direct issue of the divine order above. Tintoretto's image was particularly responsive to the contemporary political climate, his painting a fitting expression of the resurgent values of *venetianità* in the final decades of the century. Despite this, the old painter received the final plaudits of the senators by default, their affectionate embrace secured only by his pointed

emulation of Veronese's original pictorial design.[26]

Tintoretto had, though, often proved himself a sympathetic interpreter of official patrician values. This was no easy task in the second half of the sixteenth century, given the confusions surrounding the cultural identity of the Venetian ruling caste. As we have seen, the traditional identification between noble and non-noble (based on shared economic interests in trade) came under threat as the old idea of the patrician-merchant lost ground to that of the nobleman-knight. This realignment, an aspect of the wider shift in Venetian economic interests towards the west, was expressed in practical terms by the patriciate's gradual withdrawal from trade in favour of land. Members of the older patrician houses (*case vecchie*) often enjoyed close ties with the papal court in Rome, encouraging a ready identification with its non-Venetian values. In the middle decades of the century members of these *papalisti* families (such as the Corner, Grimani and Barbaro) effectively dominated the Venetian government, typically pursuing an internationalist policy of appeasement and cultural integration. However, many of the newer patrician families (*case nuove*), whose admission to the nobility was based on recent success in trade, sought to maintain or revive a more orthodox social profile, and by the early 1580s the state was under their influence and pursuing the aggressively pro-Venetian policies which culminated in the papal interdict of 1606.[27]

94 Jacopo Tintoretto, *Paradise*, 1588/92, oil on canvas, 700 × 2200.
Sala del Maggior Consiglio, Palazzo Ducale, Venice.

95 Jacopo Tintoretto, *Paradise*, *c.* 1588, oil on canvas, 164 × 492.
Museo Thyssen–Bornemisza, Madrid.

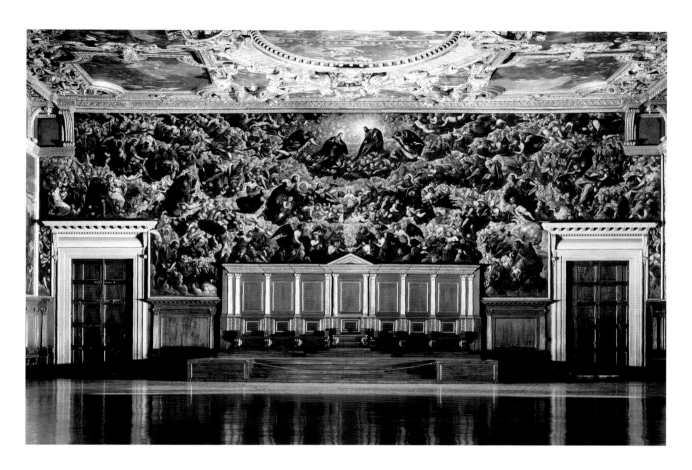

The *papalisti* were particularly active as art patrons in their period of political ascendancy, operating both in a private capacity, collecting and commissioning works for their palazzi and places of devotion, and as officials on the various committees set up to control state commissions. It was they who most strongly developed the category of artistic taste in Venice, using it as a means of expressing their cultural difference. These patrons typically promoted an overtly Romanist style which could, on occasion, be seen to challenge local artistic convention. They often gave artistic commissions to imported central Italian artists, most famously in the period of the so-called 'city renovation' (*renovatio*

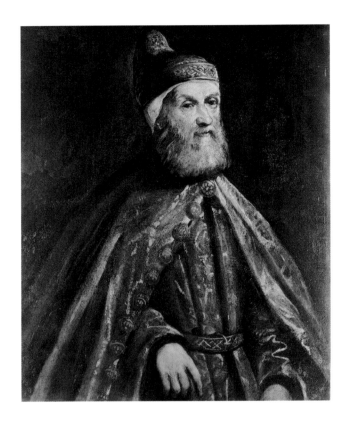

urbis) initiated by the papalist Doge Andrea Gritti (illus. 103) in the 1520s and extending beyond the mid-century. Jacopo Sansovino (who arrived from Rome in 1527) was commissioned to erect a sequence of classicizing buildings at the civic and religious heart of the city (the Libreria Marciana, the Loggetta and the Zecca). The same taste led the Corner and Grimani to import Central Italians such as Giorgio Vasari, Francesco and Giuseppe Salviati and Federico Zuccari. Alternatively, the circle favoured locally based painters whose work most obviously reflected their own cultural values. The brothers Lorenzo and Antonio Giustinian, relatives of Gritti and the Barbaro, promoted the eclectic classicizing style of Paolo Veronese, giving the painter his first Venetian commission in Sansovino's

new church of San Francesco della Vigna in 1551 (see illus. 25). His success in official commissions in the same period also owed much to the hidden patronage of this influential clique. Daniele Barbaro (see illus. 19) and another relative of his, Vettore Grimani, effectively controlled the choice of artists for the ceiling paintings in the rooms of the Council of Ten and the Libreria Marciana. Veronese's particular association with Daniele Barbaro and his brother Marcantonio was, of course, to bear especial fruits over a number of decades, most famously in the extensive decoration of the brothers' Palladian villa at Maser in the early 1560s.[28]

Certain features of Tintoretto's paintings, such as their rough finish and radical formal abbreviation, were not easily accommodated into the sophisticated *all' antica* ethos, and it may be for this reason that he lacked Veronese's especial popularity with the *papalisti* circle. His professional profile would, though, have been more conducive to the traditionalist values of the *case nuove*. It would be tempting to assume that Tintoretto struggled to get a foothold as a state painter in the age of *papalisti* supremacy (particularly the 1540s and 1550s) and that his greatest success with the patriciate dates from the later period in which the *case nuove* were in the ascendancy.[29] The turning point seems, however, to have arrived rather earlier. Soon after the election of Doge Girolamo Priuli in 1559, Tintoretto produced a painting which won him a new prominence as an official portraitist (illus. 96). Over the course of the next three decades, he and his workshop went on to produce well in excess of 50 portraits of the city's doges, senators, procurators and other officials, most of which were destined for state buildings. Some of these paintings were commissioned by the authorities, while others were

paid for by individual sitters to mark their promotion to high office or retiral from it. The commissioning of this kind of portrait was increasingly considered a *de facto* requirement of office, being understood as an expression of public service and civic duty. The typical conditions governing its production were rapid delivery and low price. Prompt supply was a necessity for newly elected or retiring officials, as it was for those holding office for a short period. The choice of Tintoretto was in many cases based on his ability to fulfil these basic functional demands rather than on any marked aesthetic preference for his work. Tintoretto was occasionally paid as much as 20 or 25 ducats for his official portraits (Appendix 1, nos 10, 24). But a bill of payment dating from 1571 tells us that he received just 70 ducats in return for more than 25 official paintings of various types, including eleven portraits, indicating that, on occasion, such works were produced for no more than a few ducats each (Appendix 1, no. 20).[30]

These quotidian working conditions are expressed in the portraits themselves which are often characterized by an effect of formal simplicity which even goes beyond Tintoretto's usual propensity for restraint in paintings of this type. Comparison of an official portrait (illus. 97) with a near-contemporary non-official one (illus. 98) indicates the extent to which Tintoretto suppressed the formal sophistications of his manner when working for the state.[31] If, in the Madrid painting, Tintoretto makes the piercing glance of the sitter the consequence of a momentary twist of his head against the direction of the sharply foreshortened body, the official painting remains essentially planar, the procurator's head and body sharing a single spatial orientation. While the gesture of Capello's

right hand, like the frank and open gaze, introduces an element of momentariness and actual presence, it is also noticeable that the painting lacks the very selective and dramatic focus on head and hands evident in the non-official portrait. Rather than opting for a suggestive play of chiaroscuro, Tintoretto uses a more Titianesque palette, his integrated, tonal approach drawing the viewer's attention to the painted surface.

The relative lack of formal elaboration in official paintings such as the Priuli and Capello portraits merely reflects, on one level, a pragmatic concern to save time in execution and to keep production costs to a minimum. The simplicity of their design, particularly with regard to pose, would also have aided Tintoretto's workshop, who were often required to produce copies (near-contemporary replicas of the Priuli portrait survive in Venice and Malibu). On many occasions, Tintoretto merely repeated the same formal schema for different sitters. Thus, in the portraits of Priuli's successors showing *Doge Pietro Loredan* (illus. 99) and *Doge Alvise Mocenigo* (illus. 100), he used an almost identical seated pose, setting and subdued palette, merely substituting the head of Mocenigo for that of Loredan. The particularities of the doges' physiognomies are carefully noted in such works – Loredan's advanced years are indicated by his more crouched posture on the ducal chair – but in deference to a long-standing Venetian convention, intimations of individual character are finally made subject to the sitter's merely representative status as a holder of high office.[32]

Tintoretto's penchant for formal repetition was noted earlier in the chapter as an aspect of his wider business practice. In the context of his state paintings, this kind of deliberate artistic 'poverty'

99 Jacopo Tintoretto, *Portrait of Doge Pietro Loredan*,
c. 1567/70, oil on canvas, 125 × 100.
Szépmüvészeti Múzeum, Budapest.

100 Jacopo Tintoretto, *Portrait of Doge Alvise Mocenigo*,
c. 1570/3, oil on canvas, 116 × 97.
Gallerie dell'Accademia, Venice.

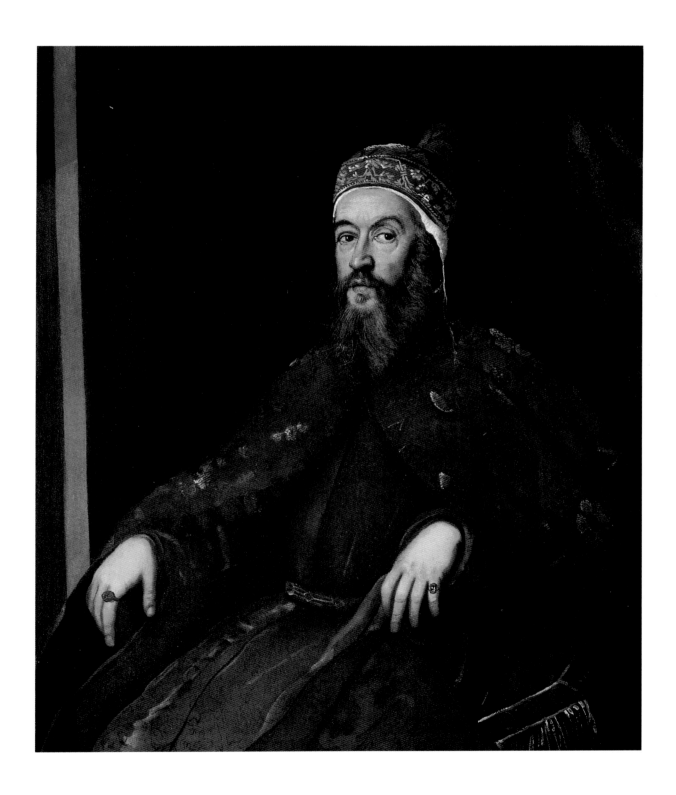

could take on ideological overtones. The simplicity
of technical and formal structure, like the shared
poses, expresses an ethos of essential continuity
between the subjects of a wider political order. The
Tintorettesque interchangeability of persons and
types in his official portraiture (which may also
reflect the fact that such works were to be seen in
sequence) is quite deliberate, the insistent effect of
similarity embodying ideals of institution specific to
the republican context. One is reminded in this
regard of the self-suppressing words of a leading
member of the *case nuove*, the Ambassador to Rome,
Leonardo Donà, who wrote to the senate in 1583
proclaiming his self-sacrificing desire 'to be known
in the Roman Curia as Ambassador of Venice; and
equally in Venice as senator of that fatherland ... and
not by my private name'.[33]

In the long sequence of official paintings
Tintoretto undertook for the Palazzo dei
Camerlenghi following the death of Bonifazio de'
Pitati in 1553, republican values are even more
directly expressed through partial repetitions of
pose, physiognomy and dress. In most of his earlier
Camerlenghi paintings, Tintoretto merely illustrated
his patrons' name-saints with prominent coats of
arms. But the *Virgin and Child with Four Senators*

(illus. 101) already includes portraits of the donors,
and the full votive-type, showing kneeling officials
before a sacred group, quickly became the preferred
norm at the palace in the following decades.[34] This
development is indicative of the new pressures on
the self-repressing ideals of the patriciate, but these
are nonetheless superbly restated in another
Camerlenghi painting known as the *Madonna of the
Treasurers* (illus. 102). An inscription at the lower left
announces the painting's underlying theme:
Unanimous Concordiae Simbolus. Perhaps drawing on
an association made by the French philosopher
Guillaume Postel (who had recently proclaimed
Venice the home of universal concord), Tintoretto
presents a perfectly ordered composition. Concord
is shown as operative not only between the sacred
actors and their secular devotees, or between the
three patricians who commissioned the work
(Micheli Pisani, Lorenzo Dolfin and Marino
Malipiero), but also between these representatives of
the ruling caste and their deferential *cittadino*
helpers shown to the right. The point is carefully
reiterated in visual terms: although each of the
Treasurers has a slightly varied physiognomy,
gesture and pose, these differentiations do not
disturb the underlying theme of similitude and
repetition. The idea of devotional/political accord is
expressed once more by the sequential arrangement
of the Treasurers and their helpers across the picture
surface, one form seeming always to predicate the
next in two staggered temporal movements of
kneeling and rising. Given the intended overlap
between earthly and supernatural domains, it may
not be too fanciful to see the work as a kind of
secularized Adoration of the Magi, the patricians
aping their biblical prototypes in their humble offer
of earthly treasures to the Christ child. Like

102 Jacopo Tintoretto, *Virgin and Child with Sts Sebastian, Mark and Theodore Adored by Three Camerlenghi (Madonna of the Treasurers)*, c. 1567, oil on canvas, 221 × 521. Gallerie dell'Accademia, Venice.

103 Titian, *Portrait of Doge Andrea Gritti*, c. 1545, oil on canvas, 133.6 × 103.2. National Gallery of Art, Washington, DC.

Tintoretto's simple official portraits, such works offered a reaffirmation of traditional republican ideals, picturing a patrician golden age of caste solidarity and willing public service. The restatement of this ideal is supported by the pictorial orthodoxy of the formal arrangement, in which stately forms process across the picture plane and movements take on something of the predestined, ritualized and timeless quality that they have in the late fifteenth-century patriotic narrative paintings of Gentile Bellini or Carpaccio (see illus. 24).[35]

The communal values of the wider political family to which such officials belong form, on the face of it, a clear antithesis to the free-thinking and self-assertive aristocrats who feature in many of Titian's portraits. Even in his official portraiture for Venice, Titian had moved away from the kind of restraint traditional to works of this type. In the powerfully expressive *Doge Andrea Gritti* (illus. 103) Titian introduces an emphasis on the sitter's personal identity alien to the conventions of Venetian ducal portraiture, even if this was well

suited to the ambitious papalist identity of Gritti himself.[36] Tintoretto remained truer to the original ideals of the Serenissima in his official works. But it would be an over-simplification to make him simply the champion of the traditionalist *case nuove* against Titian's promotion of the progressive values of the *case vecchie*. After all, in works such as the Capello portrait, Titian's lasting influence on Tintoretto's portraiture remains evident, if not in the use of warm reds and browns (colours firstly determined

104 Titian, *Portrait of Pope Paul III*, 1543, oil on canvas, 106 × 85.
Museo e Gallerie Nazionali di Capodimonte, Naples.

105 Jacopo Tintoretto, *Doge Andrea Gritti before the Virgin and
Child with Sts Marina, Bernardino, Louis and Mark*, c. 1581/4,
oil on canvas, 360 × 500.
Sala del Collegio, Palazzo Ducale, Venice.

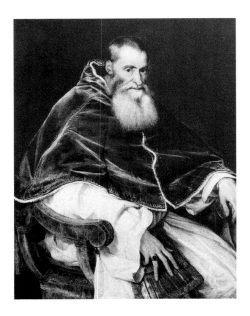

by the sitter's prescribed official dress), then in the
overall naturalism of the presentation. The two
ducal portraits illustrated here are based on Titian's
Pope Paul III (illus. 104), itself modelled on
Raphael's famous *Pope Julius II* (which Titian had
copied in Rome in the mid-1540s). The formal
cross-reference in these cases undoubtedly has a
political resonance: by adopting the diagonally
seated pose specifically associated with papal
portraiture Tintoretto was able to suggest (in
accordance with the Grittian idea of Venice as the
new Rome) an equivalence between Venetian doge
and Roman pontiff.[37]

Even if we allow that there were more practical
reasons for this formal reliance on Titian (such as
his wish to provide visual continuity with the
imagery of the state's long-favoured painter), it
remains true that Tintoretto was particularly alive
to the emergent aristocratic values of his patrician
patrons. Deliberate recall of pre-existing paintings
was central to the special Venetian conception of

ristauro, and when Tintoretto was called on to
replace the four votive paintings in the Sala del
Collegio following the 1574 fire, he made very
deliberate reference to the works he replaced. This
is most explicitly the case in his *Doge Andrea Gritti
before the Virgin and Child with Sts Marina,
Bernardino, Louis and Mark* (illus. 105), a visual
pastiche in which direct reference to earlier official
works establishes the continuity of the image with its
predecessors.[38] It is usual to notice the departures
from the destroyed Titian that Tintoretto replaced
(illus. 106), but these differences are less significant
than the insistent and literal way in which the
prototype is recalled. Tintoretto's replication of
Titian motifs such as the Virgin and Child and St
Bernardino (the latter based directly on a surviving
Titian drawing), like his use of Vincenzo Catena's
portrait for the figure of Gritti himself (illus. 107),
make his replacement painting into a visual
palimpsest, the new 'text' overlaying but not finally
erasing those it is founded on. Such overt quotations

106 Anonymous woodcut after the burnt picture of 1531
by Titian formerly in the Ducal Palace, Venice.

107 Vicenzo Catena, *Portrait of Doge Andrea Gritti, c.* 1530,
oil on canvas, 97 × 79.
National Gallery, London.

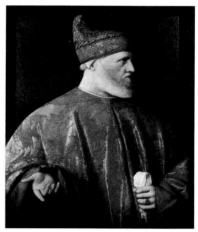

give the work a sanction from the past, even while
the original meanings of the prototypes are
significantly altered. Thus the profile view and
dynamic gesture of the right arm in Catena's
portrait now makes the doge active as an intercessor
between the spectator and the Virgin and Child,
giving him a saintly role unimagined in Titian's
original votive composition. Reference to earlier
official painting is thus simultaneous with its
appropriation into a newly heightened form of
personalized iconography. Indeed, it is likely that
Tintoretto's canonization of Gritti (his personal
elevation is emphasized by the addition of new cult
saints such as Marina, included because Gritti raised
the siege of Padua on her feast day) was tolerated by
more conservative patricians only because the doge
had been dead for more than 40 years. In 1577–8,
Veronese was made to alter his initial design for the
Allegory of the Battle of Lepanto for the same room
just because it placed too much emphasis on the
battle's hero, Doge Sebastiano Venier, and not

enough on its wider significance as a victory of the
Venetian state.[39]

If Tintoretto's state paintings often demonstrate
a retrospective quality, and by doing so depart from
the revisionist official style of Titian, this is by no
means always the case. Indeed, even when at his
most compliant to existing models, Tintoretto is
knowing, the orthodoxy he espouses peculiarly self-
conscious. In examples such as the *Madonna of the
Treasurers*, the assertion of an ideal of caste solidarity
might even have had a polemical or nostalgic
dimension. Such works should be understood not so
much as traditional but as representations *of* a
tradition under threat. If Tintoretto's style in many
of his official portraits offers a return to the simple
patrician self-image of a century earlier (in which
type likewise dominates over individual), then this is
a matter of sophisticated reversion rather than of
some naïve conformity to precedent. But, as the
Gritti votive suggests, this does not preclude a
response to the more individualistic aspirations

108 Jacopo Tintoretto, *Portrait of Procurator Marco Grimani*,
1576/83, oil on canvas, 96 × 60.
Kunsthistorisches Museum, Vienna.

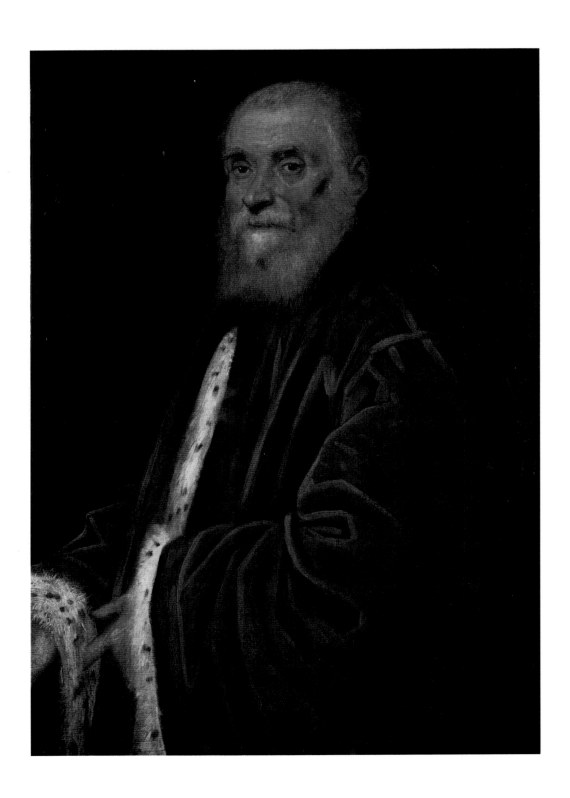

109 Jacopo Tintoretto, *Portrait of Procurator Vincenzo Morosini*, *c.* 1580, oil on canvas, 84.5 × 51.5. National Gallery, London.

within patrician culture. Nor did it stop Tintoretto from moving beyond the cultural and political dimensions highlighted above in certain of his official paintings.

In a superb sequence of official portraits showing old men in high office dating from the period of the Ducal Palace redecorations, Tintoretto deepened his imagery of the Venetian patriciate, suggesting the ultimate subjection of all men and social positions to the ravages of time (illus. 108, 109).[40] Tintoretto's approach in these works undoubtedly owed much to his contemporary religious paintings for the Scuola di San Rocco which feature a similar economy of formal means and consequent spiritual intensity. In each portrait the luminous head is seen as emerging from a darkened background and is made the central focus. The unflinching observation of desiccated flesh is made more poignant by the enlarged, sunken eyes, indicating the sitter's perception of his own mortal frailty. At the same time, the loose brushwork and detached highlights undermine the solidity of the figure in space, allowing the sitters a disturbing apparitional quality. As such it is hard to remember that these were public paintings, officially commissioned by men in power. On a superficial level, such works continue to stress the dignity of age in accordance with the gerontocratic principles of the Venetian state. But the sense of imminent earthly dissolution is so prevalent within the image that even the sitter's rich ermines and brocades, so often used as indicators of wealth and position, seem to dissolve and decay under the painter's fluid touch. Like all other worldly things, these great men and the high offices they hold must submit to the transience of earthly life.

Private and Court Patrons

The above discussion indicates that it would be easy to over-simplify Tintoretto's position *vis-à-vis* patrician culture, even in its most Romanist guise. As was noted in Chapter 1, he had an early entrée to the famous art collection housed in the palace of Giovanni and Vettore Grimani at Santa Maria Formosa, and much later (in 1578) received a significant private commission for portraits and religious paintings from the San Luca branch of the family. The new San Luca building was designed, in assertively Romanist style, by the architect Michele Sanmicheli, who earlier provided the design for Marco Gussoni's new palace on the Grand Canal at Ponte di Noele, decorated by Tintoretto in 1550–52 (see illus. 36, 37). Gussoni was also a member of the Romanist circle, and apparently shared the taste of his relations in the Corner family for antique and central Italian art: Tintoretto's frescoes, as we have seen, represent his most explicit act of homage to Michelangelo's statuary.[41]

But despite these commissions, it remains true that Tintoretto never achieved (or cultivated) a close and exclusive relationship with the *papalisti* circle. So much is perhaps evident from the distribution of artistic patronage in Sansovino's new church of San Francesco della Vigna (begun 1534). The rebuilding of this Franciscan Observant church was overseen by three friars, but these men were from leading patrician families and the project was effectively financed by private money from members of Doge Andrea Gritti's clique. Although a connection between the patriciate and the wealthy religious houses had long been a particular feature in Venice, there were few precedents for the situation at San Francesco, where artistic patronage became the

preserve of an exclusive group of (often interrelated) families sharing an assertively Romanist taste in art.[42] The painters chosen to decorate the prestigious nave chapels in San Francesco during the 1550s reflect this taste: the Roman-trained Battista Franco and Giuseppe Salviati were commissioned and, when the former died in 1561, Giovanni Grimani brought Federico Zuccari to Venice to complete the work in his chapel. Veronese's *Sacra Conversazione* (commissioned *c.* 1550–51 by the Giustiniani; see illus. 25) set the tone of *all' antica* classicism followed in all the nave chapel decorations. Tintoretto was also commissioned, but his patrons were two brothers from a non-noble family, Zuanne and Zuan'Alberto dal Basso, and the style of his painting owes little to Veronese (illus. 110). The dal Basso were the only non-nobles to be granted a nave chapel, their late admission in 1548 being forced on the Franciscans by financial necessity.[43]

Despite recent arguments to the contrary, there is little documentary, structural or stylistic evidence to suggest that the dal Basso altarpiece was painted in the 1550s. Tintoretto's altarpiece is closer in appearance to works dating from 1560–65 to which it is also thematically related, sharing their focus on the carrying and mourning of a sacred body (illus. 123, 125, 139, 146). It features a fluid treatment of light and space which is much closer to the dramatic style of the religious paintings of the 1560s than to the more coloured and finished works of the previous decade. The later date would also have the advantage of placing the dal Basso painting into a phase of decoration which saw the infiltration of other wealthy citizen families into the patrician precinct of San Francesco. Despite its pointed reference to a Roman source (see illus. 145), Tintoretto's painting, with its intense emotionality,

visually reductive chiaroscuro, sketchy brushwork and unorthodox compositional inversion, is far from the restrained classicizing orthodoxy of the earlier group of altarpieces.[44]

The commission probably coincided with Zuan' Alberto dal Basso's rise to high office in the Scuola di San Rocco in the early 1560s, where it seems likely that he backed Tintoretto's cause against rivals who had already made their mark at San Francesco. The later dating would also match the wider pattern of belatedness which characterizes Tintoretto's career in other socially exclusive patronal contexts. That his style was perceived as controversial at San Francesco is suggested by the fate of a second nave altarpiece, commissioned by the patrician Giovanni Antonio Bonomi in memory of his father, Lorenzo, between 1569 and 1576. This painting, which may be identical with a painting recently on the London art market (illus. 111), is painted in the artist's most progressive style. According to Ridolfi, the Bonomi found it 'unpleasant to look at' and promptly exchanged it for an altarpiece by the ultra-orthodox Girolamo Santa Croce (now lost).[45]

Perhaps the only patrician family to offer Tintoretto repeated commissions over an extended period, in both private and official contexts, was the *dal banco* branch of the Soranzo from the district of San Polo (the parish in which, according to an unsubstantiated report, Tintoretto himself was born). The Soranzo were a prominent *casa vecchia*, but did not have an entrée into the fashionable circle of interrelated families dominating commissions such as that at San Francesco (see Appendix 2). Their patronage of Tintoretto seems to have developed in a piecemeal fashion and cannot readily be ascribed to the machinations of taste. Tintoretto decorated the façade of the family palace on the

110 Jacopo Tintoretto, *Christ Carried to the Tomb, c.* 1564/5,
oil on canvas, 164 × 127.5.
National Gallery of Scotland, Edinburgh.

111 Jacopo Tintoretto, *Martyrdom of St Lawrence*, 1569/76, oil on canvas, 93.5 × 118.2. Private collection.

112 Jacopo Tintoretto, *Portrait of Procurator Jacopo Soranzo*,
c. 1550, oil on canvas, 106 × 90.
Gallerie dell'Accademia, Venice.

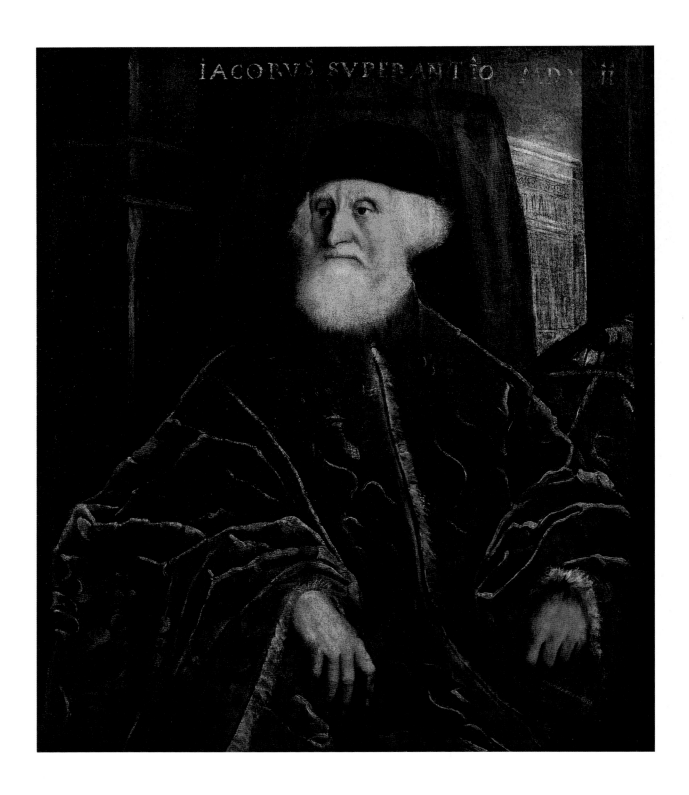

113 Jacopo Tintoretto, *Portrait of Fourteen Members of the Soranzo Family*, 1551–65, oil on canvas, 151 × 216 (left fragment).
Pinacoteca, Castello Sforzesco, Milan.

114 Jacopo Tintoretto, *Portrait of Fourteen Members of the Soranzo Family*, 1551–65, oil on canvas, 153 × 215 (right fragment).
Pinacoteca, Castello Sforzesco, Milan.

115 Jacopo Tintoretto, *Portrait of Jacopo Soranzo*, c. 1551, oil on canvas, 75 × 60 (central fragment).
Pinacoteca, Castello Sforzesco, Milan.

Campo di San Polo *c.* 1545 (see illus. 31–4), but Ridolfi tells us that this was a commission largely generated by the painter himself. In the Soranzo commissions which followed there was little opportunity for further development of the Pordenonesque manner of the frescoes.

Indeed, these demonstrate precisely the kind of recursive qualities which characterize many of Tintoretto's state paintings. The early official portrait of the head of the family, *Portrait of Procurator Jacopo Soranzo* (illus. 112), is typical of Tintoretto's works of this type. The abbreviated treatment of the sitter's beard, like the roughly scumbled highlights on the sleeve of his toga, do not distract from the overall planarity of the formal composition, whose essential simplicity is disturbed only by the later additions which altered the format from lunette to rectangle. In a very problematic group-portrait showing Jacopo Soranzo with fourteen members of his family (illus. 113–15) which now survives only in three fragments, Tintoretto adopts an approach which verges on the naïve, merely lining up the portraits in a shallow space in additive fashion. It has often been argued that this painting, which is certainly unique in Tintoretto's

career, was painted over a number of years, perhaps being completed as late as the mid-1560s. The fact that Jacopo Soranzo's grandson of the same name is shown wearing the double-rose chain awarded to him by Mary Tudor for his services as Venetian Ambassador as late as 1554 indicates that the composition was developed in piecemeal fashion, rather than being executed according to a closely pre-planned design (illus. 113). Accuracy of physiognomic portrayal, rather than aesthetic experiment, was undoubtedly the exclusive demand of Tintoretto's Soranzo patrons, and recent technical analysis has revealed that in a number of cases the

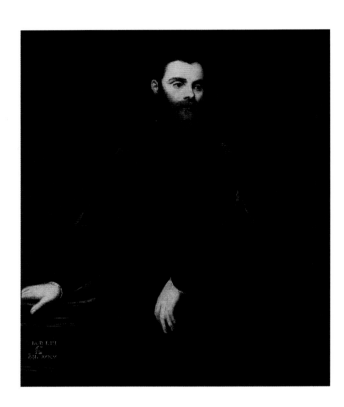

116 Jacopo Tintoretto, *Portrait of Lorenzo Soranzo*, 1553,
oil on canvas, 114 × 95.5.
Kunsthistorisches Museum, Vienna.

painter merely added pieces of canvas featuring the
sitter's heads (taken from the life) to their pre-
painted bodies (left to the workshop).[46]

The aesthetically disastrous group-portrait
sharply reveals the limitations of Tintoretto's
relations with the Soranzo family. Although he went
on to make successful independent portraits of the
three grandsons of his initial patron who feature in
the group-portrait and painted an altarpiece for
their sister, this continued employment may not
indicate a special relationship.[47] Jacopo and his heirs
gained high office in the period of Tintoretto's first
emergence as a state painter, and certain members of
the family were still prominent in the government in
the 1570s, but any influence they might have had on
his official career must remain a matter of
conjecture. It may be, for example, that Lorenzo

Soranzo, painted by Tintoretto in a fine Titianesque
portrait in 1553 (illus. 116) and elected Camerlengho
di Comun in the same year, played a role in securing
the painter's participation in the decoration of the
Palazzo dei Camerlenghi. But his father, Procurator
Jacopo, who may still have wielded influence at the
Ducal Palace, died in 1551, leaving Veronese's
supporters a free rein in that building. In any case, it
may be that the *dal banco* Soranzo themselves, like
the other *case vecchie*, ultimately preferred the
classicizing style of the younger painter, given that
they commissioned him to paint an extensive fresco
cycle for their terra-firma villa in 1551.[48]

The mere frequency of Tintoretto's official
employment at Venice cannot be taken as a measure of
his wider international reputation. While official
commissions had long been perceived as the highest
source of patronage available to artists at Venice, the
appeal of such work may have declined in the course
of the sixteenth century. In Titian's career, Venetian
state patronage played an essentially transitional role,
his interests moving quickly beyond the local artistic
orbit.[49] Seen from the high summit of Titian's
internationalism, Tintoretto's almost continual
employment as a state painter in the later stages of his
career appears an ambiguous measure of his success,
marking a limit to his artistic reputation beyond the
city. The climactic place of the *Paradise* in
Tintoretto's career appears as a kind of throwback to
an earlier age. But the central role he accorded to
such commissions was, in part, a consequence of his
continuing lack of opportunity beyond the boundaries
of the republic. By 1540, Titian's dominance as
Venetian painter to the aristocratic houses of Europe
was already unassailable. It comes as little surprise to
find that Tintoretto is not known to have received any
commissions from foreign courtly patrons prior to

Titian's death in 1576. This, though, was not for want of trying. In 1562, he sent a small battle painting (now lost) to the regent at the Mantuan court, Cardinal Ercole Gonzaga, and expressed his hope in a covering letter that his 'piccolo dono' (probably presented to the regent by the painter's brother, Domenico, who had emigrated to the city in 1553) would result in a commission (Appendix 1, no. 12). Ercole died in the following year, but it may have been Titian's continuing influence over artistic affairs at Mantua (he was still working for the court in the early 1560s) which meant that Tintoretto had to wait so long for his self-promotional gambit to bare fruit. Within a few years of Titian's death, however, Tintoretto was commissioned by Ercole's nephew, Duke Guglielmo Gonzaga (reigned 1578–87), to paint eight large battle paintings for the Mantuan Ducal Palace (illus. 117).[50]

Employment at the courts had effectively transformed Titian's career, offering ever more lucrative and flexible working conditions, and new scope for artistic experimentation. Tintoretto's Mantuan commission, on the other hand, provided no comparable springboard. Guglielmo's choice of Tintoretto was pragmatic rather than aesthetic: through his Venetian representative, Paolo Moro, the duke had undoubtedly got wind of Tintoretto's works for the state, particularly the large patriotic painting showing the *Battle of Lepanto* recently donated to Ducal Palace. The painter could be expected to produce similarly effective scenes celebrating famous Mantuan victories, and to do so under the same rigorous conditions of rapid production and low cost. Indeed, the documents tell us that Tintoretto was paid little more for each of his Mantuan paintings than he had received for a set of political allegories for the Venetian Ducal Palace,

despite the fact that the Venetian paintings were considerably smaller and contained fewer figures (Appendix 1, nos. 27, 29, see illus. 203, 204).

Each stage in the production of the Mantuan paintings was carefully monitored by the patron and his representatives. While King Philip II increasingly left the subjects and pictorial realization of his paintings to Titian, Duke Guglielmo made sure that Tintoretto followed a very precise iconographic programme. The exchange of letters between Moro and the Mantuan court in the autumn of 1579 tells us, indeed, that the usually pliant Tintoretto was dissatisfied with the stringency of the working conditions his new patrons imposed, objecting in particular to the demand that the final four paintings should be completed within three months. With the aid of his workshop, however, he finished the set of large and complex paintings by May 1580, just eight months after being commissioned. The importance Tintoretto accorded to the so-called *fasti* is indicated both by the unusually large number of preparatory studies that he made for the paintings and by his subsequent visit to Mantua in the following September to retouch and oversee installation. In the course of his visit (the first occasion on which Tintoretto is recorded away from his native city), he made a

118 Jacopo Tintoretto, *Battle of Argenta (1482)*, 1579/82, oil on canvas, 424 × 568.
Palazzo Ducale, Venice (ceiling of the Sala del Maggior Consiglio).

119 Paolo Veronese, *Annunciation*, 1583, oil on canvas, 440 × 188.
Nuevos Museos, El Escorial.

concerted effort to win a more permanent position at the court, offering himself as a suitable replacement for the local artist, Hippolito Andreasi, who was then away in Rome. The attempt at usurpation failed, for although Tintoretto apparently managed to maintain contact with the Mantuan court into the 1590s, no further large-scale commissions were forthcoming.[51]

Tintoretto's style in the paintings he made for foreign courtly clients in the decade following Titian's death was largely determined by the various manners he had already developed in the Venetian context. This derivative quality was perhaps inevitable, given that his patronage in this domain followed more than three decades of painting for Venetian clients. This necessarily contrasts with the experience of Titian and, to a lesser extent, Veronese, who gained access to such patrons at a relatively early point in their careers and were thus in a position to evolve a new approach to painting specially suited to the courts. At Mantua the replication of Tintoretto's Venetian manner was probably a requirement of his patron: thus Guglielmo's pictures are very similar in style to the battle pictures Tintoretto produced for the Sala del Maggior Consiglio (illus. 118).[52]

The only surviving Tintoretto painting commissioned by King Philip II is the altarpiece showing the *Adoration of the Shepherds* (Appendix 1, no. 31, illus. 85, see p. 100), sent to Spain in 1583 along with Veronese's *Annunciation* (illus. 119).[53] The style of this painting, too, is merely adapted from his contemporary Venetian manner, this time drawing on a recent composition from the Scuola di San Rocco (see illus. 172). In Philip's painting, however, significant modification to the naturalistic treatment of the Venetian painting is evident. The addition of a prominent heavenly stratum, populated by substantial cherubim and seraphim who encircle a more explicitly cross-like structure of beams, was only in part determined by the unusual verticality of the picture format. It also served to give a new emphasis to the upper area in the altarpiece, a reorientation which is further secured by the omission of the reaching shepherd who links lower and upper tiers in the San Rocco picture and the newly prominent Christ child, who now looks directly out at the spectator. Such modifications

were undoubtedly intended to aid the transformation from narrative to altarpiece, but the heightened iconic quality of the Madrid painting might also represent a response to Philip's well-known preference for explicit and grandiose religiosity in sacred art. Despite Tintoretto's attempt to accommodate this taste in the *Nativity*, it was Veronese who caught the required tone better. For if Tintoretto struggles to suppress the humble naturalism of his San Rocco prototype, Veronese's *Annunciation* is characterized by a more certain classicizing rhetoric, employing grandiose architecture and stately figures in a composition which pointedly recalls the work of Titian himself. The reference to Philip's erstwhile favourite was immediately recognized at the Spanish court: the art connoisseur Pere Sigüenza appreciated Tintoretto's painting, but reserved his greatest accolade for Veronese, whose painting he saw as 'seguidor de la maniera y camino de Tiziano'. Two years later, in 1585, Veronese was offered the huge sum of 9,000 ducats to come and work at the Spanish court.54

Perhaps Tintoretto's most successful modification of his Venetian style for a courtly client can be found in the mutilated painting showing the *Origin of the Milky Way* (illus. 120), one of four scenes from the Life of Hercules which were sent to the Holy Roman Emperor Rudolf II shortly after Titian's death.55 The learned subject-matter is, of course, derived from classical texts, although its more immediate source was a Byzantine botanical textbook, the *Geoponica* (1542), recently published in an Italian translation in Venice (1549). We are shown Jupiter, king of the gods, placing his illegitimate son, the infant Hercules, on the breast of his sleeping wife, Juno, in order to give him immortality. Awoken by his vigorous sucking, Juno

draws suddenly away, the milk from her breasts shooting upwards to form the Milky Way and downwards to earth to give rise to lilies. The esoteric subject was well suited to Rudolf's tastes: it defers to his knowledge of the classical world, while making particular reference to his specifically scientific interests in astrology and botany. The proliferation of identifying symbols (the eagle with the crab-like device for Jupiter and the peacocks for Juno; the winged cupids carrying bows, arrows, blindfold, torch and net emphasizing the underlying theme of love and deceit) also supports the appeal to the patron's classical learning. But, of course, Tintoretto's image has an erotic appeal: the reclining female nude (representing earth) who once reclined along the bottom of the painting would have further supported the careful attention given to the porcelain flesh of the writhing Juno, whose spurting milk simultaneously fertilizes heaven and earth.

The subject-matter of the painting is supported by Tintoretto's technical and formal approach. Immediately noticeable are the range and quality of the pigments used: the composition is built up from a carefully variegated palette which moves from intense blue to grey in the sky, and from white and gold through to orange, pink and scarlet in the draperies. The expensive ultramarine blues, in particular, seem intentionally to recall the visual *richezza* of Titian's earlier paintings for courtly patrons. The opaque density of the pigments concentrates attention on the quality of the surfaces represented, which are richly textured, patterned and jewel-bedecked. The opacity of the paint also has the effect of keeping the eye focused on the complexities of the surface design, given that it suppresses Tintoretto's more usual relief-creating chiaroscuro. Thus while the centrifugal composition constantly

120 Jacopo Tintoretto, *Origin of the Milky Way*, *c.* 1577/80,
oil on canvas, 148 × 165.1.
National Gallery, London.

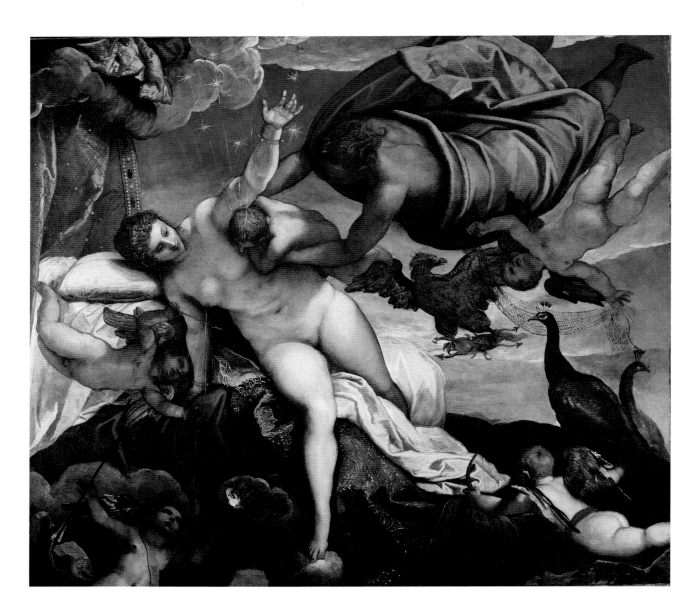

implies free movement, the three-dimensional reality
of form is never apparent, all sudden motions
appearing as if frozen in time and space. In this
sense, the *Milky Way* owes less to Titian's naturalism
than it does to the highly wrought artificiality of late
Mannerist painting favoured at Rudolf's court.[56]

All this would appear to make the work an
exception within Tintoretto's oeuvre, its polished
formalism a sharp contrast to the kind of technical
restraint developed in certain of his contemporary
Venetian works (see illus. 176, 177). Rudolf's painting
is not, however, a totally isolated example. Recent
cleaning of the altarpiece showing the *Temptation of
St Antony* (illus. 121), made for the private chapel of

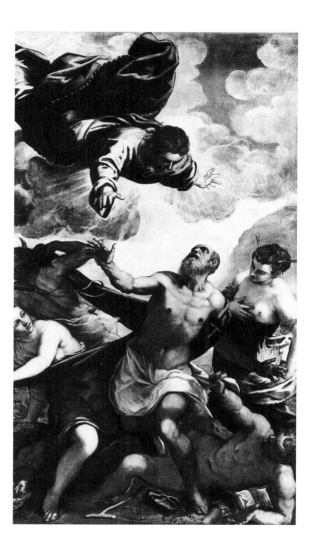

121 Jacopo Tintoretto, *Temptation of St Antony*, c. 1577/8,
oil on canvas, 282 × 165.
San Trovaso, Venice.

the *cittadino* secretary Antonio Milledonne around
1577, has revealed a similarly rich pigmentation and
high degree of finish. In this work, the chosen theme
might make a personalizing reference to Antonio's
recent failure to win high office as Venetian Grand
Chancellor, but is also suitable for a patron who had
played an important role at the Council of Trent.
Despite the moralizing content, however, the
luxuriant handling of the painting reflects the impact
of Tintoretto's secular work for Prague, an overlap
which indicates the spread of courtly tastes through
the ranks of the city's patricians and citizens. The
Origin of the Milky Way may even have originated as
a commission from a foreign patron living in Venice,
the eccentric academic and physician Tommaso
Rangone, who had the subject engraved on the
reverse side of his personal medal cast in 1562.
The idea that Tintoretto's painting was sent to the
Emperor only following Tommaso's death in 1577 is
in need of further corroborative evidence. And yet
Tommaso's individualism in the context of Venetian
artistic patronage (which had already landed him in
trouble with both state and scuola), like his previous
patronage of Tintoretto, does make the possibility an
intriguing one. Tintoretto's creative association with
such a maverick patron in Venice, to which we must
now turn, once again sets a limit on a reading of the
painter's career as simply expressing Venetian
corporate values.[57]

Scuole Patronage

The career of Tommaso Rangone epitomizes the
ambition for an elevated cultural identity in sixteenth-
century Venice. As an art patron whose lavish
benefactions were characterized more by the
conspicuous expenditure of the European courts than
by the careful moderation of the Venetian Republic,
Tommaso's career shadows that of the *papalisti* circle
within the patriciate. Perhaps just because of his lack
of a fixed position within the closed social hierarchy
in Venice, Tommaso was able to push his self-
aggrandizing further than the most determined of
Venetian patricians. If *papalisti* such as Gritti and the
Grimani still felt compelled to keep their *all' antica*
decorations out of the public eye (conforming to more
traditional expectations in the façade designs of their

new palazzi), Tommaso admitted of no such constraints, his career as an art patron being dominated by repeated attempts to have his own image erected on buildings fronting significant public spaces. Born in Ravenna in 1493, Tommaso was an outsider to the corporate ethos of Venice from the start. Like a good number of other prominent arrivistes in Venetian artistic circles, he changed his name, first to Filologo di Ravenna and then (in the 1560s) to Rangone, here adopting the surname of an earlier aristocratic patron in Modena. Although his low-born family – the Giannotti – bitterly complained, Tommaso's attention to his nomenclature was wholly in keeping with the rapid transformation in his economic position and social identity. At Venice, he won renown as an academic learned in languages and astrology, as a doctor to the Venetian fleet and as an adviser to the state on sanitation. But his courtly credentials were equally impressive: in 1572 he was knighted (like Titian before him) as Count Palatine of the Holy Roman Empire by Maximilian II. Maximilian was the father of Tintoretto's patron in Prague, Rudolf II. Even if Tommaso did not commission the *Origin of the Milky Way* from Tintoretto, it is very likely that he (rather than Jacopo Strada or his son) played an important intermediary role, bringing his own favoured Venetian painter to the attention of the imperial court.[58]

The amusing story of Tommaso's disputes with the Venetian authorities over his insistent desire to have his image portrayed on the façades of public buildings has often been told. Most famous is his attempt, in 1552, to have a personal monument erected on the façade of San Geminiano, a church which fronted the west end of St Mark's Square. In this case, the state's objection was undoubtedly determined by the especial sensitivity of the site.

Tommaso's subsequent success in getting his own visage erected in prominent public places provides a measure of both the extent of his personal influence and the weakness of the traditionalists within the patriciate at mid-century. In the late 1550s, Tommaso managed to have a monument to himself erected on the church of San Giuliano fronting the Merceria, the main mercantile street of Venice (illus. 122). By 1562 he had become *guardian grande* of a very prominent lay confraternity, the Scuola Grande di San Marco. In June of that year, Tommaso single-handedly refloated the commission for a cycle of large narrative paintings to hang in the main room of the Scuola's Meeting House (Sala Capitolare). In a typically flamboyant gesture which flouted orthodox corporate practice in the Scuola, Tommaso made himself wholly responsible for the financing of the project, and probably also for the subject programme and choice of artist. Suspicions about his unilateral approach had, however, apparently already surfaced by the autumn, when the familiar demand to have a statue of himself erected on the façade of the Meeting House was quashed by the ruling board (*banca*).[59]

As an art patron in Venice, Tommaso shared the classicizing tastes of the pro-Roman faction within the patriciate, even if he did not share their social position. It is no accident that Tommaso (following the lead of Andrea Gritti and his associates) backed the architectural and sculptural projects of Jacopo Sansovino and his young protégé Alessandro Vittoria in the 1550s and 1560s. These artists were also friends to Tintoretto, who shared certain of their aesthetic interests, such as a penchant for striking architectural perspective vistas and a sculptural approach to form. In two of the three paintings Tintoretto went on to make for Tommaso,

122 Jacopo Sansovino/Alessandro Vittoria, *Monument to Tommaso Rangone*, c. 1557/60, life-sized bronze. San Giuliano, Venice.

architectural perspectives are very evident, while formal relief (*rilievo*) is emphasized by a sequence of theatrical foreshortenings (illus. 123, 124).

If this aesthetic taste played a role in determining Tommaso's choice of Tintoretto in June 1562, he would also have been influenced by the fact that the painter's famous *Miracle of the Slave* (see illus. 48) already adorned the wall facing the altar in the Sala Capitolare of the Meeting House. In this painting, Tintoretto paid homage not only to Sansovino's sculpture but also to his architecture, basing the portico at the left on the monumental architecture of the Loggetta. The dark-haired figure peering out from among the columns may even be a portrait of Sansovino himself, his position indicating his responsibility for the building. But if these references to Tommaso's favourite helped to secure Tintoretto's further employment in the Sala Capitolare in 1562, his resumption of the decoration was by no means a foregone conclusion. Tommaso's taste was apparently not shared by others among the Scuola *fratelli*, given that the *Miracle of the Slave* was initially returned to the painter as unsatisfactory. Boschini specifically blamed the 'ignorante' *guardian grande* of the day (now established as Stefano Bontempo); but the controversy over Tintoretto's

painting may have had more deep-seated causes relating to the Scuola's special position within Venetian culture.[60]

The Scuola di San Marco was the largest, most wealthy and prestigious of the city's 200 or so lay religious confraternities. As one of only six Scuole Grandi ('Large Schools'), its particular social prominence was assured; but like the many lesser Venetian confraternities, San Marco was dominated by non-nobles, mostly (although not exclusively) from the ranks of the citizen class. Like all other Venetian confraternities too, San Marco was actively supported by the state. The ruling caste certainly understood and exploited the political value of institutions which offered a safety valve for the frustrated political ambitions of often wealthy subjects arbitrarily locked out political power by the *serrata* of 1296. The devotion of the brothers at San Marco to the patron saint of the Serenissima guaranteed a particularly intense loyalty to the ideology of the state, and the Scuola had demonstrated this time and again in its dispensation of artistic commissions. In the Renaissance period, only those architects, sculptors and painters tried and tested by the state were given commissions, and this proceeding made the choice of Tintoretto in 1548 particularly controversial. At this point, the painter had not yet worked for the state and therefore lacked a clear sanction from official culture. His sudden employment early in 1548 may have owed more to the presence of friends and relatives on the *banca* than to the wider will of the confraternity. Andrea Calmo joined the Scuola as early as 1534 and was on the *banca* in 1542, when the decision to commission paintings for the Sala Capitolare was made. In addition, Tintoretto's future father-in-law, Marco Episcopi, held a leading

123 Jacopo Tintoretto, *Removal of the Body of St Mark*,
1562/6, oil on canvas, 398 × 315 (fragment).
Gallerie dell'Accademia, Venice.

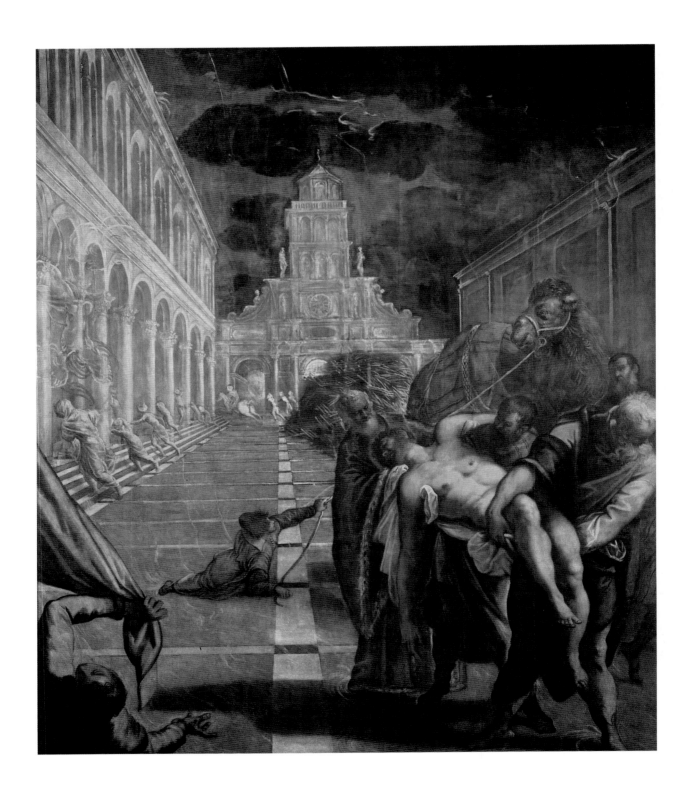

124 Jacopo Tintoretto, *Finding of the Body of St Mark*,
1562/6, oil on canvas, 405 × 405.
Pinacoteca di Brera, Milan.

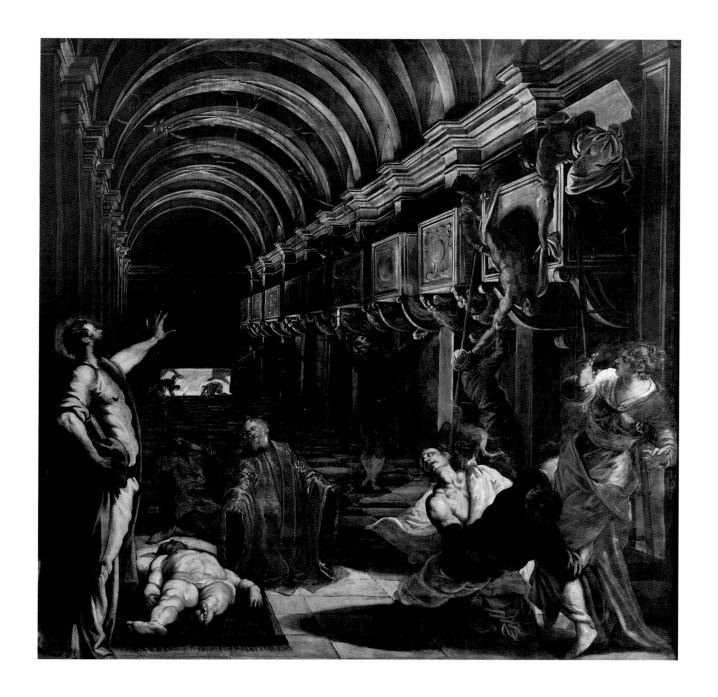

office (*guardian da matin*) in 1547. The *Miracle* was soon accepted by the Scuola, but the subsequent delay in further commissions may reflect lingering suspicions over Tintoretto's suitability. Unlike most other painters commissioned by the Scuola, Tintoretto was not admitted to the confraternity, and it is likely that his further employment was due largely to the individualist intervention of Tommaso Rangone in 1562, whose artistic taste owed decidedly little to the patriotic and corporate mentality prevalent at San Marco.[61]

Tommaso's patronage of Tintoretto was destined to generate more controversy. The paintings he commissioned were certainly traditional enough in subject-matter. Drawing primarily on Jacopo Voragine's popular *Legenda aurea* (1255–66, printed in Venice in 1475), Tintoretto's paintings illustrated three miraculous interventions from the afterlife of St Mark. These scenes would have been well known to his contemporaries, both from widely read literary texts, and from the concentration of Marcian imagery in the Basilica of St Mark's itself. Tintoretto's new paintings extended the earlier cycle by the Bellini, Mansueti, Palma Vecchio and Paris Bordone in the Scuola boardroom (*albergo*) which showed scenes from the saint's life along with two miracles performed after his death. In the *Removal of the Body of St Mark* (illus. 123) we are shown the moment shortly after the saint's martyrdom in first-century Alexandria, when a God-inspired storm intervened to allow a group of Christians to lay claim to the body and secure its proper burial. In the complementary *Finding of the Body of St Mark* (illus. 124) we witness the retrieval of the body from the Alexandrian catacombs some 800 years later by a group of Venetian merchants. Their search is halted by the miraculous intervention of the saint

himself at the left. Taken together, the two paintings establish a direct link between early Church history and the subsequent, divinely directed Venetian guardianship of the relics of St Mark.

So much would have supported only the brothers' sense of cultural identity: the suggestion of a divine hand linking the present with the time of Christ through the agency of St Mark's relics would have done little to upset their devotional and patriotic fervour. On a formal level, they would also have been able to accept Tintoretto's classicizing decision to place the main figures in front of the supporting architecture (a pointed departure from the earlier works by Mansueti and Bordone in the *albergo*). They might even have been able to appreciate the symbolic import of the dissociation of the Christian group from its spatial and architectural ambience in the *Removal*. The group are strongly lit and shown in a bold diagonal foreshortening in a forward plane, giving the impression that they will progress directly out of the picture into the world of the viewer. In contrast, pagan Alexandria is in a state of physical dissolution, its spatial unreality, like the ghostly forms of its fleeing inhabitants, aptly expressing its moral disintegration. The disjunction, supported by the widely varying degree of finish given to Alexandrian context and Christian protagonists, thus clearly marks their difference in spiritual status.[62]

But in this painting, as in the *Finding*, Tintoretto's expression of the devotional/patriotic ideology upheld with such intensity by the Scuola goes only so far. For in both works, the personal programme of his patron intervenes, even threatening to occlude the viewer's understanding of the given narrative. It had long been traditional to include portraits of the ruling members of the

commissioning institutions in Scuola narrative paintings. But these were typically multiple portraits and, at least in the *albergo* paintings at San Marco, they take up discreet positions towards the margins of the picture space, providing a supporting cast for the narrative. In Tintoretto's paintings, Tommaso is the only brother who is shown, and in both cases he is dramatically engaged in the unfolding of events. This privilege is partially to be explained by the fact that Tommaso alone funded the paintings. But the prominence of his position within each composition also suggests that he saw Tintoretto's paintings as another opportunity to promote his own image. In both works, Tommaso's head is placed at the apex of a formal pyramid towards the front of the painting and near to the vanishing point of the architectural perspective. In this sense, the patron's image threatens to displace that of the saintly protagonist, challenging his visual primacy. A special association between St Mark and Tommaso is, though, suggested in other ways. In the *Finding*, it is only Tommaso (together with the newly healed possessed man to the right) who recognizes the visionary appearance of the saint, while in the *Removal*, Tommaso's head is placed very close to Mark's as if to assert the intimacy of the two. Indeed, the image of the saint being carried off for burial can readily be associated with that of Christ himself following the Crucifixion. In scenes depicting this moment, it is usually Joseph of Arimathea who is shown carrying Christ's shoulders. That this typology was in Tintoretto's mind is strongly suggested by the formal connection of St Mark's body with that of Christ, and Tommaso with that of Joseph, in the near-contemporary *Deposition* painted for the church of the Umiltà (illus. 125). The connection allowed the artist to offer a further compliment to his

patron: not only is Tommaso pictured as the especial follower and guardian of the terrestrial remains of St Mark, he is also a latter-day Joseph of Arimathea, a generous friend of Christ.[63]

Tommaso Rangone undoubtedly saw his paintings at San Marco as a kind of painted compensation. His request to erect a sculptural portrait fronting a piazza had, after all, been turned down at San Geminiano, and it has been noted that the spectral arcade and church in the *Removal* insistently recall the west end of St Mark's Square, site of this initial rebuff. Certain details of Tintoretto's church (such as the perspective arch to the left of the main entrance) also recall the façade of the Scuola di San Marco, where Tommaso's most recent attempt to have a portrait erected had been denied. In his painting, the prohibitions of state and Scuola were readily undone, as Tintoretto carefully placed Tommaso's head against the painted façade of the church. It would seem that the surrogate nature of this arrangement was soon recognized by the Scuola. In 1568, Tommaso attempted to commission a further painting from Tintoretto for the Scuola. But the painting was never delivered and just a few years later Tommaso was in bitter dispute with the confraternity, finally severing all ties with the institution. In a rerun of the controversy of 1548, the Scuola returned Tintoretto's paintings in the summer of 1573, instructing him to 'finish them perfectly excepting the figure of Ravenna, putting something more fitting in his place'. It is not known why the required erasures were not made, although Tintoretto might fairly have pleaded that the removal of Tommaso would entirely undo the pictorial logic of the paintings.[64]

The San Marco commission of 1562 may have appeared to many contemporaries as a conspiracy

125 Jacopo Tintoretto, *Deposition of Christ from the Cross*,
c. 1560, oil on canvas, 227 × 294.
Gallerie dell'Accademia, Venice.

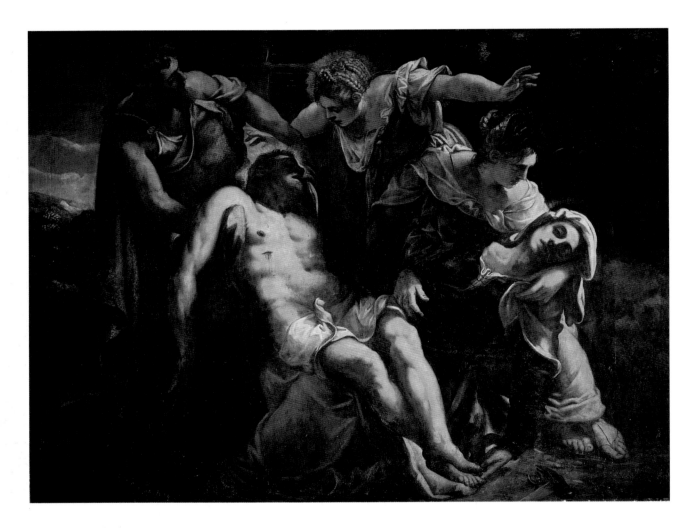

of outsiders. Tommaso's preference for the
controversial Tintoretto, who had so shocked the
Scuola in 1548 and had since been criticized by
leading art connoisseurs, suggests his identification
with the painter's more maverick tendencies.
On the other hand, Tintoretto's brilliant fulfilment
of Tommaso's plan to use his paintings as a vehicle
for self-advertisement indicates a matching
sympathy and understanding. Tintoretto had, after
all, used paintings in a similar fashion on other
occasions (for example, when he exhibited the lost

Self-Portrait with a Relief on the Merceria). Both
patron and painter were very successful but had to
struggle for final recognition, Tommaso because he
was a foreigner who remained forever excluded from
the Libro d'Oro (the book recording all patrician
births) and Tintoretto because of the hostility of
Titian and his circle, and his consequent lack of
personalized contact with leading members of the
Venetian and foreign nobilities. Both embarked on
aggressive campaigns of self-promotion in
compensation and, as a consequence, shared

ambivalent and unstable relations with the Venetian institutions they served.[65]

Tintoretto's controversial status at the Scuola di San Marco indicates that it would be an over-simplification to cast the painter merely as a faithful servant of the non-noble culture of the Venetian confraternities, as (in David Rosand's words) 'the voice of the Venetian Scuole and the society they represent'.[66] As we shall see, Tintoretto's employment at the Scuola di San Rocco in 1564 was also marked by controversy. But his problematic relations with the city's leading Scuole Grandi needs to be seen in the context of his almost continual employment by the city's smaller Scuole, among whom he was certainly a favoured painter. It was, after all, on the back of a succession of commissions from these lesser patrons that Tintoretto first rose to prominence in the late 1540s. Before 1548, he worked on at least three occasions for the small Scuole attached to the Venetian trade-guilds (those of the tailors, fishmongers and glass-blowers), and also for the parish-based Scuola del Sacramento at San Marcuola (see illus. 20). In the normative pattern, patrician commissions precede (and thereby sanction) those from less prestigious patrons. In Tintoretto's case the progression was reversed, his appeal to the 'ordinary' Venetian patron being first recognized and taken up by the most 'ordinary'.

Commissions from Venetian Scuole of all types were subsequently to bulk large in Tintoretto's patronage, at least in comparison with other leading painters of the day (he is known to have worked for as many as 27 different Venetian confraternities in the course of his career). He was still fulfilling commissions from the Scuole dell' Arte and Scuole del Sacramento in the 1580s, the extent of his work for both types of patron contrasting with that of other major Venetian painters (Titian painted just once for the Scuole dell' Arte, while Veronese's two commissions were from the most wealthy of the guilds). The trade Scuole typically commissioned lesser painters (whose lower prices they could afford) to decorate their church altars using ultra-orthodox styles. Although Tintoretto sometimes modified his manner when working for such lowly patrons (for example, in the *Adoration of the Cross* of 1584), in others, such as the *Baptism of Christ* commissioned by the Scuola dei Peateri (bargemen), his style and technique are progressive (illus. 126). The San Silvestro painting is, indeed, a fine example of Tintoretto's dramatic late style, and is characterized by the combination of figural dynamism (replete with a reference to the *Apollo Belvedere* in the figure of Christ), abbreviating chiaroscuro and bravura brushwork that is characteristic of his contemporary work for his higher-ranking patrons at the Scuola di San Rocco.[67]

Tintoretto is known to have worked for the Scuole del Sacramento on as many as nine occasions (although the true figure is probably much higher again), an area of patronage which guaranteed the presence of his paintings in many of the city's parish churches. Following the foundation of model confraternities of this type elsewhere in Italy in the late fifteenth century by leading religious figures such as Gaetano Thiene, the first Venetian example was formed in 1502. During the course of the sixteenth century, the new type of Scuola spread rapidly across the city. Initially, at least, these confraternities can be taken to reflect active piety at parish level. But they always enjoyed the full backing of the Church authorities, and in the post-Tridentine period they featured as an important

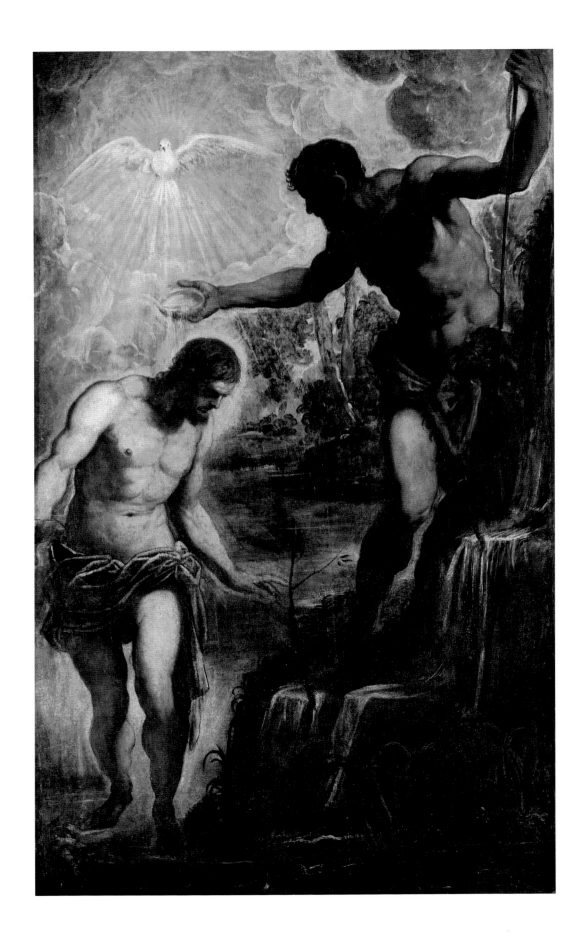

vehicle for the promotion of orthodox Counter-Reformation values. With their explicit focus on the significance of the Reserved sacrament, they necessarily reinforced the traditional teachings of the Catholic Church on the Mass (Francesco Sansovino described them as in 'the sole care of the altar of the Body of Our Lord').[68]

The social profile of these confraternities may have differed from that of other Venetian Scuole precisely in its unusual mix or reach. Unlike other types of Scuole, they were specifically attached to their local parish, a factor which undoubtedly helped to secure the participation of a representative cross-section of the lay community in each area. Although women could not hold office (probably for liturgical reasons), they were regularly admitted and membership could also be used as a proof of orthodoxy by outsiders and those suspected of heresy. The Scuole particularly attracted individuals with something to prove, such the bookseller Vincenzo Valgrisi (who had been accused by the Sacred Office of selling prohibited books) and the merchant Gaspar Ribeiro (a Portuguese Jew converted to Christianity). According to Alessandro Caravia, writing in 1543, the Scuole del Sacramento had a much lower social profile than the city's six Scuole Grandi, and recent research has tended to confirm his point. While the majority of guardians appointed by the Scuole Grandi during the sixteenth century were government secretaries, landowners and rentiers, the equivalent posts in the Scuole del Sacramento were more usually filled by small merchants, shopkeepers and artisans. When, for example, Tintoretto was commissioned to paint two narrative paintings at San Cassiano in 1568 (see illus. 141), the guardian was Cristoforo de' Gozi 'marchadante da inchodoani' (probably a rope

merchant). In like manner, the set of paintings he made for the Scuola bench (*banco*) in the nave of Santa Margherita in 1576 (see illus. 183) were paid for by one Negrin de Zuane, a 'marchadante da lana' (wool merchant).[69]

Tintoretto's commissions from these patrons continued into the later phase of his career (the latest recorded is at San Moisè dating from around 1585), another indication of his careful maintenance of the broad social base to his patronage. Again, his lasting involvement with such relatively minor patrons contrasts with that of other leading painters, who rarely worked for the Scuole del Sacramento, and when they did usually left the work to their workshops. Tintoretto, as we saw have seen, painted some of his most innovative religious paintings for these patrons, including six versions of the *Last Supper* (see illus. 20, 59, 183) four of *Christ Washing His Disciples' Feet* (see illus. 67), all in the new *laterali* format, along with a number of other very important narrative paintings and altarpieces (see illus. 131, 140, 141) typically with Christocentric themes.[70] Just as the sacramental iconography of these paintings reflects the main devotional focus of the Scuole, so the humble settings and actors which Tintoretto often introduced were a calculated response to the social range of their membership. These paintings also possess an intensity of religious feeling which was unmatched in Tintoretto's works for other patrons. It was only in the extensive cycles of narrative paintings for the Scuola Grande di San Rocco that the painter managed to capture an equivalent atmosphere of impassioned spiritual commitment. And in order to re-create this quality, he often turned to compositional prototypes developed in the humble context of the Venetian parish church.

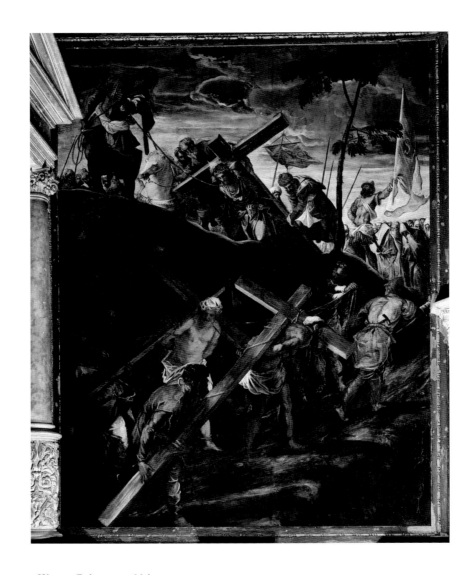

127 Jacopo Tintoretto, *Way to Calvary*, 1566/7,
oil on canvas, 515 × 390.
Scuola Grande di San Rocco, Venice (Sala dell'Albergo).

128 (opposite) The Scuola Grande di San Rocco,
exterior view from the Campo dei Frari.

CHAPTER FOUR
Tintoretto at San Rocco I: 1564–7

The Meeting House

In 1517, the year of the cessation of the Venetian war against the league of Cambrai, the architect Bartolomeo Bon was commissioned to build a new confraternity Meeting House near to the famous Franciscan church of Santa Maria Gloriosa dei Frari in Venice (illus. 128). His patrons were the brothers of the Scuola di San Rocco, the most recently constituted of the Scuole Grandi of Venice, formed in 1478 and dedicated to the plague-saint from Montpellier whose remains were brought to the city in the 1480s. But in 1525, having proceeded only as far as the ground-floor entablature, Bartolomeo was dismissed for following his own (rather than his patrons') designs. His successor, Sante Lombardo (son of the better-known Tullio), was soon locked into a similar conflict with the Scuola, ending his employment by mutual consent three years later and leaving only the richly decorated rear façade of the building as a testament to his activity (illus. 129). It was only after 1528, when Antonio Abbondi (known as Scarpagnino) was appointed, that the building moved more steadily towards completion; it was substantially finished by the time of Scarpagnino's death in 1549.[1]

The piecemeal progress of the commission was not untypical of the artistic patronage of the Renaissance Scuole Grandi, institutions in which the annual rotation of offices always threatened to undermine the smooth progression of a large-scale project. The distorting effects of such vicissitudes (exacerbated as they were by internal factions and by constant rivalry with other Scuole) were clearly apparent to many contemporaries. The scathing irony of Alessandro Caravia in his poem *Il sogno di Caravia* (1541) undoubtedly expresses a wider unease at the progress of events at San Rocco among the Venetian populace:

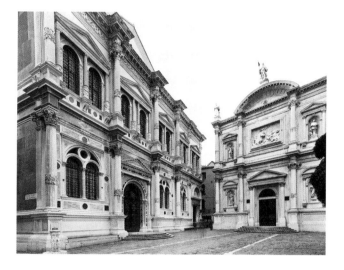

They are part of the saint of the plague
and have done such good works at the arrogant Scuola
Foliage, Harpies, and so many beautiful heads
Columns carved in the newest manner
So as to prove every one a Master

A little further on, the morality underpinning Caravia's sarcasm is revealed:

They have spent *80,000* ducats when *6,000* would have been enough
The rest, which was spent in vain
Could have been spent for the bare foot and naked who cry 'alas'

Caravia here exaggerated the brothers' spending on the Meeting House, but a surviving document reveals that between 1516 and 1564 – the year in which Tintoretto was commissioned to decorate the *albergo* – the Scuola did spend as much as 47,000 ducats on their new building. As Caravia pointed out, such massive expenditure seemed to contradict the founding statute of the institution which had

149

committed the new Scuola above all else to the charitable relief of the poor and sick.[2]

Caravia's criticism of San Rocco formed part of his wider attack on the worldly pride and vanity of the city's other Scuole Grandi, which he saw as having betrayed their origins as humble penitential institutions. Recent research has largely corroborated Caravia's perceptions: with their enormous wealth and social prestige, the Scuole Grandi were, by the sixteenth century, very unlike the democratic and levelling institutions they had started out as in the later Middle Ages. Their growing penchant for spectacular processions and lavish Meeting Houses, often sumptuously decorated with crowded and brightly coloured narrative paintings, indicates that the Scuole Grandi had become greatly concerned with displays of material magnificence. Internally, they were increasingly divided, with separate orders of rich and poor brothers being established (in 1591 at San Rocco) instead of the single commonality of earlier times. This development was wholly consistent with the rotation of leading offices within them between a limited number of leading *cittadini originarii* families. As a result, the culture of the Scuole Grandi, although non-noble, tended more and more to passively replicate that of the oligarchic patriciate. The élitism of its leading figures came in for particular criticism from Caravia, who dramatized the haughty response of a Scuola Grande brother asked to be a guardian in a parish Scuola del Sacramento: he would 'at once refuse the job, showing his discontent and saying "What have I done to deserve this? I've got my eyes on something better. Go and get a smith or a cobbler, not a good citizen like me."'[3]

Given the subservience of the Scuole Grandi to the Venetian patriciate, it may seem odd to find that Caravia's criticism of the Scuola di San Rocco was fully endorsed by the state itself. A decree of the Council of Ten from 1543 directly echoes Caravia's words, roundly condemning the 'superfluous expenditure in the Scuole Grandi ... on elaborate devices and banquets ... money which ought to go in alms to the poor'.[4] In fact, the state regularly condemned excessive ostentation, attempting to control expenditure through its own Magistrato alle Pompe and by the sumptuary laws it issued. While the Venetian Republic might never have been afflicted by an 'embarrassment of riches' equivalent to that evident in Dutch culture in the following century, widespread concern over the ethics of expenditure was certainly apparent.

This concern had initially been raised by the near-disaster of the Cambrai Wars which was blamed by some commentators on the material luxury and moral laxity of the patriciate. In the late 1520s, during a particularly severe crisis caused by the plague and by food shortages, the concern surfaced again, this time focused on the threat to social order posed by the hordes of poor and sick who filled the city streets and squares. In the following decades, the issue gained a further spiritual dimension due to the spread of ideas of religious reform through Venice. Caravia's reductive opposition of artistic and charitable expenditures is shot through with a sharp reformist morality, and his Protestant sympathies are barely concealed in other passages in *Il sogno*. As a pro-Lutheran, Caravia was, perhaps, a marginal figure in Venetian society, but in his attack on the Scuole Grandi he nonetheless gave expression to an issue of central significance to the city's culture.[5]

The ostentatious and eclectic style of the San

Rocco Meeting House is in many ways typical of the architecture of the Renaissance Scuole Grandi (illus. 128). Features such as the three-aisled Sala Terrena or ground-floor room (see illus. 192) and the biforate (two-light) windows were, indeed, based directly on the recent alterations to the Meeting Houses of the Scuola di San Marco (Sala Capitolare) and Scuola di San Giovanni Evangelista. But if Bartolomeo Bon started with the intention of emulating features in extant Scuole Grandi buildings (and was particularly influenced by Mauro Codussi in this regard), his successors certainly sought to take the new Meeting House beyond its predecessors in the direction of the new triumphal

Romanism favoured in the patrician architecture of the *renovatio urbis*. Caravia, we recall, heaped scorn on the 'Columns carved in the newest manner', and later made the Scuola's use of this particular feature symbolize its abandonment of the poor:

The investments in the poor are botched
In order to build, but not out of devotion
Columns that jut into the piazza

The reference here is to Scarpagnino's superimposition of two orders of freestanding Corinthian columns on to Bartolomeo's original 'simple' façade. When Caravia wrote, the Scuola's

decision to embellish the façade in this manner was a very recent one (1536), and was controversial given that Jacopo Sansovino's proposal for similar freestanding columns on the façade of the Scuola della Misericordia had been rejected shortly before. The addition effectively Romanized the building, given that free-standing columns before pilasters were a feature of ancient triumphal arches such as those of Septimius Severus and Constantine. The association with the new *all'antica* architecture commissioned by the Venetian patriciate in this period was equally apparent, the columns paralleling Sansovino's quotation from Roman triumphal arches in his Loggetta at the foot of the campanile in St Mark's Square.[6]

Caravia was equally fierce with regard to the 'Foliage, Harpies, and so many beautiful heads' littering the surface of the building. The proliferation of decorative details is, indeed, a striking feature of the façade, the 'foliage' on the column bases including grapevines, laurel leaves and other fruits. The vines were undoubtedly intended to symbolize the blood of Christ, while the laurel refers more specifically to the warding off of pestilence and thus to the function of the Scuola's patron saint, St Roch. But such features also supported the triumphalist associations of the columns themselves. While certain decorative motifs (such as the *griffes*) would certainly have fallen outside the purified classical vocabulary preferred by architectural theorists in the sixteenth century, they were certainly not intended to disrupt the overall impression of lavish classicizing display. Caravia, who was particularly shocked by Lombardo's rear façade (illus. 129), saw the Harpies featured there (showing the naked heads and breasts of women with birds' wings and claws) as a form of impious

profanity. In Christian imagery, Harpies symbolized the sin of avarice; by a neat inversion Caravia made them reflect the supposed greed of the Scuola brothers themselves. For him, such 'beautiful' details spoke only of vanity, outward embellishment reflecting inward corruption, *all'antica* triumphalism merely providing a cover for mortal sin.[7]

This kind of reformist thinking with regard to classicizing artistic form was destined to prove very significant for Tintoretto's subsequent pictorial decoration of the Meeting House between 1564 and 1588.[8] For, as if in answer to Caravia's castigation of the elaborate architecture of the Meeting House, the values of humility and poverty were made central to the conception of his paintings. In the process, Tintoretto broke not only with the elaborate processional typical of earlier narrative painting for the Scuole, but also with the more recent classicism of Venetian painting (to which he himself had certainly contributed in early works such as the *Miracle of the Slave*). The re-emphasis also had important technical implications. Before San Rocco, Tintoretto's loose brushwork was openly performative, moving decisively beyond Titian's mimetic *colorito* to insert the manipulative presence of the painter into the arena of the canvas. At San Rocco, Tintoretto's brushwork is, in many passages, more revealed than ever, but its signification is radically altered. Rather than functioning as a vehicle for aesthetic self-advertisement, Tintoretto's abbreviated *non-finito* comes to express a spiritual value. More widely, it was only in the great cycles for San Rocco that the painter's 'moderate' artistic persona was fully realized, his technical and formal means expressing an essential value of sacred poverty.

Winning the Commission

In the spring of 1564, as Vasari tells us, Tintoretto deliberately undermined the competition that the Scuola had organized in order to choose a painter for the *albergo* of their new Meeting House:

Having summoned Joseffo Salviati, Federico Zucchero ... Paolo Veronese, and Jacopo Tintoretto, they ordained that each of them should make a design [for the central ceiling panel], promising the work to him who should acquit himself best in this. While the others ... all possible diligence in making their designs, Tintoretto, having taken the measurements of the size that the work was to be, sketched a great canvas and painted it with his usual rapidity, without any one knowing about it, and then placed it where it was to stand. Whereupon, the men of the Scuola having assembled one morning to see the designs and to make their award, found that Tintoretto had completely finished the work and had placed it in position. At which, being angered against him, they said that they had called for designs and had not commissioned him to execute the work; but he answered them that this was his method of making designs, that he did not know how to proceed in any other manner, and that designs and models of works should always be after that fashion, so as to deceive no one, and that, finally, if they would not pay them for the work and for his labour, he would make them a present of it. And after these words, although he had many contradictions, he so contrived that the work is still in the same place.[9]

Vasari's story was undoubtedly elaborated to emphasize both Tintoretto's unscrupulous approach to obtaining major artistic commissions and his lack of diligence (*diligenzia*) in the provision of preparatory designs. But surviving documents from the Scuola do tend to support the bare bones of his account. The brothers did indeed call a competition 'between 3 or 4 of the most excellent painters in Venice' on 31 May 1564 which was annulled a month later on 29 June. By this time the Scuola had already accepted Tintoretto's donation of the central ceiling panel (on 22 June, see illus. 132).[10] Given this (at least partial) corroboration, there is no reason to doubt Vasari's word with regard to the artists invited to participate in the competition. These were (with the exception of Tintoretto) the painters most definitely associated with the *papalisti* circle of patrician patrons discussed in Chapter 3. Two of Tintoretto's rivals (Salviati and Zuccari) were central Italian, while, like them, Veronese, was neither born nor trained in Venice. All three had won recent and prestigious commissions (in both official and non-official contexts) from Romanist patrician families. The pre-selection for the competition indicates that (as in its architecture) the Scuola was initially keen to emulate the most fashionable tastes of its most progressive patrician superiors.

The name of Titian was missing only because he was no longer available, having effectively withdrawn from local commissions after 1560. Titian had, in fact, been the Scuola's first choice to paint the Meeting House. In 1552 he was admitted to the Scuola's *zonta* (an additional supervisory body to the ruling *banca*) even before beginning work on a painting for the *albergo*. This rapid promotion, we should note, contrasts with the brothers' lack of response to Tintoretto's own early request for admission after his completion of the *St Roch Healing the Plague-Stricken* for the confraternity church in 1549 (see illus. 185).[11] Titian's subsequent withdrawal from the San Rocco commission may have owed as much to finance as to old age: although

153

the documents remain silent, it is likely that his price was too high, even for the free-spending Scuola. But Titian's particular prestige at the time of the competition undoubtedly remained very high: his miracle-performing painting of *Christ Carrying the Cross* was in the Scuola church, and a further painting, showing the *Annunciation* (see illus. 194), bequeathed to the confraternity in 1555, now hung on the staircase landing at the Meeting House.[12] In 1564 Titian, we might aver, was still influential at the Scuola, where he would have backed the cause of Veronese, the young painter to whom he had recently awarded a prize for the best roundel at the Biblioteca Marciana.

In these circumstances, Tintoretto's decision to ignore the rules of the competition becomes more understandable. He was still a controversial figure in 1564. His recent contract for the choir paintings in Madonna dell' Orto (won after Tintoretto agreed to forgo his fee) had apparently caused uproar, and although Tintoretto was currently at work for Scuola Grande di San Marco (see illus. 123, 124), suspicions apparently remained and he had not been admitted to the confraternity.[13] The extent of the hostility to Tintoretto at San Rocco is evident from a document of 1564 recording the stipulation of a leading brother, Zuan Maria Zignoni, to the effect that he would give money towards the decoration of the *albergo* only if the commission were kept away from Tintoretto. Zignoni's opposition should not be underestimated: he was a prominent figure in the Scuola in this period (deacon in 1564, syndic in 1565), and he underscored the strength of his hostility by offering as much as fifteen ducats (instead of the usual one or two) in return for Tintoretto's exclusion. As at the Marciana, Tintoretto was certainly in danger of being locked

out of the commission. While we know nothing of the reasons for Zignoni's hostility, it seems likely that he was one of those within the confraternity who felt that Tintoretto's popular profile was wrong for a leading Scuola Grande. Zignoni may have preferred Tintoretto's patrician-favoured rivals, whom he felt would be more responsive to the lavish ornamentalism of the Meeting House architecture. The work of painters such as Salviati, Zuccari or Veronese was widely perceived as giving decorous expression to the classicizing artistic tastes of the most fashionable families of the nobility. Zignoni's hostility marks the extent to which the culture of the Scuole Grandi continued to be dominated by that of its social superiors.[14]

But Zignoni was not destined to get his way. If he sought to follow the gentrifying aspirations in certain sections of the Venetian nobility, then others within the Scuola were more concerned to return to the republican virtue with which their class had been associated in the quattrocento. In the earlier period, the *cittadini* had often been seen as more committed to the original values of the Serenissima than the patriciate itself.[15] This was far less apparent in the sixteenth century, with the kind of ambitious building projects noted above. But some such perception undoubtedly remained and might even be reflected in the painters commissioned in this period. The Scuole Grandi typically chose conservative (often minor) painters, who could be trusted to decorate their buildings using the established styles of the past. Thus Giovanni Mansueti carefully maintained the Bellinesque manner he had originally employed in the 1490s at the Scuola di San Giovanni Evangelista in three paintings dating from 1518–27 for the *albergo* of the Scuola di San Marco. And those commissioned

130 Jacopo Tintoretto, *Christ at the Pool of Bethesda*,
1559, oil on canvas, 238 × 560.
San Rocco, Venice.

between 1534 and 1561 for the equivalent room in the Scuola della Carità were similarly orthodox in style.[16] In the latter case, Gian Pietro Silvio and Girolamo Dente felt compelled to follow the great initial painting made by Titian between 1534 and 1538: but this work was (as we have seen) offered as a kind of self-conscious reversion to an older narrative style (see illus. 22). By 1564, Tintoretto had already proved himself a very experimental painter and it is unlikely that his prospective patrons at San Rocco saw him as one prepared to paint in a 'simple' time-honoured Scuola style. And yet, unlike any of his rivals in the competition, he was born and trained in the city, and the very fact that he was not (like them) closely connected with the élite *papalisti* circle would (among certain brothers at least) have been to his advantage.

It is very likely that Tintoretto exacted his *fait accompli* in 1564 with guidance from certain Scuola brothers sympathetic to his cause. The strategy for the collapse of the competition may have been

suggested to him by these *fratelli*, who would have advised the painter that the institution was obliged to keep 'anything offered to the saint'.[17] The painter was not without his own supporters in the Scuola, and his case would certainly have been helped by the fact that as many as 25 per cent of the brothers were cloth dyers (*tintori*) like his father. Tintoretto had already been commissioned to paint two large multi-figured narrative paintings for the confraternity church in previous decades. The second of these, painted in 1559 (illus. 130), illustrates *Christ at the Pool of Bethesda*, resulting in his famous direction to the sick man, 'Rise, take up thy bed, and walk' (John 5.8).[18] The subject is ostensibly concerned with Christ's offer of bodily and spiritual redemption to all. A subsidiary aspect is, of course, his active charity to the sick and outcast, the 'great multitude of impotent folk, of blind, halt and withered' (John 5.3). The potential of the episode to stand as a vehicle for the expression of the Scuola's own institutional commitments was undoubtedly fully

recognized at the time. This polemical element was made more pointed still by the fact that the painting decorated the Scuola's silver cupboard, which contained some of its most valuable treasures. The Scuola thus reasserted its original purity of charitable principle at the very site where it lay most open to the charge of hypocrisy. The subject was very rare in Venetian painting, but was probably more specifically determined by the contemporary moves to set up a hospital for sick brothers of the confraternity (the 'Scuoletta') in a small building adjacent to the church. In stylistic terms, as Ridolfi informs us, the picture was made 'in competition' with the long-dead Pordenone, whose *Sts Martin and Christopher* (1527) hung opposite. With its dynamic outsized figures exploding forward from a shrunken space, Tintoretto's painting revives the Pordenonesque vein evident in certain of his early paintings (see illus. 31–4). This retrospective stylistic reference would also have been encouraged by Pordenone's fresco cycle in the choir of the church (now largely destroyed), and more especially by the presence of descendants of Martino d'Anna, Pordenone's great patron, on the ruling boards of the Scuola di San Rocco in the late 1550s.[19]

In 1559, Girolamo Rota was already a leading figure in the Scuola. He held office on the *zonta* and also had a role as 'Procurator of the Ornaments' mediating between the Franciscan friars and the Scuola over the building of the Scuoletta. It seems likely that Rota played a role in securing Tintoretto his commission in the church. He was probably the single most dominant individual in the Scuola during much of the 1550s and 1560s holding office on as many as nine occasions. In May 1564 he was one of those elected to judge the competition, and his name appears again in the document recording

the acceptance of Tintoretto's donation. His 'circle' within the Scuola may also have included men who commissioned Tintoretto paintings in other contexts, such as Zuan' Alberto dal Basso, patron of the San Francesco altarpiece in the same period (see illus. 110), who was on the *zonta* in 1564, and Zuan Piero Mazzoleni, deacon in 1565, the year in which he also commissioned an altarpiece from the painter as *guardian grande* of the Scuola del Sacramento at San Cassiano (illus. 131). In this year Rota was finally elected *guardian grande*, commissioning Tintoretto's enormous *Crucifixion* (see illus. 139). In this painting, for the first and last time in the entire cycle, the painter included a dedicatory inscription (at the lower left) which makes direct reference to his support from Rota's circle on the *banca* of 1565: *Tempore Magnifici / Domini Hieronimi / Rotae, et Collegarum / Iacobus Tintorectus Facebat* ('Made by Jacopo Tintoretto in the Time of the Magnificent Girolamo Rota and Company').[20]

Tintoretto's supporters carried the day in 1564. But the painter's employment was (and was to remain) contentious. The motion of 22 June recording the acceptance of Tintoretto's gift, which also empowered the ruling bodies to commission further works, was passed only by a narrow margin (31 votes to 20), indicating the accuracy of Vasari's report that the painter faced 'many contradictions'.[21] Tintoretto's success may have owed much to the support of those Scuola brothers concerned to reform the institution along Caravian lines. As early as April 1553, the institution had issued a proclamation condemning those brothers who 'spend excessively out of their own pockets, which is an offence to the Majesty of God', and noting that 'moneys of the Scuola ... are being consumed in human luxuries when they ought to be dispensed to

the poor'. A committee of Riformatori was set up to eliminate superfluous expenditure and Rota's close associate Matteo di Marin sat on it in 1564–5.[22] By this point, as we have seen, Tintoretto had already painted two 'hospital' pictures for San Rocco, works which amply expressed the Scuola's overriding commitment to the sick. The large and multi-figured *Pool at Bethesda* had cost the Scuola just 25 ducats (Appendix 1, no. 9) and Tintoretto's more general reputation as a painter who frequently offered paintings at low or discounted prices (making reference to the tradition of *ex-voto* offerings) would have made him a favourite among those brothers concerned to reduce the Scuola's expenditure on

Diagram 1
Sala dell'Albergo, Scuola grande di San Rocco

1 *St. Roch in Glory*
 (illus.132)
2 *Winter*
3 *Female Figure*
4 *Happiness*
5 *Female Figure*
6 *Autumn*
7 *Goodness*
8 *Allegory of the Scuola
 della Carità*
9 *Truth*
10 *Summer*
11 *Allegory of the Scuola di
 San Giovanni
 Evangelista*
12 *Allegory of the Scuola
 della Misericordia*
13 *Allegory of the Scuola di
 San Marco*
14 *Spring*
15 *Hope*
16 *Allegory of the Scuola di
 San Teodoro* (illus.135)
17 *Faith* (illus.136)
18 *Way to Calvary*
 (illus.127)
19 *Ecce Homo* (illus.149)
20 *Christ Before Pilate*
 (illus.150)
21 *Prophet* (illus.147)
22 *Crucifixion* (illus.139)
23 *Prophet* (illus.148)

such 'human luxuries' as paintings. By 1564 Tintoretto had already worked on at least five occasions for the parish Scuole del Sacramento, seen by Caravia and others as a kind of benchmark of selfless confraternal piety in the period.[23] Perhaps also Tintoretto was seen as well connected with reform-minded artistic circles in Venice. The painter probably knew Caravia personally, given their mutual friends among the *poligrafi* circle, and may have shared the frequently expressed mistrust of this group for the worldly pomp and grandeur of traditional religious institutions. As we shall shortly see, he pointedly based the most important painting for the San Rocco *albergo* on a composition he had first developed in a painting for a parish Scuola.

The Albergo Paintings

In the ceiling paintings of 1564 it is evident that Tintoretto initially put aside the reformist elements introduced into his work for the parish Scuole (diagram 1). His painted ceiling is instead an exercise in fashionable orthodoxy, a sophisticated fusion of the decorative chromatism of Titian with the formal complexity of contemporary Mannerism.[24] The central ceiling panel which caused so much controversy is, paradoxically, particularly assiduous in its conformity to precedent (illus. 132). Tintoretto astutely adopted a conventional Titianesque palette (golds, creams, yellows and reds) to express a composition which knowingly pastiched the upper part of the famous *Assumption of the Virgin* hanging nearby in the Frari (illus. 57, 133). The freely painted cherubic heads inscribed 'wet-on-wet', along with St Roch's uncanonical colours (he wears the blue and red of the Virgin), were intended to make the connection

132 Jacopo Tintoretto, *St Roch in Glory*,
1564, oil on canvas, 240 × 360.
Scuola Grande di San Rocco, Venice (ceiling of the Sala dell'Albergo).

133 Titian, detail of the upper part of the *Assumption of the Virgin*,
1516/18, oil on panel.
Santa Maria Gloriosa dei Frari, Venice.

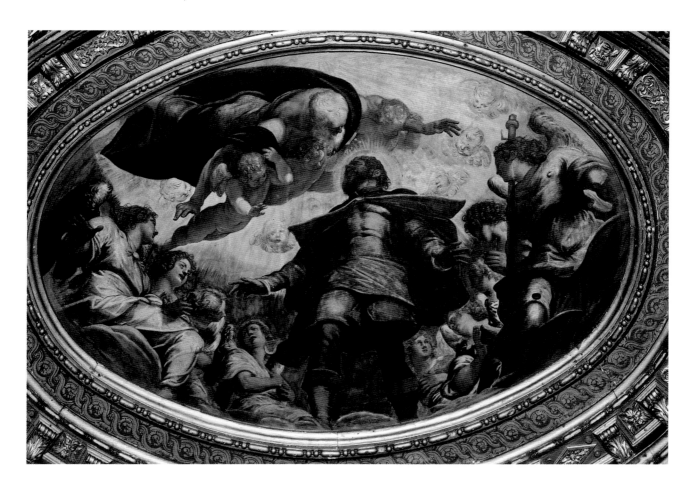

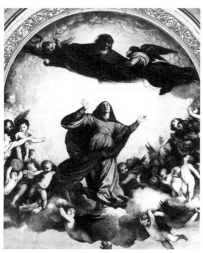

134 Michelangelo Buonarroti, *God Separating Earth and Water*, 1508/12, fresco. Ceiling of the Sistine Chapel, Rome.

explicit. Although submitted as a finished work, the panel was nonetheless conceived as a presentation piece in which Tintoretto sought to satisfy the taste of his more uncertain patrons. Reference to the style of the painter initially favoured to paint in the *albergo* was clearly apposite; but Tintoretto was also keen to show himself well versed in the central Italian manner of his competitors. The mighty figure of God the Father is accordingly adapted from a Roman source, namely Michelangelo's *God Separating Earth and Water* in the Sistine Chapel (illus. 134).

In the subsidiary ceiling paintings, also donated to the Scuola and featuring *Allegories of the Scuole Grandi* (illus. 135), *Four Cardinal Virtues* (illus. 136) and the *Four Seasons*, the painter continued in the carefully retrospective mode of the 'illegal' central panel. Neat surviving drawings, named and squared for transfer, survive for the *Virtues* and *Scuole* (illus. 137), indicating that Tintoretto here conformed to a more orthodox preparatory process, perhaps in order to arrive at a finished effect in the paintings.[25] The single reclining figures superficially recall Tintoretto's earlier graphic studies after the Michelangelo statuettes he owned (see illus. 40–42), but the final effect of both drawings and paintings is much closer to the ceiling panels of visiting central Italians of the younger generation, such as

135 Jacopo Tintoretto, *Allegory of the Scuola Grande di San Teodoro*, 1564, oil on canvas, 90 × 190. Scuola Grande di San Rocco, Venice (ceiling of the Sala dell'Albergo).

136 Jacopo Tintoretto, *Faith*, 1564, oil on canvas, 90 × 190. Scuola Grande di San Rocco, Venice (ceiling of the Sala dell'Albergo).

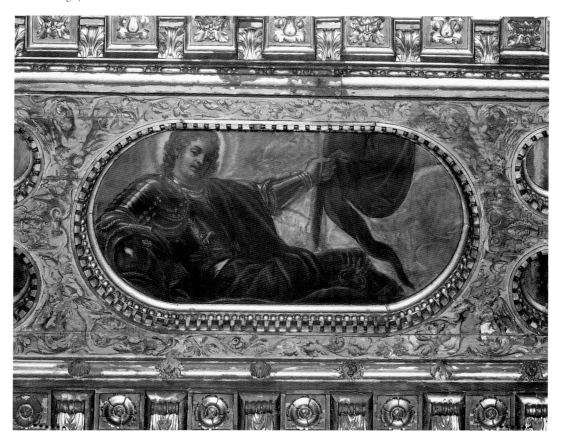

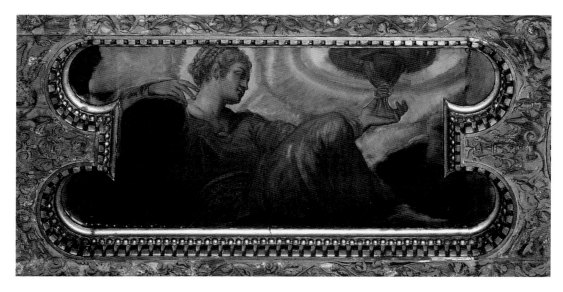

137 Jacopo Tintoretto, *Study for the Allegory of the Scuola Grande di San Teodoro*, 1564, black chalk on white paper, 2.98 × 2.10. Gabinetto dei Disegni, Galleria degli Uffizi, Florence.

138 Jacopo Tintoretto, *Doge Girolamo Priuli Assisted by St Mark before Peace and Justice*, 1564/5, oil on canvas, 230 × 230. Palazzo Ducale, Venice (central ceiling panel of the Sala dell'Atrio Quadrato).

those painted by Vasari for the Palazzo Corner in 1541. Each allegorical figure conforms to the given picture shape and frontal plane, producing an ease of posture and spatiality rarely present in Tintoretto's other work. In the *albergo* ceiling panels more generally, Tintoretto remains true to the dictates of the painting type, his imagery supporting the visual exuberance of the ornately carved gilt of the wooden surround. The paintings have much in common with the near-contemporary ceilings he painted in the Ducal Palace, which also obey the essentially planar demands of the decorative ensemble (illus. 138).[26] Tintoretto's central panel featured St Roch, the long-dead patron saint of the confraternity, rather than a living Venetian individual. But if this implies the supremacy of communal rather than individualistic values in the Scuola, other aspects of the ceiling iconography make abundantly clear the predominance of San Rocco over its rivals. While it may be that the surrounding panels allow for the God-inspired virtue and eternal presence of the city's five other Scuole Grandi, the larger scale and

central position of the *St Roch in Glory* roundly asserts the institution's role as *primus inter pares*. Tintoretto must have closely followed the requirements of his patrons: but with its clear expression of institutional primacy and its formal subservience to contemporary classicizing taste, the ceiling had not even begun to answer Caravia's ringing charges of worldly vanity and greed.

Given this background, the shift in tone apparent in the enormous *Crucifixion* Tintoretto painted for Rota in the following year is both sudden and unanticipated (illus. 139). Something of the epic and visionary quality of the new painting is already present in the huge choir paintings for Madonna dell' Orto of a few years earlier (see illus. 156), but the sheer visual power and moral conviction of the *Crucifixion* (which even threatened to render the normally loquacious Ruskin speechless) cannot be attributed merely to its enormous scale (5.36 × 12.24 m).[27] The progression beyond the orthodoxies of the ceiling may in part be attributed to the move from allegory to narrative, a mode in which

139 Jacopo Tintoretto, *Crucifixion*, 1565,
oil on canvas, 536 × 1224.
Scuola Grande di San Rocco, Venice (Sala dell'Albergo).

140 Jacopo Tintoretto, *Crucifixion*, c. 1554/5,
oil on canvas, 282 × 445.
Gallerie dell'Accademia, Venice.

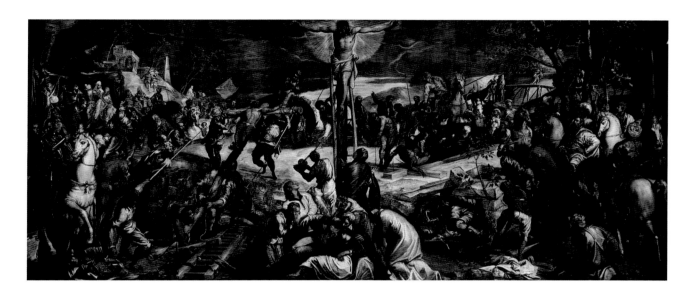

Tintoretto was always happier. But we are also describing a shift beyond the invocation of formal influence so central to the ceiling. In the *Crucifixion*, Tintoretto places himself in a newly independent relationship to fashionable artistic authorities such as Titian and Michelangelo. His style is at once more self-determining and self-reflexive than in any other painting he had made to this point.

Accordingly, Tintoretto did not (as is often assumed) draw primarily on the large paintings which hung in analogous positions in the *alberghi* of rival Scuole Grandi, such as the Bellini's *St Mark Preaching in Alexandria* in San Marco (1504–26), or Titian's equivalent in the Carità (see illus. 22).[28] He turned instead to his own Christocentric narrative paintings, in particular to the *laterale* painted for the Scuola del Sacramento of San Severo some ten years before (illus. 140). The *albergo* painting is the first (but not the last) example of Tintoretto's use of a composition originally formulated for a parish Scuola in the grandious setting of the Meeting House. While the busy and formally complex

painting from San Severo is not a particularly 'humble' composition, its ready adaptation may have made a certain point against Caravia's assumption that there was no connection (social or moral) between the two types of confraternity. Such a connection was not merely fanciful by this point, given that men such as Zuan Piero Mazzoleni simultaneously held office as *guardian grande* of a Scuola del Sacramento and *degano* at San Rocco in 1565. But the issue of the vanity of the latter confraternity still remained to be answered in visual terms. Given these circumstances, it is likely that Tintoretto's reference to the San Severo painting was a quite deliberate one, and that it may even have been suggested by the Riformatori within the Scuola who had backed the painter in the previous year.[29]

The San Severo *Crucifixion* provided the general compositional schema for the San Rocco painting and its influence is also apparent in key details such as the impassive centralized figure of Christ (shown, in Ruskin's words, as 'in perfect repose' with countenance 'cast ... altogether into shade'), the mourning group dominated by the swooning Marys, the soldiers dicing for Christ's clothes and the framing equestrian figures to each side. But the earlier painting is claustrophobic, its confused spatiality the result of a lack of resolution between the accommodation of frontal and oblique viewing positions (the off-centre arrangement of the three crosses reflects its likely location on the left side-wall of the Sacrament chapel in San Severo). Tintoretto fully resolved the problem only in the *Crucifixion* he painted in 1568 for the left wall of the choir in San Cassiano (illus. 141), in which the composition is effectively turned on its side to accommodate the vision of the congregation.[30]

At San Rocco, the central viewing position

removed the problem of the oblique view altogether, allowing Tintoretto to open up a massive centralized composition conceived as an ellipse which appears to rotate around the axial figure of Christ. Unlike in the San Severo painting, the foreground is partially cleared to allow the impression that the flattened circle of those who observe Christ's death is completed in real space by those standing in front of the painting. As at San Cassiano, the space of the painting is thus presented as a continuous extension of reality, the completion of the image made dependent on the active participation of the viewer. The overlap of real and fictive space also has a religious dimension, intimating that the meaning of Christ's death is dependent on the viewer's imaginative projection.[31]

The spatial ambiguity of Christ's position supports this effect. The placement of his body at the extreme upper edge of the painting isolates him from the space-creating forms below, while the powerful outreach of his arms along the picture plane offers the illusion that he lies flat along the surface, as he would in a Byzantine crucifix. This impression is reinforced by the placement of the mourning group below, which conceals the precise point in space at which the bole of the cross enters the ground. The effect is to release Christ from a single spatial location, and thereby to suggest his freedom from the naturalistic coordinates underpinning the composition surrounding him. Christ assumes an iconic function beyond and outside the spatially and temporally confined narratives he generates.[32]

Christ's suspension from the dictates of time and space is particularly emphasized by way of contrast with the multiplication of narrative incidents around him. Unlike in the San Severo

141 Jacopo Tintoretto, *Crucifixion*, 1568,
oil on canvas, 341 × 371.
San Cassiano, Venice.

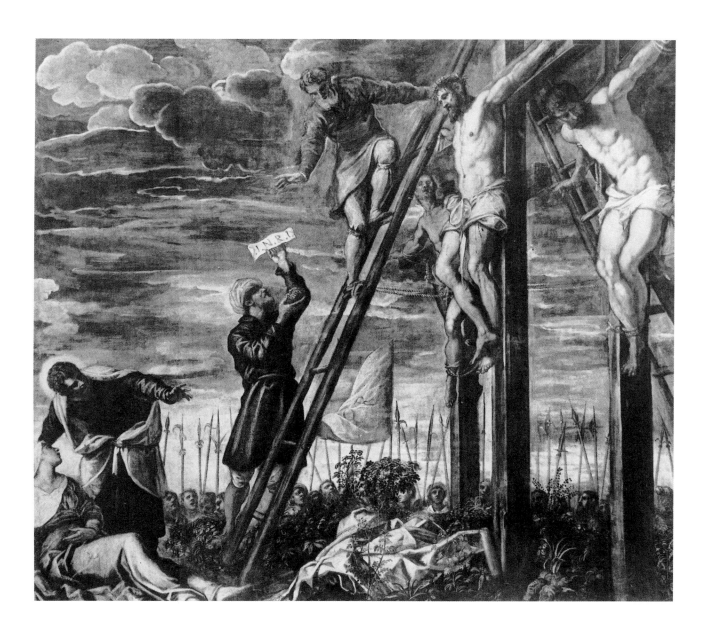

painting, each figural group is clearly defined from its neighbour by carefully worked spatial intervals, a technique which allows Tintoretto to break the narrative down into semi-autonomous units which, although shown simultaneously, refer to different moments in the story. The loading of narrative incident in a single image was a technique which Tintoretto had already developed in other religious paintings, such as the *Miracle of the Slave* and in his sequence of paintings of the *Last Supper*, in order to give added emphasis to his subject-matter.[33] In the San Rocco *Crucifixion*, it is most evident in the inclusion of three apparently sequential episodes of crucifixion. To the right, the struggling 'bad' thief (his moral character revealed by his position on the sinister side, with his back turned to Christ) is pinned to a cross which still lies on the ground. On the right side of Christ we are shown the moment at which the 'good' thief's cross is hoisted aloft, his sudden enlightenment revealed by his gaze towards the Saviour. And finally, of course, we witness the perfection of Christ's own completed crucifixion. Although these episodes are notionally happening simultaneously each one also refers to the other, backwards and forwards along a temporal and spiritual continuum. The bad thief, still physically alive, will very soon submit to a raising and crucifixion which will only end in his death. The good thief is already distinguished by his inward acknowledgement of Christ, the physical raising of his cross symbolizing his spiritual ascent. His raising also directly recalls the previous (and often depicted) moment when Christ's own cross was raised (illus. 142). Although we see only the perfected icon of the crucified Christ, we are reminded of the earlier physical suffering he has just endured in order to secure man's salvation. The three episodes

thus set in play a reversible sequence of contrasts and concordances on the central theme of the fall and redemption of man through Christ's sacrifice.

Tintoretto's attention to the purely physical mechanics of crucifixion, evident in the detailing of ropes, ladders and tools, as also in his brilliant evocation of the swarthy labourers who operate them, recalls his experiments with popular imagery in earlier narrative paintings for the parish Scuole (illus. 59, 143). The executioners are dressed as contemporary Venetians of the *popolani*, their vigorous unpremeditated action contrasting both with the disengagement of the equestrian figures and portraits at the picture margins and with the

143 Jacopo Tintoretto, detail of illus. 139.

144 Giovanni Antonio da Pordenone,
Christ Nailed to the Cross, 1520–22, fresco.
Duomo, Cremona.

abstracted mourning group beneath Christ's cross.
Tintoretto's conception of the raising of the good
thief's cross, with its potent combination of violent
foreshortening and intense naturalism, draws on the
energy and power of Pordenone, whose Passion
frescoes in the Cremona Duomo of *c.* 1520–22 (as
Rosand noticed) also feature twisting bodies,
straining ropes and angled crosses (illus. 144). As in
1559, the reference may have been quite deliberate,
given the continuing presence of Zuane di Martino
d'Anna on the *zonta* of the scuola in the mid-1560s.
Tintoretto, like Pordenone, also drew on northern

prints (illus. 142); but unlike the Friulian painter,
Tintoretto's earthy realism is not made a pretext for
caricature. Indeed the faces of the labourers are
hidden, and while their lack of awareness of Christ
is certainly significant, they are not explicitly
judged. Rather, their physical action propels the
narrative forward, appearing as both necessary and
predestined.[34]

While the presence of the labourers ensures the
painting's social scope, it also serves to point the
contrast with the idealized mourning group at the
foot of the cross, where physical effort is replaced by

145 Daniele da Volterra, *Deposition of Christ from the Cross*, *c.* 1550/1, fresco.
Santa Trinità dei Monti, Rome.

146 Jacopo Tintoretto, *Crucifixion*, *c.* 1563/5,
oil on canvas, 297 × 165.
Santa Maria del Rosario, Venice.

spiritual response. As if physically joined to Christ's cross, this group is, like Him, detached from the surrounding narrative episodes, taking on a similar timeless quality. The formal prototype for the group can be found, once again, in the San Severo painting (illus. 140), in which Tintoretto had borrowed from the mourners in Daniele da Volterra's *Deposition* in Santa Trinità dei Monti in Rome (illus. 145). Volterra's painting of the swooning Virgin supported by the other Marys was destined to become a favoured motif in a number of Tintoretto altarpieces of the earlier 1560s, including the *Crucifixion* for Santa Maria del Rosario (illus. 146) and the paintings for San Francesco and the Umiltà (see illus. 110, 125).[35] On its reappearance at San Rocco, the group retained something of its iconic 'altarpiece' character. The personnel of the group is expanded but remains essentially non-narrative, seeming to float in the amorphous space before Christ's cross. With their backs turned to the energetic cross-raisers at the left the group appears like an image within an image, losing three-dimensional reality and gravity as physical action is stilled. The foreground Marys seem not to swoon

but to levitate in their sleep, as if experiencing Christ's crucifixion as an inward dream (a model of religious visionary experience which was to recur in subsequent paintings in the Meeting House).

Out of Tintoretto's subtle combination of iconic and narrative modes a new kind of religious painting was born. But whether historical or contemporary, follower of Christ or labouring executioner, the extensive dramatis personae of Tintoretto's painting remain oddly anonymous, driven by forces they neither originate nor control. In its fatalism, Tintoretto's religious drama is very distinct from the more typically 'Renaissance' struggle between individual and destiny which characterizes the religious painting of Titian (see illus. 87). The anonymity of Tintoretto's sacred conception expresses a vision of religious life particularly suited to the ideal of communal devotion in a lay confraternity. But in the ideological purity of its religious focus – its spiritual essentialism – this drama was also very unlike the elaborative and circumstantial manner of earlier Venetian narrative painting for the Scuole (see illus. 22, 24, 188). Ignoring the specific institutional concerns evident in the equivalent paintings in the Scuola di San Marco and Scuola della Carità, and still so apparent on the ceiling of the San Rocco *albergo*, the *Crucifixion* focuses instead on the core defining moment in the Christian faith. The reforming quality of this new orientation cannot have been lost on those who had criticized the Scuola for its petty vanities.[36]

Tintoretto painted three further scenes from Christ's Passion (showing *Ecce Homo*, *Christ Before Pilate* and the *Way to Calvary*) to complete the decoration of the *albergo* in 1566–7. These hang on the wall opposite the *Crucifixion*, and are conceived

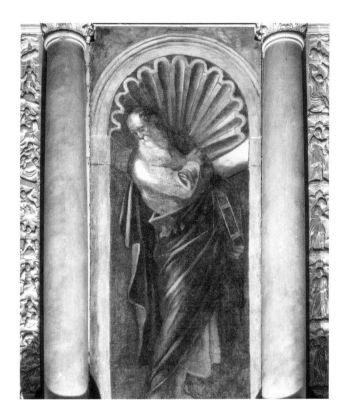

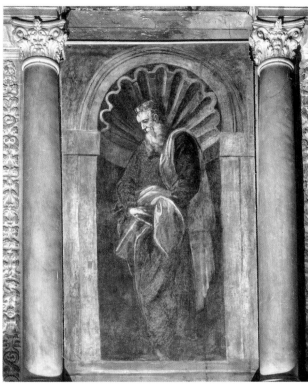

as subsidiary and preparatory to it. But the relatively small space of the *albergo* means that the viewer cannot see both walls at the same time. The point is made in visual terms by the two *Prophets* Tintoretto painted high up between the biforate windows on the side walls; they twist out of their painted shell niches, one to gaze at the entrance wall, the other at the wall of the *banca* (illus. 147, 148).[37] Perhaps because of the limits to visibility within the *albergo*, Tintoretto conceived the three paintings on the entrance wall as a kind of mirror of the huge painting opposite, initiating a series of reflections between images across the narrow space of the room. The three paintings are separated from one another only by narrow frames and, despite their different settings, are unified compositionally by an over-

arching formal pyramid which culminates in the reclining figure of Christ in the above-door (*soprapporta*) showing the *Ecce Homo* (illus. 149). In a manner which directly parallels the *Crucifixion*, this central image is dominated by the inert body of the Saviour, whose iconic treatment distinguishes it from the crowded narrative episodes to left and right (illus. 127, 150). While the gazes of Pilate and the torturers are turned away from the scene opposite, as if to re-emphasize their abdication of responsibility, Christ gazes directly across the space of *albergo* to the image of himself on the Cross. The restless gesturing of Christ's tormentors reveals their implication in his suffering, as does the dominant tonality of their robes: the reds, scarlets and vermilions pick up the trails of blood which mat

149 Jacopo Tintoretto, *Ecce Homo*, 1566/7,
oil on canvas, 260 × 390.
Scuola Grande di San Rocco, Venice (Sala dall'Albergo).

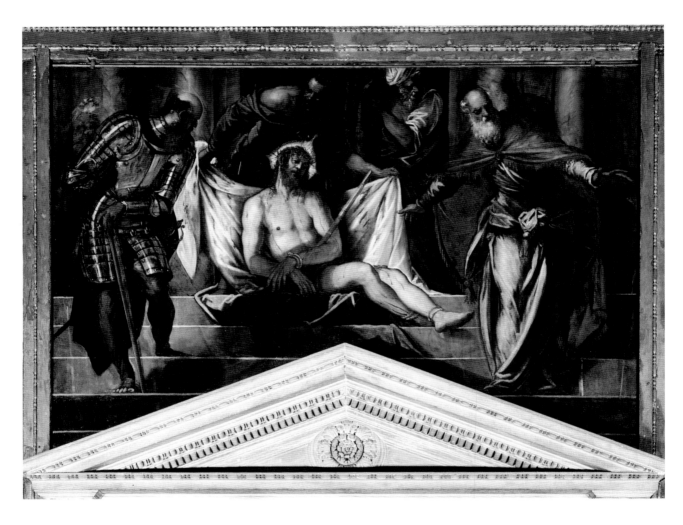

Christ's hair and fleck his body and winding sheet.
Christ's fleshy form, indeed, is presented as a kind
of Eucharistic offering, the accessibility of his body
and blood to the viewer at the Mass confirmed by
his placement on altar-type steps which appear to
descend directly into the realm of the viewer below.
The doctrinal significance of Christ's offering is
thus made more specific here than in the aloof figure
who dominates the painting hanging opposite.

In the *Christ Before Pilate* to the right, the
protagonist is again shown wrapped in his shroud,
bound by the coarse ropes which feature
prominently in all the paintings of the Passion cycle
in the *albergo* (illus. 150). Most obviously, these
ropes refer to the physical means by which Christ
was captured, tortured and crucified. Whether or
not they also refer back to the original flagellant
function of the Scuola, the repetition of such a
detail helps to secure a deeper semantic connection
between each image in the cycle, one which goes
beyond the demands of mere narrative continuity.
Rope is just one of a number of recurrent motifs

150 Jacopo Tintoretto, *Christ Before Pilate*, 1566/7,
oil on canvas, 515 × 380.
Scuola Grande di San Rocco, Venice (Sala dell'Albergo).

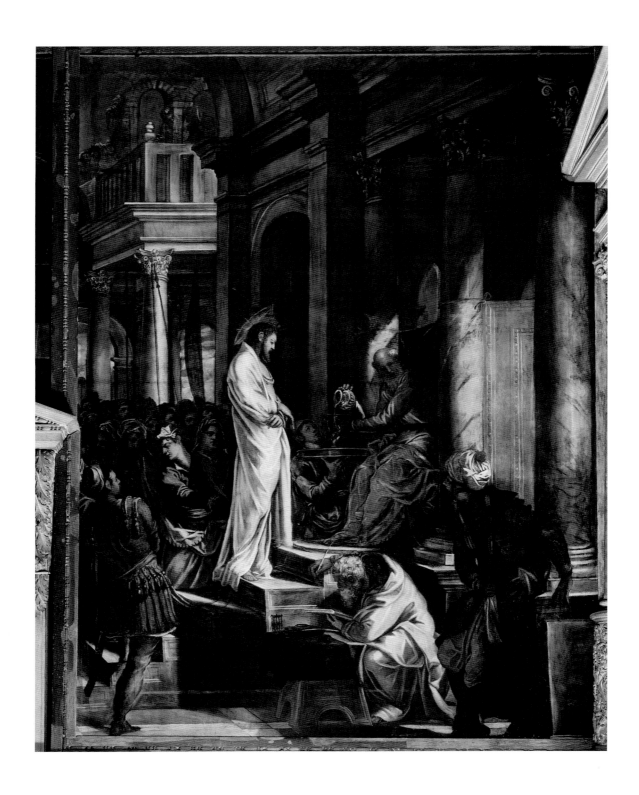

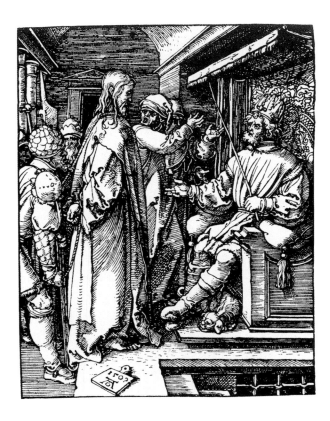

(possessed of a gathering multivalency) which bind
the imagery in the Meeting House together. In the
cycles of the Sala Superiore and Sala Terrena, such
details support the more general repetition of figural
and compositional types through which Tintoretto
establishes concordances between paintings.[38]

The ethereal figure of the protagonist in the
Christ Before Pilate retains something of the iconic
loose line quality of the *Ecce Homo* and the
Crucifixion. As in the latter painting, Tintoretto
drew on northern narrative prints, this time on
Albrecht Dürer's woodcut of *Christ Before Herod*
from the Small Passion cycle (1511), to establish the
delicately abstract Gothic quality of Christ's
elongated figure and profile view (illus. 151). The
diagonal arrangement of the composition may owe

more to Dürer's earlier *Christ Before the People*
(Large Passion, 1498), although the receding line of
the architectural frontage of Pilate's praetorium is
also a direct continuation of the adjacent wall of the
albergo itself.[39] Indeed, the architectural mouldings
(pediment and aedicule) of the nearby biforate
window obtrude slightly into the picture field, while
the foremost of Tintoretto's three great freestanding
Corinthian columns directly abuts the actual column
to its right. At either side of Pilate's judgement seat,
the ornate marbling of these grandious columns
turns an ominous red. The blood-coloured flecks on
the columns refer forward to Christ's coming torture
(perhaps specifically to the scene of his flagellation,
usually shown against a classical column), which
directly followed from Pilate's decision not to release
him. The implication of pagan Rome in Christ's
Passion is firmly established by the staining of its
grandious classical architecture with the blood of
Christ. Tintoretto's painted columns only
superficially recall those real columns on the
Meeting House façade which had provoked such
controversy. But the careful perspective alignment
indicates Tintoretto's concern to establish a link
between real and fictive architecture, his painted
world taking on a kind of reforming quality with
regard to the confraternity's Romanizing building.
His painted columns are – in keeping with Caravia's
view – symbols not of triumph and beauty but of
oppression and vanity. As in other paintings for the
Meeting House, such *all'antica* features are
subjected to a moralized order which establishes
their complicity in Christ's suffering.

The third painting on the entrance wall of the
albergo shows the *Way to Calvary*, the scene
immediately prior to the Crucifixion itself in the
biblical narrative (illus. 127). Its imagery establishes

a particularly close visual link to the vast painting opposite, not least through the unusual inclusion of all three condemned men and their crosses. In its compositional originality the painting is also a precursor to the later wall paintings in the Sala Superiore and Sala Terrena. Most noticeable in this regard is the vertical division of the composition into distinct lower foreground and upper background areas, generating a kind of *dal sotto in sù* effect more characteristic of a ceiling painting. This division is established around a series of roughly hewn diagonals which serve to define the hill of Calvary. The point of intersection at the right edge of the painting is, as we have seen, determined in part by the position of the above-door showing the *Ecce Homo* (illus. 149) towards which the grim procession of soldiers, thieves and helpers seems to move. But Tintoretto avoids using the march to Calvary as an excuse for sumptuous visual display. Rather than a triumphal procession towards glory, we witness the pain and pathos of Christ's humble submission to his fate. Although placed in the upper part of the composition (and to this extent distinguished from the two thieves in the lower foreground), Christ's slight and bowed figure is seen at a distance and is not allowed to stand out. The protagonist's removal from the central foreground position favoured in Renaissance composition was, of course, something Tintoretto had long experimented with, drawing primarily on Mannerist examples. But the displacement here serves to make a moral rather than an aesthetic point.[40] Christ's pose, with face and body bowed to the earth (and thus to the concerns of man) is, very deliberately, made identical with that of the two men who help him (the elder of whom may be identifiable as Simon of Cyrene), sharing the burden of the cross.

As with compositional inversion, repetition of posture takes on an ethical implication, the physical similarity expressing the two helpers' emulation of Christ's own charity. The point is reiterated by the contrast of this group with the posturing triumphalism of the flag-waving Roman soldier just to the right, who does not notice the human suffering and degradation around him, and whose spiritual distance from Christ is emphasized by the placement of the tree.

In the lower foreground, the two thieves also receive help with their crosses, with analogous repetitions of posture resulting. While the thieves' helpers are not directly identified as brothers of the Scuola, they are placed at the nearest point to the frontal picture plane and are dressed in contemporary clothes as if to suggest their connection with the real world of the viewer. The addition of such helpers to the scene is iconographically unusual, but can be explained as a submerged reference to the charitable activities of the commissioning confraternity. Just this kind of generalized, non-specific reference to the Scuola's charitable functions was, in fact, typical of Tintoretto's approach for the Meeting House, replacing the more overt institutional references provided by the multiple portraits which feature in earlier Scuola narrative cycles (see illus. 22). Such an adjustment was broadly in keeping with an attempt to answer the charges of worldly vanity levelled at San Rocco. But the instance of charity offered to the two condemned men in the foreground of the *Way to Calvary* may also allow for a more specific reference to the Scuola's recent (and at this point unilateral) extension of its charitable activities beyond the confines of the institution itself.[41]

152 Interior view of the Sala Superiore,
Scuola Grande di San Rocco, Venice.

153 (opposite) Jacopo Tintoretto, *St Roch Visited by an Angel
in Prison*, 1567, oil on canvas, 300 × 670.
San Rocco, Venice.

Tintoretto at San Rocco II: 1575–88

Further Progress of the Commission

The success of Tintoretto's decoration of the *albergo* was immediately acknowledged by the brothers of the Scuola. As early as 11 March 1565, he was admitted to the confraternity, and in the course of the following eighteen months served on the ruling committee as a deacon (*degano*) and syndic (*sindaco*). Soon after the completion of his work in 1567 he received a further commission for narrative paintings in the Scuola church (illus. 153). His work in the Meeting House was not then resumed until early in July 1575, when the Scuola accepted his offer to 'make the painting in the middle of the ceiling' of the Sala Superiore. By March 1577, Tintoretto had made two further offers to complete the rest of the ceiling in return for only the cost of his canvases and colours, and in a surviving petition dating from 27 November of the same year, he announced that the ensemble was almost complete. In this petition, he also expressed his desire to complete – 'for the great love I have of our venerable Scuola and for devotion to the glorious St Roch' – all further decorations required by the confraternity including 'the ten large paintings to go between the windows in the Sala', a painting for the 'large altar' in the same room, and all further works required for the Scuola church. He promised to deliver three paintings each year before the feast of St Roch (16 August), in return for a salary of 100 ducats to be paid for the duration of his life. In less than a week his ambitious proposal had been accepted by both the Scuola's *banca* (by 16 votes to 4) and by the Chapter General (45 votes to 3), and the first instalment of 100 ducats paid. Opposition to Tintoretto within the Scuola had not, though, wholly disappeared and his enemies managed to force a revote on 16 February 1578 in which the votes cast against him rose to as many as 12 in the *banca* and 28 in the Chapter General.[1]

Those who had forced the revote were, then, narrowly unsuccessful, and Tintoretto went on to complete the decoration of the Meeting House as he had proposed, finishing the wall paintings in the Sala Superiore by 1581 and a further cycle of eight paintings for the ground floor (Sala Terrena) by 1587. But as many as 40 of the 91 Scuola brothers who voted on his further employment had decided against him in 1578, a clear indicator that he continued to be seen as a very controversial choice. It is equally true, however, that the pictorial imagery Tintoretto produced for the Scuola was intended more as a reform to the institution than an attack upon it. And, as we have seen, this position had powerful support in Venice, from both within and without the institution. Paradoxically, Tintoretto's controversial status at San Rocco can also be taken as a particular measure of his concern for its founding principles.

The sequence of petitions Tintoretto made to the Scuola between 1575 and 1577 is marked by a consistent workmanlike approach: the painter offered his confraternity a large number of sizeable multi-figured paintings and gave evidence as he progressed of his ability to paint very quickly and at a low price. The pointed contrast that Tintoretto's manner of proceeding offered with the expensive stop-start progress of the architectural commission could not have been greater. Under Tintoretto's

terms, the Scuola could have (in very rapid time) an extensive and unrivalled (among the Scuole at least) decoration for their Meeting House without indulging in an orgy of expenditure. In November 1577, Tintoretto declared himself 'content to have no more money for the ceiling than the 200 ducats I have already received'. He had, in fact, already been paid 240 ducats, but 130 of these covered his expenses in canvases and colours, leaving just 110 ducats for his honorarium (Appendix 1, no. 25). As such, the painter was only slightly less generous than he had been with his first set of ceiling paintings for the *albergo*. The discount he offered was, indeed, very remarkable, given the scale and figural complexity of the paintings, and the usually high price of works of this fashionable and prestigious type.[2]

Tintoretto's offer was, of course, made as a kind of bait for his patrons which, if swallowed, would secure him not only the commission for the ten wall paintings of the Sala Superiore but a monopoly over all future Scuola commissions and an annuity of 100 ducats. The promise to deliver three paintings each year in return was still a generous one: as we have seen, similarly sized wall paintings for the Scuole Grandi typically cost over 100 ducats each in the sixteenth century, while patrons could also expect to wait a year for their delivery. As with the ceiling, Tintoretto thus offered his wall paintings at as little as a third of the going price in Venice. The Scuola decorations were, of course completed well before Tintoretto's death, and the expense of the Meeting House decorations increased with each year of his life. According to Ridolfi, the painter used to jest in his old age, saying 'that he wanted to live on for a thousand ducats of life'.[3] But at his death in 1594, the total cost of Tintoretto's paintings for the Meeting House (including those in the *albergo* and inclusive of expenses) was little more than 2,000 ducats, as opposed to the 47,000 ducats spent on the building itself.[4] This comparison could be somewhat misleading given that building work was inherently much more expensive than pictorial decoration. But it is also true that while the Scuola employed Tintoretto, it could no longer be criticized for excessive expenditure. The painter's recognition of this advantage to his patrons surely lies behind the phrases of selfless piety and institutional commitment within which he couched his ambitious offers. But his expressions of 'great love' for 'our venerable Scuola' and 'devotion to the glorious St Roch' need not be thought of as a hypocritical cover for more mercenary motives. On the contrary, it is likely that Tintoretto, as a frequent office-holder in the Scuola, shared the desire of the more reform-minded brothers to recover the good name of the institution.

The particular manner of painting which Tintoretto developed at the Meeting House was, in a sense, no more than a reflection of the straitened conditions of production he had prescribed for himself. But his undertaking to complete a large quantity of pictorial imagery relatively quickly and at low cost should not be thought of as having limited the expressive scope of his work. Indeed, such working conditions can be seen as integral to the development of a new manner of painting founded on a technical and visual restraint which now had reformist implications. Tintoretto's on-going success at the Scuola through the later 1570s and 1580s was, though, not simply based on his own manoeuvrings. Certain of the painter's original supporters remained powerful in the confraternity in these decades. While Girolamo Rota was dead, Zuan' Alberto dal Basso still held positions on the

Scuola's ruling bodies through much of the 1570s, as did Cristoforo de' Gozi, patron of the *laterali* for the choir of San Cassiano in 1568 (see illus. 141). In 1577, the year in which the three Tintoretto petitions were granted, the *guardian grande* was Paolo d'Anna, grandson of Pordenone's patron. Following the recount early in the following year, d'Anna appointed a three-man commission with 'the job of connoisseurs, to judge and approve the paintings which will be made by Tintoretto'. Appointed to this supervisory body were Giovanni di Formenti, Benedetto Marucini and d'Anna himself. Marucini had been a member of Rota's circle in the 1560s, offering as much as 50 ducats toward the decoration of the *albergo* ceiling; he was also Paolo d'Anna's uncle by marriage. Through their majority position on the committee, the two men may have been in a position to secure a more trouble-free passage for Tintoretto at the Scuola from 1578 onwards.[5]

The existence of d'Anna's commission of 1578 indicates, however, that Tintoretto was not merely left to get on with the job, as has often been presumed in the literature, and it is very unlikely that he initiated paintings and subjects at will. His prominent role in the development of the cycle's iconography is suggested by the document dated 2 July 1575 recording his initial offer of the central ceiling painting for the Sala Superiore 'with the subject that he has spoken of'. But a recent rereading of this document has shown that the painter had actually agreed the subject of the proposed painting with two brothers, Alvise Cuccina and Benedetto Ferro, the Scuola's *vicario* and *guardian da matin*. These men were probably considered to be the Scuola's leading authorities on visual art given their previous experience as patrons,

and must have been closely involved in the further progress of the commission in the Meeting House.[6] Both were on the *zonta* in 1577, when Tintoretto's final petition was granted, Cuccina going on to be *guardian grande* in the following year. In this period, these learned brothers might also have continued to collaborate with the painter over the iconographic programme for the Sala Superiore, one which is certainly more coherent than has often been allowed in the literature.[7]

Recognition of the importance of men such as Paolo d'Anna and Alvise Cuccina for the progress of the San Rocco commission need not imply their exclusive patronal commitment to Tintoretto. In other contexts, the d'Anna and Cuccina commissioned Titian and Veronese, showing that *cittadino* patrons (like their patrician superiors) could move easily between artistic camps. However, there may have been a growing distinction in this regard between private commissions in which 'courtly' artists were favoured (such as the one Cuccina gave to Veronese in his palace at Sant' Aponal), and public ones in which aesthetic taste was less significant than a show of commitment to institutional values. Tintoretto had proved himself ready to respond to criticisms of the worldliness of the Scuola di San Rocco in his wall paintings for the *albergo*, producing paintings which reasserted the original selfless values of the confraternity. If Caravia's specific role in generating this response was no longer so important in the 1570s and 1580s, the concerns raised in his text had become more generally important for Venetian culture. Caravia had gone no further than to castigate the spurious classicism of the Meeting House. But by the later decades of the century, the more positive idea of a 'humble' and purified religious art, concerned with

the clear expression of the devotional message, had been given official sanction by the theologians at the Council of Trent.[8]

In Venetian politics too, the courtly values of the *papalisti* were in decline, the rise of the so-called *giovani* in the early 1580s marking a recommitment to the orthodox Venetian values of self-restraint. This idea could have a very practical application as far as expenditure on 'human luxuries' such as art was concerned, and it is no coincidence that in 1580 the state acted to curb excessive patrician expenditure on manuscript and oil paintings in the procuracies. To some extent the very necessity of such legal action indicates that many leading Venetian patricians continued to promote themselves through conspicuous expenditure. And it would certainly be a mistake to assume that late sixteenth-century Venetian culture no longer had a place for civic display. Indeed, the Scuola di San Rocco itself still spent lavishly on occasion, as, for example, in 1585, when 300 ducats were paid out on a single procession. Perhaps just because the old conflict continued, Tintoretto's status at the Scuola remained controversial. But despite this, his development of a manner of religious narrative art based on a value of sacred poverty (*santa povertà*) now had a wider and more certain political and religious sanction.[9]

The three large paintings for the ceiling with which Tintoretto resumed work in the Meeting House were to prove fundamental to the overall iconographic programme. These works (showing the *Brazen Serpent*, *Moses Striking the Rock* and the *Gathering of Manna*) establish a threefold typological theme that runs throughout the entire Sala, the Old Testament scenes on the ceiling being anti-types to those from the life of Christ on the walls below.[10] The 'history' showing the *Brazen Serpent* initially

agreed on by Tintoretto, Cuccina and Ferro in July 1575 was undoubtedly the issue of long and careful deliberation, and was to prove the linchpin for the entire cycle. Their choice was determined both by the existing Passion cycle in the *albergo* and, it must be assumed, by a clear idea as to the future decoration and iconography of the Sala's ceiling and walls (even before finishing the ceiling, we recall, Tintoretto refers to the ten wall paintings as a matter of course). As an Old Testament type of the Crucifixion, the choice of the *Brazen Serpent* provided a clear link back to the dominant theme in the *albergo* just as it also opened the way for the development of New Testament/Old Testament concordances mentioned above.

The central panel was encircled by ovals illustrating other Old Testament scenes of sacrifice and redemption (the *Vision of Ezekiel*, *Jacob's Ladder* and the *Sacrifice of Isaac*), while on the walls below Tintoretto painted the *Resurrection of Christ*, the *Ascension of Christ*, the *Agony in the Garden* and the *Raising of Lazarus*. Around the *Moses Striking the Rock*, Tintoretto painted scenes relating to the sacrament of Baptism, with ovals featuring the *Vocation of Moses*, the *Pillar of Fire* and *Jonah and the Whale*, and wall paintings showing the *Baptism of Christ* and *Christ at the Pool of Bethesda*. Finally, the *Gathering of Manna*, a type of the sacrament of the Eucharist, was surrounded by ovals showing *Elisha Multiplying the Bread*, *Elijah Fed by the Angel*, the *Passover* and wall paintings of the *Last Supper* and the *Miracle of the Loaves and Fishes*. In addition, adjacent to the north wall, Tintoretto painted the key oval showing the *Temptation of Adam*, the Genesis story which put all the others depicted in play. Despite its relatively small size, the introductory importance of this canvas is

Diagram 2
Sala Superiore, Scuola Grande di San Rocco

1 *Brazen Serpent*
 (illus.154)
2 *Moses Striking the Rock*
 (illus.160)
3 *Gathering of Manna*
 (illus.162)
4 *Temptation of Adam*
 (illus.170)
5 *Vocation of Moses*
 (illus.167)
6 *Pillar of Fire* (illus.163)
7 *Jonah and the Whale*
 (illus.164)
8 *Vision of Ezekiel*
 (illus.168)
9 *Jacob's Ladder*
 (illus.169)
10 *Sacrifice of Isaac*
 (illus.165)
11 *Elisha Multiplying the
 Bread*
12 *Elijah Fed by the Angel*
 (illus.166)
13 *Passover*
14 *Abraham and
 Melchizedek*
15 *Daniel in the Lion's Den*
16 *Elijah on the Burning
 Chariot*
17 *Cain and Abel*
18 *Samson Draws Water
 from the Ass's Jaw*
19 *David Anointed by
 Samuel*
20 *Moses Saved from the
 Waters*
21 *Three Young Hebrews in
 the Furnace*
22 *St Roch* (illus.157)
23 *St Sebastian* (illus. 159)

24 *Adoration of the
 Shepherds* (illus.172)
25 *Baptism of Christ*
 (illus.176)
26 *Resurrection of Christ*
 (illus.178)
27 *Agony in the Garden*
 (illus.179)
28 *Last Supper* (illus.182)
29 *Miracle of the Loaves
 and Fishes* (illus.187)
30 *Raising of Lazarus*
 (illus.189)
31 *Ascension of Christ*
 (illus.190)
32 *Pool at Bethesda*
 (illus. 191)
33 *Temptation of Christ*
 (illus. 171)

emphasized by the inclusion of two related wall paintings below, showing the *Adoration of the Shepherds* and the *Temptation of Christ* (Diagram 2).[11]

The entire cycle is thus conceived as preparatory to, and explanatory of, the cycle featuring the Passion of Christ in the *albergo*. The emphasis is on deliverance from the original sin of Adam and Eve through Christ's sacrifice, with particular reference to the most important Christian sacraments of Baptism and the Eucharist. In this latter emphasis, the iconography of the cycle is like an elaboration of the kind of programmes Tintoretto had so often painted in the chapels of the Sacrament of Venetian parish churches. These often featured a pairing of subjects such as *Christ Washing His Disciples' Feet* (see illus. 67) and the *Last Supper* (see illus. 20), referring to divine cleansing and feeding. Although the Sala Superiore at San Rocco had an altar, it was not specifically a place where the reserved monstrance was kept and displayed. It may be, though, that the adaptation of the sacramental imagery first developed by the Scuole del Sacramento was a deliberate one, intended to supply the Sala with a similar aura of purified piety and religious devotion.[12] At the same time, the iconography also refers more broadly to Christian charity in its socially active sense (*amor proximi*) illustrating three kinds of Christian deliverance from thirst, hunger and death. Despite its universality, this could be read as a restatement of the basic tenets of the Scuola, affirming its active engagement in the acts of corporeal mercy which Caravia noted as having been ignored. Although submerged beneath the vastness of the historical and symbolic schema, the Scuola's duties to the poor were thus inscribed at the very heart of the iconography developed for the Sala Superiore.

In arriving at this programme, Tintoretto and the learned brothers of the Scuola were not closely dependent on any one literary text. Their approach was clearly flexible and eclectic, taking ideas from a broad range of written sources. Thus a similar emphasis on Old Testament/New Testament concordance is evident in the Catholic Reformist exigetical literature of religious orders such as the Capuchins, as it is in the preaching manuals developed by the Dominicans for the teaching of the poor and illiterate. But the particular typologies favoured in the Dominicans' *Biblia pauperum* are not closely replicated in the iconography at San Rocco. Tintoretto's imagery is often related to lay religious literature, such as Pietro Aretino's dramatic *Humanità di Christo* (1534), but the high-pitched tone and close physiognomic detail typical of works such as this again make the connection with Tintoretto's paintings rather forced.[13] It is clear, though, that the iconography actively fostered an ambiguity in its range of reference, playing on the overlap between the Scuola's institutional functions and those of the Catholic Church itself. Such an approach challenged the more narrowly site-specific references favoured in the earlier decorations of Venetian confraternities, offering to ally the Scuola di San Rocco with the institutions of Catholicism more generally. As part of its effort of self-definition in the Venetian domain, the Scuola sought to tap the wider spiritual authority of the Catholic Reformation.

The Sala Superiore Ceiling

Among the Gospels, Tintoretto particularly drew on St John.[14] It is here that we find the typological connection determining the choice of the *Brazen Serpent* for the central ceiling panel in the Sala (illus. 154): 'And as Moses lifted up the serpent in

154 Jacopo Tintoretto, *The Brazen Serpent*,
1575/6, oil on canvas, 840 × 520.
Scuola Grande di San Rocco, Venice (Sala Superiore).

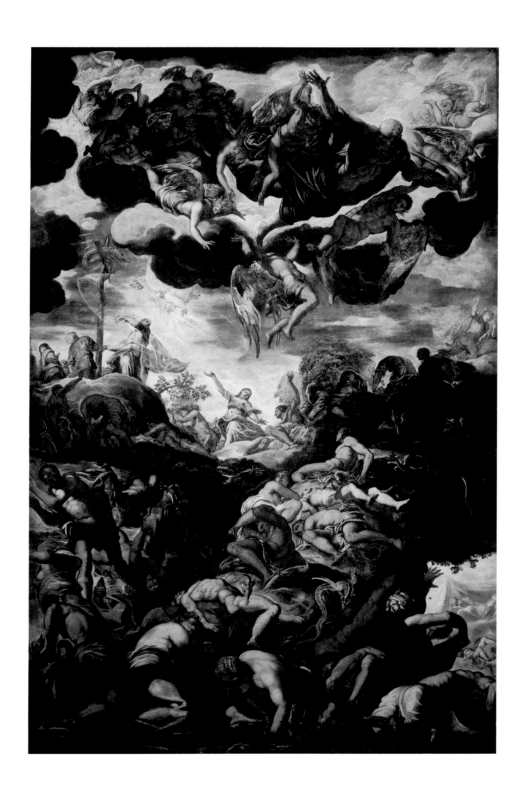

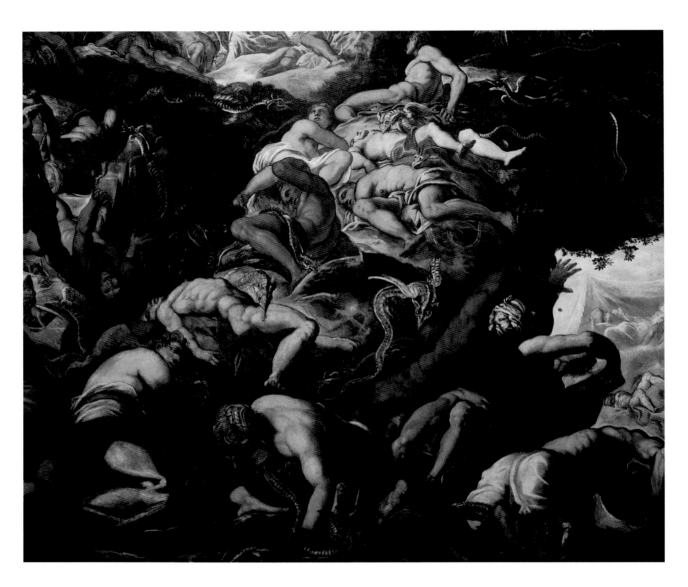

the wilderness, even so must the Son of man be lifted up: that whosoever believeth in him should not perish, but have eternal life' (John 3.14–15). John refers here to Numbers 21.5–9, which tells how God sent 'fiery serpents among the people'. It is noticeable that two of the foreground Israelites in Tintoretto's painting are bitten on the inner thigh, the place where the plague-spot initially appears,

and where it is conventionally shown as the identifying attribute of St Roch. This gives a further clue with regard to the choice of the *Brazen Serpent* for the central panel. Venice was gripped by a particularly savage outbreak of plague in 1575–6. But if Tintoretto's Israelites are to be likened to the plague-stricken Venetians, then it is also clear that their fate is in both cases to be understood as an act

156 Jacopo Tintoretto, *Last Judgement*, c. 1560/2,
oil on canvas, 1,450 × 590.
Madonna dell'Orto, Venice.

157 Jacopo Tintoretto, *St Roch*, 1578/81,
oil on canvas, 250 × 80.
Scuola Grande di San Rocco, Venice (Sala Superiore).

of divine retribution for their sins. In the Bible, the plague of serpents was brought on by those who 'spake against God and against Moses' (Numbers 21.5), while in sixteenth-century Venice the plague-sufferer carried his disease like a sign of the devil.[15]

The Israelites are attacked by devilish snakes, their stings a direct result of their disobedience to God (illus. 155). Tintoretto undoubtedly drew here on harsh Pauline metaphors such as 'the sting of death is sin and the strength of sin is the law' (1 Corinthians 15.56). The central ceiling panel thus sets a stern moral and apocalyptic tone in the Sala, one which was only to be softened in the scenes from the Life of Christ below. The 1575–6 outbreak was widely seen as a kind of forerunner of the Last

Judgement itself, and this connection would have encouraged the emphasis on God's punishment in the lower foreground of the composition.[16] Tintoretto recalls his own earlier painting of the *Last Judgement* (illus. 156) in this tumbling group (for example, in the upturned screaming female face at the left in both paintings) which appears to fall (the figural movement, as so often in the cycle, tracing a spiritual one) directly out of the bottom of the painting. Only the submerged reference to St Roch, intercessor against the plague and patron saint of the Scuola, gives some cause for hope. Tintoretto subsequently depicted *St Roch* himself in a painting on the end wall of the Sala, staring anxiously upwards at the writhing figures in the ceiling panel, as if to make his intercessory role clear (illus. 157).

The struggling foreground figures (with shadowed faces pointedly averted from Moses' redemptive serpent and from the judgemental figure of God himself) constantly remind the viewer of the formal complexities of antique and Renaissance art. But as if intent to distance himself from formal dependence on such pagan sources, Tintoretto carefully avoids any direct classical references. Thus the male figure in the central foreground with his bent arm raised behind his head might remind us of the *Laocoön* (the Hellenistic sculpture rediscovered in Rome in 1506), a subject which features a Trojan priest and his sons attacked by snakes (illus. 158).[17] The reference is, though, more pronounced in the figure of the other plague saint featured in the Sala, *St Sebastian*, which Tintoretto painted next to *St Roch* on the wall below (illus. 159). It is still more difficult to find close formal analogies for the *Brazen Serpent* in famous works such as Michelangelo's *Last Judgement* or his ceiling pendentive showing the *Brazen Serpent*, both well known in Venice by 1575 through reproductive prints. Rather, Tintoretto makes one body become a mere predicate of the next, partial repetition becoming more significant than power of contour or variety of posture. The famous integrity of Michelangelo's individual form

is undermined by Tintoretto's attention to its place within the wider visual sequence. The figures in the lower foreground writhe under the force of almost impossible torsions and foreshortenings, but are not used as a licence for purely formal display. In accordance with post-Tridentine morality, their genitals are studiously covered, while their surface coloration is contrasted to suggest the onset and progress of snake poison in their flesh.[18]

The enlightened Israelites placed above and beyond this disturbing figural pyramid effectively point the moral contrast. A seated figure stares up at Moses' crucified serpent and is cured. Beyond him, a similarly posed figure, with left arm raised, acknowledges its redemptive power, and his gesture is repeated by several others nearby, in each case mirroring that of God the Father and his swarm of angels above. Such connections are typical of the simplified gestural rhetoric of the cycle, the commonplace human movement of recognition gathering symbolic resonance through its repetition by mortal and immortal alike. The raised arm in the *Brazen Serpent* (which has a source in Titian's foreground Apostle in the Frari *Assumption*, see illus. 57) became a leitmotiv in the Meeting House (see illus. 162, 167, 172, 202). At the same time, God the Father is a development of the Sistine-derived figure in the *St Roch in Glory* (see illus. 132, 134), reiterating in formal terms the thematic connection with the *albergo* cycle. His paternity of Christ is suggested by the simple reversal of his figure in the wall painting showing the *Resurrection of Christ* below (see illus. 178). In this way Tintoretto's limited formal morphology takes on a deeper semantic potential, the Mannerist habit of repeating formal types reinforcing iconographically significant connections between paintings.[19]

159 Jacopo Tintoretto, *St Sebastian*, 1578/81,
oil on canvas, 250 × 80.
Scuola Grande di San Rocco, Venice (Sala Superiore).

The composition in the *Brazen Serpent* superficially suggests that space flows from below to above, establishing continuity with the viewer's position beneath. But the overall effect of Tintoretto's 'stepped' composition is nonetheless disjunctive and disunified. Details such as the view to the distant camp of the Israelites at the lower right undermine the spatial logic, splintering the scene into semi-independent units. Clear recession from the picture plane is also made uncertain by the contrasting mirror movements of the figures into and out of depth. Our perception of pictorial space is, though, largely dependent on these twisting bodies, given that the landscape itself is radically reduced. In this way, Tintoretto departed from the underlying assumption of Renaissance perspective theory that (in the words of Pomponius Gauricus in 1504) 'the place exists prior to the bodies brought to the place and therefore must be defined linearly'. But this departure was in part made possible by Tintoretto's understanding of the particular conditions attached to the painting type. Unlike the frescoed vaults favoured on the Italian mainland, Venetian ceilings were painted on to flat wooden surfaces, a fact which tended to move the painter's primary commitment away from unified linear perspective towards the more abstract decorative value of the surface plane. While it is true that vault-style *dal sotto in sù* arrangements became more common in Venetian ceiling painting after 1550, the type remained peculiarly open to spatial experiment beyond the usual boundaries of Renaissance illusionism.[20]

Tintoretto's ceiling paintings were set into a lavish wooden surround, featuring ornate patterning and mouldings including complex interlocking friezes and compartments, garlands and bosses with carved heads. In response, the painter produced

broken surfaces dominated by dispersed showers of golden light. Despite the impression of underlying Michelangelesque bulk in certain figures, this does not typically survive the surface treatment, formal mass being splintered into semi-transparency by the luminous brushwork. The effect is to generate painted surfaces that are analogous to the intensely decorative gilt relief structures surrounding them. In other ways, however, Tintoretto's paintings rebel against the decorative constraints of their setting. In many examples, cut-off forms, figural twists and irrational spatial plunges defy containment within the alloted frame, while the irregular and improvised brushwork seems ready to mock the careful *disegno* and orderly detail so apparent in the composition of the surround.[21]

Space can be plotted only through its momentary recessions in individual bodies, rapidly dissolving beyond their uncertain contours. This is not to say that it is denied – as Schulz has noted, Tintoretto's ceiling generates a sense of spaciousness unprecedented in Venetian paintings of this type – but rather that it is no longer tied to a single unifying principle. This more subjective conception (akin to Panofsky's notion of a pre-Renaissance 'psycho-physiological' spatiality) opened the way to the experimentation in this area so characteristic of the San Rocco cycles.[22] Within Tintorettesque space, form functions as a kind of reduced visual pointer, establishing connections not only between the constituent parts of each composition, but also between one painting and another in the cycle. At the same time, its release from the demands of a wider spatial continuum allowed Tintoretto to break up compositions in new ways, space becoming episodic jn nature and supportive of the kind of simultaneous narrative technique we have already

noted in the *Crucifixion* (see illus. 139). By loosening space from an underlying rational or objective principle, Tintoretto was also able to explore, in certain paintings, its visionary potential. In these works, pictorial space is no longer in the service of naturalism, functioning instead as an aid to the visualization of inner psychic experience.

The gravity-defying quality of the *Brazen Serpent* was to set the tone for all the ceiling paintings which followed. These are typically set in a distinct spiritual realm governed less by naturalistic laws than by divine interventions against them. The central panel also established the chromatic tone for the ceiling, the flashing chiaroscuro treatment exacting a perceptible withdrawal from the strong local colour and decorative elaboration of the *albergo* ceiling. Although colours still survive (crimsons, blues and greens lurk beneath the luminous veil), the new priority afforded to light and shadow both limits their effect and opens up symbolic possibilities. Once more, the Gospel of St John is perhaps the most significant literary source here, with its constant play on the fundamental metaphor 'God is light'. In keeping with biblical tradition, light becomes an attribute of the divine order evoking a direct association with the Logos and indicating the infusion of grace. The assertively supernatural quality of Tintoretto's light at San Rocco undoes the more typical balance between the symbolic and naturalistic potentials evident in earlier Venetian painting.[23]

The two other large ceiling paintings Tintoretto completed in 1576–7 were evidently conceived in the light of the great *Brazen Serpent* at the centre, sharing its vast scale and stern moral tone as well as its bold spatial divisions and dramatic chiaroscuro treatment. In the *Moses Striking the Rock* (illus. 160)

160 Jacopo Tintoretto, *Moses Striking the Rock*, 1576/7,
oil on canvas, 550 × 520.
Scuola Grande di San Rocco, Venice (Sala Superiore).

has been painted. At the same time, they allow Tintoretto to control (in didactic fashion) our apprehension of the narrative subject.

The prominent figure of the reaching man at the lower left, viewed from behind and below, draws the eye rapidly into space, linking lower foreground with upper background. At the same time, his form establishes wider formal analogies beyond the specific painting (illus. 162, 172), the figural repetitions helping to bind the cycle together on a visual level, while also suggesting the intertextuality of its religious subject-matter. In the secondary battle scene beyond, the abbreviations in Tintoretto's manner are more obvious still (illus. 161) The very loose technique adopted here, consisting entirely of boldly sketched highlights, only superficially refers to the optical reality of atmospheric perspective. Tintoretto's habit of composing in paint is particularly evident, the articulation of form becoming one with the rapid motion of the brush, the pale-pinkish tones giving a view into a transformed reality free of chiaroscuro definition. Here we witness the next episode in Exodus, that showing the battle of Joshua and Amalek (Exodus 8.16). The narrative combination intensifies the picture's meaning, but the luminous treatment of the future scene alters its status away from linear narrative progression. It is included only to further illuminate the meaning of the main scene: the miracle of God's intervention against the thirst of the Israelites is analogous to a military victory in the battle against evil. As is the case elsewhere in the cycle, Tintoretto's experimental technique has its roots less in visual realities than in his desire to intensify the poetic expression of his given subject-matter.

Tintoretto's final large painting for the ceiling, showing the *Gathering of Manna* (illus. 162), is

space is once again made an issue of specific form, the outsized figure of God the Father at the upper right, like the equestrian figures beyond, generating a pocket of subsidiary space which cannot be rationally connected with that containing Moses and the drinking Israelites. But rather than drawing attention to itself, God's massive form is simplified, a means of drawing the viewers' eye to the miracle of the spurting rock. In this sense God is like the foreground figures, whose physiognomies are partially (or fully) hidden to facilitate rapid movement through their forms. Techniques such as these, when combined with the abbreviations of the chiaroscuro, help the viewer to apprehend the form quickly, with the same kind of rapidity with which it

162 Jacopo Tintoretto, *Gathering of Manna*, 1576/7,
oil on canvas, 550 × 520.
Scuola Grande di San Rocco, Venice (Sala Superiore).

163 Jacopo Tintoretto, *Pillar of Fire*, 1577/8,
oil on canvas, 370 × 265.
Scuola Grande di San Rocco, Venice (Sala Superiore).

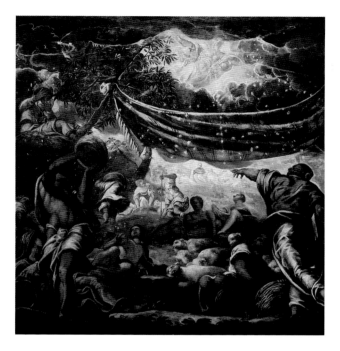

constructed around three prominent figures, all of
which refer to others in the series: Moses, now at
lower right, takes up a position which repeats an
earlier scene in his own narrative (illus. 163), while
to the left the twisting figure with the basket is a
development of the foreground Israelites catching
water in similar baskets in *Moses Striking the Rock*
(illus. 160). Finally, God the Father, now glimpsed in
a kind of transfigured glory above the tent (perhaps
an allusion to the canopy in the Temple of Jerusalem
or to the tablecloth of the Last Supper), is a
reworking of the Sistine-derived figure in the
Brazen Serpent (illus. 154).[24] These three great
figures, (God, Moses and a recipient of their
leadership and charity) establish a simple pyramidal

framework for the composition which also has a
wider thematic resonance.

In their epic tone and formal complexity, the
large central canvases contrast greatly with the ten
ovals which Tintoretto painted in 1577–8 to further
elucidate the central themes of sacrifice and
redemption.[25] The smaller among these ovals were
painted at speed, typically featuring a cast of two or
three dominant figures placed at or near the picture
surface. In works such as the *Vocation of Moses*
(illus. 167) and the *Pillar of Fire* (illus. 163) the
bulky figures are reduced to near-silhouettes, and are
set against extensive areas of undefined diaphanous
brushwork. But these ovals are nonetheless
characterized by a new sense of intimacy and

164 Jacopo Tintoretto, *Jonah and the Whale*, 1577/8,
oil on canvas, 265 × 370.
Scuola Grande di San Rocco, Venice (Sala Superiore).

165 Jacopo Tintoretto, *Sacrifice of Isaac*, 1577/8,
oil on canvas, 265 × 370.
Scuola Grande di San Rocco, Venice (Sala Superiore).

possess a psychological edge missing in the larger canvases. While physiognomies continue to be concealed, this does not lessen the sense of intense communication or dramatic interchange between the protagonists. In the *Jonah and the Whale* (illus. 164), for example, Jonah's confident stride out of the jaws of the sea monster takes him to within inches of God himself. Such a proximity is, in fact, a privilege of many of the Old Testament heroes who feature in the ceiling paintings, physical closeness expressing the idea of spiritual communication and understanding. God is typically on intimate terms with his human subjects, but he is also presented as a rational being, counting on his fingers (in the *Jonah*) the meaning of the miraculous occurrences he has caused in the manner of a rhetorician. The key biblical metaphor of God as Word is here expressed quite literally by his readiness to speak. In the *Sacrifice of Isaac* (illus. 165), Abraham's head is placed very close to the face of the restraining angel. In this example, the idea of the merciful hand of God is visualized by the angel's delicate restraining touch on Abraham's right arm, an action which

echoes the tenderness of the father's own protective clasp of his son's shoulders. At the same time, Abraham's open-armed posture cannot help but remind us of the crucified Christ himself, whose readiness for sacrifice he has just emulated.

In ovals such as *Elijah Fed by the Angel* (illus. 166), the scene is more intimate still, focusing on a moment of divine revelation. Despite the presence of large loaves of bread, we cannot doubt that the feeding here is of a spiritual kind, less a physical than a mental event. In the *Vocation of Moses* (illus. 167), bodily movement is almost stilled and sudden foreshortenings are avoided. Instead, Tintoretto suggests Moses' all-important interchange with God by means of subtle inflections of posture and response. At the same time, the simplified forms of the two protagonists, placed close to the picture plane, respond to the ovoid shape, their interlocking figures brought still closer by the endless rotating movement suggested by the curving edges of the frame. The formal delicacy of such panels is often missed by those who notice only the theatrical bombast of the larger paintings.

166 Jacopo Tintoretto, *Elijah Fed by the Angel*, 1577/8,
oil on canvas, 370 × 265.
Scuola Grande di San Rocco, Venice (Sala Superiore).

167 Jacopo Tintoretto, *Vocation of Moses*, 1577/8,
oil on canvas, 370 × 265.
Scuola Grande di San Rocco, Venice (Sala Superiore).

In the two elongated ovals to either side of the
Brazen Serpent, Tintoretto combines intimate
elements from the small paintings with something of
the epic scope and formal complexity of the huge
central canvas. The *Vision of Ezekiel* (illus. 168)
functions as a kind of mediator (both visual and
thematic) between the *Brazen Serpent* (illus. 154)
and the *Resurrection of Christ* (see illus. 178).
Ezekiel, like Moses, witnesses an act of bodily
resurrection, while his gesture also mirrors that of
the angels who open Christ's sarcophagus in the wall
painting below. The position of the painting over the
midpoint of the Sala probably encouraged
Tintoretto to show prophet and God the Father

from opposing points of view. But the formal
inversion also expresses the subject matter, in which
natural logic is itself reversed as God brings the
dead to life. At the same time, the parallel gestures
of the two protagonists make a theological point.
The prophet is God's chosen instrument and is thus
the mirror of his maker.

In the related oval on the opposite side, showing
Jacob's Ladder (illus. 169), the ladder is shown as an
ethereal staircase retreating past angels and clouds to
the tiny figure of God. But unlike the illusionistic
steps in the *Ecce Homo* (see illus. 149) these are
purely visionary. We witness Jacob's vision *as vision*,
its status as a purely mental conception emphasized

168 Jacopo Tintoretto, *Vision of Ezekiel*, 1577/8,
oil on canvas, 660 × 265.
Scuola Grande di San Rocco, Venice (Sala Superiore).

169 Jacopo Tintoretto, *Jacob's Ladder*, 1577/8,
oil on canvas, 660 × 265.
Scuola Grande di San Rocco, Venice (Sala Superiore).

by his sleeping posture and by his position at the
foreground margin of the picture space, with his
back turned to the fantastical scene beyond.
Tintoretto's composition may have been influenced
here by Catholic teaching on visionary experience,
referring to the Thomist idea that the measure of
God-inspired vision (*visio intellectus*) was its distance
from anything actually seen. As such, the non-
naturalistic treatment of the oval is an argument in
favour of the divine truth of the vision shown.
The presence of the visionary himself immediately

subjectivizes the image, making it appear as an
externalization of Jacob's spiritual experience.
But the visionary is also a communicator, his inner
experience a matter of vital significance for the
Christian community. His mediatory role is well
expressed by his position at the extreme forward
plane of the picture, a guardian at the entrance into
the visionary world.[26]

 Tintoretto's development of the imagery of
visions in the San Rocco cycle was no doubt
encouraged by the increased emphasis on meditative

170 Jacopo Tintoretto, *Temptation of Adam*, 1577/8,
oil on canvas, 265 × 370.
Scuola Grande di San Rocco, Venice (Sala Superiore).

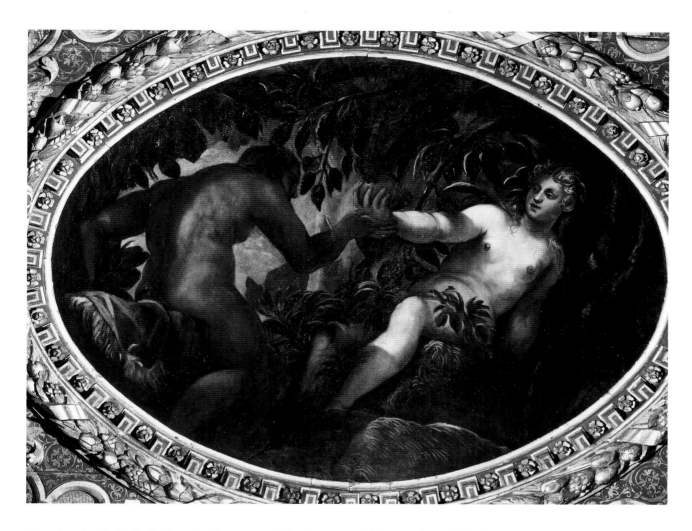

devotion in Catholic Reformist literature of the later sixteenth century. Alongside famous devotional texts such as those of St Teresa of Avila, St John of the Cross and Ignatius Loyola, one can also notice more local works such as Mattia Bellintani's *Practica dell'orazione mentale*, published in Brescia in 1573, which Tintoretto would surely have known.[27] In the context of the Scuola di San Rocco, Jacob's example, like that of the similarly isolated dreaming figure of Moses in the foreground of the *Vocation of Moses* (illus. 167), or of the Apostle in the *Ascension of*

Christ on the wall below (illus. 190), could stand as a model for individual devotional experience. But the emphasis on inward visionary experience need not be taken as contradicting the shared communal or popular aspects of Christianity so apparent in other parts of the cycle.

At the furthest point from the Sala altar, but near to the *albergo*, the oval showing the *Temptation of Adam* (illus. 170) was to have a pivotal role in the iconography of the Meeting House. The Fall of Man set in play all the extensive Old and New Testament

171 Jacopo Tintoretto, *Temptation of Christ*, 1578/81,
oil on canvas, 539 × 330.
Scuola Grande di San Rocco, Venice (Sala Superiore).

narratives of sacrifice and redemption depicted in the Sala, and finally made necessary the Passion cycle with its culminating image of the *Crucifixion* (see illus. 139). As in the great *albergo* painting, Tintoretto approached the theme with reference to his own earlier work, this time drawing on the imagery developed in the painting from the Genesis cycle in the Scuola della Trinità of *c*. 1550–53 (see illus. 81). In this wall painting, Tintoretto had, in typical fashion, developed a diagonally slanted composition with Adam at the foreground left and Eve behind him to the right. This basic idea is followed in the San Rocco painting. Adam's body is likewise turned into the picture space, as if in analogy to the position of the spectator himself, who is, like his First Parent, always open to temptation. On the other hand, the new demands of the picture-shape generate certain important modifications. Adam's proximity to the edges of the oval is emphasized by the conformity of his contours to the steep upward curve of the frame. But the physical distortion this echoing line produces reduces Adam to a kind of crouching proto-human, suggestive of his half-formed state before tasting the apple from the Tree of Knowledge. Adam's full transformation into Man will, paradoxically, be achieved only by his fall from innocence.

To this extent the scene of the Original Sin is conceived in a positive light, as a kind of 'necessary fault' (*felix culpa*) to secure Man's final redemption by Christ.[28] Tintoretto's shadowy and animalistic Adam, who has not yet tasted the apple, falls outside of all significant human history. As such he provides a contrast with the sophisticated beauty of the fallen Eve. It is the specifically sexual allure of her strongly lit body which pulls (as if by an inevitable gravitational force) the half-formed Adam into the picture space. But if he will shortly be humanized, then he will also be trapped. The radiant form of Eve is, after all, surrounded by the coils of the huge serpent, her alluring form no more than a cover for reptilian horrors. As in the Trinità painting, her reclining figure, replete with blond tresses, prominent nipples, open mouth and half-closed eyes, seems deliberately to recall earlier Venetian depictions of Venus (see illus. 73). But if Eve is thereby elided with the classical goddess of love, her *all'antica* beauty is, in the moralized context of the San Rocco cycles, no more than a mask concealing the forces of evil.

Tintoretto uses a similar device in the related wall painting below showing the *Temptation of Christ* (illus. 171).[29] Here, of course, Christ reveals his divinity by his ability to resist the devil's temptations. But the devil is not shown in his usual ugly guise, as a hideously deformed reptile. Rather, he appears centre-stage as a gravity-defying angel whose tempting beauty recalls the common types of classical statuary which had so inspired Tintoretto in his early period. The association of the classical canon of beauty with corruption and evil in the paintings under discussion was to form a kind of expressive keynote for the rest of the cycle in the Meeting House, clearing the way for the promotion of a newly purified spiritual ethos. Such a conception can easily (but not specifically) be related to the severe and ascetic religious climate of the Catholic Counter-Reformation. Developing the Council of Trent's warning against the undue worship of images in its final session of 1563–4, theologians such as Paleotti and Possevinus attacked the love of pagan imagery, asserting that the saints were displeased to see 'Jupiters, Venuses, and other unclean beings recalled from the infernal regions'.[30]

In its immediate institutional context, Tintoretto's demonizing of classical imagery formed part of the answer to the contemporary criticisms of the Scuola's worldly vanity. It also placed the artist in an antagonistic relation to the classicizing values that had been an underlying feature in the work of the painters such as Titian and Veronese. Reference to these values is now no more than an occasion for ironic inversions revealing the superficiality of the appeal of pagan art and its basis in sinful concupiscence.

The Sala Superiore Wall Paintings

Tintoretto began the cycle of ten wall paintings with the *Adoration of the Shepherds* (illus. 172), the scene showing the arrival of Christ on earth, the initial event leading finally to Man's redemption from Adam's Original Sin, as shown in the oval above.[31] As in the *albergo* wall paintings, the change in tone from the ceiling paintings is very marked, although this time the shift is from the heroic supernatural drama of the Old Dispensation to the understated naturalism of the New Dispensation. Certain of the genre elements Tintoretto includes are, of course, wholly traditional to depictions of the scene (illus. 173). The ox and the ass, for example, were ever-present indicators of Christ's humility at the Nativity, given their specific mention in the literary sources for the scene (the eighth-century Gospel of Pseudo-Matthew includes these animals based on Isaiah's Old Testament prophecy 'the ox knoweth his owner and the ass his master's crib'). The symbolism of the peacock and the eggs is equally conventional, the former referring to the new-born Christ's immortality (given that its flesh was thought never to decay), the latter (developed through the imagery

of cock and hen, egg baskets and the offering to Christ by the foreground shepherd) a reference to his Resurrection.

Other details of the rustic environment, such as the foreshortened ladder and the cross-like beams of the roof, may refer to the scene of Christ's Crucifixion shown in the *albergo*. But these symbolic and formal associations are held in check by the fullness with which the accommodating farmyard is described. Tintoretto's attention to detail in such paintings has even led one recent commentator to describe his manner at San Rocco in terms of 'Franciscan naturalism'. The observation is an important one, given its suggestion that this naturalism had its basis in an older theological concept. The painter's more general development of the theme of sacred poverty through the cycle must have taken its cue, if only in a general way, from the equation of poverty with holiness central to the ethos of the mendicant orders. After all, the Venetian Ca' Grande of the Franciscan Order was situated within yards of the Meeting House in Santa Maria Gloriosa dei Frari. Giovanni Bellini and Titian had worked directly for this Venetian house. But their Franciscan paintings can hardly be said to have provided the inspiration for Tintoretto's rustic intimacy of the San Rocco *Adoration*. For this Tintoretto had to look once more beyond Venetian monumental painting altogether to the prints of Albrecht Dürer, and in particular to his engraving of the *Nativity* (illus. 174), which also features an open cross-section into a rustic dwelling, with foreshortened cross-beams.[32]

But as the issue of a religious concept, the humble naturalism of the *Adoration* is carefully constructed. The subdued colour and flickering chiaroscuro are not strictly realistic, nor is the

172 Jacopo Tintoretto, *Adoration of the Shepherds*, 1578/81,
oil on canvas, 542 × 455.
Scuola Grande di San Rocco, Venice (Sala Superiore).

173 Jacopo Tintoretto, detail of illus. 172.

174 Albrecht Dürer, *Nativity*, engraving, 1504, 18.5 × 12.

elaborate arrangement of the composition. The verticality of the given picture-shape in the ten wall paintings is a result of their placement between the Sala's wide double-mullioned windows (see illus. 152). Tintoretto recognized the possibilities that this architectural constraint afforded him, creating vertical compositions which provide a clear link with the ceiling paintings above. As we have seen, the scenes from Christ's life were chosen to generate iconographic concordances with the ceiling and thus are not intended to be read as part of a lateral sequence progressing round the walls. Each painting is to this extent independent of the next, conceived as a separate entity rather than as part of a continuous narrative. Tintoretto's cycle was freed from the lateral scansion standard in scuola narrative painting in Venice, where the viewer's eye moves across the painting from left to right, and one image

is closely tied to the next.[33] The movement from lower foreground to upper background in the San Rocco paintings reveals, instead, the pull of the ceiling paintings above. This difference encouraged Tintoretto both to conceive his compositions in depth and to extend them over the whole extent of the picture field.

In the *Adoration*, space is effectively compartmentalized by the presentation of the Bethlehem stable as a two-storey building seen in cross-section, with the Holy Family placed in the upper area. Technical examination has shown that this idea was in Tintoretto's mind at a very early point, given that myriad tiny canvas pieces are sewn together to form the forward edge of the revealed section of the floor.[34] As viewers, we enter the painting from below, our position indicated by the foreshortened ladder, seeming to share the

amorphous forward space occupied by the peasants and their animals. These humble figures become exemplary for the viewer, indicating that we should emulate their worshipful postures and pious *ex voto* offerings. Although the particular significance of the Holy Family is suggested by their elevated position, their presentation is carefully understated so as not to contradict the communal ethos of the stable (illus. 175). They share the upper level with two serving women. Rather than the midwives of apocryphal tradition and Byzantine painting, these lowly figures might merely be included to reinforce the sense of commonality established in the lower foreground, extending the examples of pious devotion and charitable offering featured there. While the Virgin raises the Christ child's veil in readiness, the foremost woman approaches to wet-nurse him. The incipient transfer of the body of Christ may

also conceal a eucharistic reference to the instances of divine feeding prominent elsewhere in the cycle.

The figure of Christ himself is unusually small, our view of him limited by the acute viewing angle. Despite the large areas of shadow, the *Adoration* is not unambiguously shown (as it often was in Venetian painting) as a night scene.[35] For although Christ certainly glows, other strong highlights are spread evenly through the painting, picking out the Virgin's headdress, the female figures to the left and various details in the lower level below. At other points (the standing woman's right hand, the head of the seated shepherd to the left) the effect is reversed, with darkened limbs creating silhouettes against lighter backgrounds. But in each case, the lighting is localized and unexplained by the wider scheme of the painting. Neither can such effects be attributed to the fiery orange light that hovers above the complicated cross-

beams of the roof, whose supernatural source is indicated by the cherubims inscribed within it.

The chiaroscuro allows the painter to control our perception of the composition, and at the same time to radically simplify the effect of the massive and complex forms presented. The movement of broken highlights painted with a broad, dry brush across the surface of darkened compositions was to become a hallmark in the wall paintings. The effect reflects Tintoretto's use of black or dark-brown pigment-based grounds (rather than the more standard pale gesso) as a preparation for his canvases. This choice, which has very few parallels in the practice of other Venetian painters, may have been a response to his contractual commitment to paint quickly. For if the conventional gesso preparation typically required extensive coloration, this was not the case with a dark ground which could, if necessary, be left unworked to suggest shadow. If Tintoretto's dark grounds offered an opportunity to save time, they also offered new stylistic possibilities, integrating well with a painting manner based fundamentally on chiaroscuro rather than coloristic elaboration. It has been rightly noted that Tintoretto's style was not necessarily an issue of his use of dark grounds: the brightly coloured organ shutters in Madonna dell' Orto were worked up from a dark ground (see illus. 27), while the lowering chiaroscuro of the *Last Judgement* in the same church was painted on pale gesso (see illus. 156). But if, in this earlier period, the painter had not yet realized the possibilities offered by the new technique, by the time he was at work in the Sala Superiore of San Rocco, dark grounds had become more integral to his style, the preparation having a definite impact on the radically reduced manner of painting he developed.[36]

The relative independence of each composition on the walls of the Sala Superiore is readily apparent from the *Baptism of Christ* (illus. 176) to the right of the *Adoration*.[37] But while this work shares little of the cosy naturalism of the latter, it nonetheless develops certain of the first picture's techniques and themes. The composition is governed by the onrush of golden heavenly light at the top of the picture which both reduces and transforms the landscape and figures below. As in the ceiling paintings, light is here the direct issue of the divine order and effectively reduces the world to its spiritual schema. The sudden influx conversely throws much of the world into darkness, as if to expose its sinful reality. Shadow, in this conception, is less the complement of light than a separate opposing entity, a manifestation of fallen nature. Tintoretto's revival of this age-old notion of light as a kind of revelatory moral value gives works such as the *Baptism* an apocalyptic quality and may even intimate the final judgement to follow.[38] The landscape is shown only in its bare essentials: the irregular edge of an undefined rock-face at the right divides the forward planes from the banks of the River Jordan beyond. Here we see anonymous semi-nude figures drying themselves after Baptism. But once again their complex forms are only glimpsed beneath the prevalent veil of shadow. While the pose of the man to the left suggests that of a classical river god (the Jordan was symbolized by such a figure in early representations of the theme) any hint of purely aesthetic display is studiously suppressed. An unexplained pocket of light illuminates profile and breast of a mother suckling her child, as if to point the moral of the narrative as Christ's charity.

While it may be that the dark ground used in the *Baptism* has become too prominent (the pigmentation turning transparent over time), its creative use in support of Tintoretto's didactic

176 Jacopo Tintoretto, *Baptism of Christ*, 1578/81,
oil on canvas, 538 × 465.
Scuola Grande di San Rocco, Venice (Sala Superiore).

John's reed cross placed above him and by the presence of the swooning Virgin on the far bank of the river beyond.

The *Baptism* is marked by a kind of expressive restraint which eschews the values of outward drama and pictorial display. This also has a technical dimension. The colours chosen (browns, ochres and creams) are close to one another on the colour scale, basic earthy tones (one thinks again of St Francis's matrix symbol of the *humus*) which typically support the large undefined areas of rock, water and clouds where the preparatory ground is revealed. Those crimsons and roses which occasionally glow through the murk are the so-called lake pigments which Tintoretto favoured throughout the cycle. He may have procured these pigments cheaply, as they were a by-product of the local dyeing industry to which his father and many of the brothers at San Rocco belonged.[40] Expensive pigments such as ultramarine blue are little in evidence: it is fair to say that the painter sought to suppress the conventional conflation of pigment quality with high spiritual status. Tintoretto may have continued to use expensive lapis lazuli, on occasion, throughout the cycle. But he did so in progressively smaller quantities, the final cycle in the Sala Terrena containing relatively little of the pigment. Such a technical reduction may have supported his developing conviction that displays of outward *richezza* were incompatible with inward Christian virtue.

Tintoretto's love of antithesis is, though, revealed by the *Resurrection of Christ* (illus. 178) to the right, a work which certainly limits the value of generalizations about the expressive tone of the Sala Superiore.[41] With its bold emphasis on the supernatural power of Christ, visualized through an

chiaroscuro is nonetheless very clear in this instance. By engulfing the foreground in shadow and allowing an isolated shaft of light to fall on Christ's back, Tintoretto could lead the viewer's eye quickly to the protagonists in the middle distance (illus. 177). But despite this obvious stage direction, the scene retains something of the visual understatement of the *Adoration*. John's action of baptism, so often emphasized in Renaissance art by a grand dramatic gesture, is almost lost in the gloom gathered round Christ's head, the act simply achieved by the cupping of his hand.[39] Christ's humility (being without sin, he did not, of course, have to submit to being cleansed) is more significant here. His crouching posture, with head bowed toward the earth and cast in deep shadow, contrasts with the heroic upright figure who features in Tintoretto's other versions of the subject (see illus. 126). Christ is shown as ready for sacrifice, a point reiterated by

178 Jacopo Tintoretto, *Resurrection of Christ*, 1578/81,
oil on canvas, 529 × 485.
Scuola Grande di San Rocco, Venice (Sala Superiore).

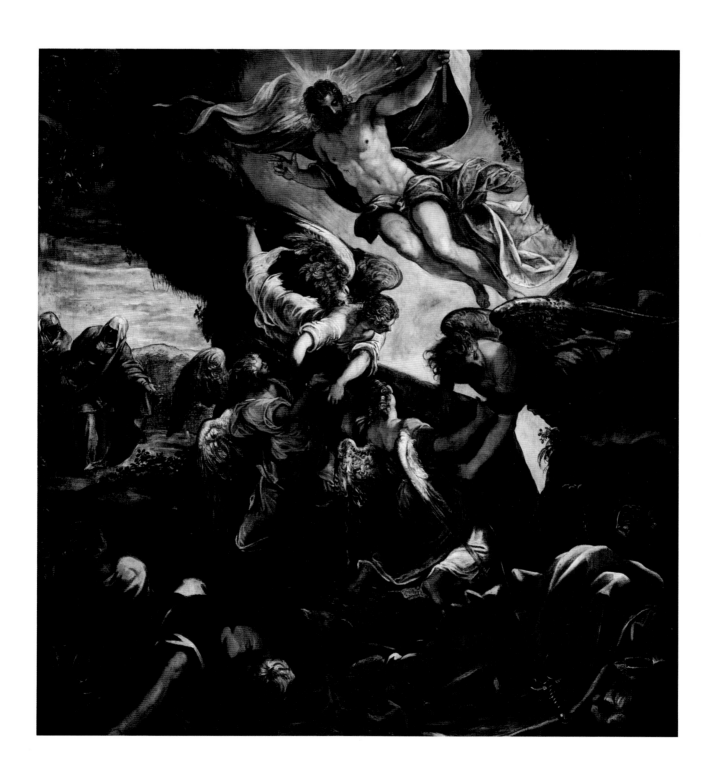

explosion of energy, the painting was evidently intended to make a sharp contrast with the quiet humility of the paintings to either side. Christ's tomb is blown open by the compressed energy of the divine light contained within it, the force of which propels his body heavenward. Its heat makes the angels involuntarily avert their heads, swinging their bodies away from the blast. Divine light now becomes divine fire, the dominant Johannine metaphor in the cycle being intensified by association with the immediate creative power and energy of a dynamic physical element.[42] The illumination of Christ's body against the flattened wall of flame allows it an iconic aura similar to that of a Byzantine mosaic. But the fire in Christ's tomb does not extend significantly into the surrounding landscape, the sharp lines of demarcation between light and shadow simultaneously marking the spiritual boundary between transfigured divinity and the fallen world beyond.

Christ's heroic body is based in part on Tintoretto's altarpiece painted for the Scuola del Sacramento of San Cassiano in 1565 (see illus. 131).[43] The San Rocco version shares its vertical composition and carefully retains the emphasis on Christ's fleshy body with its eucharistic significance. The connection would have been encouraged by the presence of members of the San Cassiano Scuola on the ruling bodies at San Rocco. But the high-pitched rhetoric of the *Resurrection* was also encouraged by its position at the midpoint of the Sala, beneath the great central ceiling painting of the *Brazen Serpent* (illus. 154). The connection is emphasized by the similarity of Christ's body to that of God the Father in the ceiling painting, towards which he rapidly ascends. The suggestion of iconographic connection across a transversal axis is then secured by the

Ascension of Christ (see illus. 190) hanging on the opposite wall of the Sala, featuring an equivalent image of Christ's soaring body.

As in many other paintings in the Sala, the space of the *Resurrection* is divided by the rough contours of the landscape in order to break down the narrative into discrete, simplified units which are often temporally distinct. In the foreground we glimpse the sleeping guards of the tomb, and at the background left the pious women approaching the sepulchre. A very similar threefold division is evident in the *Agony in the Garden* (illus. 179) to the right, although in this case Tintoretto's disintegration of continuous space is more evident still.[44] The three essential elements in the narrative are picked out in light, but their position in relation both to the picture plane and to one another is concealed by encircling shadow. Christ is positioned high in the picture space, close to the painted ceiling above, the chalice-bearing angel who offers him comfort appearing to stride in from the adjacent *Gathering of Manna* (see illus. 162). The sleeping Christ is turned away from his celestial visitor, seeming to experience divine intervention as an internal vision. But unlike his Old Testament predecessors on the ceiling, this posture may here be intended to indicate Christ's moment of mortal weakness: 'if thou be willing, remove this cup from me' (Luke 22.42).

As in the other wall paintings, the supernatural status of the fiery light brought by the angel is asserted precisely by its lack of penetration into the landscape, and by the sharp contrast it generates with the shadowed world around. Contained at the upper right of the painting, it creates a disturbing colour dissonance against the blood red of Christ's garment, the sudden illumination of which seems to

179 Jacopo Tintoretto, *Agony in the Garden*, 1578/81,
oil on canvas, 538 × 455.
Scuola Grande di San Rocco, Venice (Sala Superiore).

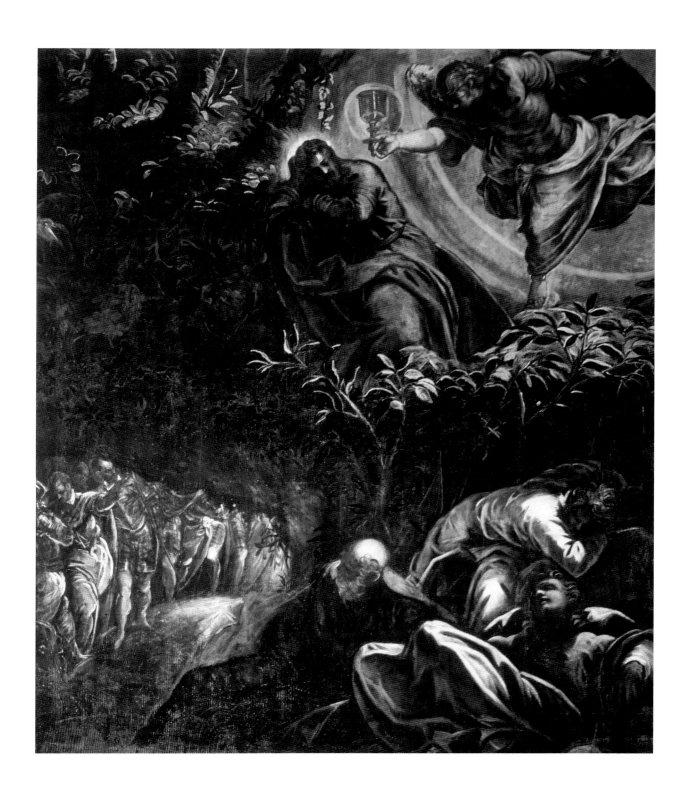

180 Jacopo Tintoretto, detail of illus. 179.

181 Jacopo Tintoretto, *Study after the head of Giuliano de' Medici by Michelangelo*, 1545/50, black chalk heightened with lead white on dark paper, 3.68 × 2.72. Christ Church Library, Oxford.

emphasize the necessity of his coming sacrifice. It also casts golden reflections over the symbolic olive leaves on which Christ rests. But this warm light is carefully differentiated from the colder naturalistic highlights illuminating the three sleeping disciples and the advancing group to the left, which suggest the splintered fall of moonlight on a nocturnal scene. In these lower groups, Tintoretto's chiaroscuro technique reaches new expressive heights, suggesting the presence of complex three-dimensional form with the minimum of painterly definition.

This is perhaps most evident in the luminous figure of St John at lower right (illus. 180). His foreshortened posture, with upturned face, refers

back to Tintoretto's early studies after Michelangelo's Medici tombs: the head is based closely on a surviving drawing after the *Giuliano de' Medici* (illus. 181).[45] By this point, however, Tintoretto had already adapted the figure in a large number of paintings, including the *Gathering of Manna* on the Sala ceiling (illus. 162, see also illus. 169), and this experience is evident in the confidence with which he abbreviates the form. The passage tells us much about the painter's penchant for telescoping conventionally distinct phases in the artistic process. Rather than predetermining his compositions by means of a carefully contoured under-drawing, Tintoretto preferred to compose in paint, his definition of form made one with the

182 Jacopo Tintoretto, *Last Supper*, 1578/81,
oil on canvas, 538 × 487.
Scuola Grande di San Rocco, Venice (Sala Superiore).

183 Jacopo Tintoretto, *Last Supper*, 1576,
oil on canvas, 349 × 530.
San Stefano, Venice.

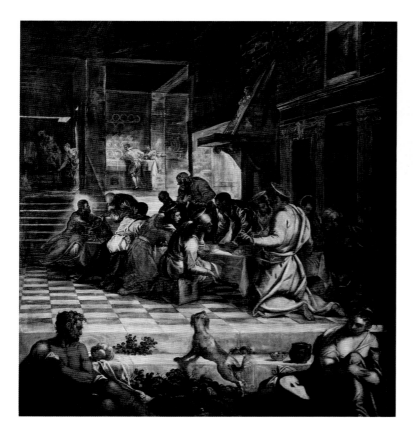

movement of his brush. He evidently used a broad
brush to establish the slanting diagonal highlights
for John's raised legs, but allowed the pink over
which they were painted to colour the highlight.
The highlight nonetheless establishes formal
contour and relief, becoming the means for the
articulation of the figure in space. But the brush is
only lightly loaded, leaving a stroke which dies at
each edge and tapers away into shadows at its
extremities. This dry-brush technique gives texture
to the surface, an effect which is supported by the
use of coarsely woven canvases.[46]

The *Agony in the Garden* and the *Last Supper* to
its right are based on the paintings Tintoretto made
for the Scuola del Sacramento at Santa Margherita

in 1576.[47] But the San Rocco paintings are more
sophisticated than their parish prototypes. This is
particularly evident in the *Last Supper* (illus. 182),
in which the more arbitrary elements in the
composition of the earlier painting (illus. 183) are
brought under a new expressive control. Thus the
oblique placement of the table now appears as a kind
of extension of the end wall of the Sala (and thus of
the Meeting House altar), while the perspective
vanishing point is placed very near to the figure of
Christ himself. The new arrangement also makes the
humility of the scene more evident. Although the
figures around the table are larger, the manner of
painting is more simple, and the details of their
bodies and faces are (in keeping with the other

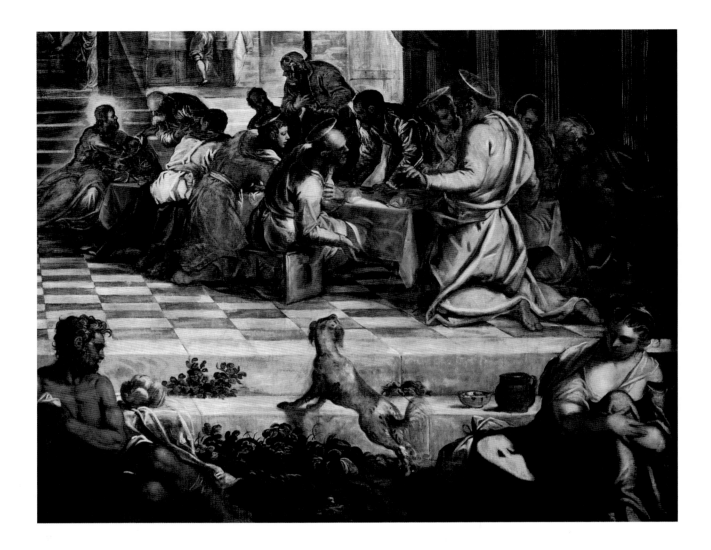

paintings in the room) typically concealed beneath a dominant fall of shadow relieved only by selective highlighting. The Apostles are shown barefooted and kneeling (rather than seated) around a low table, which is placed not in a quasi-palatial setting with classical arches and columns, but in a more believable and local interior setting. Typical of this emphasis is the addition of a kitchen view in the background, with figures in contemporary dress preparing food.

The rearrangement of the composition also brings Christ into direct contact with the foreground beggars on the steps, their positions at the two main points of visual entry and his at the vanishing point generating a triangular counterpoint within the composition (illus. 184). In order to reach the darkened figure at the far end of the table, our eye must negotiate the form of the seated beggar at the foreground left: Christ is thus directly associated with the poverty-stricken. At this moment, of course, he gives the wafer to Peter, and so institutes the sacrament of the Eucharist, referring to his supreme act of charity – 'this is my body which is given for you: this do in remembrance of me' (Luke 22.19).[48] But the association works both ways. Just as Christ's charity is symbolized in the beggar, so the beggar becomes Christ-like in his call to charity. Indeed, the identification had a strong tradition in popular religious literature. In the *Legenda aurea*, Voragine records the dream of St Martin of Tours, famous for sharing his cloak with a beggar, in which Christ tells the angels that the saint had actually given charity to him. And in a popular fifteenth-century poem, the *Historia del giudicio*, Christ explains to the saved on judgement day that he was the beggar to whom they gave charity in life.[49]

The *Last Supper* is, of course, thematically related to the other paintings near to the altar wall of the Sala Superiore illustrating instances of divine feeding with reference to the Eucharist. In works such as the *Gathering of Manna* (see illus. 162) and the *Miracle of the Loaves and Fishes* (illus. 187), the foreground is given over to anonymous groups of reclining or semi-reclining figures who await food from a divine source. The precise identity of these groups is not made clear. On one level, they are merely the necessary historical accessories to the given biblical subject: the starving Israelites in the desert or the hungry 5,000 on the shores of the Sea of Galilee. Perhaps also they refer to the contemporary sick and needy, and thus (again without making the connection explicit) to the Scuola's charitable duties to the poor. On the most general level, they can be understood as types of fallen humanity itself, in urgent need of redemption through God's miracles.

The second of the interpretations offered above is supported by the very evident contemporary concern with the problem of poverty in sixteenth-century Venice, one which, as we have seen, had driven Caravia to his outspoken attack on the ethics of the Scuole Grandi. From the late 1520s the Venetian state had, in fact, stepped up its programme of poor laws, hoping to relieve the threat to social order caused by the hordes of poor who periodically clogged the city's public spaces during times of famine and disease.[50] The onset of Catholic reform had also heightened contemporary awareness of the problem: in his *De officio episcopi* (1516) the Venetian patrician Gasparo Contarini re-emphasized the bishop's fundamental duties to the poor of the parish, and his point was extended in later works such as J. L. Vives's *De sublevatione pauperum*, published in Venice in an Italian translation in 1545.

185 Jacopo Tintoretto, *St Roch Healing the Plague-Stricken*,
1549, oil on canvas, 307 × 673.
San Rocco, Venice.

186 Jacopo Tintoretto, *St Augustine Healing the Forty Cripples*,
c. 1550, oil on canvas, 255 × 175.
Museo Civico, Vicenza.

Like Contarini, Vives was concerned to control beggary in accordance with the secular poor reforms. But he also argued that poverty should be considered a blessed condition, given by God to allow its sufferers a chance of repentance.[51]

Not surprisingly, religious themes relating to the distribution of charity greatly increased in Venetian art after 1530. A number of paintings featuring the uncharitable treatment of Lazarus, patron saint of beggars, were commissioned, and still more showing saints famed for their charity to the poor and sick such as St Homobonus, St Antonino, St John Hospitaller and St Barnabas.[52] Tintoretto had, of course, often painted themes illustrating saintly charity to the sick, and these certainly had an impact on the imagery he developed in the San Rocco paintings. Many of the struggling figures in the foreground of the *Gathering of Manna* (illus. 162), for example, draw directly on motifs showing the lame and sick in much earlier paintings such as the Scuola's own *St Roch Healing the Plague-Stricken* (illus. 185). The prominent reclining figure at the foreground right is based closely on a figure in the *St Augustine Healing the Forty Cripples* (illus. 186), which can be traced back ultimately to Tintoretto's

studies after Michelangelo's Medici allegory of *Day* (see illus. 41, 42, 45).[53] The application of such famous poses to the most humble of subjects – the anonymous accessory figures of the lame and starving – might be taken as a kind of debunking of the high idealizing ethos of classical art. But this would be to over-simplify the case, for the association could equally work the other way, allowing Tintoretto's *poveri* a newly responsive, even heroic potential. Unlike the marginal, shadowed, physically distorted and spiritually inert recipients of charity who feature in many other sixteenth-century Venetian paintings, Tintoretto's poor may even be considered, in Vives's terms, as uniquely privileged by their immediate proximity to the Christian miracle of redemption. Their poverty draws them close to the sacred and is thus envisaged as an enviable state which puts the sufferer into an intimate relationship with the divine.[54]

In the *Miracle of the Loaves and Fishes* (illus. 187), Tintoretto draws specifically on the account in the Gospel of St John (6.1–13), which mentions the boy who brings bread and fishes and the help Christ received in their distribution from Andrew.[55] Seen at some distance on a raised bank in the middle

187 Jacopo Tintoretto, *Miracle of the Loaves and Fishes*,
1578/81, oil on canvas, 541 × 356.
Scuola Grande di San Rocco, Venice (Sala Superiore).

ground, Christ and his Apostle are intentionally made difficult to identify. Christ, to the left, is only slightly distinguished by his more upright posture and pointing gesture, but both protagonists are thrown into silhouette against the paler colours of the sky, the shadow across their faces anticipating the personification of almsgiving (*elimosinaria*) in Cesare Ripa's *Iconologia* (1593),who is veiled to conceal her from the recipients of her alms.[56] The position of Christ and Andrew at some remove from the foreground, and their formal similarity and hidden physiognomies, combine to express the selfless purity of their charitable actions. Tintoretto's concern to de-emphasize Christ is also apparent from the fact that none of the surrounding crowd looks directly at him. He is embedded into the narrative action in a manner which superficially recalls the 'eyewitness' style of earlier narrative paintings for the Venetian Scuole (illus. 188). But whereas in these paintings the effect is intended to

give the *istoria* an air of literal documentary truth, in Tintoretto's *Miracle* all reference to the specifics of time and place is played down.

The crowd is historically undefined and socially mixed, sharing only a common state of want. Thus semi-nude beggars, such as the figure reaching up for food below Christ, are mixed with respectable family groups, as for example, at the foreground right. On the far bank, a woman gives suck to her child, while another to her left holds two babies on her lap. As we have seen, Tintoretto had already employed such charity motifs in the other wall paintings, threading the message of Christ's redemptive gift to Man through the cycle. At the foreground left, the standing figure turns to give a bowl to the seated woman at his side, his action closely observed by the portrait head (presumably of a Scuola brother) at the far right. Just as Christ gives charity to the 5,000, so the members of this crowd actively help one another, as if to emphasize an on-going principle of active charity (*amor proximi*). Christ's selflessness, then, forms the supreme exemplar for the charitable offerings of the rich brothers of the Scuola.

Tintoretto's technique at San Rocco finds its apogee in this painting and in the *Raising of Lazarus* (illus. 189) to its right.[57] The palette used in both compositions takes its cue from the middle tone provided by the dark brown of the preparatory ground (itself formed from a pigment mixture). Even in these earth-toned compositions, Tintoretto employs azurite blue, realgar orange-red, orpiment yellow and his favourite lake roses to generate a softly glowing chromatic effect far from the monochromatism sometimes implied by poor photographic reproductions. But the physical property of paint, its material *richezza*, is not

189 Jacopo Tintoretto, *Raising of Lazarus*, 1578/81,
529 × 485.
Scuola Grande di San Rocco, Venice (Sala Superiore).

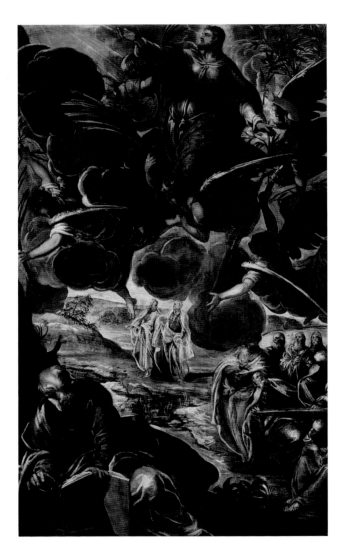

displayed to the viewer as it might be in a work by Titian or Veronese. Titian won especial renown for his active manipulation of pigments on the picture surface (his *colorito*), but his working of paint did not undermine the more material property of colour (*colore*) and its inherent decorative potential. It is this latter quality which is most challenged by Tintoretto's technique at San Rocco, his brushstroke acting at once to dematerialize and to spiritualize the painted surface. The forms of figure and landscape are continually simplified by his sketchy mark to produce a manner characterized by brevity rather than elaboration. But this new *non-finito* also invites the viewer to project into the image, to supply the missing data of a shadowed form or face. And the projection encouraged is not primarily perceptual but imaginative and emotional, as if the message of the painting were dependent upon the viewer's active participation in its completion. In this sense, Tintoretto's lack of finish functions as a kind of aid to active devotion.[58]

The *Ascension* (illus. 190) works its dramatic effect through the absolute contrast it provides with the paintings to its left, its Christocentric triumphalism sharpened by its proximity to the shadowy, marginal Christ pictured in these works.[59] Here Christ reoccupies his more conventional iconic position in a celestial region (*regione celeste*), his body taking on the shape of the symbolic mandorla, his unseeing gaze fixed only on his heavenward direction of travel. The foreshortened wings of the angels point up the direction of Christ's ascent and provide clean lines of demarcation from the desolation of the terrestrial region (*regione terrestre*) below. Christ has shed his mortal attributes and become a supernatural vision and is perceived as

such by the reclining figure in the foreground. As he reads his Bible, this apostle 'sees' the last appearance of Christ on earth: but his position (turned away from the upper area of the composition) tells us that he does so only in his mind's eye. Although one or two of the Apostles abandoned on the Mount of Olives below seem to respond physically to Christ's disappearance, the majority seem rather to be lost in thought, or they walk in the landscape deep in conversation. These eleven disciples, left in the emptied landscape of the world, are, however, treated in a sketchy, ethereal fashion and are no match for the jubilant and noisy heavenly forms shown above. In another visual inversion with theological overtones, the earthly world becomes no more than a pale reflection of the spiritual one above.

The final wall painting in the Sala Superiore showing *The Pool at Bethesda* (illus. 191) is, in certain ways, the most problematic.[60] Its early restoration by Domenico Tintoretto in 1602 following water damage, and a further one by Lelio Bonetti in 1696, certainly disguise and confuse the painter's original intentions, giving the composition a jumbled appearance. The painting picks up the theme of healing by water in the associated ceiling paintings and wall painting opposite (see illus. 176), while it is formally dependent in certain key details (such as the figure of Christ) on the earlier version of the subject painted for the Scuola church (see illus. 130). Little attention is paid to the biblical narrative recording Christ's famous directive to the lame man, however, who is a lost figure at the foreground edge of the picture space. Rather, we are shown a plague hospital, the point being made by the dominant motif of the elderly helper displaying the thigh sore of a woman. This transformation

clearly related the picture to the commissioning institution, whose own Scuoletta would certainly have catered for plague sufferers.[61]

For the jumble of bodies surrounding the pool, Tintoretto (and his restorers) drew on the stock types for suffering figures already evident in other paintings on the ceiling and walls of the Scuola. The nudity of these figures (only their genital regions are decorously covered) is, most obviously, a conventional manifestation of their condition of worldly poverty (*nuditas temporalis*).[62] But in certain figures it may have further implications, picking up the suggestive image of Eve in the oval showing the *Temptation of Adam* (see illus. 170). The sprawling foreground woman is bare-breasted, while a female figure at the far left is shown reclining on a bed in the manner of a classicizing erotic nude. The fundamental relationship between sexual concupiscence and sin had, of course, been clearly established in the *Temptation*, while a further

conflation of sin with the plague was suggested in the central ceiling painting (illus. 154). In *The Pool at Bethesda*, the hugely outsized figure of Christ makes the obvious point that this pernicious knot can be unravelled only through his agency. But the dominance allowed to him is clearly out of kilter with his presentation in the other wall paintings illustrating his acts of miraculous healing, and the smooth surfaces and physiognomic detail clearly betray the hand of the first restorer. It seems likely that Domenico's wholly orthodox sense of pictorial decorum led him to exaggerate his father's smaller and more marginal figure and thereby to ignore the ethos of Christ's *humilitas* fundamental to the imagery of the Meeting House.

The Sala Terrena Paintings

The Scuola's decision to extend the pictorial decoration of the Meeting House into the lower room (Sala Terrena) is undocumented, but Tintoretto apparently proceeded with the new cycle without a significant pause following his completion of the Sala Superiore wall paintings in August 1581. Within a year the first two paintings were completed, and although Tintoretto did not subsequently manage to keep strictly to the rate of production promised in 1578, the full cycle of eight paintings was nonetheless finished by August 1587. In the following year, he completed the decoration of the building with a painting showing the *Apotheosis of St Roch* for the main altar.[63]

The Sala Terrena paintings, placed between the biforal windows and above a marble basement, are (unlike their equivalents in the room above) horizontal in shape (illus. 192, Diagram 3). In this regard, as also in their freedom from the dictates of

a painted ceiling, they conformed more readily to the type common in Venetian Scuola narrative cycles.[64] But Tintoretto nonetheless resisted the temptation to give his works the orthodox left/right scansion, and while the paintings are more closely tied into a narrative sequence than in the Sala Superiore cycle, each painting still displays a high degree of compositional independence. The individuality of the paintings does not, however, entail thematic confusion, or a sea change in iconography, as Charles de Tolnay and others have proposed. On the contrary, the programme is broadly coherent with the paintings on the upper floor. The proximity of the Sala Terrena to the entrance of the building undoubtedly encouraged Tintoretto's advisers to conceive of the new cycle as a kind of thematic precursor to the Life and Passion of Christ depicted on the walls of the Sala Superiore and *albergo*. The ground-floor paintings thus show scenes elaborating Christ's incarnation and infancy (the *Annunciation*, the *Adoration of the Magi*, the *Flight into Egypt*, the *Massacre of the Innocents* and the *Circumcision*), works which contain repeated references to Christ's future sacrifice and the

Diagram 3
Sala Terrena, Scuola Grande di San Rocco

1 *Annunciation* (illus. 193)
2 *Adoration of the Magi* (illus. 195)
3 *Flight into Eygpt* (illus. 197)
4 *Massacre of the Innocents* (illus. 198)
5 *Female Saint Reading in a Landscape* (illus. 199)
6 *Female Saint Reading in a Landscape* (with palm)
 (illus. 200)
7 *Circumcision of Christ* (illus. 201)
8 *Assumption of the Virgin* (illus. 202)

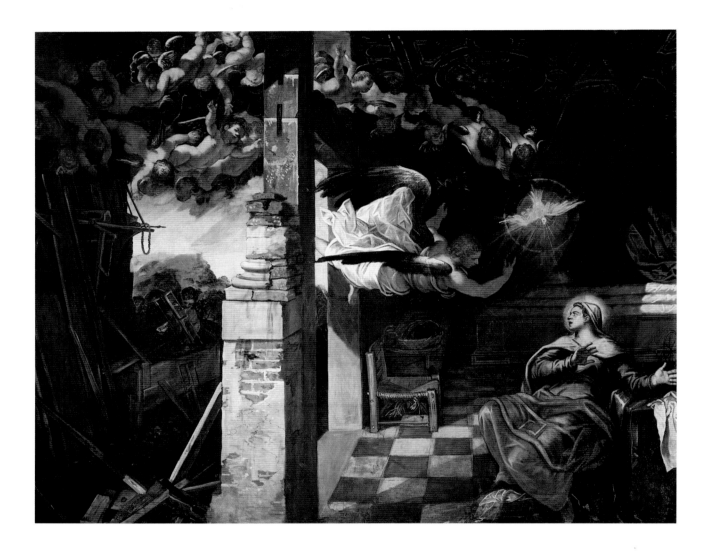

194 Titian, *Annunciation*, *c.* 1540, oil on canvas, 166 × 266. Scuola Grande di San Rocco, Venice.

salvation of Man resulting from it. Mary's role as the chosen carrier of Christ was inevitably important here (and is acknowledged by the inclusion of the *Assumption of the Virgin*), but this need not be seen as conflicting with the essentially Christocentric focus. In two narrower canvases for the end wall of the Sala, Tintoretto painted two female saints in landscapes who may represent the Virgin and Elizabeth as prophetic figures, whose meeting was recorded in a painting for the staircase landing showing the *Visitation* (1588). But the inclusion of such scenes supports the main thematic emphasis on Christ himself.[65]

The cycle begins with Tintoretto's great *Annunciation* (illus. 193), which is treated in a manner very different from Italian Renaissance depictions of the subject.[66] Tintoretto would certainly have known Titian's small painting of the subject bequeathed to the Scuola by the lawyer Melio Cortona, which had been hanging on the staircase landing since 1557 (illus. 194).[67] Titian's painting was much treasured by the Scuola brothers, and in his flying figure of Gabriel, Tintoretto drew directly on the older master's invention. But this was Tintoretto's only formal reference to Cortona's painting. If Titian offers a timeless, physically pristine environment which expresses the spiritual purity of the Virgin herself, Tintoretto's setting is worldly and includes many contemporary quotidian features (the wicker chair with tattered seat, the Virgin's sewing wheel).[68] The run-down environment, deliberately reminiscent of a decayed Venetian palazzo, reflects the Virgin's purity only by way of a typically Tintorettesque association between outward poverty and inward grace. The view of Joseph's cluttered carpentry shop is very unusual in Venetian versions of the scene, indicating

that the painter once more looked beyond local conventions to prototypes in northern painting. The recent suggestion that the small youthful figure sawing in the background is the boy Christ preparing his own cross is a little far-fetched.[69] But even if we follow instead the standard interpretation of the figure as Joseph, it remains true that the saint is shown as unusually young and active, a decision which may reflect Tintoretto's concern to play down the emphasis on the Virgin herself in favour of a wider view of the Holy Family. Although poor, Joseph and Mary are hard-working and certainly not destitute like the anonymous *poveri* featured in other paintings in the cycle. Joseph is shown as a respectable urban artisan, who would have much in common with the lower-ranking brothers in the wider body (*sodalitium*) of the Scuola. His poverty is thus of a deserving kind (a particularly well-defined concept in sixteenth-century Venice), a kind of outward assurance of inward quality. The painting hangs opposite the Meeting House entrance and so was intended as an immediate statement of the core Christian value of humility developed in the paintings which follow.[70]

In place of Titian's elaborate classical architecture (complete with portico, rows of

columns and neatly geometrical balcony), Tintoretto presents us with the excoriated surfaces of a single column, the original form of which is apparent only from the fragment of base visible above what was once a plinth. Its prominence in the composition led Ruskin to see the painting as a Christian allegory, with the ruined house as 'the Jewish Dispensation' and the column as 'the corner-stone of the old building'. Led by his squeamishness in the face of the poverty of Tintoretto's Holy Family, Ruskin certainly overstated his case. But it would also be easy to misread Tintoretto's naturalism, here as elsewhere in the Meeting House. His dilapidations in the *Annunciation* must also be intended to convey a general sense of the fallen world into which Christ is incarnated.[71]

But the visual prominence of the column may also have had a more institutionally specific meaning. It is one of a number of features that directly relate the Virgin's humble abode to the real architecture in the Sala Terrena.[72] Thus we glimpse a gilded ceiling similar to that in the Sala Superiore, and note that the red and white tiling extends that on the floor of the Sala Terrena. The overlap is reinforced by the naturalistic fall of light, as if it had passed through the east window of the Sala Terrena to the left. It comes as no surprise to find that the base of the column is lined up in perspective with the plinths of Bon's real columns in the Sala (illus. 192). Such overlaps offered the Scuola brothers a stake in the narrative presented, suggesting an overlap between their Meeting House and the sacred abode of the Holy Family. But in Tintoretto's painting these classical forms are shown as physically corrupted, the gilt of the ceiling tarnished, the pavement stained and the column decaying. They are thus made part of the unredeemed world of false

splendours into which Christ arrives. The specific inclusion of such details is, in this sense, akin to an admission of collective institutional guilt over past excesses. The emphasis on the decayed column was particularly apposite, given that it was the Scuola's 'indulgence' in its use of this particular feature which had so irritated critics such as Caravia. Its resignification as a symbol of worldy decrepitude in the opening painting in the Meeting House pronounced an immediate distance from the vainglorious classical display evident on the façade.

The *povertà* inscribed in the *Annunciation* is an unstable signifier possessed of both positive and negative meanings. It is an outward sign of the fallen state of Man prior to Christ's coming, while also referring in a narrower historical sense to the decayed conditions of life under the Jewish Old Dispensation. As such, the decayed environment prefigures the 'burnt' landscapes of the Sala Superiore paintings, with their struggling populations of the needy. But as in these works, the condition of poverty is also a kind of vital prerequisite for the redemptive process to begin, and in this sense it takes on a sacred quality of its

own. In the context of the *Annunciation* and the two paintings which follow it, the poverty of the Holy Family becomes like a badge of their sacredness.

In the *Adoration of the Magi* (illus. 195) Tintoretto pointedly eschews the opportunity for a show of material splendour, one which was typically exploited by Renaissance masters when depicting this subject.[73] The luminous brushwork at the background right certainly reveals the painter's technical virtuosity, but it also reduces the Magi's equestrian train to the status of a distant, barely described vision (illus. 196). The composition is supported by two columns with classical pedestals and bases and Ionic capitals. But these columns are decaying, their part in the overall dilapidation confirmed by the rough masonry and wood of the platform and ceiling. Such classical features, far from the 'columns carved in the newest manner' mocked by Caravia, pick up the range of symbolic and institutional reference established in the *Annunciation*. Other features, such as the broken beams of the roof, the profile view of the Virgin and the praying gesture of the kneeling Magus, refer, for obvious thematic reasons, to the *Adoration of the*

197 Jacopo Tintoretto, *Flight into Eygpt*, 1582/7,
oil on canvas, 422 × 580.
Scuola Grande di San Rocco, Venice (Sala Terrena).

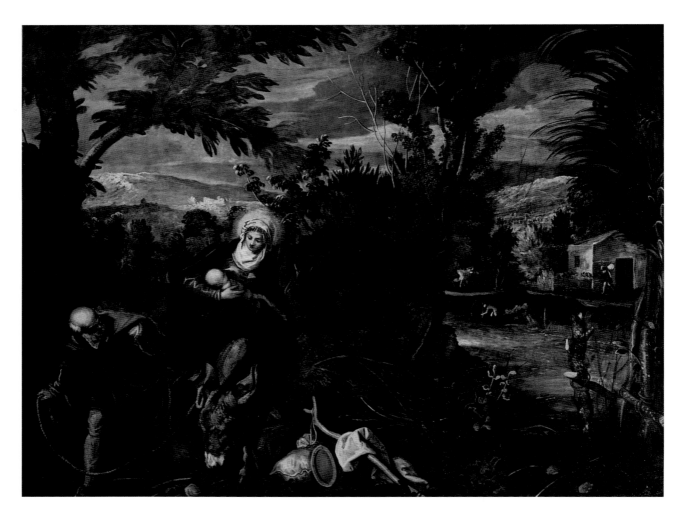

Shepherds (see illus. 172) in the Sala Superiore above.

The *Flight into Egypt* (illus. 197) shares the careful elaboration of setting characteristic of the first two paintings, a feature markedly distinct from the reductive approach typical in the Sala Superiore paintings.[74] Here the lushness of the olive and rose landscape makes a symbolic point. The harsh divisions and schematic abbreviations of the paintings of the upper floor symbolize the barren cruelty of the *civitas terrena* through which Christ moves towards his crucifixion. Here, however, the landscape is supportive and protective, the verdant clump of vegetation concealing, as if in sympathy, the escape of the Holy Family from Herod's murderous decree, while the lower branch of the tree at the left bends down over Virgin and Child to form a natural protective arch. The family flee out of a background landscape which contains intimations of fallen civilization, with distant cities, dilapidated dwellings and unaware peasants engaged in hard, unthinking labour. But if the land beyond the river is Israel, then the foreground is Egypt, as is

198 Jacopo Tintoretto, *Massacre of the Innocents*, 1582/7,
oil on canvas, 422 × 546.
Scuola Grande di San Rocco, Venice (Sala Terrena).

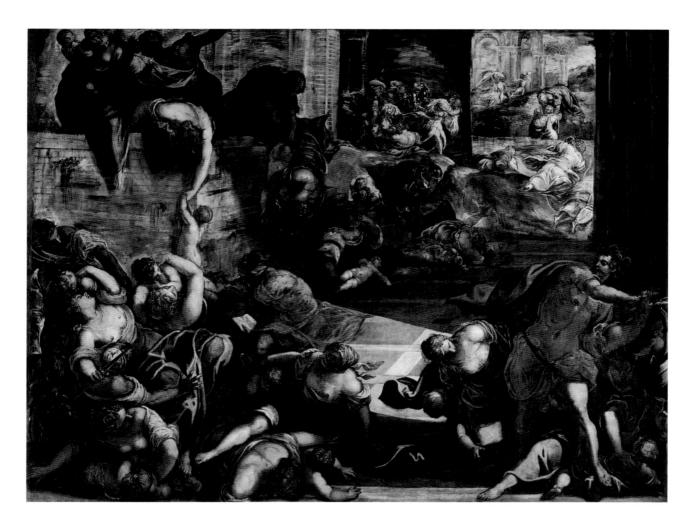

indicated by the prominent palm at the foreground
right. As many patristic commentators had argued,
Egypt was a land of spiritual enlightenment, a
veritable *civitas Dei* well suited to Christ's
protection.[75] The kind of division argued for here is,
in fact, supported by the very original decision to
show the Holy Family advancing out of the
composition, rather than across its surface, as was
more usual in Venetian depictions of the subject.[76]
Their passage out of the painting intimates, of
course, their imminent arrival in the space of the

Sala Terrena itself. By extension, the real space of
the Sala becomes imbued with the spiritually
enlightened values of the foreground landscape, the
Scuola envisaged as a special site in which the Holy
Family is protected.

In St Matthew's Gospel, the Flight into Egypt
directly follows the scene of the Adoration of the
Magi, and is itself followed by the episode of the
Massacre of the Innocents (Matthew 2.1–16).
Tintoretto's concern with narrative continuity in his
paintings of these subjects in the Sala Terrena, and

with their connection to the Passion cycle in the *albergo*, is evident by his inclusion of running references to the future sacrifice of Christ. Thus the cross-like beams of the stable roof in the *Adoration* (illus. 195) are picked up in the rough wooden cross, significantly propped against the foreground palm, in the *Flight*. Placed at the right edge of the painting, the motif effectively leads the eye into the violent scene of the *Massacre of the Innocents*, which more obviously prefigures the spilling of Christ's blood (illus. 198).[77] A parallel reference can be found in the rope motif, which, as we have seen, plays a significant connective role in the paintings showing Christ bound, tortured and crucified in the *albergo*. In the Sala Terrena it hangs noose-like in the left background of the *Annunciation* (illus. 193), runs between the hands of the servant unpacking gifts at the right of the *Adoration* (illus. 195), as it does between those of Joseph as he leads the donkey in the *Flight* (illus. 197). The play on Christ's death is continued in the *Massacre*, where the multiplication of mother/dead child motifs reinforces the message. In the middle distance a mother stares at the dead child on her lap in the manner of a *Pietà*. The theme may be picked up once more in the painting on the end wall nearby (illus. 199), where a female saint, perhaps the Virgin herself, is shown reading in a transfigured landscape. The bole of the huge tree, which she sees in her mind's eye, divides to form a shape recalling 'in large' the wooden cross in the *Flight*.

In this way, the *Massacre* is effectively framed by spiritually heightened landscapes in which may be read, under the veil of chance or natural forms, powerful intimations of Christ's fate. But in these works the forms of nature 'speak', accommodating themselves to physical and spiritual need. They

form an expressive antithesis to the hard monochrome of the man-made environment of the *Massacre*, a suitable backdrop to the scene of human horror and suffering presented. The classicism of the composition has often been remarked, but (as elsewhere in the Meeting House) it is a setting for the spilling of blood, its outward order a cover for inward chaos. The setting recalls the ghostly stage-set architecture of works such as the *Removal of the Body of St Mark* (see illus. 123), in which the classicizing buildings are directly associated with the spiritual nullity of the Alexandrians. As in the earlier painting too, the recessional logic is disrupted by the fall of light. Although this has a naturalistic source, its effect on the composition is boldly disjunctive, cutting diagonally across the pavement and figure groups in a manner which creates a hallucinatory effect.[78] If the monumentally conceived figure groups conjure up memories of the sculpture of Michelangelo and Giambologna, their placement within the composition takes no lessons from classical composition. Driven from the picture centre as if by an explosive force, their movements cut across the rational orthogonals and transversals of the pavement, generating a typically Tintorettesque tension between form and space.

Tintoretto uses chiaroscuro here much as a theatre director might use a spotlight, to focus attention on affective detail: for example, on the dying mother still hanging on to her slashed child over the corner of wall to the left, or the mother grasping the sword with bloodied hand at foreground left. This group seems to topple out of the composition into real space, the spread-eagled limbs of dead mothers and babies spilling over the white strip of pavement defining the limit of the forward plane. The group is a kind of parallel to the

199 Jacopo Tintoretto, *Female Saint Reading in a Landscape*, 1582/7, oil on canvas, 425 × 209. Scuola Grande di San Rocco, Venice (Sala Terrena).

200 Jacopo Tintoretto, *Female Saint Reading in a Landscape (with palm)*, 1582/7, oil on canvas, 425 × 211. Scuola Grande di San Rocco, Venice (Sala Terrena).

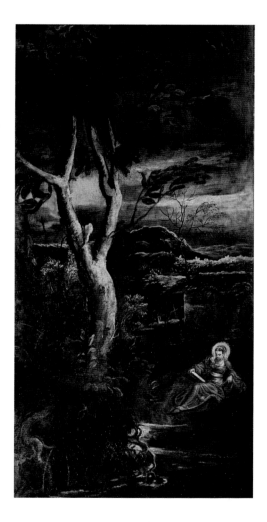

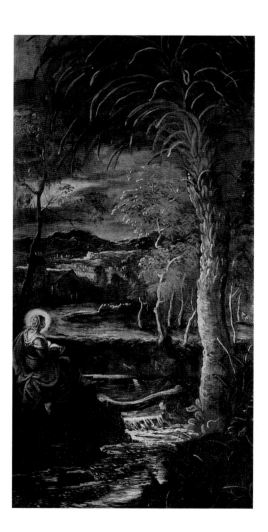

falling group in the *Brazen Serpent* (see illus. 155), which likewise refers to the necessity of Christ's sacrifice on the cross. In this case, however, it is the innocent who fall, the replication of mother and child motifs referring also to those *caritas* figures who litter the cycle. Pure unworked colour, in this frenzied environment, is used for expressive effect, breaking free from the kind of restraint imposed upon it in other paintings at San Rocco. Over the drained tones of the architecture, painted with characteristic dry brush, Tintoretto deploys reds, vermilions, oranges and scarlets to draw attention to the spilling of blood. It oozes from the bodies of mothers and babies and tints the clothing of the executioners. Blood even suffuses the atmosphere, as is evident from the middle-ground area, where the shadow itself takes on its colour.

There is little to support the identification (standard in the literature only since the early nineteenth century) of the two saints in landscapes on the end wall as Mary Magdalene and Mary of Egypt (illus. 199, 200). The recent suggestion that

Tintoretto here represented episodes from the apocryphal *Book of St James* recording the time spent by the Virgin and St Elizabeth in Egypt cannot be verified, but would certainly allow the paintings to resonate more significantly with other paintings in the cycle, especially the *Flight into Egypt*.[79] Their expressive significance is emphasized by the unusually small scale of the figures against the outsized natural forms. In both paintings, the landscape is dominated by huge trees, the one reminiscent of the cross, the other a palm, symbolic features already put together in the foreground of the *Flight*. If the palm makes forward reference to Christ's martyrdom and victory over death, then it also functions as an indicator of place. In contrast to the 'dumb' landscape predominant elsewhere in the Meeting House, that of Egypt is imbued with the spiritual power of the Word. It is a source of divine revelation, its natural features resonant with symbolic meanings confirming the truth of the holy books read by the saints. In this sense the landscape becomes a text. In the painting which may show the Virgin, her engagement with the book means that she does not literally 'see' the landscape she inhabits, but her reading nonetheless seems responsible for its transformation. In the other, the saint looks up from the book directly at the landscape, her gaze at the palm seeming to confirm the truth of what she has read.

In both paintings, detail emerges out of a play of glittering highlights laid (often without tonal transition) over the dark preparatory ground. The now familiar golden light, which elsewhere in the cycle is contained within specific areas of the composition to indicate the presence of the divine, is here diffused throughout the landscape. For more than a century, landscape had played an important and complex role in Venetian painting. Whether used as a vehicle for naturalistic interest or as a form of nostalgic poetic pastoral, it was conceived primarily as a setting. While it was certainly manipulated to express the given narrative, landscape remained essentially 'outside' of figure painting. If, in many small-scale Venetian devotional pictures featuring single figures (typically hermit saints or penitents) meditating, the dramatic setting was moulded to express their inner emotions, this was not typically allowed to collapse the objective reality of the landscape. Such paintings may have provided Tintoretto with an initial model for his San Rocco landscapes, although in these works the intimacy of the genre is transposed to a grand scale and given a public context. Moreover, in Tintoretto's paintings the objective relation of figure and landscape is undone, the latter becoming no more than a visual projection of the saint's inner imaginings. As the product of subjective vision, forms no longer obey natural laws, their scale and interrelation becoming subject to their place in the spiritual schema of the visionary. To this extent, too, the viewer's relationship with the landscape is changed, given that it can no longer be read as a simple extension of his or her own empirical experience of the world. Instead it is mediated (by the saints) and exemplary (in that it is a source of divine knowledge). Tintoretto's conception goes so far as to put the status of the naturalistic landscape as a source of knowledge in doubt. For meaningful nature is nature transformed by inner experience: if it remains a proper site for inward reflection on Christ, it is clear that this is made in emulation of the saints, and (in an age of reading) that it must constantly be shaped by authoritative sacred texts.[80]

The final paintings in the Sala Terrena are

difficult to assess, given that one, showing the
Circumcision of Christ (illus. 201), was executed (and
probably also designed) by Domenico, and the other,
showing the *Assumption of the Virgin* (illus. 202), was
very badly damaged and restored in earlier
centuries.[81] As in the Sala Superiore painting he
restored, Domenico reveals a very different artistic
temperament to his father. The *Circumcision* is
characterized by a high surface finish and literalism
in handling, and by an associated interest in details
of costume and physiognomy. The composition is
closely based on the *Adoration of the Magi* (illus.
195, 196) hanging opposite, but is made more
orthodox by Domenico's closing of the background

with a row of Scuola portraits, by the figural stasis this creates and by the careful tidying up of all humble dilapidations. As in the restored painting of *The Pool at Bethesda* (illus. 191) in the Sala above, Domenico thus reveals his essential lack of understanding of the particular mode of expression his father had developed so convincingly in the Meeting House. Despite working in the Tintorettesque idiom, he modifies this towards a display of luxuriant surface and texture underpinned by careful finish and studied composition. In such works, it is as if the son himself wished to answer the ringing charges made against his father, seeking to normalize a style which for many art connoisseurs seemed merely a product of eccentricity.

Despite its damaged state, the *Assumption of the Virgin* reveals a return to the inventive energies of the other Sala Terrena paintings. Seen within the wider iconographic scheme, the subject brings the Virgin's sub-narrative to a close, intimating the shift towards the more explicitly Christocentric theme in the rooms above (her assumption into heaven after her death is seen as a prototype for the *Ascension of Christ*, illus. 190). The composition refers back to Titian's Frari altarpiece (see illus. 57), the work which had influenced Tintoretto's own earlier versions of the subject (see illus. 54, 55) and which had acted as an initial guarantee of his orthodoxy in the competition of 1564 (see illus. 132, 133). Even at this late stage, Tintoretto seems consciously to recall Titian's famous painting, basing the figure dressed in red with left arm raised on that of Titian's prominent Apostle. This figure, as we have seen, had been thoroughly absorbed into Tintoretto's own formal vocabulary in the ceiling and wall paintings of the Sala Superiore. In the *Assumption*, he is contrasted with the Apostle with outstretched arms

to the left of the tomb, whose expansive gesture has a similarly complex resonance, drawing on Tintoretto's earlier paintings for the Scuole del Sacramento (see illus. 59) even while it refers to that of Jonah on the Sala Superiore ceiling and the crucified Christ in the *albergo* (see illus. 139, 164). The lateral treatment of a traditionally vertical subject allows the painter, finally, to draw the divine into a typically immediate proximity with reality, a point stated in visual terms by the modelling of the Virgin's tomb on the actual mouldings of the Sala door, and by the angel who has (in unorthodox fashion) entered this worldly structure to assist her rise to heaven.

Tintoretto's vast commission at San Rocco necessarily had a profound impact on the mature and later stages of his career. In the case of his contemporary work on the redecoration of the state rooms in the Ducal Palace, the effect was essentially one of formal and emotional antithesis, initiating an almost schizophrenic stylistic division which led Hans Tietze to analyse Tintoretto's later career as revolving around two wholly separate manners, a 'San Rocco style' and a 'Ducal Palace style'.[82] And yet the modes of expression he developed for these contexts were two sides of the same coin, the spiritual fire generated by the shattered spaces, writhing forms and flickering collisions of light and shade in San Rocco functioning as a kind of aesthetic prerequisite for the cool formalism and emotional detachment of the contemporary official paintings. This latter manner is best exemplified in the four mythological allegories Tintoretto completed in 1578 for an ante-room in the palace (the Sala dell' Atrio Quadrato) which are different in tone not only from the contemporary San Rocco paintings but also from the experimental group of

202 Jacopo Tintoretto, *Assumption of the Virgin*, 1582/7,
oil on canvas, 425 × 587.
Scuola Grande di San Rocco, Venice (Sala Terrena).

203 Jacopo Tintoretto, *Bacchus, Ariadne and Venus*, 1578,
oil on canvas, 146 × 167.
Sala dell'Anticollegio, Palazzo Ducale, Venice.

mythologies he had painted in the 1550s (illus. 203, 204).[83] The air of formal abstraction shared by these works was, on one level, a function of their official context and of their role as political allegories glorifying the virtues of the Venetian Republic. As Ridolfi tells us, the crowning of Ariadne on the seashore by Venus was intended as a classical anti-type to the crowning of Venice (also 'born by the seashore') by the celestial powers. Although the crowning can be traced to a definite source in classical literature (a passage in Ovid's *Fasti*), this is chosen only as a vehicle for the further development of the political allegory. Ovid's description of Bacchus/Liber's renaming of Ariadne as Libera in heaven makes possible (through an obvious linguistic pun) a further level of analogy between this and the fabled freedom of the Venetian state itself, also bequeathed 'by the divine hand'.[84]

In works such as these, the mythological cabinet painting is absorbed back into the public/patriotic realm of Venetian imagery, against which it had initially defined itself early in the sixteenth century. Shorn of its function as a source of private esoteric and erotic contemplation, it becomes a decorative carrier of generalized patriotic ideas. The revealed flesh of its classical protagonists is no longer the open-ended sensual and poetic provocation it once was. We view, with undisturbed detachment, embodiments rather than bodies, whose narrative interaction is governed by the demands of intellectual coherence and formal pattern. Tintoretto's reworking of the local conventions of erotic-mythological painting in his late period is, in this sense, as radical as his contemporary revisions in the field of religious painting, and is broadly coherent with them. For it is as if the very intensity of the Christian *furor* generated at San Rocco has

rendered the classical world an intellectual abstraction. Mythological painting becomes a mere pictorial husk, fit only as the anodyne carrier of the official narratives of Venetian worldly dominion.[85]

This point cannot be generalized to include all of Tintoretto's official paintings: we recall the power of the late state portraits (see illus. 108,109) and the pictorial ambition of large-scale paintings such as the *Paradise* (see illus. 94). But these official works certainly draw on Tintoretto's religious narrative painting at San Rocco, their deepened spiritual dimension a kind of overspill from the creative energies of the Scuola. The centrality of the San Rocco commission is more evident still in late works such as the *Christ Crowned with Thorns* (c. 1585–90; London, Private collection) and the *Flagellation of Christ* (illus. 205), both of which also revive the painter's earlier polemic with Venetian artistic tradition, as expressed in the art of Titian. The former painting clearly represents a response to the Titian painting of the same subject which Tintoretto

205 Jacopo Tintoretto, *Flagellation of Christ*, c. 1585,
oil on canvas, 118.3 × 106.
Kunsthistorisches Museum, Vienna.

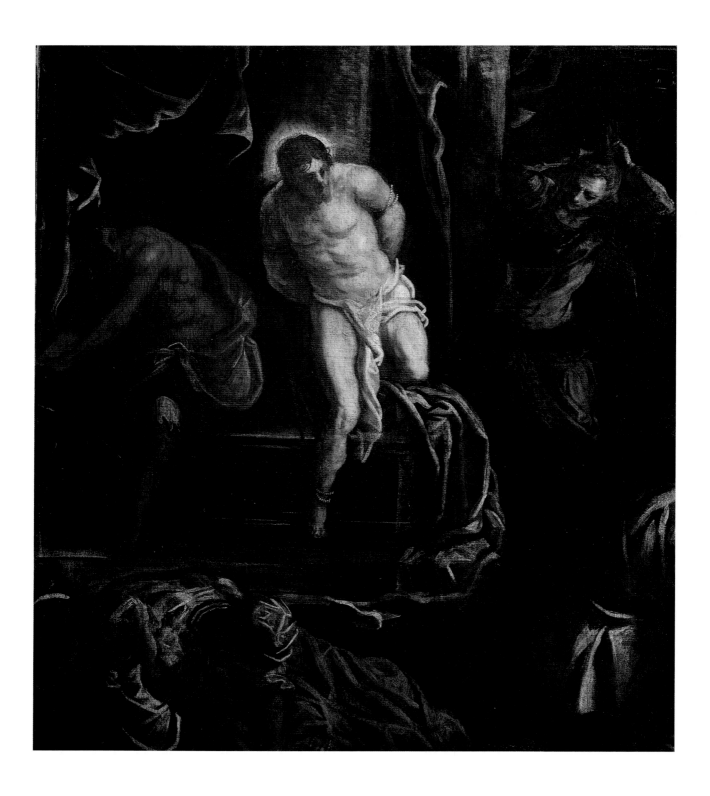

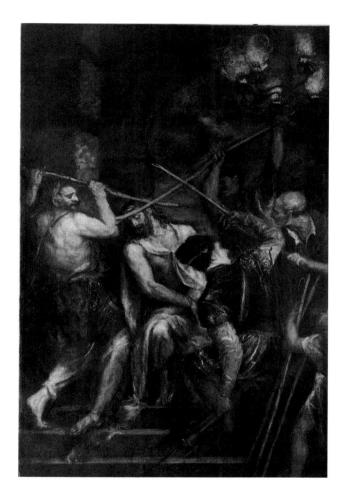

had bought from the old master's studio following
his death in 1576 (illus. 206). In the *Flagellation* the
derivation is still apparent, and yet on this occasion
(as he had so often in his youth) Tintoretto re-works
Titian's composition with reference to a Central
Italian source: as von Hadeln noted, the figure of
Christ is based on Giambologna's relief of *Christ at
the Column* (formerly in the Kaiser Friedrich
Museum, Berlin).[86] Both Tintoretto's paintings are
also very different to Titian's in their treatment of
the paint surface. Titian's almost obsessive working
of paint generates a dense and glittering effect, the
thickly applied pigment taking on a mosaic-like
quality. In contrast, Tintoretto's loose brushwork is
abbreviated and selective, acting more as an aid to
the articulation of rapidly moving form than as an
indicator of opaque surface texture. Instead of
Titian's claustrophobic clustering of form near to
the picture plane, Tintoretto's technique supports
the elastic spatiality and dynamic mirror movements
which he had developed at San Rocco.

In his last major commission, at Palladio's
church of San Giorgio Maggiore, Tintoretto was
more self-reflexive, revisiting many of the formal
and thematic ideas of his earlier religious painting.
At the same time, these very late paintings can also
be seen as beating a retreat from the more radical
formal and thematic proposals of the imagery in the
San Rocco cycles. In the huge horizontal paintings
for the high altar or sanctuary of the church, which
may have been painted in 1591–2, Tintoretto drew
primarily on the sets of *laterali* he had made for the
city's many parish churches (illus. 207, 208). The
pairing of concordant Old and New Testament
subjects may, though, reflect the iconography chosen
at San Rocco, where the two subjects (*Last Supper*
and *Gathering of Manna*) are already placed in a

close physical and typological proximity to one
another in the Sala Superiore. As at the Scuola, the
choice of themes reflect an on-going concern
amongst Tintoretto's patrons to reform their
institution with reference to Counter-Reformatory
dictates. And yet, Benedictine reform was very
different in flavour to that enacted at San Rocco.
The monks at San Giorgio were members of the
reformist Cassinese Congregation, but they did not
seek to express values of self-repressing piety in the
programme of decoration they undertook in the
early 1590s. Throughout the period, San Giorgio

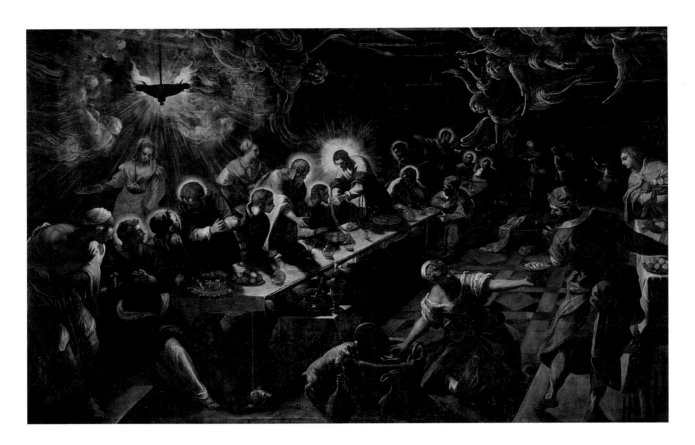

remained the wealthiest and most socially
prestigious monastery in Venice, and it is no accident
that Tintoretto received much higher prices for the
paintings commissioned by prior Michele
Alabardi.[87]

The paintings Alabardi commissioned were
intended to make the eucharistic theme amply
apparent. The *Gathering of Manna* was widely
understood to refer to the sacrament of the
Eucharist, and Tintoretto supported this emphasis
in the *Last Supper*, in which the narrative moment
chosen is not ambiguous (as in his earlier parish
Suppers), focusing directly on the Communion of
Apostles (illus. 207). The oblique angle of the table
is drawn from Tintoretto's version of the subject in
San Rocco, its placement apparently determined by
the viewpoint of the congregation far to the right of
the painting. But on this occasion, Christ and the
Apostles are placed behind the *mensa*, occupying a
space which is clearly separated from that of Judas,
the servants and, by extension, the viewer beyond
the picture frame. The modulation toward a more
hierarchic conception is evident again from
Christ's centralized position within composition:
the exaggerated explosion of light from his halo,
a reference to the Johannine metaphor of God-as-
Light, transforms him into an icon quite different
from the shadowy marginal figure depicted at
San Rocco.

By carefully controlling the composition, and by

208 Jacopo Tintoretto, *Gathering of Manna*, 1591/2,
oil on canvas, 377 × 576.
San Giorgio Maggiore, Venice.

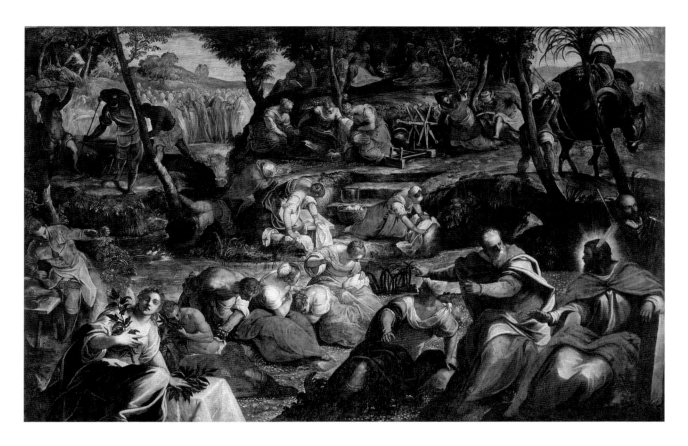

the elaboration of material context (to include servants, still-life and animals), Tintoretto modulated his treatment of the subject away from that developed for more humble patrons among the city's lay confraternities. And yet, the pendant painting is remarkable precisely because of its inclusion of many details from the artisan life of the Venetian *popolani* (illus. 208). Rather than actively gathering manna, we are shown the Israelites at work, in the guise of a blacksmith, a shoemaker, a peddler and working women who wash and spin (illus. 209). On an iconographic level it seems likely that their lack of awareness of God's gift (emphasized by the downward turn of their heads toward their work) is judged. It may even be that (following Numbers 11.4–6) they actively refuse the manna. But three of the foreground figures have already begun to pay attention, and pick up branches which may function as Messianic symbols of Christ.[88] The relationship between the physical labour of the ordinary people and spiritual enlightenment is not, in Tintoretto's hands, an antithetical one. On the contrary, it might even be taken that the one is a kind of prerequisite to the other. We are shown a gradual or sequential awakening, to which all will eventually succeed, but that at present is fully achieved only in the female figure at the foreground left who peers out across the real space of sanctuary to the pendant painting of the *Last Supper*.

The particularity of Tintoretto's conception is

209 Jacopo Tintoretto, detail of illus. 208.

209 Jacopo Tintoretto, detail of illus. 208.

210 Paolo Veronese, *Gathering of Manna*, 1580/5,
oil on canvas. Santi Apostoli, Venice.

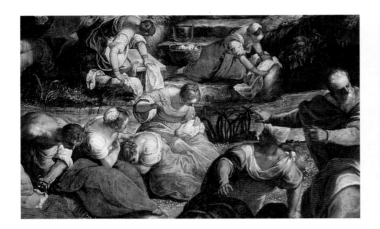

revealed by a comparison with the painting of the
same subject by the workshop of Veronese in Santi
Apostoli (illus. 210). Like Tintoretto's painting,
Veronese's was a pendant to a *Last Supper*, and it is
clear that both sets share a similar post-Tridentine
concern to contrast Old and New Testament
dispensations. But the work undertaken by
Veronese's Israelites is confined to activities of an
idealized pastoral nature, such as tending sheep or
drawing water from a stream. We need not have
recourse to Max Dvořak's idea that Tintoretto
sought to represent the medieval arts and crafts in
attempting to explain this difference.[89] As we have
seen, details of urban artisan life had often found a
place in his religious imagery from the period of his
association with the *poligrafi* onwards. Even here, in
the élite context of the sanctuary of San Giorgio
Maggiore, he sought to combine 'high' and 'low',
opening his imagery to readings on a number of
different levels, and anticipating a wide social range
within his viewing public.

Tintoretto's final painting, the small altarpiece
showing the *Deposition of Christ*, was painted for the
Capella dei Morti in San Giorgio probably in the
early months of 1594 (illus. 211).[90] The painting
immediately recalls the San Francesco altarpiece
(illus. 110) painted some three decades before,
although in the context of the mortuary chapel of
San Giorgio Christ's blood-smeared body becomes
newly significant. As in the sanctuary paintings,
Tintoretto here makes the eucharistic reference very
explicit. The painting is characterized by an
emotional immediacy and visual directness learned
at San Rocco: details of landscape, physiognomy and
gesture are reduced to schematic essentials and
colour becomes a kind of symbolic adjunct to the
theme. The Virgin's empathetic swoon allows her
body to directly mirror the cruciform shape of the
dead Christ himself, while the grey-blue and scarlet
of her robes echo the colours of Christ's loin cloth
and the blood smearing his body as if to re-
emphasize her *imitatio cristo*. As at San Rocco,
Tintoretto draws directly on formal repetition and
reversal to create an iconographically significant
connection. These colours are also repeated in the
figure of Joseph of Arimathea who supports Christ's
shoulders. In his earlier painting for the Scuola di
San Marco, Tintoretto had shown his patron
Tommaso Rangone as Joseph (illus. 123). It may be
that here the patron portrait is replaced by one of

211 Jacopo Tintoretto, *Deposition of Christ*, 1594, oil on canvas, 288 × 166. San Giorgio Maggiore, Venice.

the painter himself. The aged and bearded figure, dressed in Venetian Senatorial robes, with deep-set and sunken eyes, bears comparison with the Louvre *Self-Portrait* (see illus. 1) painted five years before. If this is indeed a self-portrait, it would certainly make a significant parallel to a painting with a similar position in Titian's career. In the unfinished *Pietà*, perhaps destined for his tomb in the Frari (Venice, Accademia), Titian included his own features as those of St Jerome tentatively approaching the Virgin and Christ. It may be that Titian's example encouraged the aged Tintoretto, in his final work for San Giorgio, to make an equivalent identification. Following his successful transformation of the field of religious painting in Venice, the image of himself as the 'man of means', whose intense devotion led him to place the body of Christ in his own tomb, was a particularly apposite one.[91]

212 Francesco Pianta the Younger, *Tintoretto as 'Painting'*,
second half of the 17th century, wood carving.
Scuola Grande di San Rocco, Venice (Sala Superiore).

Conclusion

In the pictorial imagery of San Rocco the value of poverty is universalized and sanctified, becoming a precondition for participation in the essential Christian process of fall and redemption. In response to criticism of the commissioning institution, Tintoretto promoted poverty as an outward symbol for inner spiritual life. We have seen how he showed the Holy Family as poor and how he manipulated compositional structures in order to stress the essential humility of Christ, removing him to the picture margins to allow the destitute and sick a newly privileged role. We have also noted his development of a kind of technical poverty in the Meeting House, one which transformed the abbreviated manner which he had first used as a pragmatic response to a situation of professional struggle into a suitable vehicle for the 'reformed' morality of his later religious paintings.

From this point of view, Tintoretto's manner at San Rocco is best described in negative terms, as a form of visual repression or withdrawal: it is what is *not* done with paint, the expectation denied, that becomes most significant. Contemporaries may have felt a sense of lack when confronted by Tintoretto's roughly made paintings. Following their experience of Titian, the Venetian art-loving public were more accustomed to a highly worked paint surface saturated with a wide range of pigments.[1] The Titianesque manner exploited carefully worked chromatic harmonies to create a luxuriant decorative unity across the picture surface, one which could initiate a sophisticated play with natural form, but did not ultimately challenge its primacy. Tintoretto's sketchy paint surface was very different, chiaroscuro subduing local colour, the muted tones produced with a thinly loaded or dry brush barely covering the dark ground preparation, or the coarsely woven canvas

beneath. All marks on the surface appear as improvised and approximate, with material figures and objects losing their more substantial qualities as a consequence. If the paint surface continues to draw attention to itself, its main function is to deny a simple correlation of material and spiritual splendour. The Tintoretto paint surface acts more like an austere corrective to this idea. The abbreviations of the technique are, as it were, proportionate to the expressive truth of the sacred image, its material 'poverty' securing a newly intense spirituality.

Poverty, it might be said, came to have a paradigmatic meaning for Tintoretto, one linking his professional identity, his sacred iconography and his painting technique.[2] This meaning was generated by an interplay of social and personal histories. It emerged in the wider context of sixteenth-century social and religious reforms that afforded the poor a new profile within Venetian culture. Notions of sacred poverty were, as we have noted, a commonplace in the contemporary texts of religious reformers, and were also present in the literary outpourings of Tintoretto's early associates among the *poligrafi*. But if Tintoretto's especial concern with the value of poverty at San Rocco owed much to institutional pressures, it must also have owed something to the particularities of his own professional identity: that is, to the poverty inscribed in his persona as Tintoretto, 'the little dyer'. Here we recall his defining antagonism with the supremely successful and high-ranking figure of Titian, the embodiment of artistic *richezza*, which so dominated his earlier career, and was perhaps the original cause of his self-conscious identification with the underclass of his native city.

Many aspects of Tintoretto's practice analysed in this study suggest that he readily took up the mantle

of Venetian republican painter which Titian had eschewed. But Tintoretto's were not the innocent values of the naïve patriotic and pious craftsman of Venetian convention. His professional identity was more knowing and deliberate, a matter of sophisticated artistic posture rather than of simple social position. Beneath the guise of selfless public service lurked a more independent personality whose insistence on his right to artistic licence often surfaced, leading him into conflict with the Venetian public institutions to which he was apparently so committed. At the heart of his troubled career lay the conflict between his artisan persona and his person as artist. So much is apparent in the telling image carved by Francesco Pianta for the Scuola di San Rocco in the mid-seventeenth century (illus. 212). Pianta manages to capture the fierce inner energy of the Tintoretto identity in his carving, but his use of burlesque distortion also adds a further dimension. The caricature draws out the contradictions between this mighty creative furor and the twisted body of 'the little dyer' struggling to control his crudely made brushes and pots. The humour and strength of Pianta's wood carving are generated by the contradiction he allows to surface between Tintoretto's personae: that is, between the humble artisan (*artigiano*), with his non-exclusive subservience to the demands of the wider Venetian public, and the divinely inspired artist (*artista*), with his unyielding commitment to expressive freedom. But this unresolved paradox may also be said to have facilitated his artistic achievement. Tintoretto's movement between the two roles generated a vital creative energy which took his art beyond the parochialism of the Venetian public institutions he served, just as it released it from the ever-narrowing high culture of the social and artistic élite.

The Prices of Tintoretto's Paintings

NUMBER	DATE	SUBJECT(S)	PICTURE TYPE	ORIGINAL LOCATION	SIZE IN CM	NUMBER OF FIGURES	PATRON/ RECIPIENT	PRICE IN DUCATS
1	earliest period	–	cassoni paintings	–	–	–	–	without pay
2	c. 1540–42	Battle scene; hands and feet cornice; a history; a painted frieze; female figures	façade frescoes	Palazzo Soranzo at the Ponte dell'Angelo	–	–	Soranzo family	expenses only
3	1548–49	St Marcellinus in Glory	high altarpiece	San Marziale	376 × 181	3	Scuola di San Marziale	50
4	1551	–	–	San Marziale, (Capella Maggiore)	–	–	Scuola di San Marziale	25
5	1552–6	Presentation of the Virgin Apparition of the Cross to St Peter Martyrdom of St Paul	organ doors	Madonna dell' Orto	429 × 480 420 × 240 420 × 240	17+ 5 3	Secular Canons of San Giorgio in Alga	c. 35
6	1553	Anton Francesco Doni	portrait	–	–	1	sitter	gift
7	c. 1553	Excommunication of Frederick Barbarossa (?)	wall painting	Ducal Palace (Sala del Maggior Consiglio)	–	–	state	150
8	1557	Conversion of St Paul Sts Mark and John Sts Luke and Matthew	organ doors	Santa Maria del Giglio	259 × 300 257 × 150 259 × 150	– 2 2	Procurator Giulio Contarini	20
9	1559	Christ at the Pool of Bethesda	cupboard doors	San Rocco	238 × 560	25+	Scuola Grande di San Rocco	25
10	1560	Doge Girolamo Priuli	portrait	Procuratia de Ultra	102 × 84	1	state	25
11	1562	Coronation of Frederick Barbarossa (?)	wall painting	Ducal Palace (Sala del Maggior Consiglio)	–	–	state	100
12	1562	'Turkish battle'	–	Mantua	–	–	Cardinal Ercole Gonzaga	gift
13	c. 1562–3	Last Judgement Adoration of the Golden Calf	laterali	Madonna dell' Orto	1450 × 590 1450 × 580	many	Secular Canons of San Giorgio in Alga	100
14	1563	Virgin and Child with Saints	high altarpiece	Brac, Island of Bol	–	8	Dominican order	220
15	1564	St Roch in Glory	ceiling painting	Scuola di San Rocco (albergo)	240 × 360	12	Scuola Grande di San Rocco	donation

NUMBER	DATE	SUBJECT(S)	PICTURE TYPE	ORIGINAL LOCATION	SIZE IN CM	NUMBER OF FIGURES	PATRON/ RECIPIENT	PRICE IN DUCATS
16	1565	Crucifixion	wall painting	Scuola di San Rocco (albergo)	536 × 1224	many	Scuola Grande di San Rocco	250
17	1567	St Roch in Prison Visited by an Angel St Roch Healing the Animals Annunciation	*laterali*, wall painting	San Rocco (choir) Scuola di San Rocco	300 × 670 230 × 670 —	17+ 8+ —	Scuola Grande di San Rocco	*c*. 135
18	1568	Transportation of the Body of St Mark to Venice	wall painting	Scuola Grande di San Marco (Sala Capitolare)	—	—	Tommaso Rangone	80
19	1571	Battle of Lepanto	wall painting	Ducal Palace (Sala del Scrutinio)	—	—	state	donation
20	1571	Philosophers (9); portraits (11); 'histories' (3); Pietà; Nativity; cartoons for San Marco mosaics; design for a wooden crucifix	various	Libreria Marciana (vestibule), courtyard of the Ducal Palace, San Marco etc.	250 × 160 108 × 170	—	state	70
21	1573	Raising of Lazarus; 'history of Moses'; portraits (7)	wall paintings, portraits	—	67 × 77	20 20	Procurator Gerolamo da Mula	70
22	1574	King Henri III of France	portrait	—	—	1	sitter	gift
23	1574	—	—	—	—	—	King Henri III of France	50
24	1576	Gerolamo da Mula Marcantonio Barbaro Andrea Dolfin	portraits	— — —	— — —	1	sitters	60
25	1575–8	13 Old Testament subjects	ceiling paintings	Scuola di San Rocco (Sala Superiore)	various	many	Scuola Grande di San Rocco	240
26	1578–94	19 scenes from the lives of Christ and Mary Apparition of St Roch	wall paintings, altarpiece	Scuola di San Rocco (Sala Superiore, Sala Terrena)	various	many	Scuola Grande di San Rocco	1,579
27	1578	Three Graces and Mercury Ariadne, Venus and Bacchus Minerva and Mars Forge of Vulcan	wall paintings	Ducal Palace (Sala dell'Atrio Quatrato)	146–8 × 155–67	4 3 4 4	state	200
28	1579–82	Triumph of Doge Nicolò da Ponte	ceiling painting	Ducal Palace (Sala del Maggior Consiglio)	810 × 420	many	state	accepted less than valuation

NUMBER	DATE	SUBJECT(S)	PICTURE TYPE	ORIGINAL LOCATION	SIZE IN CM	NUMBER OF FIGURES	PATRON/RECIPIENT	PRICE IN DUCATS
29	1579–80	Federico II's entry into Milan Federico II's victory at Parma Federico II's victory at Pavia Entrance of Philip II into Mantua	wall paintings	Ducal Palace, Mantua (Sala dei Duchi)	206 × 334 213 × 276 212 × 276 213 × 330	many	Duke Guglielmo Gonzaga of Mantua	234
30	1582	Luigi Groto	portrait	Adria	91 × 101	1	sitter	gift
31	1583	Nativity	altarpiece	El Escorial	315 × 190	15+	King Philip II of Spain	400 (?)
32	1584	Adoration of the Cross	altarpiece	San Marcuola	275 × 165	6	Scuola dei Tessitori di Seta	20
33	1585	Dream of St Mark Apparition of St Mark Transportation of the Body of St Mark Arrival of the Body of St Mark St Mark Giving Benediction to the Islands of Venice	wall paintings, altarpiece	Scuola di San Marco (Sala Superiore)	343 × 317	5+	Scuola Grande di San Marco	donation
34	1588	St Leonard	altarpiece	San Marco	–	5+	state	49
35	c. 1588–92	Paradise	wall painting	Ducal Palace, Sala del Maggior Consiglio	700 × 2,200	many	state	accepted less than valuation
36	c. 1591–2	Last Supper Gathering of the Manna	laterali	San Giorgio Maggiore	365 × 568 377 × 576	many	Benedictine order	180
37	1593–4	Coronation of the Virgin	altarpiece	San Giorgio Maggiore (right transept)	–	13+	Benedictine order	150
38	c. 1594	St George and the Dragon	altarpiece	San Giorgio Maggiore	–	–	Benedictine order	80
39	1594	Deposition	altarpiece	San Giorgio Maggiore	288 × 166	13	Benedictine order	70

Genealogy of the 'Tocco d'Oro' Soranzo[1]

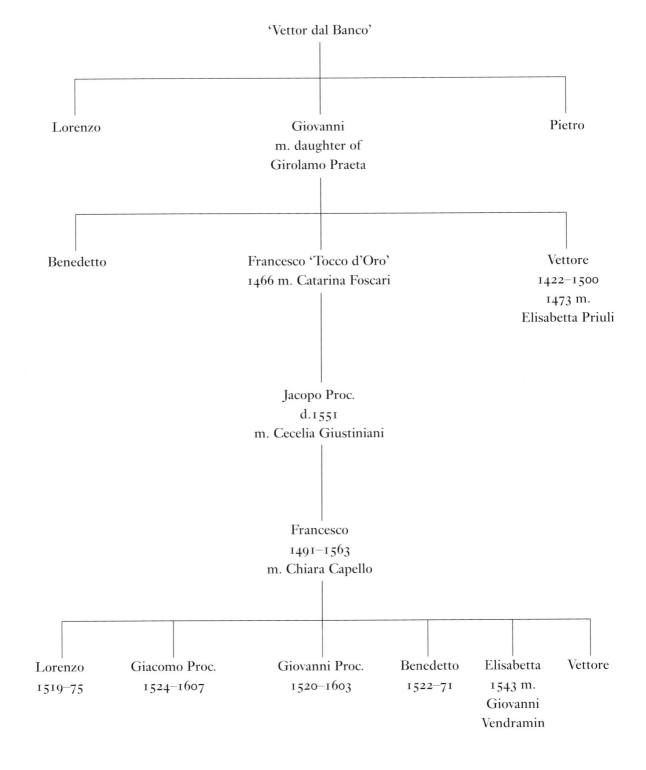

'Vettor dal Banco'

Lorenzo

Giovanni
m. daughter of
Girolamo Praeta

Pietro

Benedetto

Francesco 'Tocco d'Oro'
1466 m. Catarina Foscari

Vettore
1422–1500
1473 m.
Elisabetta Priuli

Jacopo Proc.
d.1551
m. Cecelia Giustiniani

Francesco
1491–1563
m. Chiara Capello

Lorenzo
1519–75

Giacomo Proc.
1524–1607

Giovanni Proc.
1520–1603

Benedetto
1522–71

Elisabetta
1543 m.
Giovanni
Vendramin

Vettore

References

INTRODUCTION: TINTORETTO, TRADITION, IDENTITY

1 According to the document recording Tintoretto's death on 31 May 1594, he was 75 years old: Rodolfo Pallucchini and Paola Rossi, *Jacopo Tintoretto: Le opere sacre e profane* (Milan, 1982), vol. I, p. 125. For Tintoretto's brief visit to Mantua in 1580, see Chapter 3, pp. 133–4. A Mantuan document dating from 1591 has been taken to refer to Tintoretto's presence in the city, but the identification remains questionable: Gilberto Carra, 'Il Tintoretto a Mantova nel 1591', *Civiltà mantovana*, XI (1977), pp. 233–5.

2 See notes 32 and 33 for the main literature on Tintoretto as a Mannerist.

3 Following a long-established critical position, Bernard Berenson asserted that Titian 'is the only painter who expressed nearly all of the Renaissance that could find expression in painting' and that 'it is this which makes him even more interesting than Tintoretto'. He also argued that 'with Tintoretto ends the universal interest the Venetian school arouses', the decline setting in with the painter's 'natural followers' Palma Giovane and Domenico Tintoretto: Bernard Berenson, *The Venetian Painters of the Renaissance* (New York and London, 1894), pp. 48, 60, 71–2. In the introductory survey of Venetian Renaissance painting published a century later, the same broad schema is followed, with Venetian art seen as going into a 'rapid decline after 1590': Peter Humfrey, *Painting in Renaissance Venice* (New Haven and London, 1995), p. 266. For a more detailed examination of the underlying causes of this 'decline' see David Rosand, 'The Crisis of the Venetian Renaissance Tradition', *L'arte*, XI–XII (1970), pp. 5–53, esp. p. 35.

4 The quotations from Vasari used in this book are taken from the (incomplete) translation by Gaston de Vere, originally published in 1912, and now available in a two-volume set as the *Lives of the Painters, Sculptors and Architects* (London, 1996). For the passage quoted here: vol. II, pp. 509–10. Where no translation from Vasari is available, I have used the edition of Gaetano Milanesi, published between 1878 and 1885. For a reading of Vasari's comments in terms of the author's *toscanità*, see Anna Laura Lepschy, *Tintoretto Observed: A Documentary Survey of Critical Reactions from the 16th to the 20th Century* (Ravenna, 1983), p. 21.

5 Tintoretto was a member of the Accademia Pellegrina in 1552 (see Chapter 2, p. 76 below) and the Accademia Veneziana seconda in 1593 (see Rosand, 'The Crisis of the Venetian Renaissance Tradition', p. 35). The studio motto is noted by Carlo Ridolfi (1648), *Le Maraviglie dell' Arte*, ed. Detlev von Hadeln (Berlin, 1924), vol. II, p. 14. In a recent translation by Catherine and Robert Enggass, *The Life of Tintoretto and of His Children Domenico and Marietta* (University Park, PA and London, 1984), p. 16, the word 'colorito' is incorrectly rendered as 'colour'. The idea of an eclectic combination of Venetian and central Italian styles was already current in Tintoretto's early period: Paolo Pino, *Dialogo della pittura* (1548) in *Trattati d'arte del cinquecento*, ed. Paola Barocchi, vol. I (Bari, 1960), p. 127. For Vasari's Accademia del Disegno, see Carl Goldstein, 'Vasari and the Florentine Accademia del Disegno', *Zeitschrift für Kunstgeschichte*, XXXVIII (1975), pp. 145–52; M. A. Jack, 'The Accademia del Disegno in Late Renaissance Florence', *The Sixteenth Century Journal*, VII (1976), pp. 3–20. A. Hughes, '"An Academy for Doing" I: The Accademia del Disegno, the Guilds and the Patriciate in Sixteenth-Century Florence', *Oxford Art Journal*, IX/1 (1986), pp. 3–10; '"An Academy for Doing" II: Academies, Status and Power in Early Modern Europe', *Oxford Art Journal*, IX/1 (1986), pp. 50–62.

6 Tintoretto's will, dated 30 May 1594, the day before the registration of his death, reads, 'My son Domenico is to finish those of my works which remain incomplete, in the usual manner and with the diligence that he has used on my many of my works': Archivio di Stato di Venice, Notarial Testaments, notary Antonio Brinis, busta 157, n. 483.

7 The idea that 'self-fashioning' was the defining characteristic of Renaissance literary culture is pursued in Stephen Greenblatt, *Renaissance Self-Fashioning* (London, 1980), pp. 1–9. The most famous visual artist in sixteenth-century Italy may also have knowingly fashioned his identity: see Paul Barolsky, *Michelangelo's Nose: A Myth and its Maker* (University Park, PA and London, 1991)

8 For the *serrata* and a more general introduction to Venetian Renaissance society, see Frederic C. Lane, *Venice: A Maritime Republic* (Baltimore and London, 1973), pp. 237–73. The Venetian patriciate and the divisions within it are analysed by Robert Finlay, *Politics in Renaissance Venice* (New Brunswick, 1980).

9 For the conflicts over patrician identity, see Ugo Tucci, 'The Psychology of the Venetian Merchant in the Sixteenth Century', in *Renaissance Venice*, ed. J. R. Hale (London, 1973), pp. 346–78; Edward Muir, 'Images of Power: Art and Pageantry in Renaissance Venice', *American Historical Review*, LXXXIV (1979), pp. 16–52. For the growing cultural contrast between Venice and other Italian States in the sixteenth century, see H. G. Koenigsberger, 'Estates and Revolutions', *Past and Present*, LXXXIII (1979), pp. 36–9. The conflict between *mediocritas* and *magnificentia* within Venice is elucidated in Manfredo Tafuri, *Venice and the Renaissance* (Cambridge, Mass., and London, 1989), especially pp. 1–13.

10 In addition to Vasari's *Lives*, the most significant contributors to Italian Renaissance art theory were Cennino Cennini (c. 1400), *The Craftsman's Handbook: 'Il libro dell' arte'* (New York, 1960); Leon Battista Alberti (1435–85), *L'architectura (De re aedificatoria)*, ed. Pietro Portoghesi (Milan, 1966); *On Painting and Sculpture*, ed. Cecil Grayson (London, 1972); Lorenzo Ghiberti, *Lorenzo Ghibertis Denkwürdigkeiten (I Commentari)*, ed. Julius von Schlosser (Berlin, 1912); Leonardo da Vinci, *Das Buch von der Malerei: Nach dem Codex Vaticanus (Urbinas) 1270*, ed. Heinrich Ludwig (Vienna, 1888). The fundamental study of this body of literature remains Julius von Schlosser, *Die Kunstliteratur* (Vienna, 1924). For painting and the Liberal Arts, see Rudolf Wittkower, *The Artist and the Liberal Arts* (London, 1952). For the changing status of the artist in the Renaissance, see Nicolaus Pevsner, *Academies of Art Past and Present* (Cambridge, 1940), pp. 31–42; Rudolf and Margot Wittkower, *Born Under Saturn: The Character and Conduct of Artists* (London, 1963), pp. 14–16; Andrew Martindale, *The Rise of the Artist* (London, 1972); Sergio Rossi, *Dalle botteghe alle accademie: Realtà sociale e teorie artische a Firenze dal XIV al XVI secolo* (Milan, 1980).

11 The most important recent discussion of the Venetian painter's guild, with full bibliography, is David Rosand, *Painting in Sixteenth-Century Venice: Titian, Veronese, Tintoretto* (rev. edn, Cambridge, 1997), pp. 5–10.

12 For the Venetian artisan democracy of painters and Cima da Conegliano's attempt to weight the board, *ibid.*, p. 7. For the guild's action against painters combining illegally with chestmakers (*castelleri*), see Elena Favaro, *L'arte dei pittori in Venezia e i suoi statuti* (Florence, 1975), p. 72. Pietro Malombra was the son of the learned Bartolomeo, author of devotional poems and, according to Ridolfi, a friend of Tintoretto: C. and R. Enggass, *The Life of Tintoretto and his Children Domenico and Marietta*, p. 77. For Contarini's knighthood and court artists more generally, see Martin Warnke, *The Court Artist: On the Ancestry of the Modern Artist* (Cambridge, 1993), p. 170 and passim.

13 A useful overview of Titian's patronage is provided in *Titian: Prince of Painters*, exh. cat., National Gallery of Art, Washington, DC, and Ducal Palace, Venice (London, 1990), pp. 85–93. See also Charles Hope, 'Titian as a Court Painter', *Oxford Art Journal*, II/2 (1979), pp. 7–10.

14 Ridolfi, *La Maraviglie dell' Arte*, p. 69 and C. and R. Enggass, T*he Life of Tintoretto and of His Children Domenico and Marietta*, p. 77. For the well-established literary genre of artistic biography and the conventional function of status anecdotes within it, see Ernst Kris and Otto Kurz, *Legend, Myth and Magic in the Image of the Artist: A Historical Experiment* (London, 1979), pp. 38–60.

15 The careful elaboration of Ridolfi's anecdote in Mariette's *Abecedario* (Paris, 1858–9), vol. V, p. 1 indicates, as von Hadeln noticed (Ridolfi, *La Maraviglie dell' Arte*, p. 69, n. 3), that the author knew the earlier writer's source. For the public office of the Episcopi, see Rodolfo Gallo, 'La famiglia di Jacopo Tintoretto', *Ateneo veneto*, CXXXII (1941), p. 76. For the definition of the *cittadini originarii*, see Brian Pullan, *Rich and Poor in Renaissance Venice: The Social Institutions of a Catholic State to 1620* (Oxford, 1971), pp. 99–131. For their privileged position at the Ducal Chancery, see Giuseppe Trebbi, 'La cancelleria veneta nei secoli XVI e XVII', *Annali della Fondazione Luigi Einaudi*, XIV (1980), esp. pp. 70–73. Significantly, in the case of the anecdote under discussion here, the *originarii* were even allowed to wear the red toga of patrician senators from 1485 onwards. The Episcopi feature in Tassini's manuscript list of Venetian citizen families while the Robusti do not, an omission which may indicate that Tintoretto's father worked in his shop, see Giuseppe Tassini, *Cittadini veneziani*, 5 vols (1888), in the Biblioteca Museo Correr, 33D 76/1–5.

16 Quotations from Sartre are taken from *Essays in Aesthetics*, trans. W. Baskin (New York, 1963), pp. 26, 33–4. For the normality of Tintoretto's social origins as an artist, see Peter Burke, *Culture and Society in Renaissance Italy 1420–1540* (London, 1972), p. 280. See Gallo, 'La famiglia di Jacopo Tintoretto', p. 73, for the document establishing Giovanni Battista's occupation.

17 A useful summary of the shifting nomenclature of Renaissance artists is provided by Evelyn Welch, *Art and Society in Italy, 1350–1500* (Oxford, 1997), p. 87. For the documents of 1539 and 1544, see Detlev von Hadeln in *Italienische Forschungen: Archivalische Beiträge zur Geschichte der venezianischen Kunst aus dem Nachlass G. Ludwigs* (Berlin, 1911), p. 126. For the 1540 painting, see pp. 34–5. The suggestion that the symbol relates to dyeing was made by Carlo Banari, 'Il Teatrale Tintoretto', in Pierluigi de Vecchi, *L'Opera completa del Tintoretto* (Milan 1970), p. 5. For Aretino's letter of 1545, see Pietro Aretino, *Lettere sull' arte di Pietro Aretino*, ed. E. Camesasca (Milan, 1957–60), II, pp. 52–3.

18 The Madonna dell' Orto contract was published by Angelo Mercati, 'La scrittura per la "Presentazione della Madonna al Tempio" del Tintoretto a Madonna dell' Orto', *La mostra del Tintoretto a Venezia* (1937), fasc. I, pp. 4–5. For Doni's letter, see Anton Francesco Doni, *Tre libri di Lettere* (Venice, 1552), p. 75.

19 For Veronese's adoption of the Caliari name, see Giuseppe Trecca, *Paolo Veronese e Verona* (Verona, 1940), pp. 9–10. For Palladio, see Guido Piovene, 'Trissino e Palladio nell' Umanesimo vicentino', *Bolletino Centro Internazionali di Studi di Architettura A. Palladio*, V (1963), pp. 13–23.

20 The document recording Domenico's position in the Arte was published by Von Hadeln, *Italienische Forschungen*, p. 130. It was Gallo, 'La famiglia di Jacopo Tintoretto', p. 75, however, who first suggested that this document referred to Jacopo's brother rather than to his son.

21 The quotation from Zuccari is taken from a translation in Lepschy, *Tintoretto Observed*, pp. 32–3.

22 In addition to the three paintings illustrated here, Tintoretto's self-portraits were present in the collections of Alessandro Vittoria and Peter Paul Rubens in the early seventeenth century. The sixth painting is the *Self-Portrait with a Relief* mentioned by Ridolfi, which was still known in the eighteenth century when Antonio Maria Zanetti saw it in Venice. See *Jacopo Tintoretto ritratti*, exh. cat., ed. Paola Rossi, Gallerie dell' Accademia, Venice, and Kunsthistorisches Museum, Vienna (Milan, 1994), cat. no. 3. The Tintoretto painting now at the Scuola di San Rocco, sometimes identified as a self-portrait, is more likely to represent Marco Balbiani, *guardian grande* of the confraternity in 1573, see Maria Elena Massimi, 'Religione 1573: Committenza e contesto del *Ritratto virile* di Jacopo Tintoretto nella Scuola Grande di San Rocco', *Venezia cinquecento*, VII/14 (1997), pp. 141–62.

23 Ridolfi, *La Maraviglie dell' Arte*, p. 16 (C. and R. Enggass, *The Life of Tintoretto and of His Children Domenico and Marietta*, p. 18).

24 Palma's *Self-Portrait* and Britto's woodcut after Titian are discussed in *The Genius of Venice*, 1500–1600, exh. cat., ed. by Jane Martineau and Charles Hope, Royal Academy of Arts, London (1983), cat. nos 69 and P41. For the Berlin painting, see *Titian: Prince of Painters*, cat. no. 59. In his patent of nobility, Charles V described Titian as the 'Apelles of this century': Charles Hope, *Titian* (London, 1980), pp. 77–8.

25 For the lost Titian *Self-Portrait, ibid.*, p. 125. The ambiguity of Titian's activity in the Britto woodcut may have been intended, referring to the Horatian idea of the equivalence of poetry and painting (*ut pictura poesis*). For further discussion, see Luba Freedman, *Titian's Portraits Through Aretino's Lens* (University Park, PA, 1995), pp. 145–59.

26 Quoted in Lepschy, *Tintoretto Observed*, p. 25.

27 See *Jacopo Tintoretto ritratti*, cat. no. 41.

28 For the *divino artista* topos in the Renaissance, see Kris and Kurz, *Legend, Myth and Magic in the Image of the Artist*, pp. 38–60.

29 Manet's painting is now in the Musée des Beaux-Arts, Lille. For van Veen's engraving see *Jacopo Tintoretto e i suoi incisori*, exh. cat. by Maria Wiel, Ducal Palace, Venice (Milan, 1994), cat. no. 6.

30 For more on Vittoria's collection of self-portraits and on Venetian activity in this genre generally, see Jennifer Fletcher, '"Fatto al specchio": Venetian Renaissance Attitudes to Self-Portraiture', in *Imaging the Self in Renaissance Italy* (Boston, 1992), pp. 45–60.

31 The classical-academic view of Tintoretto is usefully summarized by Lepschy, *Tintoretto Observed*, pp. 57–77. The words of Boschini (from *Le ricche minere* of 1674) are quoted *ibid.*, p. 46. For an extended analysis of Boschini's art criticism in its literary and wider cultural context, see Philip Sohm, *Pittoresco: Marco Boschini, His Critics, and Their Critiques of Painterly Brushwork in Seventeenth- and Eighteenth-Century Italy* (Cambridge, 1991). The quote from Ruskin is taken from *Modern Painters* (London, 1846), in *The Works of John Ruskin*, eds Edward Tyas Cook and Alexander Wedderburn (London, 1903), IV, pp. 250–51. For 'Imagination Penetrative', see *ibid.*, pp. 249–88. See also Nicholas Penny, 'John Ruskin and Tintoretto', *Apollo*, XCIX (1974), pp. 268–73.

32 The quote is from Rodolfo Pallucchini, 'Jacopo Tintoretto', *The Encyclopedia of World Art* (New York, 1958), XIV, p. 118. The now extensive literature proclaiming Tintoretto an arch-Mannerist includes: Max Ŕak, *Geschichte der italienischen Kunst* (Munich, 1927–9); Luigi Coletti, 'La crisa manieristica nella pittura veneziana', *Convivium*, XIII (1941), pp. 109–26, and *Il Tintoretto* (Bergamo, 1940); Rodolfo Pallucchini, *La giovinezza del Tintoretto* (Milan, 1950); Pallucchini and Rossi, *Jacopo Tintoretto*.

33 The idea that Mannerism was born out of a cultural crisis is closely followed in the literature listed in the previous note. But Sydney J. Freedberg ('Observations on the Painting of the Maniera', *Art Bulletin* [1965], pp. 187–97), John Shearman ('Maniera as an Aesthetic Ideal', in *Studies in Western Art: Acts of the Twentieth International Congress of the History of Art*, ed. Millard Meiss [Princeton, 1963]), and C. H. Smyth (*Mannerism and Maniera* [Vicenza, 1992]), have convincingly shown that the style was ultra- rather than anti-classical. Paradoxically, this was also the conclusion of Rodolfo Pallucchini's own exhibition, which demonstrated the widespread diffusion of Mannerism in Venice in the mid-sixteenth century: *Da Tiziano a El Greco: Per la storia del manierismo a Venezia*, 1540–1590, exh. cat., ed. Rodolfo Pallucchini, Ducal Palace, Venice (Milan, 1981). For Titian's debt to Mannerism, see the essays in Rodolfo Pallucchini, ed., *Tiziano e il manierismo europeo* (Florence, 1978).

34 Rosand, *Painting in Sixteenth-Century Venice*, pp. 134–64. The author's scepticism of the formalistic view of Tintoretto and his belief in the painter's fundamental 'Venetianness' (*venezianità*) are summed up in his review of Pallucchini and Rossi's catalogue in *The Burlington Magazine*, CXXVI (July 1984), pp. 444–5. See also the perceptive review of Rosand's book (and the problems with his Tintoretto chapter) by Charles Cohen, *Art Bulletin*, LXVI (June 1984), pp. 337–42.

35 Sohm, *Pittoresco*, passim. A further study which pursues an analogous contextual approach is Karl M. Swoboda, *Tintoretto: Ikonographische und stilistische Untersuchungen* (Vienna and Munich, 1982).

36 Arnold Hauser, *Mannerism: The Crisis of the Renaissance and the Origin of Modern Art* (London, 1965); Sartre in *Essays in Aesthetics*, p. 26. We should add here the contribution of the Soviet art historian Boris Vipper, who claimed in a work published in 1948 that Tintoretto's art reflects 'a love of the ordinary people, belief in their inner vitality, disappointment with reality, indignation at man's inequality, at the oppression of the poor': quoted in Lepschy, *Tintoretto Observed*, pp. 149–54.

37 For Marx's original argument for a causal relationship between economic base and ideological superstructure, see Karl Marx and Friedrich Engels, *On Literature and Art* (Moscow, 1976), p. 41. The neo-Marxist modification of this position in favour of the 'relative autonomy' and 'specific effectivity' of the superstructure is argued (most influentially) by Louis Althusser, *For Marx* (Harmondsworth, 1969), pp. 111–28.

38 Simmel's essay ('Venedig') was originally published in *Zur Philosophie der Kunst* (Potsdam, 1922). The translation used here is from the quotation given in Tony Tanner, *Venice Desired* (Oxford, 1992), pp. 366–8. The idea of a widespread 'defection of the bourgeoisie' in Mediterranean countries in the later sixteenth century is expounded by Alfred von Martin, *Sociology of the Renaissance* (London, 1944), pp. 59–76; see also Fernand Braudel, *The Mediterranean and the Mediterranean World in the Age of Philip II* (London, 1973), vol. II, pp. 725–34.

I TINTORETTO, TITIAN, MICHELANGELO

1 The central importance of this relationship has long been recognized in the main literature on Tintoretto in the twentieth century, which includes Henry Thode, *Tintoretto* (Bielefeld and Leipzig, 1901); Erich von der Bercken and August L. Mayer, *Jacopo Tintoretto*, 2 vols (Munich, 1923); Mary Pittaluga, *Il Tintoretto* (Bologna, 1925); Luigi Coletti, *Il Tintoretto* (Bergamo, 1940); Erich von der Bercken, *Die Gemälde des Jacopo Tintoretto* (Munich, 1942); Hans Tietze, *Tintoretto: The Paintings and Drawings* (London, 1948); Eric Newton, *Tintoretto* (London, 1952). A more recent study specially devoted to the topic is Paola Rossi, 'Tiziano e Jacopo Tintoretto', in *Tiziano e il manierismo europeo*, ed. R. Pallucchini, pp. 171–92.

2 C. Ridolfi (1648), *Le Maraviglie dell' Arte*, ed. Detlev von Hadeln (Berlin, 1924), vol. I, p. 13 (Catherine and Robert Enggass, *The Life of Tintoretto and His Children Domenico and Marietta* [University Park, PA and London, 1984], p. 15); Marco Boschini (1660), *La carta del navegar pitoresco*, ed. Anna Pallucchini (Venice, 1966), p. 730.

3 For Tintoretto as an auto-didact, see Ridolfi, *Le Maraviglie dell' Arte*, pp. 13–16. Tintoretto's apprenticeship to Bonifazio was first proposed by Bernard Berenson in *Venetian Painters* (New York and London, 1894, p. 135), while von Hadeln suggested Bordone (Ridolfi, *Le Maraviglie dell' Arte*, p. 13, n. 6). Ridolfi himself mentions Tintoretto's early association with Schiavone (p. 15).

4 For the spread of Mannerism to Venice, see *Da Tiziano a El Greco: Per la storia del manierismo a Venezia, 1540–1590*, exh. cat, ed. Rodolfo Pallucchini, Ducal Palace, Venice (Milan, 1981), and also the useful recent summary in Peter Humfrey, *Painting in Renaissance Venice* (New Haven and London, 1995), pp. 185–98. For the impact of Mannerism on Tintoretto's early career, see the literature listed at Introduction, note 32.

5 Rodolfo Pallucchini and Paola Rossi, *Jacopo Tintoretto: Le opere sacre e profane* (Milan, 1982), vol. I, cat. no. 79. For the influence of Pordenone's drawing and other possible sources for the painting, see Guillaume Cassegrain, '"Ces choses ont été des figures de ce qui nous concerne". Une lecture de la Conversion de Saint Paul du Tintoret', *Venezia cinquecento*, VI/12 (1996), pp. 55–85. The influence of Raphael's lost cartoon for one of the Sistine tapestries is noted in Rossi, 'Tiziano e Jacopo Tintoretto', p. 172.

6 On the Grimani Collection (and the family's taste and patronage), see Marilyn Perry, 'Cardinal Domenico Grimani's Legacy of Ancient Art to Venice', *Journal of the Warburg and Courtauld Institutes*, XLI (1978), pp. 215–44, and 'A Renaissance Showplace of Art: the Palazzo Grimani at Santa Maria Formosa', *Apollo*, CXIII (1981), pp. 215–21; Michel Hochmann, *Peintres et commanditaires à Venise*, 1540–1628, Collection de l'Ecole Française de Rome, CLV (Paris and Rome, 1992), pp. 229–42. For Tintoretto's portrait of *Giovanni Grimani*, see Rodolfo Pallucchini, 'Un nuovo ritratto di Jacopo Tintoretto', *Arte veneta*, XXXVII (1983), pp. 184–7.

7 Pallucchini and Rossi, *Jacopo Tintoretto*, cat. no. 41. See also *The Genius of Venice*, exh. cat. by Jane Martineau and Charles Hope, Royal Academy of Arts, London (1983), cat. no. 99.

8 Cecil Gould, 'Sebastiano Serlio and Venetian Painting', *Journal of the Warburg and Courtauld Institutes*, XXV (1962), pp. 56–84. See also Chapter 2, p. 82.

9 John Shearman, *Mannerism* (Harmondsworth, 1967), p. 29.

10 Francesco Arcangeli, 'La "Disputa" del Tintoretto a Milano', *Paragone*, LXI (1955), pp. 21–34. For a recent assessment of Tintoretto's brushwork, see David Rosand, 'Tintoretto e gli spiriti nel penello', in *Jacopo Tintoretto nel quarto centenario della morte*, eds Paola Rossi and Lionello Puppi (Venice, 1996), pp. 133–7.

11 Pallucchini and Rossi, *Jacopo Tintoretto*, cat. no. 11. The painting, previously in a private collection in London, recently appeared on the New York art market (Berry-Hill Galleries, spring 1998).

12 The figures of St Francis and St Joseph draw on Bonifazio prototypes: see Philip Cottrell, 'Bonifazio and the Young Tintoretto', *Inferno* (St Andrews Journal of Art History), IV (1997), pp. 17–36.

13 Leo Steinberg, 'Michelangelo's Madonna Medici and Related Works', *The Burlington Magazine*, CXIII (1971), pp. 145–9.

14 Ridolfi, *Le Maraviglie dell' Arte*, p. 16 (C. and R. Enggass, *The Life of Tintoretto and His Children Domenico and Marietta*, pp. 18–19).

15 For the recent (largely convincing) revisions to Pallucchini and Rossi, *Jacopo Tintoretto*, see Robert Echols, 'Jacopo Tintoretto and Venetian Painting, 1538–48', unpublished PhD thesis, University of Maryland, 1993, and 'Giovanni Galizzi and the Problem of the Young Tintoretto', *Artibus et Historiae*, XVI/31 (1995), pp. 69–110.

16 The sets of cassoni paintings now in Vienna and London are genuine works from Tintoretto's early period, while those in Verona are probably from his workshop: Pallucchini and Rossi, *Jacopo Tintoretto*, cat. nos 36–9, 48–53, 59–60. For the façade frescoes, see pp. 49–52. The significance of the *laterale* type in relation to Tintoretto was first defined by Paul Hills, 'Piety and Patronage in Cinquecento Venice: Tintoretto and the Scuole del Sacramento', *Art History*, VI (1983), pp. 30–43.

17 For the Carmini altarpiece, see Pallucchini and Rossi, *Jacopo Tintoretto*, cat. no. 40. The patrons of this picture were identified by Peter Humfrey and Richard Mackenny, 'Venetian Trade Guilds as Patrons of Art in the Renaissance', *The Burlington Magazine*, CXXVIII (1986), pp. 317–30. Before 1548, Tintoretto also worked for the guild of the tailors (Scuola dei Sartori) on a frieze showing scenes from the Life of St Barbara (Ridolfi, *Le Maraviglie dell' Arte*, p. 16), and probably for the guild of glassblowers in Santa Maria Maddalena. These paintings cannot be identified today. For his patronage from the Scuole del Sacramento, see Hills, 'Piety and Patronage in Cinquecento Venice'.

18 Pallucchini and Rossi, *Jacopo Tintoretto*, cat. nos 21–34. The patron of the octagonals has been more precisely established by Stefania Mason, 'Intorno al soffitto di San Paternian: gli artisti di Vettore Pisani', in *Jacopo Tintoretto nel quarto centenario della morte*, pp. 71–5. For Titian's Santo Spirito ceiling, see *Titian: Prince of Painters*, exh. cat. National Gallery of Art, Washington, DC, and Ducal Palace, Venice (London, 1990), cat. no. 38, and Robert Echols, 'Titian's Venetian *Soffitti*: Sources and Transformations', in *Titian 500*, ed. J. Manca (Washington, 1994), pp. 29–49.

19 Pallucchini and Rossi, *Jacopo Tintoretto*, cat. no. 82. For Schiavone, see Frances Richardson, *Andrea Schiavone* (Oxford, 1980).

20 The seated figure seen from behind also features in the near-contemporary *Supper at Emmaus* (Budapest, Szépmüvészeti Múzeum) and in the *Last Supper* of 1547 for San Marcuola (illus. 20): Pallucchini and Rossi, *Jacopo Tintoretto*, cat. nos 42, 127. For a full transcription of Aretino's letter of 1545, see Lepschy, *Tintoretto Observed*, p. 16. For more on Aretino's paintings, see Lora Ann Palladino, 'Pietro Aretino: Orator and Art Theorist', PhD thesis, Yale University, 1981, pp. 326–36.

21 For Tintoretto's portrait, see Paola Rossi, *Tintoretto i ritratti* (Milan, 1974), cat. no. 54. For Titian's, see *Titian: Prince of Painters*, cat. no. 49, where the portrait is dated *c.* 1555. See also Rossi, 'Tiziano e Jacopo Tintoretto', p. 175.

22 The source for both the Venetian *Suppers* illustrated here was probably Marcantonio Raimondi's engraving of *c.* 1515 after a design by Raphael: *The Engraving of Marcantonio Raimondi*, exh. cat., Spencer Museum of Art, University of Kansas, Lawrence (Kansas, 1981), cat. no. 30.

23 For the *disegno/colorito* controversy, see Sydney J. Freedberg, '*Disegno* versus *colore* in Florentine and Venetian Painting of the Cinquecento', in *Florence and Venice: Comparisons and Relations* (Florence, 1980), vol. II, pp. 309–22; David Rosand, *Painting in Sixteenth-Century Venice: Titian, Veronese, Tintoretto* (rev. edn, Cambridge, 1997), pp. 10–25. For Vasari on Venetian art, see Patricia Rubin, *Giorgio Vasari: Art and History* (New Haven and London, 1995), pp. 135–7. For a useful introduction to Venetian art theory and a full translation of Dolce, see Mark Roskill, *Dolce's 'Aretino' and Venetian Art Theory of the Cinquecento* (New York, 1968).

24 'Giovanni Bellini was (in-so-far as his period allowed) a good and careful master. But he was then outdone by Giorgione of Castelfranco. And Giorgione has himself been a thousand leagues outdistanced by Titian', *ibid.*, p. 85. For Dolce's particular stress on Titian's *disegno*, see Maurice Poirier, ' "Disegno" in Titian: Dolce's Critical Challenge to Michelangelo', in *Tiziano e Venezia*, Convegno Internazionale di Studi (Venice, 1976), pp. 249–53.

25 Roskill, *Dolce's 'Aretino' and Venetian Art Theory of the Cinquecento*, pp. 187–9.

26 Vasari describes the effect of Michelangelo's *Last Judgement* in similar terms: 'This work leads after it bound in chains those who persuade themselves that they have mastered art', *Lives of the Painters, Sculptors and Architects*, trans. Gaston de Vere (London, 1996), vol. II, p. 695. For the traditions of history writing Vasari (and, by extension, Dolce) drew on, see Rubin, *Giorgio Vasari*, pp. 148–86.

27 Roskill, *Dolce's 'Aretino' and Venetian Art Theory of the Cinquecento*, p. 185.

28 For a detailed discussion of this painting, with extensive bibliography, see Rosand, *Painting in Sixteenth-Century Venice*, pp. 62–106.

29 For Renaissance theories of imitation, see G. Pigman III, 'Versions of Imitation in the Renaissance', *Renaissance Quarterly*, XXXIII (1980), pp. 1–32; David Summers, *Michelangelo and the Language of Art* (Princeton, 1981), pp. 193–4. For Veronese and Titian, see Ridolfi, *Le Maraviglie dell' Arte*, vol. I, p. 349.

30 For Veronese's altarpiece, see Terisio Pignatti and Filippo Pedrocco, *Veronese* (Milan, 1995), vol. I, cat. no. 25; Peter Humfrey, 'La pala Giustinian a San Francesco della Vigna: Contesto e commitenza', in *Nuovi studi su Paolo Veronese*, ed. Massimo Gemin (Venice, 1990), pp. 299–307. For Titian's Pesaro altarpiece, see Rosand, *Painting in Sixteenth-Century Venice*, pp. 45–51.

31 Pallucchini and Rossi, *Jacopo Tintoretto*, cat. no. 159; Joyce Plesters, 'The Examination of the Tintorettos', in *Restoring Venice: The Church of Madonna dell' Orto*, eds A. Clarke and P. Rylands (London, 1977), pp. 84–91. The use of gold leaf on the organ-shutter paintings would have matched the gilt-wood of the original fifteenth-century organ (destroyed in 1865): for further discussion, see Michael Douglas-Scott, 'Art Patronage and the Function of Images at the Madonna dell' Orto in Venice, 1462–1668', unpublished PhD thesis, University of London, 1995, pp. 225–34.

32 Simon H. Levie, 'Daniele da Volterra e Tintoretto', *Arte veneta*, VII (1953), pp. 168–70.

33 A useful review of this Venetian literature is provided in Caterina Furlan, 'La 'Fortuna' di Michelangelo a Venezia nella prima metà del cinquecento', in *Jacopo Tintoretto nel quarto centenario della morte*, pp. 19–25. The standard modern edition of Doni's Disegno is ed. Mario Pepe (Rome, 1970).

34 For Tintoretto's supposed trip to Rome *c.* 1546–7, see Pittaluga, *Il Tintoretto*, p. 58. For the availability of Michelangelo prints and casts in the sixteenth century, see *The Fortuna of Michelangelo: Prints, Drawings and Small Sculpture from California Collections*, exh. cat. by L. Price Amerson Jr, Crocker Art Gallery, Sacramento (1975); Paul James LeBrooy, *Michelangelo Models* (Vancouver, 1972).

35 Bruce Boucher, *The Sculpture of Jacopo Sansovino*, 2 vols (New Haven and London, 1991); Charles E. Cohen, *The Art of Giovanni Antonio da Pordenone: Between Dialect and Language*, 2 vols (Cambridge, 1996). For Tintoretto's early portrait of Sansovino, see Rossi, *Tintoretto i ritratti*, cat. no. 1. He painted Sansovino again in the mid-1560s in a work which may have been sent to the Medici court at Florence, perhaps in connection with his application for entry into the Accademia del Disegno (*ibid.*, cat. no. 46).

36 For the fresco tradition, see Eve Borsook, *The Mural Painters of Tuscany* (London, 1960); Millard Meiss, *The Great Age of Fresco: Discoveries, Recoveries, and Survivals* (New York, 1970). For further discussion of the reasons why Venice lacked an equivalent body of fresco paintings, see Hills, 'Piety and Patronage in Cinquecento Venice', pp. 30–31.

37 For the vogue of façade frescoes in Venice, see Ludovico Foscari, *Affreschi esterni a Venezia* (Milan, 1936); Michelangelo Muraro, 'L'affresco a Venezia: Dall' intonaco allo stile', in *Tecnica e stile, esempi di pittura murale del Rinascimento italiano*, eds Eve Borsook and Fiorella superbi Gioffredi (Florence 1986), vol. I, pp. 124–30; Francesco Valcanover *et al.*, *Pittura murale esterna nel Veneto: Venezia*

e Provincia (Bassano, 1991). Philippe de Commynes is quoted in Patricia Fortuni Brown, *Venice and Antiquity: The Venetian Sense of the Past* (New Haven and London, 1996), p. 261.

38 Vasari, *Lives of the Painters, Sculptors and Architects*, vol. II, p. 151. For the d'Anna frescoes, see Cohen, *The Art of Giovanni Antonio da Pordenone*, vol. II, pp. 709–14. For Michelangelo's commendation, see Ridolfi, *Le Maraviglie dell' Arte*, vol. I, p. 120. For Pino's *paragone* of the media, see *Dialogo di pittura*, ed. Paola Barocchi (Bari, 1960), vol. I, p. 120.

39 Vasari, *Lives of the Painters, Sculptors and Architects*, II, p. 788; Ridolfi *Le Maraviglie dell' Arte*, vol. I, pp. 120–23; André Chastel, *The Art of the Renaissance* (New York, 1988), pp. 170–87.

40 See Chapter 3, pp. 127–32, and Appendix 2.

41 Pallucchini and Rossi, *Jacopo Tintoretto*, cat. nos 17–20. The engravings illustrated here are from Antonio Maria Zanetti, *Varie pitture a fresco de'principali maestri veneziani* (Venice, 1760), pls 10–13.

42 Pallucchini and Rossi, *Jacopo Tintoretto*, p. 262. For further discussion, Pallucchini, 'Jacopo Tintoretto', *The Encyclopedia of World Art* (New York, 1958), pp. 83–8; Diana Gisolfi, 'Tintoretto e le facciate affrescate di Venezia', in *Jacopo Tintoretto nel quarto centenario della morte*, pp. 111–14.

43 Pallucchini and Rossi, *Jacopo Tintoretto*, p. 261. For the engravings, see Zanetti, *Varie pitture a fresco de' principali maestri veneziani*, pls 8–9. See also David Coffin, 'Tintoretto and the Medici Tombs', *Art Bulletin*, XXXIII (1951), pp. 119–25.

44 Ridolfi, *Le Maraviglie dell' Arte*, vol. II, p. 14. Michel Hochmann, 'Tintoret au Palais Gussoni', in *Jacopo Tintoretto nel quarto centenario della morte*, pp. 101–7.

45 Paolo Rossi, *I Disegni di Jacopo Tintoretto* (Florence, 1975), pp. 43 (n. 100), 52 (n. 5384), 49 (n. 0356), 49 (n. 0354). Rossi's catalogue cannot be taken as a full corpus of Tintoretto's drawings. For some important recent additions, W. Roger Rearick, 'From Drawing to Painting: The Role of "Disegno" in the Tintoretto Shop', in *Jacopo Tintoretto nel quarto centenario della morte*, pp. 173–81.

46 Translation in Lepschy, *Tintoretto Observed*, p. 27.

47 Vasari, *The Lives of the Painters, Sculptors and Architects*, vol. II, p. 781. A recent analysis of the group of drawings under discussion is Lucy Whitaker, 'Tintoretto's Drawings after Sculpture and His Workshop Practice', *The Sculpted Object, 1400–1700*, eds S. Currie and P. Motture (Aldershot, 1997), pp. 177–200. For a rather unconvincing attempt to link Tintoretto's later paintings to sculptures by minor followers of Michelangelo, see Katherine Dobai, *Studien zu Tintoretto und die florentinische Skulptur der Michelangelo-Nachfolge* (Bern, 1991), esp. pp. 117–28, 284–5.

48 *Florentine Drawings of the Sixteenth Century*, exh. cat. by N. Turner, British Museum, London (1986), cat. no. 130.

49 Pallucchini and Rossi, *Jacopo Tintoretto*, cat. no. 132. See the discussion in all the main literature (as at Chapter 1, n. 1); also Roland Krischel, *Jacopo Tintoretto's 'Sklavenwunder'* (Munich, 1991). Rosand, *Painting in Sixteenth-Century Venice*, pp. 134–9, was the first to draw attention to the connection with Michelangelo's fresco.

50 For the *Samson* drawing, see Rossi, *I disegni di Jacopo Tintoretto*, p. 43 (n. 99). Reference to the Medici allegories is also evident in the turbaned figure just to the left of the soldier where *Dusk* is the model, and in the two reclining figures over the background portal.

See Coffin, 'Tintoretto and the Medici Tombs', pp. 119–20.

51 For a Neoplatonic reading of the Ca' Gussoni frescoes: Coffin, *ibid.*, p. 121.

52 Boucher, *The Sculpture of Jacopo Sansovino*, cat. no. 22. Rosand, *Painting in Sixteenth-Century Venice*, pp. 136–8, Krischel, *Jacopo Tintoretto's 'Sklavenwunder'*, pp. 38–40. See also Erasmus Weddigen, 'Il secondo pergolo di San Marco e la Loggetta del Sansovino: Preliminari al Miracolo dello Schiavo di Jacopo Tintoretto', *Venezia cinquecento*, I (1991), pp. 101–29.

53 For the existing cycle of paintings in the *albergo* of the Scuola di San Marco, see Peter Humfrey, 'The Bellinesque Life of St. Mark Cycle for the Scuola Grande di San Marco in its Original Arrangement', *Zeitschrift für Kunstgeschichte*, XLVIII (1985), pp. 225–42. For Aretino's letter, see Lepschy, *Tintoretto Observed*, pp. 16–17. For Tintoretto's 'Titianesque' phase, see Tietze, *Tintoretto*, pp. 41–2.

54 Michael Levey, 'Tintoretto and the Theme of Miraculous Intervention', *Journal of the Royal Society of Arts*, CXIII (1965), pp. 707–25; Pierluigi De Vecchi, 'Invenzioni sceniche e iconografia del miracolo nella pittura di Jacopo Tintoretto', *L'arte*, XVII (1972), pp. 101–32.

55 References to Michelangelo's paintings in the Sistine Chapel increase after 1550, for example, in the organ shutters he painted in 1553 for Santa Maria del Giglio, where the figure of St Luke is based on the *Libyan Sibyl*: Pallucchini and Rossi, *Jacopo Tintoretto*, cat. no. 166.

56 Hauser, *Mannerism: The Crisis of the Renaissance and the Origin of Modern Art* (London, 1965). For the literature of 'crisis' Mannerism, see Introduction, notes 32 and 33.

57 Pallucchini and Rossi, *Jacopo Tintoretto*, cat. no. 173. It has been argued that the patrons of the altarpiece, originally in the hospital church of the Incurabili, were a 'Scuola di S. Orsola': Silvia Gramigna and Annelisa Perissa, *Scuole di arti mestieri e devotione a Venezia* (Venice, 1981), pp. 98–100. But the patrons are much more likely to have been the Orsolini (the Ursulines), a female religious congregation involved in running the hospital: Vincenzo Coronelli, *Guida de' forestieri sacro-profana per osservere il piu ragguardevole nella città di Venezia ...* (Venice, 1700), pp. 383–4. For Carpaccio's cycle, see Patricia Fortuni Brown, *Venetian Narrative Painting in the Age of Carpaccio* (New Haven and London, 1988), pp. 193–6 and 279–82. For the idea that Tintoretto's stylistic switches anticipate those of Baroque virtuosi see K. M. Swoboda, *Tintoretto: Ikonographische und stilistische Untersuchungen* (Vienna, 1982), pp. 7–8.

58 Pallucchini and Rossi, *Jacopo Tintoretto*, cat. nos 167, 170. Ridolfi, *Le Maraviglie dell' Arte*, p. 38 (C. and R. Enggass, *The Life of Tintoretto and of His Children Domenico and Marietta*, p. 43); W. Roger Rearick, 'Tintoretto's Bamberg Assunta', in *Art the Ape of Nature* (Studies in Honour of H. W. Janson), eds Moshe Barasch and Lucy Freedman Sandler (New York, 1981), pp. 367–73; Erasmus Weddigen, 'Zur Ikonographie der Bamberger "Assunta"' von Jacopo Tintoretto', in *Die Bamberger 'Himmelfahrt Mariae' von Jacopo Tintoretto*, Internationales Kolloquium in München, 1986 (Munich, 1986), pp. 61–112.

59 For Tintoretto's more general debt to Veronese in the mid-1550s, see Pallucchini and Rossi, *Jacopo Tintoretto*, pp. 46–53. For Tintoretto's exclusion at the Marciana, see Ridolfi, *Le Maraviglie dell' Arte*, p. 26; Juergen Schulz, *Venetian Painted Ceilings of the Renaissance* (Berkeley and London, 1968), cat. no. 33.

60 For Veronese's opinion of Tintoretto, see Ridolfi, *Le Maraviglie dell' Arte*, vol. 1, p. 349. For the significance of Cennini's advice, see Summers, *Michelangelo and the Language of Art*, p. 194. For Vasari's observation that Tintoretto 'worked in every manner' and his repeated emphasis on the painter's uncontrolled *fantasia*, see Vasari, *Lives of the Painters, Sculptors and Architects*, pp. 509-10.

61 Pallucchini and Rossi, *Jacopo Tintoretto*, cat. no. 162. For Bonifazio, see Giorgio Faggin, 'Bonifazio ai Camerlenghi', *Arte veneta*, XVII (1963), pp. 79–95.

62 Roskill, *Dolce's 'Aretino' and the Venetian Art Theory of the Cinquecento*, p. 127. The identification of the painting mentioned here with Tintoretto's Camerlenghi picture (first noted by Coletti, *Il Tintoretto*, p. 18) is convincing. Confusion over the iconography still reigned in the seventeenth century, when Ridolfi identified the armoured saint as St Theodore and (following Dolce) the seated female as St Margaret: Ridolfi, *Le Maraviglie dell' Arte*, p. 58.

2 TINTORETTO AND VENETIAN LITERARY CULTURE

1 Michel Hochmann, *Peintres et commanditaires à Venise, 1540–1628*, Collection d'Ecole Française de Rome, CLV (Paris and Rome, 1992), pp. 95–168.

2 Cecil Grayson, *A Renaissance Controversy: Latin or Italian* (Oxford, 1960); Oliver Logan, *Culture and Society in Renaissance Venice 1470–1790* (London, 1972), pp. 93–104; Eric Cochrane, *Italy 1530–1630* (New York, 1988), pp. 19–25.

3 For the *poligrafi* contribution to Italian Renaissance literature: Carlo Dionisotti, 'La lettaratura italiana nel'eta del Consiglio', in *Il Concilio di Trento e la riforma tridentina*, Atti del Convegno storico internazionale, I (Rome, 1965), pp. 317–43; Paul F. Grendler, *Critics of the Italian World, 1530–60* (London, 1969). For a revision to Grendler's view, see Cochrane, *Italy, 1530–1630*, pp. 84–6. See also Hochmann, *Peintres et commanditaires à Venise, 1540–1628*, pp. 99–122.

4 Patricia Labalme, 'Personality and Politics in Venice: Pietro Aretino' in *Titian, His World and Legacy*, ed. David Rosand (New York, 1982), pp. 119–32; Christopher Cairns, *Pietro Aretino and the Republic of Venice 1527–56* (Florence, 1986).

5 Anna Laura Lepschy, *Tintoretto Observed: A Documentary Survey of Critical Reactions from the 16th to the 20th Century* (Ravenna, 1983), pp. 16–17. For an alternative translation, see *Venice: A Documentary History, 1450–1630*, eds David S. Chambers, Brian Pullan and Jennifer Fletcher (Oxford, 1992), pp. 431–2. For further discussion, see Lora Ann Palladino, 'Pietro Aretino: Orator and Art Theorist', PhD thesis, Yale University, 1981, pp. 346–51.

6 For Dolce's charge of 'avarice', see Mark Roskill, *Dolce's 'Aretino' and the Venetian Art Theory of the Cinquecento* (New York, 1968), p. 195. In this now standard edition, Roskill casts doubt on the identity of the unnamed artist who is repeatedly criticized by 'Aretino' in Dolce's text. The criticism of the *Excommunication of Frederick Barbarossa by Pope Alexander III* in the Ducal Palace is seen as an attack on a painting by Giovanni Bellini. But while no such painting ever existed by Bellini, Tintoretto's recently completed work showing this subject is well documented. In disputing the accepted identification of the 'St Margaret Riding the Serpent' criticized by

Dolce with Tintoretto's *St Louis, St George and the Princess*, Roskill can again find no convincing alternative. It was evidently Dolce's aim to give an updated critical report on Tintoretto's 'progress' in the period following Aretino's letter of 1548. The charge of avarice in the final paragraph of the *Dialogo* would also fit in the context of Tintoretto criticism, developing as it does Aretino's earlier remarks into a wider attack on the painter's business practice.

7 Giulio Lorenzetti, 'Il Tintoretto e l'Aretino', *La mostra del Tintoretto a Venezia*, I (February 1937), pp. 7–14; Roskill, *Dolce's 'Aretino' and the Venetian Art Theory of the Cinquecento*, pp. 31–2.

8 The Zeuxis anecdote is from Plutarch, see Adolphe Reinach, *Textes grecs et latins relatifs à l'histoire et le peinture ancienne, recueil Milliet* (Paris, 1985), no. 248. For Michelangelo's comment, see Giorgio Vasari, *The Lives of the Painters, Sculptors and Architects*, trans. Gaston de Vere (London, 1996), vol. II, p. 1042. The Apelles anecdotes are from Eugenie Sellers, ed., *The Elder Pliny's Chapters on the History of Art* (Chicago, 1968), pp. 120–21 and Reinach, *Textes grecs et latins relatifs à l'histoire et la peinture ancien, recueil Millet*, n. 420.

9 Vasari, *The Lives of the Painters, Sculptors and Architects*, vol. II, p. 794, pp. 509–10. For the concept of *sprezzatura*, see Baldissare Castiglione, *Il libro del cortegiano*, ed. Centro studi sulla societa di antico regime (Rome, 1986), p. 31. For its application to the criticism of painting in the sixteenth century, see Roskill, *Dolce's 'Aretino' and the Venetian Art Theory of the Cinquecento*, pp. 21–2, 156–7.

10 The Venetian authorities regularly threatened to revoke Titian's official salary: Giambattista Lorenzi, *Monumenti per servire alla storia del Palazzo Ducale di Venezia* (Venice 1868), nos 366, 373, 462.

11 Marco Boschini, *La carta del navegar pitoresco*, ed. Anna Pallucchini (Venice, 1966), pp. 711–12; Hannelore Glasser, *Contracts of the Early Renaissance* (New York and London, 1977), pp. 40, 80–81.

12 Paolo Pino, *Il dialogo della pittura* (Venice, 1946), eds Rodolfo and Anna Pallucchini, pp. 113–15. The translation given here is taken from Robert Klein and Henri Zerner, *Italian Art, 1500–1600: Sources and Documents* (New Jersey, 1966), pp. 59–60.

13 Boschini, *La carta del navegar pitoresco*, pp. 711–12. See also Rensselaer Lee, *Ut Pictura Poesis: The Humanist Theory of Painting* (New York, 1943).

14 For Vasari's commendation of Bembo, see Giorgio Vasari, *Le vite de' più eccellenti pittori, scultori e architettori*, ed. Gaetano Milanesi (Florence, 1878–85), vol. II, pp. 170–72. For Titian's portrait, see *Titian: Prince of Painters*, exh. cat., National Gallery of Art, Washington, DC, and Ducal Palace, Venice (London, 1990), cat. no. 31. For Petrarchism and painting, see Elizabeth Cropper, 'On Beautiful Women, Parmigianino, *Petrarchismo* and the Vernacular Style', *Art Bulletin*, LVIII (1976), pp. 376, 390–94.

15 For Titian's influence on Aretino's attitudes to painting and literature, see Frans Saxl, *A Heritage of Images* (London, 1970), pp. 71–88; Mina Gregori, 'Tiziano e l'Aretino', in *Tiziano e il manierismo europeo*, ed. R. Pallucchni (Florence, 1978), pp. 271–306. For Aretino's influence on Titian, see Jaynie Anderson, 'Pietro Aretino and Religious Imagery', in *Interpretazione veneziane: Studi di storia dell' arte in onore di M. Muraro* (Venice, 1984), ed. David Rosand, pp. 284–7. For more on Aretino's complex attitude to artistic *prestezza*, see Palladino, 'Pietro Aretino', pp. 337–57.

16 Giovanni Aquilecchia, 'Pietro Aretino e altri poligrafi a Venezia', in *Storia della cultura veneta: Dal primo quatrocento al Consilio di Trento* (Vicenza, 1980), vol. II, pp. 77–80, 84–5. For the pro-Bembist letters, see Pietro Aretino, *Lettere sull'arte di Pietro Aretino*, ed. E. Camesasca (Milan, 1957–60), vol. I, pp. 56–8, 94–100. Cochrane, *Italy, 1530–1630*, p. 25, cites works by Aretino such as *La cortigiana* (1525) and *La passione di Gesu* (1535) as early examples of 'correct' Bembist literature. For Aretino's negative reaction to the Pitti portrait, see Philip Sohm, *Pittoresco: Marco Boschini: His Critics and Their Critiques of Painterly Brushwork in Seventeenth- and Eighteenth-Century Italy* (Cambridge, 1991), pp. 11–12 and Palladino, 'Pietro Aretino', pp. 339–41.

17 Aretino, *Lettere sull'arte di Pietro Aretino*, vol. I, pp. 55–6.

18 Charles Hope, 'Titian as a Court Painter', *Oxford Art Journal*, II/2 (1979), pp. 7–10. See also the literature mentioned at Chapter 2, note 4.

19 For Doni's communications with Tintoretto, see Anton Francesco Doni, *Tre libri di lettere* (Venice, 1552), pp. 75–9; *I marmi*, ed. E. Chioroboli (Bari, 1929), vol. I, p. 69, and *Rime del Burchiello* (Venice, 1553), pp. 3–6. See also Grendler, *Critics of the Italian World, 1530–60*, p. 58. The closeness of the relationship is indicated again by Doni's commendation of Tintoretto's brother, Domenico, in his *Infermi* (Venice, 1553): Gallo, 'La famiglia di Jacopo Tintoretto', *Ateneo veneto*, pp. 74–5. The Tintoretto–Doni relationship was first explored by Paul Hills, 'Tintoretto's Marketing', in *Venedig und Oberdeutschland in der Renaissance*, eds Bernd Roeck, Klaus Bergdolt and Andrew John Martin (Venice, 1993), pp. 107–20.

20 Calmo published two volumes of satirical verse and four of letters between 1547 and 1566. Calmo described Doni as a 'modern prophet' in a letter of 1552 (Andrea Calmo, *Lettere*, ed. Vittorio Rossi [Turin, 1888], pp. 210–11), while Doni praised Calmo as a 'brave intellect' in *I marmi*, vol. I, p. 96. For Doni's collection of engravings and Calmo's relations with Tintoretto and other Venetian artists, see Hochmann, *Peintres et commanditaires à Venise, 1540–1628*, pp. 104–6.

21 For Calmo's letter to Tintoretto, see Calmo, *Lettere*, pp. 132–3. A translation is provided by Lepschy, *Tintoretto Observed*, pp. 17–18. For a fully annotated version of the letter, see Roland Krischel, 'Andrea Calmos Brief an Jacopo Tintoretto', *Wolfenbütteler Renaissance-Mitteilungen*, XVI (1992), pp. 8–19.

22 For Doni, see Grendler, *Critics of the Italian World, 1530–60*, pp. 49–62. Beolco's support from Cornaro is noted by Giorgio Padoan, 'La commedia rinascimentale a Venezia: dalla sperimentazione umanistica alla commedia "regolare"', in *Storia della cultura veneta* (Vicenza, 1981), vol. III, p. 430. For a list of Calmo's published work, see *ibid.*, p. 434.

23 Grendler, *Critics of the Italian World, 1530–60*, p. 59. For the quote from Doni, see *La zucca*, ed. E. Allodoli (Scrittori Italiani e Stranieri, without date or place of publication), p. 9. See also Kathleen Margurite Lea, *Italian Popular Comedy: A Study in the Commedia dell' Arte, 1580–1620* (New York, 1962), p. 245.

24 Caravia, *Il sogno di Caravia* (Venice, 1541), Biiiv: 'Many ignorant people, who would be Doctors, talk constantly of the sacred writings, barbers, smiths and tailors, theologising without measure.' See also Nelli (Andrea da Bergamo), fol. 31r. For Doni's weaver's confession, see Grendler, *Critics of the Italian World, 1530–60*, pp. 250–52. For the rejection of the *studi liberali*, see Doni, *I marmi*, vol. II, p. 67.

25 Doni, *La zucca*, p. 15.

26 See Mikhail Bakhtin, *Rabelais and His World*, trans. H. Iswolsky (Cambridge, 1968); Richard M. Berrong, *Rabelais and Bakhtin: Popular Culture in Gargantua and Pantagruel* (Lincoln and London, 1986); Deborah J. Haynes, *Bakhtin and the Visual Arts* (Cambridge, 1995).

27 See the discussion in Carlo Ginzburg, *The Cheese and the Worms: The Cosmos of a Sixteenth-Century Miller* (London, 1980), pp. xvi–xvii.

28 Pietro Vescovo, 'Sier Andrea Calmo. Nuovi documenti e proposte', *Quaderne veneti*, II (1985), pp. 25–47; Roland Krischel, 'Jacopo Tintoretto: Una biographie da rintracciare', in *Jacopo Tintoretto nel quarto centenario della morte*, eds P. Rossi and L. Puppi (Venice, 1996), pp. 65–9. For further discussion, see R. Krischel, *Jacopo Tintorettos 'Sklavenwunder'*, pp. 23, 153.

29 For Doni's ready mockery of the suggestion that he could claim noble ancestry: Grendler, *Critics of the Italian World, 1530–60*, p. 49. For Calmo's fabrication of his lowly background, Ludovico Zorzi, 'Andrea Calmo', in *Dizionario biografico degli Italiani* (Rome, 1973), vol. XVI, p. 776.

30 Doni was elected secretary of the Medici-sponsored Accademia Fiorentina in 1546, and his own academy in Venice was dependent on financial backing from powerful patrician families: Aquilecchia, 'Pietro Aretino e altri poligrafia Veneziana', pp. 94–5. In like fashion, Alessandro Caravia (the goldsmith with *poligrafi* connections) was jeweller to the Medici court in the early 1560s: E. Benini, 'Alessandro Caravia, gioielliere dei Medici a Venezia', *Quaderno di teatro rivista trimestriale del teatro toscano*, II/7 (1980), pp. 177–94.

31 The relevant Cassiodorus passage is from *Variarum libri XII*, 12.24 and is quoted in Patricia Fortuni Brown, *Venice and Antiquity: The Venetian Sense of the Past* (New Haven and London, 1996), p. 6.

32 Rodolfo Pallucchini and Paola Rossi, *Jacopo Tintoretto: Le opere sacre e profane* (Milan, 1982), cat. no. 259. The San Trovaso painting, like its pendant now in London (cat. no. 260), probably dates from 1556–8 given the inscription '1556' on the pilaster at the left of the entrance to the Chapel of the Sacrament in the church. The later date (1564–6) given by Pallucchini and Rossi and others is not justified by the appearance of the paintings.

33 The broad connection between sixteenth-century Catholic reform and the rise of vernacular literature was noted by Dionisotti, 'La letteratura italiana nel'eta del Consiglio', p. 321. For Valgrisi and the Scuola del Sacramento at San Giuliano, see Giovanni Sforza, 'Riflessi della controriforma nella republica', *Archivio storico 1*, XCIII (1935), pp. 185–6. For Caravia on the Scuole Grandi, see below, pp. 149–52. A useful study of the pictorial iconography of the chapels where the reserved Sacrament was kept was Maurice Cope, *The Venetian Chapel of the Sacrament in the Sixteenth Century* (New York and London, 1979).

34 Pallucchini and Rossi, *Jacopo Tintoretto*, cat. no. 128. An autograph replica of the painting is now at the Shipley Art Gallery, Newcastle-upon-Tyne (cat. no. 124), although the related paintings at Wilton House and Toronto (cat. nos 122, 123) are probably the work of Tintoretto's followers. The combination of 'high' and 'low' in the Prado painting was first noted by Paul Hills, ' Decorum and Desire in Some Works by Tintoretto', in *Decorum in Renaissance Narrative Art*, ed. Frances Ames-Lewis and Anka Bendarek (London 1992), p. 127.

35 The derivation from Serlio is noted by Cecil Gould, 'Sebastiano Serlio and Venetian Painting', *Journal of the Warburg and Courtauld Institutes*, XXV (1962), pp. 56–84. The relevant Vitruvius passage is *De Architectura*, book VI, chapter 6: 'Genera autem sunt scaenarum tria: unum quod dicitur tragicus, alterum comicum, tertium satyricum. Horum autem arnatus sunt inter se dissimili disparique ratione, quod tragicae deformantur columnis et fastigiis et signis reliquisque regalibus rebus; comicae autem aedificiorum privatorum et maeniarorum habent speciem profesctusque fenestris dispositos imitatione communium aedificiorum rationibus.' For Vitruvius and Italian Renaissance theatre see Robert Klein and Henri Zerner, 'Vitruve et le théâtre de la Renaissance italienne', in *Le lieu théâtrale à la Renaissance*, Colloque Internationale du Centre National de la Recherche Scientifique, ed. Jean Jacquot *et al.* (Paris 1964), pp. 49–60. For the application of Vitruvian modes to fifteenth-century Italian painting, see Richard Krautheimer, 'The Tragic and Comic Scenes of the Renaissance. The Baltimore and Urbino Panels', *Gazette des Beaux-Arts*, XXXIII (1948), pp. 327–48.

36 'La composition de ce morceau [Tintoretto's *Last Supper* at San Rocco: see illus.182] est sans noblesse, ni dignite ... la scene est dans une véritable auberge de campagne': Andre Félibien, *Entretiens sur les vies et sur les ouvrages des plus excellents peintres anciens et modernes* (Paris, 1679), vol. III, p. 138; Lanzi is quoted in Lepschy, *Tintoretto Observed*, p. 65. For an illustration of the San Marcuola *Last Supper* with its classical backdrop, see *La Mostra del Tintoretto*, exh. cat. by Nino Barbantini, Ca' Pesaro, Venice (1937), p. 20.

37 Burckhardt's *Der Cicerone* is quoted in Lepschy, *Tintoretto Observed*, p. 93; Ruskin, *Modern Painters* (1846), in *The Works of John Ruskin*, eds E.T. Cook and A. Wedderburn (London, 1903), XI, p. 435.

38 Thomas Worthen, 'Tintoretto's Paintings for the Banco del Sacramento in Santa Margherita', *Art Bulletin*, LXXVIII (1996), pp. 707–32.

39 Terisio Pignatti, Filippo Pedrocco, *Veronese* (Milan, 1995), vol. I, cat. no. 194. For Veronese's interrogation and a full translation of the relevant text, Philip Fehl, 'Veronese and the Inquisition: A Study of the Subject-matter of the So-called "Feast in the House of Levi"', *Gazette des Beaux-Arts*, LVIII (1961), pp. 348–54. See also Philip Fehl, *Decorum and Wit: The Poetry of Venetian Painting* (Vienna, 1992), p. 263.

40 For the humour in Venetian mythological painting, see Jean Seznec, *The Survival of the Pagan Gods: The Mythological Tradition, Its Place in Renaissance Humanism and Art* (New York, 1953), pp. 219ff.; Paul Barolsky, *Infinite Jest: Wit and Humour in Italian Renaissance Art* (Pennsylvania, 1975), pp. 158–81. For Veronese's Turin painting, see Pignatti and Pedrocco, *Veronese*, cat. no. 252.

41 In addition to the paintings discussed, paintings such as the *Danae* (Lyons, Musée des Beaux Arts), the *Narcissus* (Rome, Galleria Colonna) and the *Liberation of Arsinoe* (Dresden, Gemäldegalerie) might also date from the *poligrafi* period (*c.* 1550–55), sharing the mix of mockery and morality which typifies the other mythologies from this phase: Pallucchini and Rossi, *Jacopo Tintoretto*, cat. nos 378, 201, 203. For a recent reading of Tintoretto's artistic personality in Rabelaisian terms, see L. Gnocchi, *Paolo Veronese fra artisti e letterati* (Florence, 1994), p. 45.

42 Carlo Ginzburg, 'Titian, Ovid, and Sixteenth Century Codes for Erotic Illustration', in *Titian's Venus of Urbino*, ed. Rona Goffen (Cambridge, 1997), pp. 23–36.

43 *Jacopo Tintoretto, 1519–1594: Il grande collezionismo mediceo*, exh. cat., eds Marco Chiarini, Sergio Marinelli and A. Tartuferi, Palazzo Pitti, Florence (1994), cat. nos 12, 13. For Titian's painting, see *Titian: Prince of Painters*, cat. no. 48.

44 Following a northern iconographic tradition, Tintoretto's caged birds undoubtedly had a sexual meaning: Barolsky, *Infinite Jest*, p. 178. Tintoretto's irreverent approach to his antique source is not, of course, like the moralized editions of Ovid fashionable in the later Middle Ages. In common with other sixteenth-century painters, he drew on contemporary classicizing translations: Bodo Guthmüller, 'Tintoretto e Ovidio. Il problema dei testi mediatori', in *Jacopo Tintoretto nel quarto centenario della morte*, pp. 257–62.

45 Pallucchini, and Rossi, *Jacopo Tintoretto*, cat. no. 155. See also Barolsky, *Infinite Jest*, pp. 175–6.

46 A useful introduction to this subject is the collection of essays edited by Goffen, *Titian's Venus of Urbino*. See also Charles Hope, 'Problems of Interpretation in Titian's Erotic Paintings', in *Tiziano e Venezia*, Convegno Internazionale di Studi (Venice, 1976), pp. 113–23; Rona Goffen, *Titian's Women* (New Haven and London, 1997).

47 Beverly L. Brown, 'Mars's Hot Minion or Tintoretto's Fractured Fable', in *Jacopo Tintoretto nel quarto centenario della morte*, pp. 199–205. See also, in the same volume, Erasmus Weddigen, 'Nuovi percorsi di avvicinamento a Jacopo Tintoretto: Venere, Vulcano e Marte: l'inquisitione dell' informatica', pp. 155–62.

48 'He trained himself by concocting in wax and clay small figures which he dressed in scraps of cloth, attentively studying the folds of the cloths on the outlines of the limbs. He also placed some of the figures in little houses and in perspective scenes made of wood and cardboard, and by means of little lamps he contrived for the windows he introduced therein lights and shadows': Carlo Ridolfi (1648), *Le Maraviglie dell' Arte*, ed. Detlev von Hadeln (Berlin, 1924), vol. II, p. 15 (Catherine and Robert Enggass, *The Life of Tintoretto and of His Children Domenico and Marietta* (University Park, PA and London, 1984), p. 17. See also von Hadeln (note 10) for other artists' use of similar models.

49 Rossi, *I disegni di Jacopo Tintoretto* (Florence, 1975), p. 15 (n. 4193).

50 For Tintoretto's contributions to Venetian comedies, see Ridolfi, *Le Maraviglie dell' Arte*, vol. II, p. 69 (Catherine and Robert Enggass, *The Life of Tintoretto and of His Children Domenico and Marietta*, p. 76). Calmo's *Il Magnifico* was later to become Pantaleone, one of the best-known characters in the *commedia dell'arte*. For the connection with the Tintoretto workshop in the 1550s, see M. A. Katritzky, 'Lodewyk Toeput and Some Pictures Related to the *Commedia dell'arte*', *Renaissance Studies*, I/1 (1987), pp. 71–125. The more general link between Mannerism and the emergence of the *commedia* is explored in P. C. Castagno, *The Early Commedia dell'arte (1550–1621): The Mannerist Context* (New York, 1994).

51 Pallucchini and Rossi, *Jacopo Tintoretto*, cat. nos 144, 200. See also Barolsky, *Infinite Jest*, pp. 176–8; Hills, 'Decorum and Desire in Some Works by Tintoretto', pp. 124–5.

52 For Titian's Venus, see *Titian: Prince of Painters*, cat. no. 51. For Veronese's *Susanna*, see Pignatti and Perdocco, *Veronese*, cat. no. 320.

53 For the connection of the mirror (which also features, with similar implications, in the *Venus, Vulcan and Mars*) with 'False Love', see Cesare Ripa, *Iconologia*, 3rd edn (Rome, 1603), p. 154. The connection of Tintoretto's Elders with the old lechers of contemporary comedies is established by Barolsky, *Infinite Jest*, pp. 176–8. For Doni's reference, see *La zucca*, p. 46.

54 Pallucchini and Rossi, *Jacopo Tintoretto*, cat. no. 151. The painting formed part of a cycle of five pictures showing scenes from Genesis painted between 1550 and 1553 for the Scuola della Trinità (cat. nos 149–52). See also Hills, 'Decorum and Desire in Some Works by Tintoretto', p. 124.

55 For Giovio's role in the conception of Vasari's *Lives*, see Patricia Rubin, *Giorgio Vasari: Art and History* (New Haven and London, 1995), pp. 107, 151, 162–4. See also Anton Francesco Doni, *Disegno*, pp. 96–7, esp. n. 4. The influence of Burchiello on the *poligrafi* is noted in Lucia Lazzarerini, ed., *La Spagnolas commedia di Andrea Calmo* (Milan, 1978), pp. 134–5.

56 For Boschini's 'painterly' manner, see Philip Sohm, *Pittoresco: Marco Boschini, His Critics, and Their Critiques of Painterly Brushwork in Seventeenth- and Eighteenth-Century Italy* (Cambridge, 1991), p. 22. See also Pietro Bembo, *Prose della volgar lingua*, ed. Carlo Dionisotti (Turin, 1931), p. 33.

57 Doni, *Disegno*, p. 22r. See also David Summers, *Michelangelo and the Language of Art* (Princeton, 1981), pp. 124–5. For the connection with Tintoretto's brushwork, see Sohm, *Pittoresco*, pp. 39–40. The painting of grotesques was revived following the discovery of ancient 'grottoes' on the site of Nero's Golden House on the Esquiline Hill in Rome in the early sixteenth century: Nicole Dacos, *La découverte de la Domus Aurea et la formation des grotesques à la Renaissance*, Studies of the Warburg Institute, XXXI (London, 1969).

58 Giorgio Vasari, *The Lives of the Painters, Sculptors and Architects*, trans. G. de Vere (London, 1996), vol. II, pp. 509, 512. Technical examination has tended to confirm Vasari's suspicions with regard to the *Last Judgement*, indicating that the painter used a fluid *ad hoc* approach: Joyce Plesters in *Restoring Venice: The Church of Madonna dell' Orto*, eds Ashley Clarke and Philip Rylands (London, 1977), pp. 84–91. But Tintoretto's technique was as variable as his style. For further discussion of his materials and techniques in other paintings, see Joyce Plesters and Lorenzo Lazzarini, 'Preliminary Observations on the Techniques and Materials of Tintoretto', in *The Conservation and Restoration of Pictorial Art*, eds N. Bromelle and P. Smith (London, 1976), pp. 7–26; Joyce Plesters, 'Tintoretto's paintings in the National Gallery', *National Gallery Technical Bulletin* (1979), pp. 3–24 and (1980), pp. 32–48.

59 Sohm, *Pittoresco*, p. 57.

60 For Mengs and Lanzi on the contrast between Titian and Tintoretto, see Lepschy, *Tintoretto Observed*, pp. 60–63. See also Joshua Reynolds, *Discourses on Art*, ed. R. R. Wark (New Haven and London, 1975), pp. 66–7.

61 *The Princes Gate Collection*, exh. cat. by Helen Braham, Courtauld Institute Galleries, London (1981), cat. no. 118 (see also nos 117, 119). For other cassoni works by Tintoretto, painted in a similar shorthand manner, see Chapter 1, note 16.

62 For wider discussion of Tintoretto and Venetian cassoni painting, see Tom Nichols, 'Tintoretto. The Painter and his Public', unpublished PhD thesis, University of East Anglia, 1992, pp. 190–206.

63 Tintoretto's mimicry of Veronese at the Crociferi has a parallel in Calmo's parodies of 'correct' Bembist style in works such as the

Rime piscatorie (1553) and in plays such as *La potione* and *La fiorina* (both 1552), in which he used as many as seven different dialects. For the playwright's wholesale borrowings from Machiavelli and Beolco in *La potione* and *La rhodiana*, and Doni's in *I marmi*, see Cochrane, *Italy 1530–1630*, pp. 70, 80.

64 For Doni's departure, perhaps precipitated by an argument with Aretino, see Grendler, *Critics of the Italian World*, *1530–60*, pp. 62–3. Tintoretto seems to have kept up his connection with Calmo into a later period. A document, probably dating from the 1570s, records the presence of Tintoretto and his son Domenico at the house of Pietro Calmo, Andrea's brother: Gallo, 'La famiglia di Jacopo Tintoretto', pp. 91–2.

3 PRICES AND PATRONS

1 For a probing discussion of Tintoretto's business practice, see Paul Hills, 'Tintoretto's Marketing', in *Venedig und Oberdeutschland in der Renaissance*, eds Bernd Roeck, Klaus Bergdolt and Andrew John Martin (Venice, 1993), pp. 107–20. See also K.W. Swoboda, *Tintoretto: Ikonographische und stilistische Untersuchungen* (Vienna, 1982), pp. 9–10.

2 For an introduction to the working conditions of Venetian painters in the sixteenth century, see David Rosand, *Paintings in Sixteenth-Century Venice: Titian, Veronese, Tintoretto* (rev. edn, Cambridge, 1997), pp. 1–14. For a general overview of Venetian prices for paintings in the period, see Michel Hochmann, *Peintres et commandataires à Venise, 1540–1628*, Collection d'Ecole Française de Rome, CLV (Paris and Rome, 1992), pp. 15–40. The general parity of Venetian and Florentine rewards for paintings by the mid-sixteenth century is established by Michelle O'Malley, 'The Business of Art: Contracts and Payment Documents for Fourteenth and Fifteenth Century Italian Altarpieces and Frescoes', unpublished PhD thesis, University of London, 1994, p. 106. The *sansaria* paid to Gentile Bellini (1474–1507), Giovanni Bellini (1507–16) and Titian (1516–76) remained unchanged in value. For the other Venetian salaries quoted here, see Frederic Lane, *Venice: A Maritime Republic* (Baltimore and London, 1973), p. 324.

3 For Bordone and Tintoretto's daughters, see Hochmann, *Peintres et commandataires à Venise, 1540–1628*, p. 47; Roland Krischel, 'Jacopo Tintoretto: Una biographie da rintracciare', in *Jacopo Tintoretto nel quarto centenario della morte*, eds Paola Rossi and Lionello Puppi (Venice, 1996), p. 67. For Faustina's plea, see Pier Liberale Rambaldi, 'Un appunto intorno al Tintoretto e ad Andrea Vicentino', *Rivista d'arte*, VII (1910), pp. 14–15. For Tintoretto's tithe declaration, see A. Giuseppe Cadorin, 'Della casa di Jacopo Robusti detto il Tintoretto', *Giornali di belle arti*, II (1834), p. 87.

4 For Veronese's land speculation, see Terisio Pignatti, *Veronese* (Venice, 1976), vol. I, pp. 257–9, docs 49–51, 61, 63, 65. Palma left more than 3,000 ducats to his daughters in 1625, see Stefania Mason Rinaldi, *Palma Giovane: L'opera completa* (Milan, 1984), p. 70. For Titian's house, see Juergen Schulz, 'The Houses of Titian, Aretino and Sansovino', in *Titian: His World and Legacy*, ed. David Rosand (New York, 1982), pp. 73–82. For Lavinia's dowry, see Rosand, *Painting in Sixteenth-Century Venice*, p. 12. Titian's salaries in 1550 are noted by Charles Hope, *Titian* (London, 1980), pp. 119–20.

A more contemporary picture of the business practice of Venetian painters in the period is given by the surviving account books of Lorenzo Lotto and Jacopo Bassano: *Lorenzo Lotto: Il Libro di spese diverse (1536–1556)*, ed. Pietro Zampietti (Venice and Rome, 1969); Michelangelo Muraro, *Il libro secondo di Francesco e Jacopo dal Ponte* (Bassano, 1992).

5 See Chapter 2, note 10. Titian's disputes with religious patrons are noted by Hope, *Titian*, pp. 99–100. For Orazio's petition, see Giambattista Lorenzi, *Monumenti per servire alla storia del Palazzo Ducale di Venezia* (Venice, 1868), nos 689, 695. For the Brescia dispute, see Harold Wethey, *The Paintings of Titian* (London, 1969–75), vol. III, p. 225.

6 Lorenzi, *Monumenti per servire alla storia del Palazzo Ducale di Venezia*, nos 188, 192; David S. Chambers, *Patrons and Artists in the Italian Renaissance* (London, 1970), n. 28. The practice of offering discounts to religious confraternities was more widespread. For another Venetian example (Cima), see Peter Humfrey, *The Altarpiece in Renaissance Venice* (New Haven and London, 1993), p. 153.

7 For the non-payment of Tintoretto's promised *sansaria*, see Rambaldi, 'Un appunto intorno al Tintoretto e ad Andrea Vicentino', p. 15.

8 For further discussion, see pp. 175–6.

9 Hills, 'Tintoretto's Marketing', p. 113. Tintoretto's fee for the linen-weavers' altarpiece was in keeping with that paid to other painters by the trade-guild Scuole. The obscure Antonio Bressan received 25 ducats from the bakers' guild for his altarpiece in Madonna dell' Orto in 1552: *Mestieri e Arti a Venezia*, exh. cat., Ducal Palace, Venice (1986), pp. 80–81. The financial limitations of the canons at Madonna dell' Orto are evident from the ceiling of 250 ducats set on annual expenditure on the church and monastic buildings in 1550: Jacobus Philippus Tommassini, *Annale Canonicorum Secularium |S. Giorgio in Alga* (Udine, 1642), p. 500. For further discussion, see Michael Douglas-Scott, 'Art Patronage and the Function of Images at the Madonna dell' Orte in Venice, 1462–1668', unpublished PhD thesis, University of London, 1995, pp. 25–6.

10 C. Ridolfi, *Le Maraviglie dell' Arte*, ed. Detlev von Hadeln (Berlin, 1924), vol. II, pp. 19, 63 (Catherine and Robert Enggass, *The Life of Tintoretto and of His Children Domenico and Marietta*, pp. 22, 69); Giovanni Domenico Ottonelli, *Trattato della pittura e scultura uso, et abuso loro* (Florence. 1652), pp. 234–5.

11 Titian took seven years to deliver his *Last Supper* (1557–64) to Philip II (illus. 21), and might even have withheld the king's version of the *Martyrdom of St Lawrence* (1565–80): M. Roy Fisher, *Titian's Assistants During His Later Years* (New York and London, 1977), p. 58. Titian's *Battle of Spoleto*, commissioned in 1516, was not delivered until 1539, while his *Faith Adored by Marco Grimani*, commissioned in 1557, was finally completed by Marco Vecellio in 1575.

12 The usual contractual expectation of Venetian patrons was that a large-scale painting for a public institution should be finished in one year: see, for example, Lorenzi, *Monumenti per servire alla storia del Palazzo Ducale di Venezia*, n. 661. This expectation corresponded with the annual rotation of public offices: Hills, 'Tintoretto's Marketing', p. 111.

13 Even Titian worked quickly on occasion. *The Entombment* for Philip II was painted in seven weeks in the summer of 1559: Roy Fisher, *Titian's Assistants During his Later Years*, p. 83. Painters from the

younger generation could work even more quickly. Veronese completed three altarpieces in as many months for a Mantuan church in 1562 and Francesco Bassano finished four ceiling paintings in five months for the Ducal Palace in 1577: Pignatti, *Veronese*, p. 253, doc. 21; Stefania Mason Rinaldi, 'Francesco Bassano e il soffitto del Maggior Consiglio in Palazzo Ducale', *Arte veneta*, XXXIV (1980), p. 219. But Tintoretto increased this rate of production as much as fourfold in his works for da Mula and Contarini.

14 Sansovino is quoted in Anna Laura Lepschy, *Tintoretto Observed: A Documentary Survey of Critical Reactions from the 16th to the 20th century* (Ravenna, 1983), p. 20. For Vasari's claim, see *Le vite de' più eccellenti pittori, scultori e architettori*, ed. Gaetano Milanesi (Florence, 1878–85), vol. IV, p. 13. See also Rodolfo Pallucchini and Paola Rossi, *Jacopo Tintoretto: Le opere sacre e profane* (Milan, 1982), and Paola Rossi, *Tintoretto I ritratti* (Milan, 1974). The standard catalogue of Titian's work lists only 321 paintings, produced over a much longer time span: see Wethey, *The Paintings of Titian*, vols I–III.

15 For the Tintoretto workshop, see Robert Echols, 'Giovanni Galizzi and the Problem of the Young Tintoretto', *Artibus et Historiae*, XVI/31 (1995), pp. 69–110; Pallucchini and Rossi, *Jacopo Tintoretto*, pp. 81–2, 93–9.

16 For Titian's workshop, see Erika Tietze-Conrat, 'Titian's Workshop in His Late Years', *Art Bulletin*, XXVI (1946), pp. 76–88; Roy Fisher, *Titian's Assistants During His Later Years*, pp. xiii, xv–xvi; Wethey, *The Paintings of Titian*, vol. I, nos 2–3. For Veronese, see David Rosand, 'Veronese and Company: Artistic Production in a Venetian Workshop', in *Veronese and His Studio in North American Collections*, exh. cat., Birmingham, Alabama (1972), pp. 5–11. Veronese also seems to have operated a hierarchy among patrons, albeit on a more restricted social scale. For example, with only a few exceptions he left non-noble Scuole commissions to his workshop: Pignatti, *Veronese*, A62, A64, A214, A321-7; Peter Humfrey and Richard Mackenny, 'Venetian Trade Guilds as Patrons of Art in the Renaissance', *The Burlington Magazine*, CXXVII (1986), nos 11 and 37. He may also have operated a price differential between autograph paintings for prominent Venetian locations and workshop paintings for provincial export. Thus the *Marriage at Cana* for the Benedictine monastery of San Giorgio Maggiore (1563) cost 380 ducats, while the workshop version for the same order at San Teonisto, Treviso (c. 1580) was priced at just 82 ducats: Pignatti, *Veronese*, p. 258, docs 56–7.

17 For the Tintoretto paintings mentioned here, see Pallucchini and Rossi, *Jacopo Tintoretto*, cat. nos 408, A10, A37, A110, 468. It appears that Titian's pupils were often closely dependent on autograph works. In contrast, Tintoretto often encouraged pupils to make independent remodellings and enlargements of his works: Roy Fisher, *Titian's Assistants during His Later Years*, pp. xiii, 91; Hans Tietze, *Tintoretto: The Paintings and Drawings* (London, 1948), p. 57.

18 Tintoretto's seven paintings of the *Raising of Lazarus*: Pallucchini and Rossi, *Jacopo Tintoretto*, cat. nos 217, 223, 243, 327, 353, 357, 452. The *Philosophers* are listed as cat. nos 318–23, the *St Jerome* as cat. no. 325. For the identification of the painting formerly at Fort Worth with the da Mula commission, see Mary Pittaluga, *Il Tintoretto* (Bologna, 1925), p. 272. See also Tietze, *Tintoretto: The Paintings and Drawings*, p. 57.

19 For a listing of Tintoretto's church commissions, see Tom Nichols, 'Tintoretto: The Painter and His Public', unpublished PhD thesis, University of East Anglia, 1992, vol. II, p. 290. For a list of his Scuole commissions, see *ibid.*, Appendix 2.

20 For a useful overview of Venetian patronage in the sixteenth century, see Jennifer Fletcher, 'Patronage in Venice', in *The Genius of Venice, 1500–1600*, exh. cat. by Jane Martineau and Charles Hope, Royal Academy of Arts, London (1983), pp. 16–20. For the social and historical character of the Scuole, see Brian Pullan, *Rich and Poor in Renaissance Venice: The Social Institutions of a Catholic State to 1620* (Oxford, 1971). For their artistic patronage Terisio Pignatti, ed., *Le Scuole di Venezia* (Milan, 1981). The art patronage of the 'lesser' Scuole has been studied in Humfrey and Mackenny, 'Venetian Trade Guilds as Patrons of Art in the Renaissance' and Paul Hills, 'Piety and Patronage in Cinquecento Venice: Tintoretto and the Scuole del Sacramento', *Art History*, VI (1983). For the spread of visual imagery into the private houses of the wider Venetian populace by 1600, see Isabella Palumbo-Fossati, 'L'interno della casa dell' artigiano e dell' artista nella Venezia del Cinquecento', *Studi veneziani*, n.s. 8 (1984), pp. 109–53.

21 An example of Titian's selectivity, even between high-ranking patrons, is the fate of the *Adoration of the Magi* (El Escorial), which began as a commission from Cardinal Ippolito d'Este in 1556, but ended up in the hands of Philip II, while d'Este was supplied with a workshop replica: Hope, *Titian*, p. 82. For Vasari's promotion of selectivity, see Giorgio Vasari, *The Lives of the Painters, Sculptors and Architects*, trans. Gaston de Vere (London, 1996), vol. II, pp. 364, 509–10.

22 Pierre Bourdieu, *Distinction: A Social Critique of the Judgement of Taste* (London and New York, 1979), pp. 232–3.

23 Tietze, *Tintoretto*, pp. 50–53.

24 The documents relating to Tintoretto's earliest official commissions were published by Detlev von Hadeln, 'Beiträge zur Tintorettoforschung', in *Jahrbuch der Königlich Preussischen Kunstsammlungen*, XXXII (1911), doc. 1; 'Beiträge zur Geschichte des Dogenpalastes', *ibid.*, p. 32. For Titian's 1508 commission, see Wethey, *The Paintings of Titian*, vol. III, cat. no. 18. The idea that Titian became the republic's 'official' painter when he received Bellini's *sansaria* has been disputed by Michelangelo Muraro, 'Tiziano pittore ufficiale della Serenissima', in *Tiziano nel quarto centenario della sua morte, 1576–1976* (Venice, 1977), pp. 82–100. For Veronese's early official commissions, see Juergen Schulz, *Venetian Painted Ceilings of the Renaissance*, cat. nos 33, 35. See also Ridolfi, *Le Maraviglie dell' Arte*, p. 26.

25 For Tintoretto's contributions to the Libreria Marciana, see Pallucchini and Rossi, *Jacopo Tintoretto*, cat. nos 246, 318–23. For the redecoration in the Ducal Palace after the fires, see Staale Sinding-Larsen, *Christ in the Council Hall: Studies in the Religious Iconography of the Venetian Republic*, Institutum Romanum Norvegiae (Rome, 1974); Wolfgang Wolters, *Der Bilderschmuck des Dogenpalastes: Untersuchungen zur Selbstdarstellung der Republik Venedig im 16. Jahrhundert* (Wiesbaden, 1983). For Veronese's Collegio ceiling, see Schulz, *Venetian Painted Ceilings of the Renaissance*, cat. no. 41.

26 Pallucchini and Rossi, *Jacopo Tintoretto*, cat. no 465; Ridolfi, *Le Maraviglie dell' Arte*, p. 62 (Catherine and Robert Enggass, *The Life*

of Tintoretto and of His Children Domenico and Marietta, p. 69). The Doge's tribune was moved from the centre of the Sala to the east wall in the mid-1580s: Patricia Fortuni Brown, *Venetian Narrative Painting in the Age of Carpaccio* (New Haven and London, 1988), p. 273. For Veronese's sketch, see Pignatti and Pedrocco, *Veronese* (Milan, 1985), vol. I, cat. no. 277. It may be that as many as three competitions for the commission were held, dating from 1563–4, 1579–82 and 1588: Juergen Schulz, 'Tintoretto and the First Competition for the Ducal Palace "Paradise"', *Arte veneta*, XXXIII (1980), pp. 112–26. Two autograph sketches for Tintoretto's painting survive in Madrid and Paris, but Domenico Tintoretto's dominant role in the execution (and perhaps even the design) of the final painting is indicated by the copies he went on to execute, probably at the request of private patrons: Pallucchini and Rossi, *Jacopo Tintoretto*, cat. nos 400, 461, A61, A123.

27 See Introduction, note 9, for literature on Venetian patrician identity in the mid- and later sixteenth century. For the *papalisti*, see Gaetano Cozzi, 'Politica, cultura e religione', in *Cultura e societa nel Rinascimento fra riforme e manierismo*, eds Vittorio Branca and Carlo Ossola (Florence, 1984), pp. 21–42; Manfredo Tafuri, *Venice and the Renaissance* (Cambridge, Mass., and London, 1989), pp. 112–14. The conflict between *vecchie* and *giovani* is elucidated by William J. Bouwsma, *Venice and the Defense of Republican Liberty: Renaissance Values in the Age of the Counter-Reformation* (Berkeley and Los Angeles, 1968).

28 For the *renovatio urbis*, Manfredo Tafuri, ed., *'Renovatio Urbis': Venezia nel'eta di Andrea Gritti (1523–1538)* (Rome, 1984). Sansovino's buildings around San Marco are discussed in Deborah Howard, *Jacopo Sansovino: Architecture and Patronage in Renaissance Venice* (London, 1975), pp. 14–16. Veronese's patronage by the Giustiniani is discussed by Peter Humfrey, 'La pala Giustiniana a San Francesco della Vigna: Contesto e commitenza', in *Nuovi studi su Paolo Veronese*, ed. M. Gemin (Venice, 1990). For the Maser decorations, see Pignatti and Pedrocco, *Veronese*, cat. no. 123.

29 See Bouwsma, *Venice and the Defense of Republican Liberty*, where he dates the victory of the *giovani* to the winter of 1582–3: pp. 95–232.

30 For the Priuli portrait, see Paola Rossi, *Tintoretto I ritratti* (Milan, 1974), cat. no. 34. See also *Jacopo Tintoretto Ritratti*, exh. cat. by Paola Rossi, Gallerie dell'Accademia, Venice, and Kunsthistorisches Museum, Vienna (Milan 1994); W. Roger Rearick, 'Reflections on Tintoretto as a Portraitist', *Artibus et Historiae*, XVI/31 (1995), pp. 51–68.

31 *Jacopo Tintoretto ritratti*, cat. nos 19, 20.

32 For the Priuli copies, see Rossi, *Tintoretto I ritratti*, cat. nos 77, A92. For the Loredan and Mocenigo portraits, see *ibid.*, cat. nos 27, 130; see also *Jacopo Tintoretto Ritratti*, cat. no. 34.

33 Quoted in Bouwsma, *Venice and the Defense of Republican Liberty*, p. 234.

34 Tintoretto's Camerlenghi paintings are listed by Pallucchini and Rossi, *Jacopo Tintoretto*, cat. nos 162, 163, 164, 205, 317, 406, A119. They originally hung in the rooms of the Magistrato del Sale (162, 163, 164), the Camerlenghi di Comun (317, 406), the Governatori Alle Entrate, Room I (no. 205) and the Provveditori sopra le Ragioni delle Camere (A119).

35 See *Jacopo Tintoretto ritratti*, cat. no. 30.

36 *Titian: Prince of Painters*, exh. cat., National Gallery of Art, Washington, DC, and Ducal Palace, Venice (London, 1990), cat. no. 37.

37 For Titian's papal portrait, see *ibid.*, cat. no. 34. For Raphael's prototype, see Randolph Starn and Loren Partridge, *A Renaissance Likeness: Art and Culture in Raphael's Julius II* (Berkeley, 1980). For the idea of Venice as the new Rome, see David S. Chambers, *The Imperial Age of Venice, 1380–1580* (London, 1970), pp. 12–30.

38 The peculiar Venetian idea of *ristauro* (which typically meant the replacement, rather than the repair, of existing paintings) was first elucidated by Erika Tietze-Conrat, 'Decorative Paintings of the Venetian Renaissance Reconstructed from Drawings', *Art Quarterly*, III (1940), pp. 15–39; see also Brown, *Venetian Narrative Painting in the Age of Carpaccio*, pp. 83–5. For this votive painting and the other replacements Tintoretto and his workshop made for the Sala del Collegio, see Pallucchini and Rossi, *Jacopo Tintoretto*, cat. nos 418–22. See also Giovanna Nepi Sciré, 'I Dipinti votivi di Jacopo Tintoretto', in *Jacopo Tintoretto ritratti*, pp. 39–49.

39 *Ibid.*, pp. 44–5. For Veronese's *Allegory of the Battle of Lepanto*, see Pignatti and Pedrocco, *Veronese*, cat. no. 261. For the political significance of his enforced alteration, see Staale Sinding-Larsen, 'The Changes in the Iconography and Composition in Veronese's Allegory of the Battle of Lepanto in the Doge's Palace', *Journal of the Courtauld and Warburg Institutes*, XIX (1956), pp. 298–302.

40 See the portraits listed in Rossi, *Tintoretto I ritratti*, cat. nos 11, 39, 57, 60, 76, 148. Also *Jacopo Tintoretto ritratti*, cat. nos 37 and 38.

41 For the Grimani Collection, see Chapter 1, note 6. The commission from the San Luca branch of the family was discovered by Michel Hochmann, 'Le mécénat de Marino Grimani. Tintoret, Palma le Jeune, Jacopo Bassano, Giulio del Moro et le décor du palais Grimani; Véronèse et Vittoria à San Giuseppe', *Revue de l'art*, LXXXXV (1992), pp. 41–51. For Marco Gussoni, see Michel Hochmann, 'Tintoret au Palais Gussoni', in *Jacopo Tintoretto nel quatro centenario della morte*, eds Paola Rossi and Lionello Puppi (Venice, 1996), pp. 101–7

42 For an overview, see Antonio Foscari and Manfredo Tafuri, *L'armonia e conflitti: La chiesa di S. Francesco dell Vigna nella Venezia del'500* (Turin, 1983).

43 For the Grimani Chapel, see W. Roger Rearick, 'Battista Franco and the Grimani Chapel', *Saggi e memorie dell' storia dell'arte* (1958–9), pp. 105–39. For the Giustiniani Chapel, see Chapter 1, note 30, and also Peter Humfrey and Stephen Holt, 'More on Veronese and His Patrons at San Francesco della Vigna', *Venezia cinquecento*, V/10 (1995), pp. 187–214. For Tintoretto's altarpiece and its patrons, see Hugh MacAndrew, Deborah Howard, John Dick and Joyce Plesters, 'Tintoretto's "Deposition of Christ" in the National Gallery of Scotland', *The Burlington Magazine*, CXXVII (1985), pp. 501–17. The renaming of the altarpiece followed here was proposed in *National Gallery of Scotland, Concise Catalogue of Paintings* (Edinburgh, 1997), p. 346.

44 The work may have been contemporary with Veronese's lost altarpiece in the Sacristy painted for the *cittidino* Cuccina family *c.* 1560–62, which also differed in style from the simplified classicism of the Giustiniani painting: Humfrey and Holt, 'More on Veronese and His Patrons at San Francesco della Vigna', pp. 196–204.

45 The patron of Tintoretto's second altarpiece for San Francesco was

established by Paola Rossi in *The Cinquecento*, exh. cat., Walpole Gallery, London (1991), pp. 44–7. The San Francesco painting may be identifiable with the previously unknown painting illustrated here, rather than with the version of the subject in Oxford (Pallucchini and Rossi, *Jacopo Tintoretto*, cat. no. 453). See also Ridolfi, *Le Maraviglie dell' Arte* (Catherine and Robert Enggass, *The Life of Tintoretto and of His Children Domenico and Marietta*, p. 59).

46 For the Soranzo portraits, see *Jacopo Tintoretto ritratti*, cat. nos 8–11.

47 For the portraits of Jacopo's grandsons (Benedetto, Lorenzo and Jacopo), see Rossi, *Tintoretto I ritratti*, cat. nos 58, 139, 150. See also *Jacopo Tintoretto ritratti*, cat. nos 15, 18. The altarpiece for the local parish church was commissioned by their sister Elisabetta, wife of Giovanni Vendramin, in the mid-1570s: see Pallucchini and Rossi, *Jacopo Tintoretto*, cat. no. 358.

48 For Veronese's patronage from the Soranzo, see Stephen Holt, 'Paolo Veronese and His Patrons', unpublished PhD thesis, University of St Andrews, 1990, pp. 72–8.

49 An overview of Titian's patronage pattern is provided by Charles Hope, 'Titian and his Patrons', in *Titian: Prince of Painters*, pp. 77–84.

50 The letter to Ercole Gonzaga was published by Alessandro Luzio, 'Tre Lettere di Tiziano al Cardinale Ercole Gonzaga', *Archivio storico dell'arte*, (1890), vol. III, pp. 207–8, n. 2. For the Mantuan battle paintings, see Pallucchini and Rossi, *Jacopo Tintoretto*, cat. nos 392–9; Peter Eikemeier, 'Der Gonzaga-Zyklus des Tintoretto in der Alten Pinakothek', *Münchner Jahrbuch der Bildenden Kunst*, XX (1969), pp. 25–142.

51 For the progress of the Mantua commission, see Alessandro Luzio, 'I Fasti Gonzagheschi dipinti dal Tintoretto', *Archivio storico dell' arte* (1890), vol. III, pp. 397–9. For the apparent presence of the painter in 1591, see Gilberto Carra, 'Il Tintoretto a Mantova nel 1591', *Civiltà montavana*, XI (1977), pp. 223–5.

52 For the Ducal Palace battle paintings, see Pallucchini and Rossi, *Jacopo Tintoretto*, cat. nos 402–5.

53 Pallucchini and Rossi, *Jacopo Tintoretto*, cat. no. A37. For the early provenance of the painting (missed by Pallucchini and Rossi), see Appendix 1, n. 31. For Veronese's altarpiece, see Pignatti and Pedrocco, *Veronese*, cat. no. 341.

54 Veronese's painting recalls Titian's *Annunciation* in San Salvador: *Titian: Prince of Painters*, cat. no. 56. For Sigüenza's comments and the offer to Veronese, see Annie Cloulas, 'Les Peintres du grand retable au monastère de l'Escurial', *Mélanges de la Casa de Vélasquez*, IV (1968), pp. 181–8. Tintoretto did, however, work again for the Spanish court, painting a 'Giudizio' (now lost) for Philip II in 1587: Mary Pittaluga, 'Altre due opere del Tintoretto, ed un ritratto', *L'arte*, XXV (1922), p. 94, n. 1.

55 Pallucchini and Rossi, *Jacopo Tintoretto*, cat. no. 390. See also Cecil Gould, *National Gallery Catalogues: The Sixteenth-Century Schools* (London, 1975), pp. 259–61. For the other paintings in the cycle, see Klara Garas, 'Le tableau du Tintoret du Musée de Budapest et le cycle peint pour l'empereur Rodolphe II', *Bulletin du Musée Hongrois des Beaux-Arts*, XXX (1967), pp. 29–48.

56 Thomas DaCosta Kaufmann, *The School of Prague: Painting at the Court of Rudolf II* (Chicago and London, 1988).

57 For the San Trovaso altarpiece, see Pallucchini and Rossi, *Jacopo Tintoretto*, cat. no. 370. For some important suggestions with regard to the painting's meaning in relation to the thwarted career of its patron, see Paul Hills, 'Decorum and Desire in Some Works by Tintoretto', in *Decorum in Renaissance Narrative Art*, eds Frances Ames-Lewis and Anka Bednarek (London, 1992), pp. 121–4. The possibility that Tommaso Rangone was the original patron of the *Origin of the Milky Way* was raised by Cecil Gould, 'An X-Ray of Tintoretto's "Milky Way"', *Arte veneta*, XXXII (1978), pp. 211–13.

58 For a comprehensive overview of Rangone's career, see Erasmus Weddigen, 'Thomas Philologus Ravennas: Gelehrter, Wohltäter und Mäzen', *Saggi e memorie di storia dell'arte*, IX (1974), pp. 7–76. Tintoretto painted a portrait of the son of Maximilian's antiquary Jacopo Strada during their visit to Venice in 1567: *Jacopo Tintoretto ritratti*, cat. no. 29.

59 Weddigen, 'Thomas Philologus Ravennas', pp. 12–16.

60 For the original position of the *Miracle of the Slave*, see Roland Krischel, *Jacopo Tintorettos 'Sklavenwunder'* (Munich, 1991), p. 27. For the Sansovinesque architecture and portrait in the same painting see *ibid.*, pp. 58–9 and Erasmus Weddigen, 'Il secondo pergolo di San Marco e la Loggetta del Sansovino: Preliminari al Miracolo dello Schiavo di Jacopo Tintoretto', *Venezia cinquecento*, I (1991), p. 116. For the initial return of the painting, see Marco Boschini, *La carta del navegar pittoresco*, ed. Anna Pallucchini (Venice, 1966), p. 516.

61 The patronage and position of the Scuola di San Marco is discussed in Pietro Paoletti, *La Scuola Grande di San Marco* (Venice, 1929); Philip Sohm, *The Scuola Grande di San Marco, 1437–1550: The Architecture of a Venetian Lay Confraternity* (New York and London, 1982). For Calmo at San Marco, see Pietro Vescovi, 'Sier Andrea Calmo: Nuovi documenti e proposte' *Quaderne veneti*, II (1985), pp. 25–47. For Episcopi's office in 1547 and his friends and relatives in the confraternity, see Krischel, *Jacopo Tintorettos 'Sklavenwunder'*, pp. 18–26.

62 For Tintoretto's paintings, see Pallucchini and Rossi, *Jacopo Tintoretto*, cat. nos 243–5. The subject of the third painting, not mentioned here, is *St Mark Saving a Saracen During a Sea Storm*. For further discussion of all three, see Elaine Banks, *Tintoretto's Religious Imagery of the 1560s*, PhD thesis (Princeton University, 1978), pp. 7–43. An oil sketch related to the *Removal of the Body of St Mark* is now in Brussels: Pallucchini and Rossi, *Jacopo Tintoretto*, cat. no. 126.

63 Banks, 'Tintoretto's Religious Imagery of the 1560s', pp. 29–31.

64 Paoletti, *La Scuola Grande di San Marco*, p. 182.

65 In his will Rangone stipulated (in characteristic fashion) that three portraits of himself were to be carried at his funerary procession, two of which were by Tintoretto ('simulacrum meum Tintoretti aureum'): Weddigen, 'Thomas Philologus Ravennas', pp. 51–3.

66 Rosand, *Painting in Sixteenth-Century Venice: Titian, Veronese, Tintoretto*, p. 161.

67 For the patronage of the trade Scuole, see Humfrey and Mackenny, 'Venetian Trade Guilds as Patrons of Art in the Renaissance'. For Tintoretto's San Silvestro altarpiece, see Pallucchini and Rossi, *Jacopo Tintoretto*, cat. no. 408.

68 For the history and function of the Scuole del Sacramento, and their rapid spread in sixteenth-century Venice, see Maurice Cope, *The Venetian Chapel of the Sacrament in the Sixteenth Century* (New York and London, 1979). Tintoretto was commissioned by Scuole del Sacramento at San Cassiano, San Felice, San Marcuola, Santa

Margherita, San Moise, San Polo, San Severo, San Simeone Grande and San Trovaso. See Hills, 'Piety and Patronage in Cinquecento Venice'; Thomas Worthen, 'Tintoretto's Paintings for the Banco del Sacramento in Santa Margherita', *Art Bulletin*, LXXVIII (1996), pp. 707–32.

69 For Valgrisi, see Giovanni Sforza, 'Riflessi della controriforma nella republica', *Archivio storico Italiano*, XCIII (1935), pp. 185–6. For Ribeiro, see Brian Pullan, *The Jews of Europe and the Inquisition of Venice, 1550–1670* (Oxford, 1983), pp. 234–5. For the Grandi office-holders, Pullan, *Rich and Poor in Renaissance Venice*, pp. 109–11. For de' Gozi, see Hills, 'Piety and Patronage in Cinquecento Venice', p. 36. For Negrin, see Worthen, 'Tintoretto's Paintings for the Banco del Sacramento in Santa Margherita', p. 708, n. 9.

70 The Scuole del Sacramento at San Salvatore, San Angelo Gabriele, San Pantaleone, San Giuliano and San Giacomo dall' Orio had to make do with paintings from the workshops of Bellini, Titian, Bordone and Veronese. For Tintoretto's exceptional output for these patrons, see Pallucchini and Rossi, *Jacopo Tintoretto*, cat. nos 127, 128, 171, 225, 232, 259, 260, 291, 303, 304, 305, 410, 411, 412, 448. Palma Giovane evidently followed in Tintoretto's wake, working regularly for the Venetian Scuole del Sacramento into the seventeenth century: Stefania Mason Rinaldi, 'Un percorso nella religiosità veneziana del cinquecento attraverso le immagini eucaristiche', in ed. G. Gullino, *La chiesa di Venezia tra riforma protestante e riforma cattolica* (Rome, 1984), pp. 183–94.

4 TINTORETTO AT SAN ROCCO I: 1564–7

1 Ludwig Heinrich Heydenreich and Wolfgang Lotz, *Architecture in Italy, 1400–1600* (Harmondsworth, 1974), p. 317; John McAndrew, *Venetian Architecture of the Early Renaissance* (London and Cambridge, MA., 1980), pp. 519–24; Ralph Lieberman, *Renaissance Architecture in Venice* (New York, 1982), entries 86–9; Norbert Huse and Wolfgang Wolters, *The Art of Renaissance Venice* (Chicago and London, 1990), pp. 109–12; Manfredi Tafuri, *Venice and the Renaissance* (Cambridge, MA, and London, 1989), pp. 81–101.

2 For more on the patronage of the Scuole Grandi, see William Wurthmann, 'The Scuole Grandi and Venetian Art, 1260–c. 1500', PhD thesis (University of Chicago, 1976); Philip Sohm, *The Scuola Grande di San Marco, 1437–1550: The Architecture of a Venetian Lay Confraternity* (New York and London, 1982). The translations from Caravia are taken from Tafuri, *Venice and the Renaissance*, p. 81. For the expenditure on the new building, see Brian Pullan, *Rich and Poor in Renaissance Venice: The Social Institutions of a Catholic State to 1620* (Oxford, 1971), p. 130.

3 For the social composition and culture of the Scuola di San Rocco (and the other sixteenth-century Grandi), see Pullan, *Rich and Poor in Renaissance Venice*, pp. 63–83, 99–131. Pullan describes the *cittadini originarii* as 'a parallel minor aristocracy with no distinct culture or outlook of their own'; the Caravia quotation is given at p. 121, n. 87.

4 *Ibid.*, p. 126.

5 For *magnificentia* versus *mediocritas* in Venetian culture, see Tafuri, *Venice and the Renaissance*, pp. 1–13. For the decrees of the Magistrato alle Pompe, see Pullan, *Rich and Poor in Renaissance Venice*, pp. 126–7. For patrician self-blame during the Wars of

Cambrai, see Felix Gilbert, 'Venice and the Crisis of the League of Cambrai', in ed. John R. Hale, *Renaissance Venice* (London, 1973), pp. 274–92. For the crisis of the late 1520s, see Pullan, *Rich and Poor in Renaissance Venice*, pp. 239–57. For Caravia's Lutheran sympathies, see Carlo Ginzburg, *The Cheese and the Worms: The Cosmos of a Sixteenth-Century Miller* (London, 1980), pp. 23–4. For the analogous situation in the seventeenth-century Dutch Republic: Simon Schama, *The Embarrassment of Riches: An Interpretation of Dutch Culture in the Golden Age* (New York, 1987).

6 For the rejection of Sansovino's proposed freestanding columns, see Huse and Wolters, *The Art of Renaissance Venice*, p. 111. For the connections with antique triumphal arches and the Loggetta, see Tafuri, *Venice and the Renaissance*, p. 88.

7 *Ibid.*, pp. 88–9.

8 The main works on Tintoretto's paintings for the Scuola di San Rocco are Rudolf Berliner, 'Forschungen über die Tätigkeit Tintorettos in der Scuola di San Rocco', *Kunstchronik und Kunstmarkt*, XXXI (1920), pp. 468–97; Rodolfo Pallucchini and Mario Brunetti, *Tintoretto a San Rocco* (Venice, 1937); Charles de Tolnay, 'L'Interpretazione dei cicli pittorici del Tintoretto nella Scuola di San Rocco', *Critica d'arte*, VII (1960), pp. 341–76; Edward Huttinger, *Die Bilderzyklen Tintorettos in der Scuola di San Rocco zu Venedig* (Zurich, 1962); K. M. Swoboda, 'Die grosse Kreuzigung Tintorettos in Albergo der Scuola di San Rocco', *Arte veneta*, XXV (1971), pp. 145–52; Josef Grabski, 'The Group of Paintings by Tintoretto in the "Sala Terrena" in the Scuola di San Rocco in Venice and Their Relationship to the Architectural Structure', *Artibus et Historiae*, I (1980), pp. 115–31; Francesco Valconover, *Jacopo Tintoretto and the Scuola Grande di San Rocco* (Venice, 1983); Giandomenico Romanelli et al., *Tintoretto: La Scuola Grande di San Rocco* (Milan, 1994).

9 Giorgio Vasari, *The Lives of the Painters, Sculptors and Architects*, trans. Gaston de Vere (London, 1996), vol. II, pp. 513–14.

10 Berliner, 'Forschungen über die Tätigkeit Tintorettos in der Scuola di San Rocco', p. 470.

11 For Titian's position on the *zonta* and Tintoretto's request for admission to the Scuola in 1549, see Maria Elena Massimi, 'Jacopo Tintoretto e i confratelli della Scuola Grande di San Rocco: Strategie culturali e committenza artistica', *Venezia cinquecento*, V/9 (1995), pp. 35, 162.

12 *Titian: Prince of Painters*, exh. cat., National Gallery of Art, Washington, DC, and Ducal Palace, Venice (London, 1990), cat. nos 2, 24.

13 Artists were typically admitted to the confraternities they worked for in Venice, frequently as deacons: Sohm, *The Scuola Grande di San Marco, 1437–1550*, pp. 240–42. Tintoretto was finally admitted to San Marco, along with his son, son-in-law and two friends, in 1585: Pietro Paoletti, *La Scuola Grande di San Marco* (Venice, 1929), p. 184.

14 For Zignoni, see Massimi, 'Jacopo Tintoretto e i confratelli della Scuola di San Rocco', pp. 32–4.

15 Guido Ruggiero, *Violence in Early Renaissance Venice* (New Brunswick, 1980), pp. 82–94; Patricia Fortuni Brown, *Venetian Painting in the Age of Carpaccio* (New Haven and London, 1988), p. 21.

16 For Mansueti's paintings, see Peter Humfrey, 'The Bellinesque Life of St Mark Cycle for the Scuola Grande di San Marco in Its Original Arrangement', *Zeitschrift für Kunstgeschichte*, XLVIII (1985),

pp. 225–42; Brown, *Venetian Narrative Painting in the Age of Carpaccio*, pp. 291–5. For the Carità cycle, see David Rosand, *Painting in Sixteenth-Century Venice: Titian, Veronese, Tintoretto* (rev. edn, Cambridge, 1997), pp. 103–6.

17 Carlo Ridolfi, *Le Maraviglie dell' Arte*, ed. Detlev von Hadeln (Berlin, 1924), vol. II, p. 28.

18 Rodolfo Pallucchini and Paola Rossi, *Jacopo Tintoretto: Le opere sacre e profane* (Milan, 1982), vol. I, cat. no. 226.

19 For the Scuoletta, see Massimi, 'Jacopo Tintoretto e I confratelli della Scuola Grande di San Rocco', pp. 46–85. For the connection with Pordenone see Ridolfi, *Le Maraviglie dell' Arte*, p. 26; Charles E. Cohen, *The Art of Giovanni Antonio da Pordenone: Between Dialect and Language* (Cambridge, 1996), vol. II, pp. 623–30. Martino d'Anna's son Zuane was on the *zonta* in 1558 and 1560, and again in 1564: Massimi, 'Jacopo Tintoretto e i confratelli della Scuola di San Rocco', pp. 15–20. The d'Anna also patronized Titian, however, indicating that their backing of Tintoretto was not exclusive.

20 For the role of the *zonta* in the Scuole Grandi, see Pullan, *Rich and Poor in Renaissance Venice*, p. 69. For a detailed discussion of Girolamo Rota's position at San Rocco, see Massimi, 'Jacopo Tintoretto e i confratelli della Scuola di San Rocco', pp. 21–46. Dal Basso was also *guardian grande* in 1562 while Mazzoleni was on the *zonta* in 1568 (pp. 114, 142).

21 Berliner, 'Forschungen über die Tätigkeit Tintorettos in der Scuola di San Rocco', pp. 468–70.

22 Pullan, *Rich and Poor in Renaissance Venice*, p. 127. For Matteo di Marin, see Massimi, 'Jacopo Tintoretto e i confratelli della Scuola di San Rocco', p. 41.

23 Caravia made the Scuole del Sacramento the standard of selfless piety against which he measures the 'arrogant' culture of the Scuole Grandi. Both Vincenzo Valgrisi and Gaspar Ribeiro used their activities in the parish scuole as a proof of their piety when they were called before the Sacred Office: Giovanni Sforza, 'Riflessi della controriforma nella repubblica', *Archivio storico italiano*, XCIII (1935), pp. 185–6; Brian Pullan, *The Jews of Europe and the Inquisition of Venice, 1550–1670* (Oxford, 1983), pp. 234–5.

24 Pallucchini and Rossi, *Jacopo Tintoretto*, cat. nos 261–82; Juergen Schulz, *Venetian Painted Ceilings of the Renaissance* (Berkeley and London, 1968), cat. no. 28.

25 Paola Rossi, *I disegni di Jacopo Tintoretto* (Florence, 1975), p. 19 (12922F), p.28 (12966F), p. 24 (12941F), p. 34 (12997F).

26 For an illustration of an analogous figure from Vasari's Corner ceiling, see Peter Humfrey, *Painting in Renaissance Venice* (New Haven and London, 1995), p. 2, illus. 3. *The Four Seasons* are adapted from the equivalent figures in Tintoretto's contemporary ceiling in the Sala dell' Atrio Quadrato of the Ducal Palace featuring, in the central panel, a votive image of *Doge Girolamo Priuli Assisted by St Mark Before Peace and Justice*: Pallucchini and Rossi, *Jacopo Tintoretto*, cat. nos 250–58 (see illus. 138). For a discussion of the style of Venetian ceiling paintings, see Schulz, *Venetian Painted Ceilings of the Renaissance*, pp. 3–58.

27 Pallucchini and Rossi, *Jacopo Tintoretto*, cat. no. 283. Tintoretto was paid 250 ducats for his painting, which was finished within eighteen months: see Appendix 1, no. 16. Ruskin famously announced that he would 'not insult this marvellous picture by an effort at a verbal account of it'. His silence was, though, immediately broken, for he went on to devote several expressive paragraphs to the painting: John Ruskin, *Modern Painters* (1846), Edward Tyas Cook and Alexander Wedderburn, eds, *The Works of John Ruskin* (London, 1903), vol. II, p. 263.

28 See, for example, Elaine Banks, *Tintoretto's Religious Imagery of the 1560s* (Michigan, 1978), pp. 76–8.

29 For the San Severo painting, see Pallucchini and Rossi, *Jacopo Tintoretto*, cat. no. 171.

30 For the radical spatial adjustments Tintoretto made to his paintings of the *laterale* type, see Michael Matile, '"Quadri laterali", ovvero consequenze di una collocazione ingrata: Sui dipinti di storie sacre nell'opera di Jacopo Tintoretto', *Venezia cinquecento*, VI/12 (1996), pp. 110–12.

31 A similar idea underlies the composition of other major paintings such as the *Miracle of the Slave* and the *Paradise*: see pp. 58–61 and pp. 110–2.

32 Rosand, *Painting in Sixteenth-Century Venice*, pp. 148–9.

33 *Ibid.*, pp. 136–8. In the *Last Suppers* for San Marcuola and San Trovaso (illus. 20, 59) the two textual/temporal moments of the Annunciation of the Betrayal and the Institution of the Eucharist are simultaneously referred to: Maurice Cope, *The Venetian Chapel of the Sacrament in the Sixteenth Century* (New York and London, 1979), pp. 90–119.

34 Tintoretto's conception owes little to the Bellinesque drawing of the *Raising of the Cross* in Oxford (see Colin Eisler, *The Genius of Jacopo Bellini: The Complete Paintings and Drawings* [New York 1989], p. 58). For Pordenone's Cremona frescoes, see Cohen, *The Art of Giovanni Antonio da Pordenone*, vol. II, cat. no. 33, pp. 578–88. But the physiognomic exaggeration in these paintings allies them much more closely with Northern tradition: Rosand, *Painting in Sixteenth-Century Venice*, pp. 144–7.

35 For the Santa Maria del Rosario altarpiece, see Pallucchini and Rossi, *Jacopo Tintoretto*, cat. no. 249.

36 Rosand, *Painting in Sixteenth-Century Venice*, pp. 150–53, makes a similar point. For the Carità paintings, see *ibid.*, pp. 97–106. For the equivalent paintings in the Scuola di San Marco, see Peter Humfrey, 'The Bellinisque Life of St Mark Cycle for the Scuola Grande di San Marco in the Original Arrangement'. For Venetian Scuole narrative painting more generally, see Brown, *Venetian Narrative Painting in the Age of Carpaccio*.

37 Pallucchini and Rossi, *Jacopo Tintoretto*, cat. nos 284–8.

38 The connection of the ropes with the flagellant function of the Scuola was made by Paul Hills in a lecture given at the conference entitled 'Conformity and Dissent in Renaissance Venice' at the National Gallery, London, in 1995.

39 For the Dürer prints, see Willi Kurth, ed., *The Complete Woodcuts of Albrecht Dürer* (New York, 1963), nos 123, 238.

40 Tintoretto had used compositional inversion in a similar way in his very first painting for the Scuola in 1549: Pallucchini and Rossi, *Jacopo Tintoretto*, cat. no. 134. See illus. 185 below.

41 The spread of the Scuola's charitable activities beyond its own membership in the mid-sixteenth century (in response to three large bequests) was unprecedented and unrivalled. About 25 years after Tintoretto painted his *Way to Calvary*, the Scuola began targeting

its charity specifically to prisoners and condemned men: Pullan *Rich and Poor in Renaissance Venice*, pp. 157–87.

5 TINTORETTO AT SAN ROCCO II: 1575–88

1 For Tintoretto's various positions on the ruling bodies of the Scuola (which continued through the 1570s and 1580s), see Pittaluga, *Il Tintoretto* (Bologna, 1925), p. 196. For the commission in the church of 1567 (which completed that begun in 1549), see Rodolfo Pallucchini and Paola Rossi, *Jacopo Tintoretto: Le opere sacre e profane* (Milan, 1982), vol. I, cat. nos 300, 301. For Tintoretto's offers of 1575 and 1577 and the responses of the Scuola, see Rudolf Berliner, 'Forschungen über die Tätigkeit Tintorettos in der Scuola di San Rocco', *Kunstchronik und Kunstmarkt*, XXXI (1920), pp. 473, 492–4.

2 *Ibid.*, p. 493. In the official domain, at least, ceiling paintings were among the most expensive commissioned. Those for the Reading Room ceiling in the Libreria Marciana cost a total of 420 ducats, while Giuseppe Salviati received as much as 670 ducats in 1566–7, and Veronese 480 ducats in 1575–8 in return for their ceiling paintings in the Ducal Palace: Juergen Schulz, *Venetian Painted Ceilings of the Renaissance* (Berkeley and London, 1968), nos 33, 41, 90.

3 The average price of large-scale Scuole narrative paintings was around 100 ducats. See those commissioned by the Scuola Grande della Carità: David Rosand, *Painting in Sixteenth-Century Venice: Titian, Veronese, Tintoretto* (rev. edn, Cambridge, 1997), pp. 230–38, docs 13, 19, 25, 26. For Tintoretto's jest, see Carlo Ridolfi (1648), *Le Maraviglie dell' Arte*, ed. Detlev von Hadeln (Berlin, 1924), vol. II, p. 28.

4 For this calculation see Appendix 1, nos 16, 25, 26.

5 Dal Basso was a syndic in 1575 and was on the *zonta* in 1576, 1578, 1580 and 1582; de' Gozi was on the *zonta* in 1577, 1579, 1581, 1584, 1586 and 1588: Maria Elena Massimi, 'Jacopo Tintoretto e i confratelli della Scuola Grande di San Rocco: Strategie culturali e committenza artistica', *Venezia cinquecento*, V/9 (1995), pp. 114, 135. For Paolo d'Anna's supervisory commission, see *ibid.*, pp. 19–21.

6 Berliner, 'Forschungen über die Tätigkeit Tintorettos in der Scuola di San Rocco', p. 473. Alvise Cuccina had recently commissioned four paintings from Veronese for the family palace at Sant' Aponal (1571) while his brother, Gerolamo, was *guardian grande* at San Rocco in 1559, the year in which Tintoretto painted the *Pool of Bethesda*. Ferro was guardian in 1567, commissioning three more Tintoretto paintings for the confraternity church: Giandomenico Romanelli *et al.*, *Tintoretto: La Scuola Grande di San Rocco* (Milan, 1994), pp. 25–6; Massimi, 'Jacopo Tintoretto e I confratelli della Scuola Grande di San Rocco', p. 44.

7 Scepticism over Tintoretto's 'control' of the commission was expressed early this century by Henry Thode (*Tintoretto* [Bielefeld and Leipzig, 1901]). But Berliner, De Tolnay and Schulz have all assumed that the painter played a dominant role in the commission, deciding on its progress and iconography. For an overview of this question, see Giandomenico Romanelli, 'Tintoretto a San Rocco: Committenza, teologia, iconografia', in *Jacopo Tintoretto nel quarto centenario della morte*, eds Paola Rossi and Lionello Puppi (Venice, 1996), pp. 91–5.

8 For a translation of the relevant session of the Council of Trent, see Robert Klein and Henri Zerner, *Italian Art, 1500–1600: Sources and Documents* (New Jersey, 1966), pp. 119–33.

9 See Chapter 3, pp. 112–14. For the official decree of 1580, see David S. Chambers, Brian Pullan and Jennifer Fletcher, eds, *Venice: A Documentary History, 1450–1630* (Oxford, 1992), p. 409.

10 For the San Rocco ceiling, see Pallucchini and Rossi, *Jacopo Tintoretto*, cat. nos 332–44.

11 For the wall paintings in the Sala Superiore, see *ibid.*, cat. nos 345–56. The iconographic concordances noted here were established by Charles de Tolnay, 'L'interpretazione dei cicli pittorici del Tintoretto nella Scuola di San Rocco', *Critica d'arte*, VII (1960), pp. 341–76. See also Juergen Schulz, *Venetian Painted Ceilings of the Renaissance* (Berkeley and London, 1968), cat. no. 29.

12 The *Last Supper* and the *Washing of the Feet* were paired, for example, at San Marcuola and San Trovaso, with obvious sacramental meanings. For the iconographic connection of the Sala Superiore of San Rocco with Venetian chapels of the Sacrament, see *ibid.*, p. 90.

13 For the connection with the *Biblia pauperum*, see De Tolnay, 'L'interpretazione dei cicli pittorici del Tintoretto nella Scuola di San Rocco', pp. 368–70. The connection with Aretino's religious works was first noticed by Edward Huttinger, *Die Bilderzyklen Tintorettos in der Scuola di San Rocco zu Venedig* (Zurich, 1962), pp. 75–9.

14 *Ibid.*, p. 26; Romanelli, *Tintoretto*, p. 28.

15 For the plague and its imagery in Venice, see Stefania Mason Rinaldi, 'La peste e le sue immagini nella cultura figurativa veneta', in *Venezia a la Peste, 1348–1797*, exh. cat., Ducal Palace, Venice (1979), pp. 209–24.

16 Paola Rossi, 'Venezia, la peste e le sue immagini', *Arte veneta*, XXXIII (1980), pp. 257–60.

17 Phyliss Pray Bober and Ruth Rubenstein, *Renaissance Artists and Antique Sculpture: A Handbook of Sources* (London, 1986), no. 122.

18 The covering of the genitals was undoubtedly a response to the recent (1563–4) over-painting of those exposed in Michelangelo's *Last Judgement*. This had been undertaken primarily by Daniele da Volterra, an artist whose work had proved particularly influential on Tintoretto: Simon H. Levie, 'Daniele da Volterra e Tintoretto', *Arte veneta*, VII (1953), pp. 168–70.

19 The religious significance of the formal repetitions in the San Rocco cycle was first noted by De Tolnay, 'L'interpretazione dei cicli pittorici dell Tintoretto nella Scuola di San Rocco'.

20 For the quotation from Gauricus, see Erwin Panofsky, *Perspective as Symbolic Form* (New York, 1991), p. 59. More recent studies in Renaissance perspective space include John White, *The Birth and Rebirth of Pictorial Space* (London, 1967); Martin Kemp, *The Science of Art: Optical Themes in Western Art from Brunelleschi to Seurat* (New Haven and London, 1990); Hubert Damisch, *The Origin of Perspective* (Cambridge, Mass., 1994).

21 The painter himself may have been responsible for the employment of Baldissare di Guglielmo (or 'delle Grottesche') to ornament and gild the frame, given that he had worked with Baldissare in the Ducal Palace (in the Saletta degli Inquisitori) and was on the committee set up to value his work early in 1575. See Pallucchini and Rossi, *Jacopo Tintoretto*, cat. nos 293–7.

22 Specialist studies of the extraordinary spatiality of Tintoretto's paintings include Lucien Rudrauf, 'Vertiges, chutes et ascensions dans l'espace picturial du Tintoret', in *Venezia e l'Europa*, Atti del XVIII Congresso internazionale di Storia dell' Arte (Venice, 1955); Cecil Gould, 'The Cinquecento at Venice III: Tintoretto and Space', *Apollo*, CXVI (1972), pp. 32–7; Sergio Marinelli, 'La costruzione dello spazio nelle opere di Jacopo Tintoretto', in *La Prospettiva Rinascimentale*, ed. Marissa Dalai Emiliani (Florence, 1980), pp. 319–30.

23 For Tintoretto's play on metaphors of light from St John, see Huttinger, *Die Bilderzyklen in der Scuola di San Rocco zu Venedig*, p. 26.

24 For the possible symbolic meanings of the tent, see De Tolnay, 'L'interpretazione dei cicli pittorici del Tintoretto nella Scuola di San Rocco', p. 348.

25 Pallucchini and Rossi, *Jacopo Tintoretto*, cat. nos 335–44.

26 The relevant text from Thomas Aquinas is the *Summa theologica*, I, q. LXVII, a.1, in which the essentially non-perceptual nature of true 'vision' is elucidated. Most of the mystical literature follows Thomas's definition that visionary experience is to some extent indescribable in sensual terms: see Victor I. Stoichita, *Visionary Experience in the Golden Age of Spanish Art* (London, 1995), for further discussion.

27 For the possible influence of the Spanish Counter-Reformatory mystics St John and St Teresa, see De Tolnay, 'L'interpretazione dei cicli pittorici del Tintoretto nella Scuola di San Rocco', p. 370. For that of the Capuchin monk Bellintani, see Anna Pallucchini, 'Venezia religiosa nella pittura del cinquecento', *Studi veneziani*, XIV (1972), pp. 179–84.

28 For this point see Schulz, *Venetian Painted Ceilings of the Renaissance*, p. 33.

29 Pallucchini and Rossi, *Jacopo Tintoretto*, cat. no. 356.

30 The words of Possevinus, quoted by Pierre Janelle, *The Catholic Reformation* (London, 1963), p. 162. The standard modern accounts of the progress of the Counter-Reformation are Hubert Jedin, *The Council of Trent*, 2 vols (London, 1957 and 1961) and Jean Delumeau, *Catholicism Between Luther and Voltaire* (London, 1977).

31 Pallucchini and Rossi, *Jacopo Tintoretto*, cat. no. 347.

32 For Tintoretto's 'naturalism' see K. M. Swoboda, 'Die grosse Kreuzigung Tintorettos in Albergo der Scuola di San Rocco', *Arte veneta*, XXV (1971), p. 146. This quality had, in fact, been observed in Tintoretto's work at San Rocco in much earlier Swiss and German criticism. In *Der Cicerone* (1855), for example, Jacob Burckhardt argued that Tintoretto 'gives form to the sacred history from beginning to end in the sense of absolute naturalism ... in his desire for reality he falls into the commonplace' (quoted in Anna Laura Lepschy, *Tintoretto Observed: A Documentary Survey of Critical Reactions from the 16th to the 20th Century* [Ravenna, 1983], p. 91). Henry Thode described Tintoretto's 'return to the primitiveness of a simple and natural human existence', but also noted that 'every natural event becomes an expression of the Christian soul': Thode, *Tintoretto* (Bielefeld and Leipzig, 1901), pp. 132–4. For the (very different) Franciscan influence on the paintings of Bellini and Titian, see Rona Goffen, *Piety and Patronage in Renaissance Venice: Bellini, Titian and the Franciscans* (New Haven and London, 1986).

33 As, for example, in Carpaccio's *St Ursula* cycle (1490–1500, Venice, Accademia): Patricia Fortuni Brown, *Venetian Narrative Painting in the Age of Carpaccio* (New Haven and London, 1988), pp. 193–6, 279–82. Titian follows this traditional format in his contribution to the Scuola della Carità cycle.

34 Joyce Plesters and Lorenzo Lazzarini, 'I materiali e la tecnica del Tintoretto della Scuola di San Rocco', in *Jacopo Tintoretto nel quarto centenario della morte*, eds Paola Rossi and Lionello Puppi (Venice, 1996), p. 275.

35 For example, in Lotto's paintings of this subject: Peter Humfrey, *Lorenzo Lotto* (New Haven and London, 1997), pp. 58, 100.

36 Tintoretto's use of dark grounds is established by Plesters and Lazzarini, 'I materiali e la tecnica del Tintoretto della Scuola di San Rocco', pp. 275–6.

37 Pallucchini and Rossi, *Jacopo Tintoretto*, cat. no. 348.

38 For the tradition under consideration, see Paul Hills, *The Light of Early Italian Painting* (New Haven and London, 1987), pp. 13–16.

39 Beginning with Lorenzo Ghiberti's relief for the north door of the Baptistery in Florence (*c.* 1409), John's gesture is typically emphasized in Italian Renaissance imagery. In Venice, it is prominent in Titian's very early painting of the theme (*c.* 1507, Rome, Pinacoteca Capitolina), as it is in Veronese's version, which is nearly contemporary with Tintoretto's at San Rocco (*c.* 1576–8, Florence, Palazzo Pitti): see Charles Hope, *Titian* (London, 1980), pp. 19–20; Terisio Pignatti and Filippo Pedrocco, *Veronese* (Milan, 1995), cat. no. 288.

40 This suggestion was made by Plesters and Lazzarini, 'I materiali e la tecnica del Tintoretto della Scuola di San Rocco', p. 277.

41 Pallucchini and Rossi, *Jacopo Tintoretto.*, cat. no. 349.

42 Paul Hills, 'Tintoretto's Fire', in *Jacopo Tintoretto nel quarto centenario della morte*, pp. 267–71.

43 Pallucchini and Rossi, *Jacopo Tintoretto*, cat. no. 291.

44 *Ibid.*, cat. no. 350.

45 Paola Rossi, *I disegni di Jacopo Tintoretto*, p. 50 (n. 0358).

46 Plesters and Lazzarini, , 'I materiali e la tecnica del Tintoretto della Scuola di San Rocco', p. 278.

47 For the San Rocco *Last Supper*, see Pallucchini and Rossi, *Jacopo Tintoretto*, cat. no. 351. For the Santa Margherita paintings, see Thomas Worthen, 'Tintoretto's Paintings for the Banco del Sacramento in Santa Margherita', *Art Bulletin*, LXXVIII (1996), pp. 707–32.

48 The narrative simultaneity of the earlier Suppers (at San Marcuola, San Trovaso, San Felice) is thus superseded by a more definite emphasis on the sacramental moment, as it is in the other paintings of the theme from the 1560s and 1570s (at San Simeon Grande, Santa Margherita, San Polo): Maurice Cope, *The Venetian Chapel of the Sacrament in the Sixteenth Century* (New York and London, 1979), pp. 101–19.

49 'To him you gave for love of God/Know that I was that beggar': the *Historia del giudicio* quoted in Carlo Ginzburg, *The Cheese and the Worms* (London, 1980), p. 38. See also Jacopo de Voragine, *The Golden Legend* (Salem, 1987), p. 664: 'Martin, while yet a catechumen has clothed Me with his garment'.

50 For the Venetian poor laws of 1528–9, see Brian Pullan, 'The Famine in Venice and the New Poor Law 1527–9', *Bolletino dell' istituto di storia della societa e dello stato veneziano*, V–VI (1963–4). For the context of the Venetian legislation in wider European moves towards

the centralization and control of almsgiving, see Giovanni Scarabello, 'Strutture assistenziali a Venezia nella prima meta del 1500 e avii europei riforma dell' assistenza', in *'Renovatio urbis': Venezia nel'eta di Andrea Gritti, 1523–1538*, ed. Manfredo Tafuri (Rome, 1984), pp. 119–33. See also John Bossy, 'The Counter-Reformation and the People', *Past and Present*, XLVII (1970), pp. 140–52. These moves may have initiated the 'grand renfermement' described so compellingly by Michel Foucault, *Madness and Civilisation: A History of Insanity in the Age of Reason* (London, 1965).

51 For Contarini and Vives, see Brian Pullan, *Rich and Poor in Renaissance Venice: The Social Institutions of a Catholic State to 1620* (Oxford, 1971), pp. 228, 281–3.

52 For further discussion of the altarpieces by Bonifazio, Lotto, Titian and Veronese showing the charitable saints mentioned here, see Tom Nichols, 'Tintoretto's Poverty', in *New Interpretations of Venetian Renaissance Painting*, ed. Francis Ames-Lewis (London, 1994), pp. 99–110. For Venetian depictions of Lazarus and the imagery of Venetian charity more generally, see Bernard Aikema, 'L'immagine della "Carità Veneziana"', in *Nel regno dei poveri: Arte e storia dei grandi ospedali veneziani in età moderna 1474–1797*, eds B. Aikema and D. Meijers (Venice, 1989), pp. 71–98. For the representation of the poor in Italian art of the period 1400–1800, see Thomas Riis, 'I poveri nell'arte italiana (secoli XV–XVIII)', in *Timor e carità: I poveri nell' Italia moderna*. Atti del convegno 'Pauperismo e assistenza negli antichi stati italiani' (Cremona, 1976–9), pp. 45–58.

53 For the Vicenza altarpiece, see Pallucchini and Rossi, *Jacopo Tintoretto*, cat. no. 136. For the formal connection with Michelangelo's sculpture, see Rodolfo Pallucchini, *La giovenezza del Tintoretto* (Milan, 1950), pp. 126–7. A similar figure also recurs in the *St Roch* painting of 1549 at the foreground right.

54 Tintoretto's *poveri* are thus something more than the 'embarrassed poor' (*poveri vergognosi*) which contemporaries were so concerned to establish in the sixteenth century: Pullan, *Rich and Poor in Renaissance Venice*, pp. 267–8.

55 Pallucchini and Rossi, *Jacopo Tintoretto*, cat. no. 352.

56 Cesare Ripa, *Iconologia*, 3rd edn (Rome, 1603), p. 120.

57 Pallucchini and Rossi, *Jacopo Tintoretto*, cat. no. 353.

58 For Tintoretto's 'spirits in the brush', see David Rosand, 'Tintoretto e gli spiriti nel penello', in *Jacopo Tintoretto nel quatro centenario della morte*, pp. 133–8.

59 Pallucchini and Rossi, *Jacopo Tintoretto*, cat. no. 354.

60 *Ibid.*, cat. no. 355.

61 For San Rocco's Scuoletta, see Massimi, 'Jacopo Tintoretto e i confratelli della Scuola Grande di San Rocco', pp. 46–85.

62 For a useful summary of the four conditions of nudity recognized by the medieval church, see James Hall, *Dictionary of Subjects and Symbols in Art* (London, 1974), pp. 226–7.

63 For the above information (which slightly revises the dates given in Pallucchini and Rossi, *Jacopo Tintoretto*, cat. nos 435–2), see Antonio Gallo in *Tintoretto*, ed. Giandomenico Romanelli *et al.*, p. 320.

64 The architecture by Bartolomeo Bon (dating from the early 1520s) was likewise based on that of the Sala Superiore in the Scuola Grande di S. Marco designed by Mauro Codussi: Norbert Huse and Wolfgang Wolters, *The Art of Renaissance Venice*, pp. 109–10.

65 De Tolnay, on the contrary, saw the *Assumption* as an unexplained iconographical leap from the childhood of Christ to the triumph of the Virgin, suggesting that the iconography of the cycle was incoherent and had been altered in the course of execution: De Tolnay, 'L'interpretazione dei cicli pittorici del Tintoretto nella Scuola di San Rocco', p. 368. For the *Visitation* and the altarpiece for the Sala Superiore (also of 1588): Pallucchini and Rossi, *Jacopo Tintoretto*, cat. nos 459, 460.

66 *Ibid.*, cat. no. 435.

67 *Titian: Prince of Painters*, exh. cat., National Gallery of Art, Washington, DC, and Ducal Palace, Venice (London, 1990), cat. no. 24.

68 This departure was noted by Ruskin in his famous description of the painting in *Modern Painters* (1846), although with reference to the 'pure ideal' for the subject established by Fra Angelico: 'Severe would be the shock and painful the contrast, if we could pass in an instant from that pure vision to the wild thought of Tintoret. For ... the Virgin sits, not in the quiet loggia, not by the green pasture of the restored soul, but houseless, under the shelter of a palace vestibule ruined and abandoned, with the noise of the axe and the hammer in her ears, and the tumult of a city round about her desolation. The spectator turns away at first, revolted ...', Edward Tyas Cook and Alexander Wedderburn, eds, *The Works of John Ruskin* (London, 1903), vol. II, p. 263.

69 Augusto Gentili, 'Personaggi e metafore nell'*Annunciazione* di Jacopo Tintoretto per la Scuola Grande di San Rocco', *Venezia cinquecento*, VI/12 (1996), pp. 235–42.

70 For the emphasis on the poverty of the Holy Family, see De Tolnay, 'L'interpretazione dei cicli pittorici del Tintoretto nella Scuola di San Rocco', p. 368; Bernard Aikema, '"Santa Povertà" e *pietas venetiana*: Osservazioni sul significato della decorazione della sala terrena della Scuola di San Rocco', in *Jacopo Tintoretto nel quarto centenario della morte*, pp. 185–90.

71 Ruskin, in Cook and Wedderburn, eds, *The Works of John Ruskin*, vol. II, pp. 263–4. For a corrective to Ruskin, stressing instead Tintoretto's naturalism, see Nicholas Penny, 'John Ruskin and Tintoretto', *Apollo*, XCIX (1974), pp. 268–73.

72 Josef Grabski, 'The Group of Paintings by Tintoretto in the "Sala Terrena" in the Scuola di San Rocco in Venice and Their Relationship to the Architectural Structure', *Artibus and Historiae*, I (1980), pp. 119–20.

73 Pallucchini and Rossi, *Jacopo Tintoretto*, cat. no. 436.

74 *Ibid.*, cat. no. 437.

75 Gallo in *Tintoretto*, eds Romanelli *et al.*, p. 321.

76 See, for example, Jacopo Bassano's versions of the subject: *Jacopo Bassano c. 1510–1592*, exh. cat., eds Beverly L. Brown and Paola Marini, Museo Civico, Bassano and Kimbell Museum, Fort Worth (Fort Worth, 1993), cat. nos I, II.

77 Pallucchini and Rossi, *Jacopo Tintoretto*, cat. no. 438.

78 Grabski, 'The Group of Paintings by Tintoretto in the "Sala Terrena" in the Scuola di San Rocco in Venice and Their Relationship to the Architectural Structure', p. 123.

79 Romanelli *et al.*, *Tintoretto*, pp. 43–4; Gallo, however, in the same volume, is more circumspect, indicating the two pictures as representing 'Reading Female Saints' (p. 321). Pallucchini and Rossi, *Jacopo Tintoretto*, cat. nos 439, 440.

80 For the earlier tradition of Venetian landscape painting, see A. Richard Turner, *The Vision of Landscape in Renaissance Italy* (Princeton, 1966); Göte Pochat, *Figur und Landschaft: Eine historische Interpretation der Landschaftsmalerei von der Antike bis zur Renaissance* (Berlin and New York, 1973); David Rosand, 'Pastoral Topoi: On the Construction of Meaning in Landscape', in *The Pastoral Landscape*, Studies in the History of Art [National Gallery of Art], 36, ed. John Dixon Hunt (Washington, 1992), pp. 161–77.

81 Pallucchini and Rossi, *Jacopo Tintoretto*, cat. nos 441, 442.

82 Hans Tietze, *Tintoretto: The Paintings and Drawings* (London, 1948), p. 53.

83 Pallucchini and Rossi, *Jacopo Tintoretto* I, cat. nos 373–6.

84 Ridolfi, *Le Maraviglie dell' Arte*, pp. 43–4. The relevant passage from Ovid's *Fasti* is Book 3, 505–16: 'He [Liber] put his arms about her, with kisses dried her tears, and 'Let us fare together' quoth he, 'to heaven's height. As though hast shared my bed, so shalt thou my name, for in thy changed state thy name shall be Libera', *Ovid's Fasti* (Loeb Classical Library) (London and New York, 1931), pp. 156–9.

85 See, however, the late painting of *Tarquin and Lucretia*, known in two versions at Chicago and Cologne, in which Tintoretto makes the classical narrative a carrier of 'serious' moral values: Pallucchini and Rossi, *Jacopo Tintoretto*, cat. nos 450, 451. The paintings were presumably private commissions (although the patrons are unknown).

86 For the Tintoretto paintings mentioned here: Pallucchini and Rossi, *Jacopo Tintoretto*, cat. nos. 456 and 457. For the source of the figure of Christ in the Vienna painting: Detlev von Hadeln, 'Some Paintings and Drawings by Tintoretto', *The Burlington Magazine*, XLVIII (1926), pp. 115–16.

87 Pallucchini and Rossi, *Jacopo Tintoretto*, cat. nos. 466 and 467. For more on the patronal context of Tintoretto's commission, see Tracey E. Cooper, 'The History and Decoration of the Church of San Giorgio Maggiore in Venice', unpublished PhD thesis, Princeton University, 1990, pp. 121–77, 231–46. For Tintoretto's payment see Appendix 1 no. 39.

88 For the idea that Tintoretto here represented the passage from Numbers in which the Israelites refuse the manna, see Nicola Ivanoff, 'Il ciclo eucaristico di San Giorgio Maggiore a Venezia', *Notizie da Palazzo Albani*, IV/2 (1975), pp. 51–4. For the textual source as Exodus 16.3, and idea of the branch as a Messianic symbol: Cope, *The Venetian Chapel of the Sacrament*, pp. 206–8. See also Cooper, 'The History and Decoration of the Church of San Giorgio Maggiore in Venice', pp. 234–6.

89 Max Dvořák, *Geschichte der italienischen Kunst* (Munich, 1927–9), p. 163.

90 Pallucchini and Rossi, *Jacopo Tintoretto*, cat. no. 468.

91 The identification of a self-portrait in the San Giorgio *Deposition* was first made by John Pope-Hennessy in *The Portrait in the Renaissance* (Princeton, 1966), pp. 295–6. For the comparison with Titian's *Pietà*, see Peter Humfrey, *Painting in Renaissance Venice* (New Haven and London, 1995), p. 238. For Joseph of Arimathea: Matthew 27: 57–60.

CONCLUSION

1 See Lorenzo Lazzarini, 'Il colore nei pittori veneziani tra il 1480 e il 1580', *Bolletino d'arte*, V (1983), pp. 135–44; Jill Dunkerton, 'Developments in Colour and Texture in Venetian Painting of the Early 16th Century', in *New Interpretations of Venetian Renaissance Painting*, ed. Frances Ames-Lewis (London, 1994), pp. 63–75.

2 See Tom Nichols, 'Tintoretto's Poverty', in *New Interpretations of Venetian Renaissance Painting*, ed. Francis Ames-Lewis (London, 1994), pp. 109–110.

APPENDIX 1: THE PRICES OF TINTORETTO'S PAINTINGS

1 Carlo Ridolfi (1648), *Le Maraviglie dell' Arte*, ed. Detlev von Hadeln (Berlin, 1924), vol. II, p. 15: 'Practicava in oltre co' Pittori di minor fortuna, che dipingevano alla piazza di San Marco le banche per dipintori, per apprendere i modi loro. Piacevale nondimeno più il colorire dello Schiavone, quale coaiutava volentieri ne' suoi lavori, senza veruna mercede, per impadronirsi di quella bella via di colorire.'

2 *Ibid.*, vol. II, pp. 18–19: 'e fabicandosene una al ponte dell'Angelo, parve al Tintoretto opportuna occasione al suo pensiero, ragionandone co'Muratori, à quali spesso veniva ... dato il carico di provedere del Pittore; e n'hebbe in risposta, che i Padroni non volevano farui veruna spesa. Mà egli, che haveva terminato dipigerla ad ogni maniera, propose di farla con la recognitione de' soli colori; il che riferito à Padroni, con difficoltà ancora ... se ne compiacquero.' The house on Rio dell'Angelo belonged to the 'Tocco d'Oro' branch of the Soranzo family, who were subsequently to patronize Tintoretto over the next three decades.

3 Detlev von Hadeln, 'Archivalische Beiträge zur Geschichte der venezianischen Kunst aus dem Nachlass G. Ludwigs', in *Italienische Forschungen*, IV (1911), p. 127.

4 *Ibid.*, p. 127.

5 Angelo Mercati, 'La scrittura per la "Presentazione della Madonna al Tempio' del Tintoretto a Madonna dell' Orto"', *La Mostra del Tintoretto a Venezia*, fasc. II (1937), pp. 4–5. In the contract dated 6 November 1551, Tintoretto was promised 30 ducats. But he had already received "una botta di vino da circa de bigonzi 6 et farina stara doi et scudi cinque d'oro" when the commission was originally awarded in 1548. The final payment was made on 14 May 1556.

6 Anton Francesco Doni, *Rime del Burchiello comentate dal Doni* (Venice, 1553), cc. 3–6.

7 Detlev von Hadeln, 'Beiträge zur Geschichte des Dogenpalastes', extract from *Jahrbuch der Koniglich Preussischen Kunstsammlungen*, XXXII (1911), p. 32.

8 Giulio Lorenzetti, 'Una nuova data sicura nella cronologia tintorettiana', *Ateneo veneto*, XVI (1938), pp. 129–38. In an initial contract dated 20 April 1552, Tintoretto agreed to paint 'le portelle dentro et di fora et tutta la casa [cassa] et tutto il barco di legname'. From a second contract dated 6 March 1557 it is clear that Tintoretto had not begun the work. In this document he promised to have the paintings 'finide et compide' by 22 March. It is not possible to read the date of the second contract as '1553' as proposed in Rodolfo Pallucchini and Paola Rossi, *Jacopo Tintoretto. Le opere sacre e profane* (Milan, 1982), vol. I, pp. 166–7.

9 Giuseppe Nicoletti, 'Illustrazione della Chiesa e Scuola di S. Rocco in Venezia', *Miscellanea R. deputazione veneta sopra gli storia patria*, III (1885), pp. 59–60; Rudolf Berliner, 'Forschungen über die Tätigkeit Tintorettos in der Scuola di San Rocco', *Kunstchronik und Kunstmarkt*, XXXI (1920), p. 496. The two payments (2 April, 15 October) indicate that the work was finished in about 6 months.

10 Giambattista Lorenzi, *Monumenti per servire alla storia del Palazzo Ducale di Venezia* (Venice, 1868), n. 656.

11 *Ibid.*, n. 665. This may have been one of the two final paintings for the Alexander cycle still to be commissioned on 7 January. The cycle was complete by 23 October, which might mean that Tintoretto finished his painting in about 10 months.

12 Alessandro Luzio, 'Tre lettere di Tiziano al Cardinale Ercole Gonzaga', *Archivio storico dell' arte*, III (1890), pp. 207–8, n. 2.

13 Ridolfi, *La Maraviglie dell' Arte*, p.19: 'Quindi si offerse a' Padri della Madonna dell' Horto di fargli quei due gran quadri della Capella maggiore, che può ascendere lo spatio di cinquanta piedi in altezza. Se ne rise il Priore, stimando non essere bastevole per quella operatione l'entrata dell'anno, licentiandone il Tintoretto, il quale senza smarrisi soggionse, che altro non pretendeva per quella operatione, che una ricognitione per le spese, volendo delle fatiche sue farglene un dono. Sopra che riflettendo il saggio Priore, pensò non si lasciar fuggir di mano così bella occasione, e conchiuse seco l'accordo in ducati cento.'

14 S. Krasic, 'Troskovi narudzbe Tintorettove slike u Bolu', in *Spomenica u povodu 500. Obljetnice osnutka dominikanskog samostana u Bolu 1474-1975* (Bol-Zagreb, 1976), pp. 376–7.

15 Berliner, 'Forschungen über die Tätigkeit Tintorettos in der Scuola di San Rocco', p. 470. The painting was presumably completed between 31 May, when the Scuola agreed to organize the competition for the commission, and 22 June, when they formally accepted Tintoretto's donation.

16 *Ibid.*, p. 471. The painting was certainly finished within 18 months, given that the Scuola commissioned further work in the *albergo* on 29 June 1564 and that the painting is dated 1565.

17 Nicoletti, 'Illustrazione della Chiesa e Scuola di San Rocco in Venezia', p. 59. The two *laterali* were commissioned on 13 April and finished by 14 September.

18 Detlev von Hadeln, 'Beiträge zur Tintorettoforschung', *Jahrbuch der Königlich Preussischen Kunstsammlungen*, XXXII (1911), p. 52. The painting was never made.

19 Lorenzi, *Monumenti per servire alla storia del Palazzo Ducale di Venezia*, n. 801.

20 Von Hadeln, 'Beiträge zur Tintorettoforschung', p. 30, n. 5. Tintoretto had already been paid an advance of 25 ducats for the *Pietà* on 19 February 1563: von Hadeln, 'Archivalische Beiträge zur Geschichte der venezianischen Kunst aus dem Nachlass G. Ludwigs', p. 129.

21 Francesco Galanti, 'Il Tintoretto', in *Atti della reale Accademia di Belle Arti in Venezia dell'anno 1875* (Venice, 1876), pp. 78–9; Anon., 'Un documento relativo a Giacomo Tintoretto', *L'arte*, II (1899), p. 500.

22 Ridolfi, *La Maraviglie dell' Arte*, pp. 36–7: 'Presentò poi il ritratto al Rè, che con lieto volto il vide, parendole maraviglia, poiche di furto quasi tolto lo haveva sì al naturale, che rappresentava al viso l'Imagine sua e il Regio decoro.' Ridolfi goes on to note that the King then gave the portrait to Doge Luigi Mocenigo.

23 Pierre de Nolhac and Angelo Solerti, *Il Viaggio in Italia di Enrico III re di Francia e le feste a Venezia, Ferrara, Mantova e Torino* (Turin, 1890), p. 251.

24 Von Hadeln, 'Beiträge zur Tintorettoforschung', p. 31, nos 14–15.

25 Berliner, 'Forschungen über die Tätigkeit Tintorettos in der Scuola di San Rocco', pp. 492–6. The ceiling took about two and a half years to complete (begun 2 July 1575, almost finished 27 November 1577).

26 *Ibid.*, pp. 492–3.

27 Lorenzi, *Monumenti per servire alla storia del Palazzo Ducale di Venezia*, n. 880.

28 Giovanni Domenico Ottonelli, *Trattato della Pittura e Scultura* (Florence, 1652), pp. 234–5.

29 Giovanni Gaye, *Carteggio inedito d'artisti dei secoli XIV–XVI* (Florence, 1840), vol. III, pp. 428 (n.CCCLXII), 433–4 (n.CCCLXXIII); A. Bertolotti, *Artisti in relazione coi Gonzaga signori di Mantova* (Modena, 1885), pp. 156–7.

30 Luigi Groto, *Lettere Famigliari* (Venice, 1601), p. 130.

31 Julien Zarco-Bacas y Cuevas, *Pintores italians en San Lorenzo 1575–1611* (Madrid, 1932), p. 54, doc. 18. Tintoretto probably shared the sum of 800 ducats with Veronese, who sent his *Annunciation* to El Escorial in the same package.

32 Pallucchini and Rossi, *Jacopo Tintoretto*, vol. I, pp. 227–8, no. 446.

33 Pietro Paoletti, *La Scuola Grande di San Marco* (Venice, 1929), p. 184. Tintoretto donated the paintings in return for the admission of his son, son-in-law and two friends to the scuola.

34 Von Hadeln, 'Beiträge zur Tintorettoforschung', p. 32, n. 21.

35 Ridolfi, *Le Maraviglie dell' Arte*, pp. 62–3: 'Ricercato poi da Signori, a' quali aspettava la cura della ricognitione ch'ei richiedesse, qual premio à lui piacesse per la sua fatica, volendo eglino in tutto riferirsi alla sua richiesta, rispose non volere, che rimettersi nella gratia loro; dalla cui gentil maniera legati gli assegnarono una generosa mercede. Mà egli (per quello si dice) non volle meno accetarla, contentandosi di molto meno, volendo per avventura in quella guisa far preda degli affetti loro, che seguì con ammiratione non solo de' Signori, mà de Pittori medisimi, che havevano di secreto estimata quell'opera gran summa di scudi.'

36 Emmanuele Cicogna, *Delle iscrizione veneziane* (Venice, 1824–53), vol. IV, p. 352, n. 259.

37 *Ibid.*, vol. IV, p. 353, n. 264.

38 *Ibid.*, vol. IV, p. 353, n. 270.

39 *Ibid.*, vol. IV, p. 344, n. 245.

APPENDIX 2: GENEALOGY OF THE 'TOCCO D'ORO' SORANZO

1 Archivio di Stato, Venice: 'Barbaro Albori', Misc. Cod. 898, The Soranzo (L); Biblioteca Nazionale Marciana, Venice: 'Nozze scritte da Marco Barbaro', Mss. H. Cl.VII cod.156 (=8492), cod. 925–8 (=8594–7), p. 115; Biblioteca Nazionale Marciana, Venice: Capellari, 'Il Campiodoglio Veneto', Mss. It. Cl. VII 16 (=8305), the Soranzo (D).

Select Bibliography

Aikema, Bernard, 'L'immagine della "Carità Veneziana"', in *Nel regno dei poveri: Arte e storia di grande ospedali veneziani in età moderna*, eds B. Aikema and D. Meijer (Venice, 1989), pp. 71–98

Arcangeli, Francesco, 'La "Disputa" del Tintoretto a Milano', *Paragone*, LXI (1955), pp. 21–34

Aretino, Pietro, *Lettere sull'arte di Pietro Aretino*, ed. E. Camesasca, 2 vols (Milan, 1957–60)

Banks, Elaine, *Tintoretto's Religious Imagery of the 1560s* (Michigan, 1978)

Barolsky, Paul, *Infinite Jest: Wit and Humor in Italian Renaissance Art* (Pennsylvania, 1975)

Bembo, Pietro, *Prose della volgar lingua* (Venice, 1525), ed. C. Dionosotti (Turin, 1960)

Bercken, Erich von der, *Die Gemälde des Jacopo Tintoretto* (Munich, 1942)

—, and August L. Mayer, *Jacopo Tintoretto*, 2 vols (Munich, 1923)

Berliner, Rudolf, 'Forschungen über die Tätigkeit Tintorettos in der Scuola di S. Rocco', *Kunstchronik und Kunstmarkt*, XXXI (1920), pp. 468–97

Boschini, Marco, *La carta del navegar pitoresco* (Venice, 1660), ed. A. Pallucchini (Rome and Venice, 1966)

Bouwsma, William, *Venice and the Defense of Republican Liberty. Renaissance Values in the Age of the Counter-Reformation* (Berkeley and Los Angeles, 1968)

Brown, Patricia Fortuni, *Venetian Narrative Painting in the Age of Carpaccio* (New Haven and London, 1988)

—, *Venice and Antiquity: The Venetian Sense of the Past* (New Haven and London, 1996)

Calmo, Andrea, *Le Lettere di Messer Andrea Calmo* (Venice, 1548), ed. V. Rossi (Turin, 1888)

Caravia, Alessandro, *Il sogno di Caravia* (Venice, 1541)

Cassegrain, Guillaume, '"Ces choses ont été des figures de ce qui nous concerne": Une lecture de la "Conversion de Saint Paul" du Tintoret', *Venezia cinquecento*, VI/12 (1996), pp. 55–85

Chambers, David S., Brian Pullan and Jennifer Fletcher, *Venice: A Documentary History, 1450–1630* (Oxford, 1992)

Cicogna, Emmanuele Antonio, *Delle iscrizione veneziane*, 6 vols (1824–53)

Cloulas, Annie, 'Les Peintures du grand retable au monastere de L'escurial', *Mélanges de la Casa de Velasquez*, IV (1968), pp. 174–88

Coffin, David, 'Tintoretto and the Medici Tombs', *Art Bulletin*, XXXIII (1951), pp. 119–25

Cohen, Charles E., *The Art of Giovanni Antonio da Pordenone: Between Dialect and Language*, 2 vols (Cambridge, 1996)

Coletti, Luigi, *Il Tintoretto* (Bergamo, 1940)

Cope, Maurice, *The Venetian Chapel of the Sacrament in the Sixteenth Century* (New York and London, 1979)

De Tolnay, Charles, 'L'interpretazione dei cicli pittorici del Tintoretto nella Scuola di San Rocco', *Critica d'arte*, VII (1960), pp. 341–76

—, 'Il Paradiso del Tintoretto', *Arte veneta*, XXIV (1970), pp. 103–10

De Vecchi, Pierluigi, *L'opera completa del Tintoretto* (Milan, 1970)

—, 'Invenzioni sceniche e iconografia del miracolo nella pittura di Jacopo Tintoretto', *L'arte*, XVII (1972), pp. 101–32

Dolce, Ludovico, *Dialogo della pittura* (Venice, 1557), in *Dolce's 'Aretino' and Venetian Art Theory of the Cinquecento*, English trans. by M. Roskill (New York, 1968)

Doni, Anton Francesco, *Disegno* (Venice, 1549), ed. Mario Pepe (Rome, 1970)

—, *Rime del Burchiello comentate dal Doni* (Venice, 1553)

—, *Tre libri di lettere* (Venice, 1552)

Dvořak, Max, *Geschichte der italienischen Kunst* (Munich, 1907–9)

Echols, Robert, 'Giovanni Galizzi and the Problem of the Young Tintoretto', *Artibus et Historiae*, XVI/31 (1995), pp. 69–110

Eikemeier, Peter, 'Der Gonzaga-Zyklus des Tintoretto in der Alten Pinacothek', *Münchener Jahrbuch der Bildenden Kunst*, XX (1969), pp. 75–142

Favaro, Elena, *L'arte dei pittori in Venezia e i suoi statuti* (Florence, 1975)

Finlay, Robert, *Politics in Renaissance Venice* (New Brunswick, 1980)

Fletcher, Jennifer, '"Fatto al specchio": Venetian Renaissance Attitudes to Self-Portraiture', in *Imagining the Self in Renaissance Italy* (Boston, 1992), pp. 45–60

Gallo, Rodolfo, 'La famiglia di Jacopo Tintoretto', *Ateneo veneto*, CXXXII (1941), pp. 73–92

Garas, K., 'Le tableau du Tintoret du Musée de Budapest et le cycle peint pour l'empereur Rodolphe II', *Bulletin du Musée Hongrois des Beaux-Arts*, XXX (1967), pp. 29–48

Gemin, Massimo, ed., *Nuovi studi su Paolo Veronese* (Venice, 1990)

Gentili, Augusto, 'Personaggi e metafore nell'Annunciazione di Jacopo Tintoretto per la Scuola Grande di San Rocco', *Venezia cinquecento*, VI/12 (1996), pp. 235–42

Ginzburg, Carlo, 'Titian, Ovid and Sixteenth-Century Codes for Erotic Illustrations', in *Titian's Venus of Urbino*, ed. R. Goffen (Cambridge, 1997), pp. 23–36

—, *Il formaggio e I vermi: Il cosmo di un mugnaio del '500* (Florence, 1976), in *The Cheese and the Worms: The Cosmos of a Sixteenth-Century Miller*, English trans. J. and A. Tedeschi (London and Henley, 1980)

Gould, Cecil, 'Sebastiano Serlio and Venetian Painting', *Journal of the Warburg and Courtauld Institutes*, XXV (1962), pp. 56–84

—, 'An X-ray of Tintoretto's "Milky Way"', *Arte veneta*, XXXII (1978), pp. 211–13

—, 'The Cinquecento at Venice III: Tintoretto and Space', *Apollo*, XCVI (1972), pp. 32–7

Grabski, Josef, 'The Group of Paintings by Tintoretto in the "Sala Terrena" of the Scuola di S. Rocco in Venice and Their Relationship to the Architectural Structure', *Artibus et Historiae*, I (1980), pp. 115–31

Grayson, Cecil, *A Renaissance Controversy: Latin or Italian* (Oxford, 1960)

Grendler, Paul, *Critics of the Italian World, 1530–60* (London, 1969)

Hauser, Arnold, *Mannerism: The Crisis of the Renaissance and the Origin of Modern Art* (London, 1965)

Hadeln, Detlev von, 'Archivalische Beiträge zur Geschichte der venezianischen Kunst aus dem Nachlass G. Ludwigs', *Italienische Forschungen*, IV (1911), pp. 124–31

—, 'Beiträge zur Tintorettoforschung', *Jahrbuch der Königlich Preussischen Kunstsammlungen*, XXXII (1911)

Hale, John, ed., *Renaissance Venice* (London, 1973)

Hills, Paul, 'Piety and Patronage in Cinquecento Venice: Tintoretto and the Scuole del Sacramento', *Art History*, VI (1983), pp. 30–43

—, 'Decorum and Desire in Some Works by Tintoretto', in *Decorum in Renaissance Narrative Art*, eds F. Ames-Lewis and A. Bednarek (London, 1992), pp. 121–8

—, 'Tintoretto's Marketing', in *Venedig und Oberdeutschland in der Renaissance*, eds B. Roeck, K. Bergholt and A. Martin (Venice, 1993), pp. 107–20

Hochmann, Michel, *Peintres et commanditaires à Venise, 1540–1628*, Collection de l'Ecole Française de Rome, CLV (Paris and Rome, 1992)

Hope, Charles, 'Titian as a Court Painter', *Oxford Art Journal*, II/2 (1979), pp. 7–10

—, *Titian* (London, 1980)

Humfrey, Peter, *Painting in Renaissance Venice* (New Haven and London, 1995)

—, and Richard Mackenny, 'Venetian Trade Guilds as Patrons of Art in the Renaissance', *The Burlington Magazine*, CXXVIII (1986), pp. 317–30

Huse, Norbert, and Wolfgang Wolters, *The Art of Renaissance Venice* (Chicago and London, 1990)

Huttinger, Eduard, *Die Bilderzyklen Tintorettos in der Scuola di S. Rocco zu Venedig* (Zurich, 1962)

Ivanoff, Nicola, 'Il ciclo eucaristico di S. Giorgio Maggiore a Venezia', *Notizie da Palazzo Albani*, IV/2 (1975), pp. 50–57

Jacopo Tintoretto 1519–1594. Il grande collezionismo mediceo, exh. cat. by Marco Chiarini, Sergio Marinelli and Angelo Tartuferi, Palazzo Pitti, Florence (1994)

Jacopo Tintoretto ritratti, exh. cat., ed. Paola Rossi, Gallerie dell' Accademia, Venice, and Kunsthistorisches Museum, Vienna (Milan, 1994)

Knopfel, Dagmar, 'Sui dipinti di Tintoretto per il coro della Madonna dell'Orto', *Arte veneta*, XXXVII (1984), pp. 149–54

Kris, Ernst and Otto Kurz, *Legend, Myth and Magic in the Image of the Artist: A Historical Experiment* (London, 1979)

Krischel, Roland, *Jacopo Tintorettos 'Sklavenwunder'* (Munich, 1991)

—, *Tintoretto* (Hamburg, 1994)

—, 'Tintoretto e la scultura veneziana', *Venezia cinquecento*, VI/12 (1996), pp. 5–54.

Lane, Frederic C., *Venice: A Maritime Republic* (Baltimore and London, 1973)

Lepschy, Anna Laura, *Tintoretto Observed: A Documentary Survey of Critical Reactions from the 16th to the 20th Century* (Ravenna, 1983)

Levey, Michael, 'Tintoretto and the Theme of Miraculous Invention', *Journal of the Royal Society of Arts*, CXIII (1965), pp. 707–25

Levie, Simon H., 'Daniele da Volterra e Tintoretto', *Arte veneta*, VII (1953), pp. 168–70

Logan, Oliver, *Culture and Society in Renaissance Venice, 1470–1790* (London, 1972)

Lorenzetti, Giulio, 'Il Tintoretto e l'Aretino', *La mostra del Tintoretto a Venezia*, fasc. I (1937), pp. 7–14

—, 'Una nuova data sicura nella cronologia tintorettiana', *Arte veneto*, XVI (1938), pp. 129–38

Lorenzi, Giambattista, *Monumenti per servire alla storia del Palazzo Ducale di Venezia* (Venice, 1868)

Luzio, Alessandro, 'I fasti gonzagheschi dipinti dal Tintoretto', *Archivio storico dell' arte* (1890), vol. III, pp. 397–9

MacAndrew, Hugh, Deborah Howard, John Dick and Joyce Plesters, 'Tintoretto's "Deposition of Christ" in the National Gallery of Scotland', *The Burlington Magazine*, CXXVII (1985), pp. 501–17

Manno, Antonio, *Tintoretto. Sacre rappresentazioni nelle chiese di Venezia* (Venice, 1994)

Marinelli, Sergio, 'La costruzione dello spazio nelle opere di Jacopo Tintoretto', in *La Prospettiva rinascimentale*, ed. M. Dalai Emiliani (Florence, 1980), pp. 319–30.

Martin, Alfred von, *Sociology of the Renaissance*, trans. Wolfgang Luetkins (London, 1944)

Massimi, Maria Elena, 'Jacopo Tintoretto e i confratelli della Scuola Grande di San Rocco: Strategie culturali e committenza artistica', *Venezia cinquecento*, V/9 (1995), pp. 5–169

Matile, Michael, '"Quadri laterali", ovvero conseguenze di una collocazione ingrata: Sui dipinti di storie sacre nell'opera di Jacopo Tintoretto', *Venezia cinquecento*, VI/12 (1996), pp. 151–206

Mercati, Angelo, 'La scrittura per la "Presentazione della Madonna al Tempio" del Tintoretto a Madonna dell' Orto, in *La Mostra del Tintoretto a Venezia*, (Venice, 1937), vol. II, pp. 1–7

Muir, Edward, 'Images of Power: Art and Pageantry in Renaissance Venice', *American Historical Review*, LXXXIV (1979), pp. 16–52

Newton, Eric, *Tintoretto* (London, 1952)

Nichols, Tom, 'Tintoretto's Poverty', in *New Interpretations of Venetian Renaissance Painting*, ed. F. Ames-Lewis (London, 1994), pp. 99–110

—, 'Price, Prestezza and Production in Jacopo Tintoretto's Business Strategy', *Venezia cinquecento*, VI/12 (1996), pp. 207–33

—, 'Tintoretto, Prestezza and the Poligrafi: A Study in the Literary and Visual Culture of Cinquecento Venice', *Renaissance Studies*, X/1 (1996), pp. 72–100

Nicoletti, Giuseppe, 'Illustrazione della Chiesa e Scuola di S. Rocco in Venezia', *Miscellanea R. deputazione veneta sopra gli storia patria*, III (1885), pp. 1–69

Pallucchini, Anna, 'Venezia religiosa nella pittura del cinquecento', *Studi veneziani*, XIV (1972), pp. 179–84

Pallucchini, Rodolfo, *La giovanezza del Tintoretto* (Milan, 1950)

—, and Paola Rossi, *Jacopo Tintoretto: Le opere sacre e profane*, 2 vols (Milan, 1982)

Penny, Nicholas, 'John Ruskin and Tintoretto', *Apollo*, XCIX (1974), pp. 268–73

Pignatti, Terisio, and Filippo Pedrocco, *Veronese*, 2 vols (Milan, 1995)

Pino, Paolo, *Dialogo della pittura* (Venice, 1548), in *Trattati d'arte del cinquecento*, ed. Paola Barocchi (Bari, 1960)

Pittaluga, Mary, *Il Tintoretto* (Bologna, 1925)

Plesters, Joyce, 'The Examination of the Tintorettos', in *Restoring Venice: The Church of the Madonna dell' Orto*, eds A. Clarke and P. Rylands (London, 1977), pp. 84–91

—, 'Tintoretto's Paintings in the National Gallery', *National Gallery Technical Bulletin* (1979), pp. 3–24; (1980), pp. 32–48

—, and Lorenzo Lazzarini, 'Preliminary Observations on the Techniques and Materials of Tintoretto', in *Conservation and Restoration of Pictorial Art*, eds N. Bromelle and P. Smith (London, 1976), pp. 7–26

Pullan, Brian, *Rich and Poor in Renaissance Venice: The Social Institutions of a Catholic State to 1620* (Oxford, 1971)

Rambaldi, Pier Luigi, 'Un oppunto intorno al Tintoretto e ad Andrea Vicentino', *Rivista d'arte*, VII (1910)

Rearick, W. Roger, 'Reflections on Tintoretto as a Portraitist', *Artibus et Historiae*, XVI/31 (1995), pp. 51–68

Ridolfi, Carlo, *Vita di Giacomo Robusti detto il Tintoretto* (Venice, 1642),

English trans. by C. and R. Enggass as *The Life of Tintoretto and of His Children Domenico and Marietta* (University Park, PA and London, 1984)

—, *Le Maraviglie dell' Arte* (Venice, 1648), ed. D. von Hadeln, 2 vols (Berlin, 1914–24)

Ripa, Cesare, *Iconologia* (Rome, 1603)

Romanelli, Giandomenico, *et al.*, *Tintoretto: La Scuola Grande di San Rocco* (Milan, 1994)

Rosand, David, *Painting in Sixteenth-Century Venice: Titian, Veronese, Tintoretto* (rev. edn, Cambridge, 1997)

Rossi, Paola, *Jacopo Tintoretto: I ritratti* (Venice, 1974)

—, *I disegni di Jacopo Tintoretto* (Florence, 1975)

—, and Lionello Puppi, eds, *Jacopo Tintoretto nel quarto centenario della morte* (Venice, 1996)

Ruskin, John, *Modern Painters* (London, 1846), vol. II, of *The Works of John Ruskin*, eds E. T. Cook and A. Wedderburn (London, 1903)

Sartre, Jean-Paul, 'Le Séquestré de Venise', *Les temps modernes*, XIII (1957), as 'The Venetian Pariah', in *Essays in Aesthetics*, English trans. W. Baskin (New York, 1963), pp. 1–45

Schulz, Juergen, *Venetian Painted Ceilings of the Renaissance* (Berkeley and London, 1968)

—, 'Tintoretto and the First Competition for the Ducal Palace "Paradise"', *Arte veneta*, XXXIII (1980), pp. 112–26

Sforza, Giovanni, 'Riflessi della controriforma nella repubblica', *Archivio storico*, XCIII (1935), pp. 181–6

Sohm, Philip, *Pittoresco: Marco Boschini, His Critics, and Their Critiques of Painterly Brushwork in Seventeenth- and Eighteenth-Century Italy* (Cambridge, 1991)

Sinding-Larsen, Staale, *Christ in the Council Hall: Studies in the Religious Iconography of the Venetian Republic*, Acta ad archaeologiam et actium historiam pertinentia, Institutum Romanum Norvegiae, V (Rome, 1974)

Steinberg, Leo, 'Michelangelo's Madonna Medici and Related Works', *The Burlington Magazine*, CXIII (1971), pp. 145–9

Swoboda, Karl M., *Tintoretto: Ikonographische und stilistische Untersuchungen* (Vienna and Munich, 1982)

Tafuri, Manfredo, *Venezia e il Rinascimento* (Turin, 1985), English trans. J. Levine as *Venice and the Renaissance* (Cambridge, MA, and London, 1989)

—, ed., *'Renovatio Urbis': Venezia nell' eta di Andrea Gritti (1523–1538)* (Rome, 1984)

Tardito, Rosalba, *Il ritrovamento del corpo di San Marco del Tintoretto: Vicende e restauri* (Florence, 1990)

Thode, Henry, *Tintoretto* (Bielefeld and Leipzig, 1901)

Tietze, Hans, *Tintoretto: The Paintings and Drawings* (London, 1948)

Da Tiziano a El Greco. Per la storia del Manierismo a Venezia, 1540–1590, exh. cat., ed. by Rodolfo Pallucchini, Ducal Palace, Venice (Milan, 1981)

Vasari, Giorgio, *Le vite de' più eccellenti pittori, scultori ed architettori* (Florence, 1568), ed. G. Milanesi, 9 vols (Florence, 1878–85); *Lives of the Painters, Sculptors and Architects*, English trans. G. de Vere, 2 vols (London, 1996)

Vescovi, Pietro, 'Sier Andrea Calmo: Nuovi documenti e preposte', *Quaderne veneti*, II (1985), pp. 25–47

Weddigen, Erasmus, 'Thomas Philologus Ravennas: Gelehrter, Wohltäter und Mäzen', *Saggi e memorie di storia dell' arte*, IX (1974), pp. 7–76

—, 'Il secondo pergolo di San Marco e la loggetta del Sansovino: Preliminari al Miracolo dello Schiavo di Jacopo Tintoretto', *Venezia cinquecento*, I (1991), pp. 101-29.

—, 'Zur Ikonographie der Bamberger "Assunta" von Jacopo Tintoretto', in *Die Bamberger 'Himmelfahrt Mariae' von Jacopo Tintoretto*, Internationales Kolloquium in München (Munich, 1986), pp. 61–112

Whitaker, Lucy, 'Tintoretto's Drawings after Sculpture and His Workshop Practice', in *The Sculpted Object, 1400–1700* (Aldershot, 1997), pp. 177–200

Wiel, Maria, ed., *Jacopo Tintoretto e i suoi incisori* (Milan, 1994)

Wolters, Wolfgang, *Der Bilderschmuck des Dogenpalastes: Untersuchungen zur Selbstdarstellung der Republik Venedig im 16. Jahrhundert* (Wiesbaden, 1983)

Zanetti, Anton Maria, *Varie pitture a fresco de'principali maestri veneziani* (Venice, 1760)

Zuccari, Federico, *Il lamento della pittura su l'onde venete* (Parma, 1605), *Scritti d'arte di Frederico Zuccari*, ed. D. Heikamp (Florence, 1961)

List of Illustrations

3.33 × 2.75. Christ Church Library, Oxford. Photo: Courtesy of the Governing Body, Christ Church.

43 Jacopo Tintoretto, *Study after a statuette of Michelangelo's 'Giuliano de' Medici'*, 1545/50, black chalk heightened with white lead on blue paper, 3.15 × 2.66. Christ Church Library, Oxford. Photo: Courtesy of the Governing Body, Christ Church.

44 Francesco Salviati, *Seated Female Nude*, c. 1554/6, black chalk, 2.19 × 2.62. British Museum, London.

45 Michelangelo Buonarroti, *Day*, 1526–34, marble, 1.185 high. Medici Chapel, San Lorenzo, Florence. Photo: Alinari.

46 Michelangelo Buonarroti, *Giuliano de' Medici*, 1521–34, marble, 172.72 high. Medici Chapel, San Lorenzo, Florence. Photo: Alinari.

47 Nicolas Beatrizet, *Conversion of St Paul after Michelangelo*, 1547, engraving. Bibliothèque Nationale de France, Paris.

48 Jacopo Tintoretto, *Miracle of the Slave (Miracle of St Mark)*, 1548, oil on canvas, 416 × 544. Gallerie dell'Accademia, Venice. Photo: Osvaldo Böhm.

49 Jacopo Tintoretto, *Study after a statuette of Michelangelo's 'Samson and the Philistines'*, 1545/50, charcoal heightened with white lead on grey paper, 4.52 × 2.74. Collection of the Courtauld Institute of Art, London.

50 Jacopo Tintoretto, detail from illus. 48. Photo: Osvaldo Böhm.

51 Jacopo Sansovino, *Miracle of the Slave (Miracle of St Mark)*, 1541/4, bronze relief, 48.3 × 65.4. Tribune, San Marco, Venice. Photo: Osvaldo Böhm.

52 Jacopo Tintoretto, *Voyage of St Ursula and the Virgins*, 1550/5, oil on canvas, 330 × 178. San Lazzaro dei Mendicanti, Venice. Photo: Osvaldo Böhm.

53 Vittore Carpaccio, *Arrival in Rome*, c. 1494/5, oil on canvas, 281 × 307. Gallerie dell'Accademia, Venice. Photo: Osvaldo Böhm.

54 Jacopo Tintoretto, *Assumption of the Virgin*, c. 1555, oil on canvas, 440 × 260. Church of the Assunta ai Gesuiti, Venice. Photo: Osvaldo Böhm.

55 Jacopo Tintoretto, *Assumption of the Virgin*, c. 1555, oil on canvas, 437 × 265. Obere Pfarrkirche, Bamberg.

56 Jacopo Tintoretto, *St Louis, St George and the Princess*, 1552, oil on canvas, 226 × 146. Gallerie dell'Accademia, Venice. Photo: Osvaldo Böhm.

57 Titian, *Assumption of the Virgin*, 1516–18, oil on panel, 690 × 360. Santa Maria Gloriosa dei Frari, Venice. Photo: Osvaldo Böhm.

58 Bonifazio de' Pitati, *St James the Greater and St Jerome*, 1548, oil on canvas. Fondazione Cini (on loan from Gallerie dell'Accademia, Venice).

59 Jacopo Tintoretto, *Last Supper*, c. 1556/8, oil on canvas, 221 × 413. Chapel of the Sacrament, San Trovaso, Venice. Photo: Osvaldo Böhm.

60 Anon, *Portrait of Lodovico Dolce*, 1561, woodcut from Dolce, *Impresa del conte Orlando* (Venice, 1572).

61 Jacopo Sansovino, *Head of Francesco Sansovino*, c. 1545, bronze relief. Sacristy Door, San Marco, Venice. Photo: Osvaldo Böhm.

62 Titian, detail of the lower foreground of *Diana and Acteon*, 1556/9, oil on canvas. National Gallery of Scotland, Edinburgh.

63 Tintoretto, detail of central part from illus. 156. Photo: Osvaldo Böhm.

64 Titian, *Portrait of Cardinal Pietro Bembo*, c. 1540, oil on canvas, 94.5 × 76.5. National Gallery of Art, Washington, DC (Samuel H. Kress Collection).

65 Titian, *Portrait of Pietro Aretino*, 1545, oil on canvas, 96.7 × 77.6. Pitti Palace, Florence. Photo: Soprintendenza per i Beni Artistici e Storici, Firenze (Gabinetto Fotografico).

66 Enea Vico, *'Medal' of Anton Francesco Doni*, engraving from A. F. Doni, *La prima parte de le medaglie del Doni* (Venice, 1550).

67 Jacopo Tintoretto, *Christ Washing His Disciples' Feet*, c. 1547–9, oil on canvas, 210 × 533. Museo del Prado, Madrid (on loan from El Escorial). Photo: Scala.

68 Sebastiano Serlio, *Scena Tragica*, woodcut from *Il secondo libro dell' architettura* (Paris, 1545), fol. 69.

69 Jacopo Tintoretto, detail of illus. 20. Photo: Osvaldo Böhm.

70 Paolo Veronese, *Feast in the House of Levi*, 1573, oil on canvas, 555 × 1280. Gallerie dell'Accademia, Venice. Photo: Osvaldo Böhm.

71 Paolo Veronese, *Venus, Mars and Cupid*, c. 1561/2, oil on canvas, 47 × 47. Galleria Sabauda, Turin.

72 Jacopo Tintoretto, *Leda and the Swan*, 1550/5, oil on canvas, 167 × 221. Galleria degli Uffizi, Florence. Photo: Scala.

73 Titian, *Venus with an Organist and Dog*, c. 1550, oil on canvas, 136 × 220. Museo del Prado, Madrid.

74 Jacopo Tintoretto, *Venus, Vulcan and Mars*, c. 1550/1, oil on canvas, 135 × 198. Alte Pinakothek, Munich. Photo: Artothek.

75 Jacopo Tintoretto, *Venus and Vulcan*, c. 1550–51, pen and brush, black ink and white lead on blue paper, 20.4 × 27.3. Staatliche Museen zu Berlin (Kupferstichkabinett). Photo: Preußischer Kulturbesitz/Jörg P. Anders.

76 Jacopo Tintoretto, *Susanna and the Elders*, c. 1550, oil on canvas, 167 × 238. Musée du Louvre, Paris. Photo: © Photo RMN/Bellot/Schormans.

77 Jacopo Tintoretto, *Susanna and the Elders*, c. 1555, oil on canvas, 146.6 × 193.6. Kunsthistorisches Museum, Vienna.

78 Marcantonio Raimondi, *Venus Drying Her Foot*, engraving. Bibliothèque Nationale de France.

79 Titian, *Venus with a Mirror*, c. 1555, oil on canvas, 124.5 × 105.5. National Gallery of Art, Washington, DC (Andrew W. Mellon Collection).

80 Paolo Veronese, *Susanna and the Elders*, 1580/5, oil on canvas, 151 × 177. Museo del Prado, Madrid.

81 Jacopo Tintoretto, *Temptation of Adam*, c. 1550/3, oil on canvas, 150 × 220. Gallerie dell'Accademia, Venice. Photo: Osvaldo Böhm.

82 Jacopo Tintoretto, detail of upper right from illus. 156. Photo: Osvaldo Böhm.

83 Jacopo Tintoretto, *Latona Changing the Lycian Peasants into Frogs*, c. 1542/3, oil on panel, 22.6 × 65.5. Courtauld Gallery, London.

84 Jacopo Tintoretto, *The Prophecy of David*, c. 1543/4, oil on panel, 29 × 153.5. Kunsthistorisches Museum, Vienna.

85 Jacopo Tintoretto, *Adoration of the Shepherds*, 1583, oil on canvas, 315 × 190. Nuevos Museos, El Escorial. Photo: Scala.

86 Jacopo Tintoretto, *Triumph of Doge Nicolò da Ponte*, c. 1579–82, oil on canvas. Palazzo Ducale, Venice (ceiling of the Sala del Maggiore Consiglio). Photo: Osvaldo Böhm.

87 Titian, *Martyrdom of St Lawrence*, 1547–56, oil on canvas,

493 × 277. Church of the Assunta Ai Gesuiti, Venice. Photo: Osvaldo Böhm.

88 Jacopo Tintoretto, *Raising of Lazarus*, c. 1580/5, oil on canvas, 178 × 254. Museum der Bildenden Künste, Leipzig.

89 Jacopo Tintoretto, *Raising of Lazarus*, 1573, oil on canvas, 67.5 × 77.5. Private collection, courtesy of Sotheby's.

90 Jacopo Tintoretto, *Philosopher*, 1571–2, oil on canvas, 250 × 160. Libreria Marciana, Venice. Photo: Osvaldo Böhm.

91 Jacopo Tintoretto, *St Jerome*, c. 1571/2, oil on canvas, 143.5 × 103. Kunsthistorisches Museum, Vienna.

92 Paolo Veronese, *Paradise*, c. 1579/82, oil on canvas, 87 × 234. Musée des Beaux-Arts, Lille. Photo: RMN - Hervé Lewandowski.

93 Jacopo Tintoretto, *Paradise*, c. 1579/82, oil on canvas, 143 × 362. Musée du Louvre, Paris. Photo: RMN - R. G. Ojeda.

94 Jacopo Tintoretto, *Paradise*, 1588/92, oil on canvas, 700 × 2200. Sala del Maggior Consiglio, Palazzo Ducale, Venice. Photo: Osvaldo Böhm.

95 Jacopo Tintoretto, *Paradise*, c. 1588, oil on canvas, 164 × 492. Museo Thyssen-Bornemisza, Madrid.

96 Jacopo Tintoretto, *Portrait of Doge Girolamo Priuli*, c. 1559/60, oil on canvas, 99.7 × 81.3. Detroit Institute of Arts. (Gift of Dr Wilhelm R. Valentiner). Photo: © The Detroit Institute of Arts 1998.

97 Jacopo Tintoretto, *Portrait of Procurator Antonio Capello*, c. 1560/2, oil on canvas, 114 × 80. Gallerie dell'Accademia, Venice. Photo: Osvaldo Böhm.

98 Jacopo Tintoretto, *Man with a Golden Chain*, c. 1560, oil on canvas, 103 × 76. Museo del Prado, Madrid. Madrid. Photo: Scala.

99 Jacopo Tintoretto, *Portrait of Doge Pietro Loredan*, c. 1567/70, oil on canvas, 125 × 100. Szépmüvészeti Múzeum, Budapest.

100 Jacopo Tintoretto, *Portrait of Doge Alvise Mocenigo*, c. 1570/3, oil on canvas, 116 × 97. Gallerie dell'Accademia, Venice. Photo: Osvaldo Böhm.

101 Jacopo Tintoretto, *Virgin and Child with Four Senators*, 1553, oil on canvas, 188 × 146. Gallerie dell'Accademia, Venice. Photo: Osvaldo Böhm.

102 Jacopo Tintoretto, *Virgin and Child with Sts Sebastian, Mark and Theodore Adored by Three Camerlenghi (Madonna of the Treasurers)*, c. 1567, oil on canvas, 221 × 521. Gallerie dell'Accademia, Venice. Photo: Osvaldo Böhm.

103 Titian, *Portrait of Doge Andrea Gritti*, c. 1545, oil on canvas, 133.6 × 103.2. National Gallery of Art, Washington, DC (Samuel H. Kress Collection).

104 Titian, *Portrait of Pope Paul III*, 1543, oil on canvas, 106 × 85. Museo e Gallerie Nazionali di Capodimonte, Naples.

105 Jacopo Tintoretto, *Doge Andrea Gritti before the Virgin and Child with Sts Marina, Bernardino, Louis and Mark*, c. 1581/4, oil on canvas, 360 × 500. Sala del Collegio, Palazzo Ducale, Venice.

106 Anonymous woodcut after the burnt picture of 1531 by Titian formerly in the Ducal Palace, Venice.

107 Vicenzo Catena, *Portrait of Doge Andrea Gritti*, c. 1530, oil on canvas, 97 × 79. National Gallery, London.

108 Jacopo Tintoretto, *Portrait of Procurator Marco Grimani*, 1576/83, oil on canvas, 96 × 60. Kunsthistorisches Museum, Vienna.

109 Jacopo Tintoretto, *Portrait of Procurator Vincenzo Morosini*, c. 1580, oil on canvas, 84.5 × 51.5. National Gallery, London.

110 Jacopo Tintoretto, *Christ Carried to the Tomb*, c. 1564/5, oil on canvas, 164 × 127.5. National Gallery of Scotland, Edinburgh, purchased by Private Treaty with the aid of the National Heritage Memorial Fund 1984. Photo: National Galleries of Scotland.

111 Jacopo Tintoretto, *Martyrdom of St Lawrence*, 1569/76, oil on canvas, 93.5 × 118.2. Private collection. Photo: courtesy of the Walpole Gallery, London.

112 Jacopo Tintoretto, *Portrait of Procurator Jacopo Soranzo*, c. 1550, oil on canvas, 106 × 90. Gallerie dell'Accademia, Venice. Photo: Osvaldo Böhm.

113 Jacopo Tintoretto, *Portrait of Fourteen Members of the Soranzo Family*, 1551–65, oil on canvas, 151 × 216 (left fragment). Pinacoteca, Castello Sforzesco, Milan.

114 Jacopo Tintoretto, *Portrait of Fourteen Members of the Soranzo Family*, 1551–65, oil on canvas, 153 × 215 (right fragment). Pinacoteca, Castello Sforzesco, Milan.

115 Jacopo Tintoretto, *Portrait of Jacopo Soranzo*, c. 1551, oil on canvas, 75 × 60 (central fragment). Pinacoteca, Castello Sforzesco, Milan.

116 Jacopo Tintoretto, *Portrait of Lorenzo Soranzo*, 1553, oil on canvas, 114 × 95.5. Kunsthistorisches Museum, Vienna.

117 Jacopo Tintoretto, *Ludovico Gonzaga II defeats the Venetians at the Battle of Adige (1439)*, 1578/9, oil on canvas, 273 × 385.5. Alte Pinakothek, Munich. Photo: Bayerische Staatsgemäldesammlungen, Munich.

118 Jacopo Tintoretto, *Battle of Argenta (1482)*, 1579/82, oil on canvas, 424 × 568. Palazzo Ducale, Venice (ceiling of the Sala del Maggior Consiglio).

119 Paolo Veronese, *Annunciation*, 1583, oil on canvas, 440 × 188. Nuevos Museos, El Escorial.

120 Jacopo Tintoretto, *Origin of the Milky Way*, c. 1577/80, oil on canvas, 148 × 165.1. National Gallery, London.

121 Jacopo Tintoretto, *Temptation of St Antony*, c. 1577/8, oil on canvas, 282 × 165. San Trovaso, Venice. Photo: Osvaldo Böhm.

122 Jacopo Sansovino/Alessandro Vittoria, *Monument to Tommaso Rangone*, c. 1557/60, life-sized bronze. San Giuliano, Venice. Photo: Osvaldo Böhm.

123 Jacopo Tintoretto, *Removal of the Body of St Mark*, 1562/6, oil on canvas, 398 × 315 (fragment). Gallerie dell'Accademia, Venice. Photo: Osvaldo Böhm.

124 Jacopo Tintoretto, *Finding of the Body of St Mark*, 1562/6, oil on canvas, 405 × 405. Pinacoteca di Brera, Milan. Photo: Scala.

125 Jacopo Tintoretto, *Deposition of Christ from the Cross*, c. 1560, oil on canvas, 227 × 294. Gallerie dell'Accademia, Venice. Photo: Osvaldo Böhm.

126 Jacopo Tintoretto, *Baptism of Christ*, c. 1580, oil on canvas, 283 × 162. San Silvestro, Venice. Photo: Osvaldo Böhm.

127 Jacopo Tintoretto, *Way to Calvary*, 1566/7, oil on canvas, 515 × 390. Scuola Grande di San Rocco, Venice (Sala dell'Albergo).

128 The Scuola Grande di San Rocco, exterior view from the Campo dei Frari. Photo: Osvaldo Böhm.

129 The Scuola Grande di San Rocco, exterior view of the rear façade.

130 Jacopo Tintoretto, *Christ at the Pool of Bethesda*, 1559, oil on canvas, 238 × 560. San Rocco, Venice.

131 Jacopo Tintoretto, *Resurrection of Christ with Sts Cassiano and*

Cecilia, 1565, oil on canvas, 450 × 225. San Cassiano, Venice. Photo: Osvaldo Böhm.

132 Jacopo Tintoretto, *St Roch in Glory*, 1564, oil on canvas, 240 × 360. Scuola Grande di San Rocco, Venice (ceiling of the Sala dell'Albergo). Photo: Antonio Quattrone.

133 Titian, detail of the upper part of the *Assumption of the Virgin*, 1516/18, oil on panel. Santa Maria Gloriosa dei Frari, Venice. Photo: Osvaldo Böhm.

134 Michelangelo Buonarroti, *God Separating Earth and Water*, 1508/12, fresco. Ceiling of the Sistine Chapel, Rome. Photo: Musei Vaticani (Archivio Fotografico).

135 Jacopo Tintoretto, *Allegory of the Scuola Grande di San Teodoro*, 1564, oil on canvas, 90 × 190. Scuola Grande di San Rocco, Venice (ceiling of the Sala dell'Albergo).

136 Jacopo Tintoretto, *Faith*, 1564, oil on canvas, 90 × 190. Scuola Grande di San Rocco, Venice (ceiling of the Sala dell'Albergo).

137 Jacopo Tintoretto, *Study for the Allegory of the Scuola Grande di San Teodoro*, 1564, black chalk on white paper, 2.98 × 2.10. Gabinetto dei Disegni, Galleria degli Uffizi, Florence.

138 Jacopo Tintoretto, *Doge Girolamo Priuli Assisted by St Mark before Peace and Justice*, 1564/5, oil on canvas, 230 × 230. Palazzo Ducale, Venice (central ceiling panel of the Sala dell'Atrio Quadrato). Photo: Osvaldo Böhm.

139 Jacopo Tintoretto, *Crucifixion*, 1565, oil on canvas, 536 × 1224. Scuola Grande di San Rocco, Venice (Sala dell'Albergo).

140 Jacopo Tintoretto, *Crucifixion*, c. 1554/5, oil on canvas, 282 × 445. Gallerie dell'Accademia, Venice. Photo: Osvaldo Böhm.

141 Jacopo Tintoretto, *Crucifixion*, 1568, oil on canvas, 341 × 371. San Cassiano, Venice.

142 Albrecht Altdorfer, 'Raising of the Cross' from the Small Passion cycle, c. 1513, woodcut, 7.2 × 4.8.

143 Jacopo Tintoretto, detail of illus. 139.

144 Giovanni Antonio da Pordenone, *Christ Nailed to the Cross*, 1520–22, fresco. Duomo, Cremona.

145 Daniele da Volterra, *Deposition of Christ from the Cross*, c. 1550/1, fresco. Santa Trinità dei Monti, Rome.

146 Jacopo Tintoretto, *Crucifixion*, c. 1563/5, oil on canvas, 297 × 165. Santa Maria del Rosario, Venice. Photo: Osvaldo Böhm.

147, 148 Jacopo Tintoretto, *Two Prophets*, 1566/7, oil on canvas, 340 × 135 each. Scuola Grande di San Rocco, Venice (Sala dell'Albergo).

149 Jacopo Tintoretto, *Ecce Homo*, 1566/7, oil on canvas, 260 × 390. Scuola Grande di San Rocco, Venice (Sala dell'Albergo).

150 Jacopo Tintoretto, *Christ Before Pilate*, 1566/7, oil on canvas, 515 × 380. Scuola Grande di San Rocco, Venice (Sala dell'Albergo).

151 Albrecht Dürer, 'Christ Before Herod', woodcut from the Small Passion cycle, 1511.

152 Interior view of the Sala Superiore, Scuola Grande di San Rocco, Venice.

153 Jacopo Tintoretto, *St Roch Visited by an Angel in Prison*, 1567, oil on canvas, 300 × 670. San Rocco, Venice.

154 Jacopo Tintoretto, *Brazen Serpent*, 1575/6, oil on canvas, 840 × 520. Scuola Grande di San Rocco, Venice (Sala Superiore). Photo: Antonio Quattrone.

155 Jacopo Tintoretto, detail from illus. 154 .

156 Jacopo Tintoretto, *Last Judgement*, c. 1560/2, oil on canvas, 1,450 × 590. Madonna dell'Orto, Venice. Photo: Osvaldo Böhm.

157 Jacopo Tintoretto, *St Roch*, 1578/81, oil on canvas, 250 × 80. Scuola Grande di San Rocco, Venice (Sala Superiore).

158 Roman copy after the *Laocoön*, 1st century AD, marble. Belvedere, Vatican, Rome.

159 Jacopo Tintoretto, *St Sebastian*, 1578/81, oil on canvas, 250 × 80. Scuola Grande di San Rocco, Venice (Sala Superiore).

160 Jacopo Tintoretto, *Moses Striking the Rock*, 1576/7, oil on canvas, 550 × 520. Scuola Grande di San Rocco, Venice, Sala Superiore.

161 Jacopo Tintoretto, detail of illus. 160.

162 Jacopo Tintoretto, *Gathering of Manna*, 1576/7, oil on canvas, 550 × 520. Scuola Grande di San Rocco, Venice (Sala Superiore). Photo: Antonio Quattrone.

163 Jacopo Tintoretto, *Pillar of Fire*, 1577/8, oil on canvas, 370 × 265. Scuola Grande di San Rocco, Venice (Sala Superiore).

164 Jacopo Tintoretto, *Jonah and the Whale*, 1577/8, oil on canvas, 265 × 370. Scuola Grande di San Rocco, Venice (Sala Superiore).

165 Jacopo Tintoretto, *Sacrifice of Isaac*, 1577/8, oil on canvas, 265 × 370. Scuola Grande di San Rocco, Venice (Sala Superiore).

166 Jacopo Tintoretto, *Elijah Fed by the Angel*, 1577/8, oil on canvas, 370 × 265. Scuola Grande di San Rocco, Venice (Sala Superiore).

167 Jacopo Tintoretto, *Vocation of Moses*, 1577/8, oil on canvas, 370 × 265. Scuola Grande di San Rocco, Venice (Sala Superiore).

168 Jacopo Tintoretto, *Vision of Ezekiel*, 1577/8, oil on canvas, 660 × 265. Scuola Grande di San Rocco, Venice (Sala Superiore).

169 Jacopo Tintoretto, *Jacob's Ladder*, 1577/8, oil on canvas, 660 × 265. Scuola Grande di San Rocco, Venice (Sala Superiore).

170 Jacopo Tintoretto, *Temptation of Adam*, 1577/8, oil on canvas, 265 × 370. Scuola Grande di San Rocco, Venice (Sala Superiore).

171 Jacopo Tintoretto, *Temptation of Christ*, 1578/81, oil on canvas, 539 × 330. Scuola Grande di San Rocco, Venice (Sala Superiore).

172 Jacopo Tintoretto, *Adoration of the Shepherds*, 1578/81, oil on canvas, 542 × 455. Scuola Grande di San Rocco, Venice (Sala Superiore).

173 Jacopo Tintoretto, detail of illus. 172.

174 Albrecht Dürer, *Nativity*, engraving, 1504, 18.5 × 12.

175 Jacopo Tintoretto, detail of illus. 172.

176 Jacopo Tintoretto, *Baptism of Christ*, 1578/81, oil on canvas, 538 × 465. Scuola Grande di San Rocco, Venice (Sala Superiore).

177 Jacopo Tintoretto, detail of illus. 176.

178 Jacopo Tintoretto, *Resurrection of Christ*, 1578/81, oil on canvas, 529 × 485. Scuola Grande di San Rocco, Venice (Sala Superiore).

179 Jacopo Tintoretto, *Agony in the Garden*, 1578/81, oil on canvas, 538 × 455. Scuola Grande di San Rocco, Venice (Sala Superiore).

180 Jacopo Tintoretto, detail of illus. 179.

181 Jacopo Tintoretto, *Study after the head of Giuliano de' Medici by Michelangelo*, 1545/50, black chalk heightened with lead white on dark paper, 3.68 × 2.72. Christ Church Library, Oxford.

182 Jacopo Tintoretto, *Last Supper*, 1578/81, oil on canvas, 538 × 487. Scuola Grande di San Rocco, Venice (Sala Superiore).

183 Jacopo Tintoretto, *Last Supper*, 1576, oil on canvas, 349 × 530. San Stefano, Venice. Photo: Osvaldo Böhm.

184 Jacopo Tintoretto, detail of illus. 182.

185 Jacopo Tintoretto, *St Roch Healing the Plague-Stricken*, 1549, oil on canvas, 307 × 673. Church of San Rocco, Venice.

186 Jacopo Tintoretto, *St Augustine Healing the Forty Cripples*, *c.* 1550, oil on canvas, 255 × 175. Museo Civico, Vicenza.

187 Jacopo Tintoretto, *Miracle of the Loaves and Fishes*, 1578/81, oil on canvas, 541 × 356. Scuola Grande di San Rocco, Venice (Sala Superiore).

188 Vittore Carpaccio, *Healing of the Possessed Man by the Patriarch of Grado*, 1494, oil on canvas, 365 × 389. Gallerie dell'Accademia, Venice. Photo: Osvaldo Böhm.

189 Jacopo Tintoretto, *Raising of Lazarus*, 1578/81, 529 × 485. Scuola Grande di San Rocco, Venice (Sala Superiore).

190 Jacopo Tintoretto, *Ascension of Christ*, 1578/81, oil on canvas, 538 × 325. Scuola Grande di San Rocco, Venice (Sala Superiore).

191 Jacopo Tintoretto, *The Pool at Bethesda*, 1578/81, oil on canvas, 533 × 529. Scuola Grande di San Rocco, Venice (Sala Superiore).

192 Interior view of the Sala Terrena.

193 Jacopo Tintoretto, *Annunciation*, 1581/2, oil on canvas, 422 × 545. Scuola Grande di San Rocco, Venice (Sala Terrena).

194 Titian, *Annunciation*, *c.* 1540, oil on canvas, 166 × 266. Scuola Grande di San Rocco, Venice.

195 Jacopo Tintoretto, *Adoration of the Magi*, 1581/2, oil on canvas, 425 × 544. Scuola Grande di San Rocco, Venice (Sala Terrena).

196 Jacopo Tintoretto, detail of illus. 195.

197 Jacopo Tintoretto, *Flight into Eygpt*, 1582/7, oil on canvas, 422 × 580. Scuola Grande di San Rocco, Venice (Sala Terrena).

198 Jacopo Tintoretto, *Massacre of the Innocents*, 1582/7, oil on canvas, 422 × 546. Scuola Grande di San Rocco, Venice (Sala Terrena).

199 Jacopo Tintoretto, *Female Saint Reading in a Landscape*, 1582/7, oil on canvas, 425 × 209. Scuola Grande di San Rocco, Venice (Sala Terrena).

200 Jacopo Tintoretto, *Female Saint Reading in a Landscape (with palm)*, 1582/7, oil on canvas, 425 × 211. Scuola Grande di San Rocco, Venice (Sala Terrena).

201 Jacopo Tintoretto, *Circumcision of Christ*, 1582/7, oil on canvas, 440 × 482. Scuola Grande di San Rocco, Venice (Sala Terrena).

202 Jacopo Tintoretto, *Assumption of the Virgin*, 1582/7, oil on canvas, 425 × 587. Scuola Grande di San Rocco, Venice (Sala Terrena).

203 Jacopo Tintoretto, *Bacchus, Ariadne and Venus*, 1578, oil on canvas, 146 × 167. Sala dell'Anticollegio, Palazzo Ducale, Venice. Photo: Osvaldo Böhm.

204 Jacopo Tintoretto, *Mercury and the Three Graces*, 1578, oil on canvas, 146 × 155. Sala dell'Anticollegio, Palazzo Ducale, Venice. Photo: Osvaldo Böhm.

205 Jacopo Tintoretto, *Flagellation of Christ*, *c.* 1585, oil on canvas, 118.3 × 106. Kunsthistorisches Museum, Vienna.

206 Titian, *Christ Crowned with Thorns*, 1570/6, oil on canvas, 280 × 182. Alte Pinakothek, Munich.

207 Jacopo Tintoretto, *Last Supper*, 1591/2, oil on canvas, 365 × 568. San Giorgio Maggiore, Venice. Photo: Osvaldo Böhm.

208 Jacopo Tintoretto, *Gathering of Manna*, 1591/2, oil on canvas, 377 × 576. San Giorgio Maggiore, Venice. Photo: Osvaldo Böhm.

209 Jacopo Tintoretto, detail of illus. 208 .

210 Paolo Veronese, *Gathering of Manna*, 1580/5, oil on canvas. Santi Apostoli, Venice. Photo: Osvaldo Böhm.

211 Jacopo Tintoretto, *Deposition of Christ*, 1594, oil on canvas, 288 × 166. San Giorgio Maggiore, Venice. Photo: Osvaldo Böhm.

212 Francesco Pianta the Younger, *Tintoretto as 'Painting'*, second half of the 17th century, wood carving. Scuola Grande di San Rocco, Venice (Sala Superiore). Photo: Osvaldo Böhm.

Index

Illustration numbers are in *italics*.